DAVID BUSCH'S

MASTERING DIGITAL SLR PHOTOGRAPHY

FOURTH EDITION

David D. Busch

Cengage Learning PTR

Professional • Technical • Reference

Australia, Brazil, Japan, Korea, Mexico, Singapore, Spain, United Kingdom, United States

CENGAGE Learning

Professional • Technical • Reference

David Busch's Mastering Digital SLR Photography, Fourth Edition
David D. Busch

Publisher and General Manager, Cengage Learning PTR:
Stacy L. Hiquet

Associate Director of Marketing:
Sarah Panella

Manager of Editorial Services:
Heather Talbot

Senior Marketing Manager:
Mark Hughes

Product Team Manager:
Kevin Harreld

Project Editor:
Jenny Davidson

Series Technical Editor:
Michael D. Sullivan

Interior Layout Tech:
Bill Hartman

Cover Designer:
Mike Tanamachi

Indexer:
Katherine Stimson

Proofreader:
Michael Beady

For product information and technology assistance, contact us at **Cengage Learning Customer & Sales Support, 1-800-354-9706**

For permission to use material from this text or product, submit all requests online at **cengage.com/permissions**
Further permissions questions can be emailed to **permissionrequest@cengage.com**

Library of Congress Control Number: 2014937101

ISBN-13: 978-1-305-27840-0

ISBN-10: 1-305-27840-2

Cengage Learning PTR
20 Channel Center Street
Boston, MA 02210
USA

Cengage Learning is a leading provider of customized learning solutions with office locations around the globe, including Singapore, the United Kingdom, Australia, Mexico, Brazil, and Japan. Locate your local office at: **international.cengage.com/region**

Cengage Learning products are represented in Canada by Nelson Education, Ltd.

For your lifelong learning solutions, visit **cengageptr.com**

Visit our corporate website at **cengage.com**

Printed in Canada
1 2 3 4 5 6 7 16 15 14

CENGAGE
Learning

Professional • Technical • Reference

#1 SELLING CAMERA
GUIDE AUTHOR

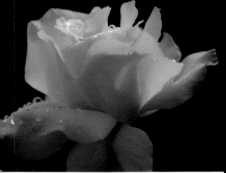

David Busch's

MASTERING

Digital SLR
Photography

Fourth Edition

The Serious
Photographer's Guide
to High-Quality
Digital SLR
Photography

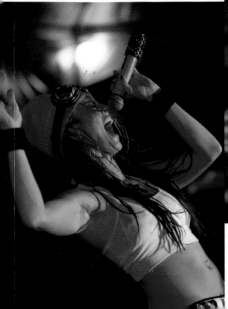

OVER
2 MILLION
BOOKS
IN PRINT

David D. Busch

For Cathy

Acknowledgments

Once again thanks to the folks at Cengage Learning PTR, who have pioneered publishing digital imaging books in full color at a price anyone can afford. Special thanks to product team manager, Kevin Harreld, who always gives me the freedom to let my imagination run free with a topic, as well as my veteran production team including project editor Jenny Davidson and series technical editor Mike Sullivan. Also thanks to Bill Hartman, layout; Katherine Stimson, indexing; Mike Beady, proofreading; Mike Tanamachi, cover design; and my agent, Carole Jelen, who has the amazing ability to keep both publishers and authors happy. I'd also like to thank the Continents of Europe and Asia, without which this book would have a lot of blank spaces where illustrations are supposed to go.

About the Author

With more than two million books in print, **David D. Busch** is the world's #1 selling digital camera guide author, and the originator of popular digital photography series like *David Busch's Compact Field Guides, David Busch's Pro Secrets*, and *David Busch's Quick Snap Guides*. He has written more than 100 hugely successful camera-specific guidebooks, compact guides, and general digital photography books on topics ranging from infrared and macro photography to electronic flash and lighting techniques. As a roving photojournalist for more than 20 years, he illustrated his books, magazine articles, and newspaper reports with award-winning images. He's operated his own commercial studio, suffocated in formal dress while shooting weddings-for-hire, and shot sports for a daily newspaper and upstate New York college. His photos and articles have appeared in *Popular Photography, Rangefinder, Professional Photographer*, and hundreds of other publications. He's also reviewed dozens of digital cameras for CNet and *Computer Shopper*. His advice has been featured on National Public Radio's *All Tech Considered*.

When About.com named its top five books on Beginning Digital Photography, debuting at the #1 and #2 slots were Busch's *Digital Photography All-In-One Desk Reference for Dummies* and *Mastering Digital Photography*. During the past year, he's had as many as five of his books listed in the Top 20 of Amazon.com's Digital Photography Bestseller list—simultaneously! Busch's 100-plus other books published since 1983 include bestsellers like *David Busch's Quick Snap Guide to Using Digital SLR Lenses*.

Busch is a member of the Cleveland Photographic Society (www.clevelandphoto.org), which has operated continuously since 1887. Visit his website at http://www.dslrguides.com/blog. There you'll find news, tips, and an errata page with typo alerts from sharp-eyed readers.

Contributor Bio

Series technical editor Michael D. Sullivan has added a great deal to this book through its four editions dating back more than a decade. In addition to checking all the text for technical accuracy, the veteran photographer (in the military sense of the word!), offered valuable input about current photographic techniques and technology, as well as insights into where both may be headed in the future. Mike also volunteered his expertise in Mac OS X for important behind-the-scenes testing of software and hardware.

Mike began his photo career in high school where he first learned the craft and amazed his classmates by having Monday morning coverage of Saturday's big game pictured on the school bulletin board. Sullivan pursued his interest in photography into the U.S. Navy, graduating in the top ten of his photo school class. Following Navy photo assignments in Bermuda and Arizona, he earned a BA degree from West Virginia Wesleyan College.

He became publicity coordinator for Eastman Kodak Company's largest division where he directed the press introduction of the company's major consumer products and guided their continuing promotion. Following a 25-year stint with Kodak, Sullivan pursued a second career with a PR agency as a writer-photographer covering technical imaging subjects and producing articles that appeared in leading trade publications. In recent years, Sullivan has used his imaging expertise as a technical editor specializing in digital imaging and photographic subjects for top selling books.

Contents

Chapter 3
dSLR Foibles 45

Chapter 4
Mastering Your Exposure Controls 83

Chapter 5
Mastering the Mysteries of Focus 117

Chapter 6
Working with Lenses 133

Chapter 7
Working with Light 169

PART II: EXPLORING NEW TOOLS

Chapter 8
Live View and Movies 189

Chapter 9
Exploring GPS and Wi-Fi 209

Chapter 10
Using Apps 219

Chapter 11
Great Gadgets 227

PART III: EXPAND YOUR SHOOTING WORLD

Chapter 12
Travel Photography 253

Chapter 13
People Photography 275

Chapter 14
Photographing Concerts and Performances 321

Chapter 15
Scenic, Wildlife, and Nature Photography 345

Chapter 16
Capturing Action 373

Chapter 17
Close-Up Photography 401

Index 421

Preface

Let David Busch—the mentor who helped you learn how to use your new digital SLR camera through his comprehensive guidebooks—give you the inside knowledge of how your camera can be used to master the tools and techniques for capturing the best images of your life. You won't find one word telling you how to overcome your digital camera's shortcomings in Photoshop. There are lots of great Photoshop books that can do that. The best part about the new breed of digital SLRs is that they have exciting new capabilities that will let you take great pictures *in the camera*, if you know how to use the tools at your fingertips. This book emphasizes digital *photography*. It shows you how to take compelling pictures and make great images using imaging technology, while taking into account the special strengths of digital SLR cameras. Whether you're a snap-shooting tyro, or a more experienced photographer moving into the digital SLR realm, you'll find the knowledge you need here. Every word in this book was written from the viewpoint of the serious photographer.

Introduction

The world of digital SLR photography has changed incredibly since the first edition of this book was published back at the dawn of the affordable digital single lens reflex in 2004. That's why this Fourth Edition is virtually a ground-up overhaul. It has new chapters, new examples, a stem-to-stern refreshing of every topic I covered the last time around, and coverage of things like HDR photography, Wi-Fi, and built-in GPS features that weren't even dreamt of a few years ago. I worked hard to make this the best-ever general guide to dSLR photography.

In the past few years, the dSLR camera has grown from being simply an upgrade from point-and-shoot and advanced non-SLR cameras to the predominant platform for serious photographers. Today, anyone who is an avid photographer can afford a digital SLR camera and lenses and other accessories for it. Those who need basic instruction for the most popular cameras can find the get-started information they need in one of the *David Busch's Guides* series. But for those of you who are looking for a deeper grounding in dSLR concepts and techniques, the information you need is between these covers.

Here are some of the latest innovations you'll want to learn about:

- Full-frame cameras are becoming more affordable and increasing in popularity.
- High-definition movie making has become standard in new cameras.
- Features like live view, image stabilization, built-in high dynamic range (HDR) features, and even touch-screen LCDs, all completely unknown when the first edition was published, are common.
- Wireless links to Flickr and other websites are available, directly from the dSLR camera, using built-in Wi-Fi and accessories like the Eye-Fi card.
- Owners of dSLR cameras should consider the rise of mirrorless interchangeable lens cameras (ILCs) like the Sony Alpha and Olympus lineups, plus additional models from Panasonic, Nikon, Canon, Fuji, and others.
- GPS tagging has become an integral part of dSLR technology.
- iPhone/iPad/iPod Touch apps help owners of dSLR cameras on-the-go.

All these exciting advances will appeal to those of you who want to expand your knowledge through this book. This Fourth Edition will be compelling for anyone new to the world of digital photography, who wants to exercise their creativity, enrich their lives, or do their jobs better.

What's in This Book?

The digital SLR has special advantages, special features, and special problems that need to be addressed and embraced. In addition, those of you who work with these cameras tend to expect more from their photography, and crave the kind of information that will let you wring every ounce of creativity out of their equipment.

Some of your questions involve the equipment. What are the best and most cost-effective accessories for digital SLRs? What are the best lenses for portrait photography, or sports, or close-ups? Is it possible to use lenses and accessories accumulated for a previous version of the same vendor's cameras?

Other questions deal with photography, and how to apply the advanced capabilities of dSLRs to real-world picture taking. What are the best ways to use exposure features creatively? How can pictures be better composed with a dSLR? Selective focus is easier with digital SLRs than with other models; how can it be applied to improve compositions? Now that digital cameras with almost zero shutter lag are available, what are the best ways to capture a critical moment at an exciting sports event? How can you make your family portraits look professional? What's the best way to create a last-minute product shot in time to get it on your company website? You'll find the answers in *David Busch's Mastering Digital SLR Photography, Fourth Edition*.

This isn't a general digital camera book. It's a book about digital SLR *photography*: how to take great pictures with the newest cameras and make great images that leverage the strengths of computer technology, while taking into account the special needs of digital cameras. Minutes after cracking the cover of this book, you'll be able to grab action pictures that capture the decisive moment at a sports event; create portraits of adults, teens, and children that anyone can be proud of; and understand how to use the controls of your dSLR to optimize your images even before you transfer them to your computer. This is the book that will show you how to explore the fascinating world of photography with digital technology.

The heavy hardware discussions enrich the introductory material in the first few chapters, giving the basic information needed to choose and use a digital SLR camera, and to satisfy curiosity about what goes on inside. Readers don't need to understand internal combustion to drive a car, but, even so, it's a good idea to know that an SUV may roll over during hairpin turns. The nuts-and-bolts portions of this book won't teach readers about internal combustion, but will help them negotiate those photographic hairpins.

Why This Book?

I've aimed this book squarely at digital camera buffs and business people who want to go beyond point-and-shoot snapshooting and explore the world of photography to enrich their lives or do their jobs better. For anyone who has learned most of a digital camera's basic features and now wonder what to do with them, this is a dream guide to pixel proficiency. Of course, once you've read this book and are ready to learn more, you might want to pick up one of my other guides to digital SLR photography. I'm listing them here not to hawk my other books, but because a large percentage of the e-mails I get are from readers who want to know if I've got a book on this topic or that. Again, that's only for the benefit of those who want to delve more deeply into a topic. My other guides offered by Cengage Learning include:

David Busch's Guides to Digital SLR Photography

I've written individual guidebooks for specific digital SLRs, including the most popular models from Nikon, Canon, Sony, and Olympus. If you want to learn more about your camera's specific features and how to apply them to photography, check out one of my camera guides. Some of the same topics covered in this book are included, such as use of lenses and electronic flash, but everything is related directly to your specific model.

David Busch's Compact Field Guides

Throw away your command cards and cheat sheets! The basic settings suggestions and options for many specific dSLRs have been condensed from my comprehensive guides into these spiral-bound, lay-flat, pocket-sized books you can tuck in your camera bag and take with you anywhere. Available for an expanding line of camera models, there are also totable *Compact Field Guides* for topics including Close-Up/Macro Photography, Electronic Flash Photography, dSLR Movie Making, and Portrait/People/Street Photography.

David Busch's Quick Snap Guide to Using Digital SLR Lenses

A bit overwhelmed by the features and controls of digital SLR lenses, and not quite sure when to use each type? This book explains lenses, their use, and lens technology in easy-to-access two- and four-page spreads, each devoted to a different topic, such as depth-of-field, lens aberrations, or using zoom lenses.

David Busch's Quick Snap Guide to Lighting

This book tells you everything you need to know about using light to create the kind of images you'll be proud of, including some of the most common lighting setups for portraiture.

Who Am I?

After spending years as the world's most successful unknown author, I've become slightly less obscure in the past few years, thanks to a horde of camera guidebooks and other photographically oriented tomes. You may have seen my photography articles in *Popular Photography* magazine. I've also written about 2,000 articles for magazines including *Rangefinder, Professional Photographer,* and dozens of other photographic publications. But, first, and foremost, I'm a photojournalist and commercial photographer and made my living in the field until I began devoting most of my time to writing books.

Although I love writing, I'm happiest when I'm out taking pictures, which is why I invariably spend several days each week photographing landscapes, people, close-up subjects, and other things. I spend a month or two each year traveling to events, such as Native American "powwows," Civil War re-enactments, county fairs, ballet, and sports (baseball, basketball, football, and soccer are favorites). I wrote much of this book during a month I spent in the Florida Keys, photographing the scenery, wild life, and wild people I found there. I can offer you my personal advice on how to take photos under a variety of conditions because I've had to meet those challenges myself on an ongoing basis.

Like all my digital photography books, this one was written by someone with an incurable photography bug. I've worked as a sports photographer for an Ohio newspaper and for an upstate New York college. I've operated my own commercial studio and photo lab, cranking out product shots on demand and then printing a few hundred glossy 8 × 10s on a tight deadline for a press kit. I've served as a photo-posing instructor for a modeling agency. People have actually paid me to shoot their weddings and immortalize them with portraits. I even prepared press kits and articles on photography as a PR consultant for a large Rochester, N.Y., company, which was a dominant force in the industry at the time, but is now a mere shadow of its former self. My trials and travails with imaging and computer technology have made their way into print in book form an alarming number of times.

But, like you, I love photography for its own merits, and I view technology as just another tool to help me get the images I see in my mind's eye. And, also like you, I had to master this technology before I could apply it to my work. This book is the result of what I've learned, and I hope it will help you master your digital SLR, too.

I hope you visit me at David D. Busch Photography Guides on Facebook, or at my blog at www.dslrguides.com/blog. There is an E-Mail Me tab, and an Errata page listing any goofs and typos spotted by sharp-eyed readers. If you see something in these pages that needs improvement, let me know!

Part I

Basic Digital SLR Technology

The manual packaged with your camera lists what each and every control, button, and dial does. But unless you understand *why* you need to use each setting and adjustment, you really can't put them to work improving the technical quality of your images. In this book, I'm going to help you understand *why* and *when* you should use each of the tools at your disposal, and to do that, you need to understand some of what's going on under the hood.

For example, it's not enough to learn that high ISO sensitivity settings are "bad" and low ISO settings are "good"—because that's simply not true. Once you understand how the camera's sensor captures images, and what boosting ISO sensitivity does to that image, you'll understand the tradeoffs. Yes, using a higher ISO setting may give you more visual noise in your image, but the photo may be, overall, much sharper because you were able to use a faster, blur-canceling shutter speed or an f/stop that produces a sharper image. You'll also understand that settings like "noise reduction" may cancel some of that visual noise—but at the cost of some image detail. Armed with a deep understanding of how your camera works, you will be better equipped to choose the best settings for any situation.

This first Part offers a detailed look at the most important aspects of how your dSLR's technology works. You don't have to be a gear-head to enjoy learning these things; I've put together some examples that I think will make everything clear and easy to absorb.

- **Chapter 1: The Incredible Transformation.** The technology of photography has changed more in the last five years than in the previous fifty. Learn why, and where, imaging is headed in the future.

- **Chapter 2: Inside Your Digital SLR.** Learn about the most important controls and settings of your camera.

- **Chapter 3: dSLR Foibles.** This chapter looks at some of the special quirks and strengths of the dSLR that you'll need to be aware of to use your camera's tools most effectively.

- **Chapter 4: Mastering Your Exposure Controls.** To get the best exposure—or to adjust exposure to produce creative effects—you need to understand exactly how your camera measures light, as you optimize the tonal range of your images.

- **Chapter 5: Mastering the Mysteries of Autofocus.** In this chapter, you'll master the mysteries of focus, and learn the difference between the traditional *phase detection* autofocus systems and the *contrast detection* systems used in live view and movie modes.

- **Chapter 6: Working with Lenses.** Here, you'll find an explanation of everything you need to know about how to use lenses to change perspective, use depth-of-field creatively, and compensate or leverage the innate peculiarities of various lens types.

- **Chapter 7: Working with Light.** This chapter explores the wonders of light, from the sun to electronic flash.

The Incredible Transformation

It was the snapshot heard 'round the world. Eventually.

Roughly 40 years ago, few people were aware that the planet's first digital camera had been successfully tested—even within Eastman Kodak Company, where Kodak engineer Steven Sasson spent the better part of a year developing an 8-pound prototype that was the size of a small toaster. The first photograph taken by this first digital camera in December 1975 was in black-and-white and contained only 10,000 pixels—one hundredth of a megapixel. Each image took 23 seconds to record to magnetic media (tape!) and a similar amount of time to pop up for review on a television screen.

But the age of digital photography had begun and, ironically, the dominance of the largest company devoted to fostering the photographic arts was coming to an end. Kodak, which developed the first successful image scanners and pioneered development of the first megapixel sensor (and coined the term "megapixel" to describe it), never fully exploited the innovations that came out of its research labs. The company failed to reap the rewards of innovating the first "Photo" CD-ROMs, the first widely used consumer digital camera (the Apple QuickTake 100, developed by Kodak's Chinon subsidiary), and the first digital SLRs (built on Nikon and, later, Canon film bodies).

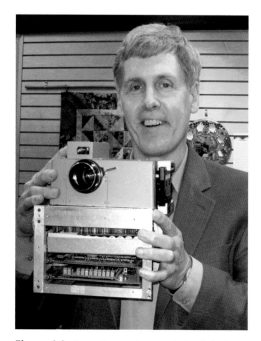

Figure 1.1 Steve Sasson invented the digital camera in 1975.

Instead, you and I have been the happy beneficiaries of the digital camera revolution. Even though the transition from film to digital took a long time, by 2008 it was essentially completed. The first digital cameras that could partially replace their film counterparts were expensive, relatively low-resolution devices suitable for specialized applications such as quickie snapshots you could send by e-mail or post on a web page (at the "low," $1,000 end) to news photographs of breaking events you could transmit over telephone lines to the editorial staff in minutes (at the stratospheric $30,000 price point).

Then, in 2003–2004, Canon and Nikon finally made interchangeable lens digital SLR cameras affordable with the first Canon EOS Digital Rebel and Nikon D70 models, which cost around $1,000—with lens. Digital SLRs had been available for years—but now the average photographer could afford to buy one.

But enough history. Many of the readers of this book have never shot film at all. So, this initial chapter provides a summary of where the dSLR is *today* and how it works, as an introduction to the technology that will help you avoid the pitfalls in your path, and put your tools to work most effectively. You don't need to understand Ohm's law to operate a toaster or Newton's laws of motion to drive a car, but it's helpful to understand why you shouldn't use a fork to retrieve a waffle, or make a hairpin turn at high speed when driving a vehicle with a high center of gravity.

In later chapters, I'll show you how to use your digital and optical tools to raise the bar on image quality and improve your creative vision. By the time we're done, you'll be well on the road to mastering your digital SLR. From time to time I will mention a parallel technology—such as that found in so-called *mirrorless* cameras—but only to compare them with the models that are the heart of this book. If you are interested in learning how to use interchangeable lens mirrorless cameras, you might want to pick up a companion to this book, *David Busch's Mastering Mirrorless Interchangeable Lens Photography*. While both books cover some of the same territory, each concentrates on the advantages and use of their respective technologies.

THE MIRROR'S THE THING

Although this book is entitled *David Busch's Mastering Digital SLR Photography*, not all digital SLRs are created equally. Although Sony marketed a line of traditional dSLRs for a number of years, eventually it diverged to embrace a slightly different technology, which, like its previous dSLRs, included a mirror to bounce light up to a conventional optical viewfinder system. However, *unlike* the mirrors in other digital SLRs, the Sony Alpha SLT (single lens translucent) mirrors are fixed during shooting (you can flip them up manually when you want to clean the sensor, however). They are partially silvered, allowing 70 percent of the light passing through the lens to continue on to the sensor, while the remaining 30 percent is reflected upward to a full-time autofocus system. No optical viewfinder is available; what you see through the viewfinder window is a simulation provided by an *electronic viewfinder*. In most other respects, the SLT models perform like SLRs (but with some advantages I'll describe later in this book). So, for practical purposes, SLR and SLT cameras are equivalent, and that's how I will treat them in this book.

Amazing New Features

Photography has changed more in the last five years than it did in the previous half-century. Indeed, in my case, film cameras and lenses I purchased while still in college were my main tools for several decades. While my equipment wasn't really state-of-the-art, the functional differences between my original film gear and later, more electronic film cameras, were slight.

But now, consider the incredible array of new features found in the latest crop of digital SLRs—and promised for future cameras that are just around the corner. Cameras that are scarcely five years old are considered obsolete (although they still take the same fine pictures they always did), and, for most photographers, the urge to gain new, exciting features through an equipment upgrade happens much more frequently.

I'll explain each of the innovations that are sweeping over the photographic arena in more detail later in the book, but, for now, just take a look at the new capabilities that have helped make the dSLR the fastest growing segment of the photography market. The list is long, and can be divided into three segments: improvements in the sensor/sensor assembly; improvements in the other camera hardware/software components; and improvements in software used to manipulate the digital images we've captured.

Sensor Sensations

I'll cover each of these breakthroughs in more detail later in this chapter and elsewhere in this book, but if you want a quick summary of the most important improvements to the sensor and its components, here's a quick list:

- **Full frame isn't just for pros anymore.** So-called "full-frame" cameras—those with 24mm × 36mm sensors sized the same as the traditional 35mm film format—are becoming more common and affordable. Nikon, Canon, and Sony already offer 20–24-megapixel full-frame dSLR camera bodies for less than $2,000. Several of these can be purchased in the $1,500–$1,600 price range. During the life of this book I expect to see prices go even lower. Full-frame dSLRs are prized for their low-noise characteristics, especially at higher ISOs, and the broader perspective they provide with conventional wide-angle lenses. I'll cover the advantages of the full-frame format later in this book.

- **Resolution keeps increasing.** Vendors vie to up the resolution ante to satisfy consumers' perception that more pixels are always better. In practice, of course, lower resolution cameras often produce superior image quality at higher ISO settings (my 16MP camera beats the pants off my 36MP resolution demon). So, the megapixel race has been reined in, to an extent, by the need to provide higher resolution, improved low-light performance, and extended dynamic range (the ability to capture detail in inky shadows, bright highlights, and every tone in-between).

When I wrote the last edition of this book, super-high-res professional cameras topped out at 24MP. Today, every consumer dSLR in Nikon's line—even the most modest entry-level model—boasts 24MP, and Canon and Sony dSLRs are right in the fray. The new plateau, if you can call it that, is 36MP, found in several upscale models of both the dSLR and mirrorless persuasion. As the value of higher resolutions is a bit overrated (which is why Canon has "lagged" a bit behind in the megapixel race), nevertheless you can expect more hi-res cameras in the future.

■ **ISO sensitivity skyrocketing.** Larger and more sensitive pixels mean improved performance at high ISO settings. Do you really need ISO 102400 or ISO 409600? Certainly, if those ridiculous ratings mean you can get acceptable image quality at ISO 25600. For concerts and indoor sports events, I've standardized on ISO 6400, and have very little problem with visual noise. In challenging lighting conditions, ISO 12800 isn't out of the question, and ISO 25600 (which allows 1/1,000th second at f/8 or f/11 in some of the gyms where I shoot) is practical.

Figure 1.2 shows a recent shot of legendary bassist Jack Casady (Jefferson Airplane, Hot Tuna), taken at 1/1,000th second and f/6.3 at ISO 6400 with an 85mm f/1.4 lens mounted on a

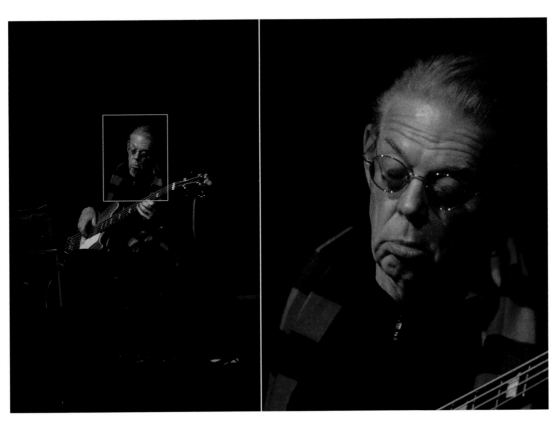

Figure 1.2 Today's sensors can impart almost no visible noise at ISO settings of 6400 or even higher.

full-frame camera with a measly 16MP of resolution. At left is the full, uncropped frame, and at right is an enlargement of roughly 5 percent of the image, indicated by the yellow box at left. Although fine detail is invariably masked by the printing process, I can assure you that there is almost no visible noise. Nikon, Canon, and Sony all produce cameras with similar results at ISO 6400—and beyond.

■ **Professional full HDTV video is possible with a dSLR.** The opening title sequences of *Saturday Night Live* were shot in HDTV by Alex Buono with Canon dSLRs. The award-winning film *Act of Valor*, directed by Mike McCoy and Scott Waugh was shot by cinematographer Shane Hurlbut using a Canon 5D Mark II. The HDTV capabilities of the latest dSLRs aren't just a camcorder replacement. If you're a wedding photographer, you can use them to add video coverage to your stills; photojournalists can shoot documentaries; and amateur photographers can come home from their vacation with once-in-a-lifetime still photos and movies that won't put neighbors to sleep, too.

■ **Live view has come of age.** Only a few years ago, the ability to preview your images on an LCD screen was a point-and-shoot feature that most digital SLR users could see no need for. Today, of course, live view is an essential part of movie shooting, but improvements like "face detection" (the camera finds and focuses on the humans in your image), "subject tracking" (the camera is able to follow-focus specific subjects shown on the screen as they move), and zoom in (to improve manual focusing on the LCD screen) can be invaluable in certain situations. Something as simple as the ability to focus at any point in the frame (rather than just at the few fixed focus points marked in the optical viewfinder) can be very helpful.

The latest innovation is embedding special autofocus sensors *right in the sensor*, making full-time, full-speed phase detection autofocus possible during live view and movie making. In the past, once the mirror of a conventional dSLR flipped up, the faster phase detect AF was lost, and the camera had to rely on slower contrast detect autofocus. (You'll find more on autofocus technology and techniques in Chapter 5.)

■ **Sensor cleaning that actually works.** Every time you change lenses on your dSLR, you allow dust to enter the camera body and, potentially, make its way past the shutter and onto the sensor. Every digital SLR introduced in the past few years has a "shaker" mechanism built into the sensor that does a pretty good job of removing dust and artifacts before it can appear on your photos. You'll still need to manually clean your sensor from time to time, but the chore can be performed monthly (or less often), rather than daily or weekly.

■ **Image stabilization.** Camera movement contributes to blurry photographs. Optimizing anti-shake compensation by building it into a lens means you have to pay for image stabilization (IS) in every lens you buy. So, some vendors are building IS into the camera body in the form of a sensor that shifts to counter camera movement. Unfortunately, "one-size-fits-all" image stabilization doesn't work as well with every lens that can be mounted on a camera, but vendors are learning to adjust the amount/type of in-camera IS for different focal lengths.

- **Marginalia.** Other sensor improvements have been talked about, and, in some cases, even implemented, without generating much excitement. Foveon continues to improve its "direct image" sensors, with separate red, green, and blue layers that allow each pixel to detect one of the primary colors. ("Normal" sensors are segmented into an array in which each pixel can detect red, green, *or* blue, and the "missing" information for a given photosite interpolated mathematically.) But, few people are buying the Sigma cameras that use these sensors. Vendors continue to improve the tiny "microlenses" so they can focus converging light rays on the photosites more efficiently. CMOS sensors have more or less replaced their CCD counterparts, for reasons that nobody cares about anymore. None of these enhancements are as interesting as the others I've listed in this section.

Other Camera Hardware Improvements

Of course, the great strides forward in digital SLR technology (and digital photography in general) aren't limited to sensor breakthroughs. Other components of the cameras, including lenses and accessories, have seen significant improvements, too. Here are some of the most important:

- **Digital Signal Processing (DSP) chips.** As sensors grab more and better data, sophisticated signal processing chips have to be developed to convert the analog data captured to digital format, while optimizing it to produce better images. Faster frame rates (driven partly by the need to shoot more full-resolution images for action/sports, and by the requirements of movie making at 24/30/60 fps) call for beefier processing power. Some high-end cameras have *two* DSP chips to boost throughput even more. Vendors give their chips powerful-sounding names, such as EXPEED (Nikon), DIGIC (Canon), or BIONZ (Sony), but the end results are similar: better pictures, processed more rapidly.

- **Built-in high dynamic range (HDR) photography.** One of the limitations of digital sensors is their inability to record details in both the brightest highlights and darkest shadows simultaneously. Most vendors have developed cameras with the ability to snap off several exposures in a row, and then combine them to produce an optimized, "HDR" image. This effectively extends the tonal range (dynamic range) of the sensor. Within a few more years, I expect that digital sensors will improve to the point where built-in HDR isn't necessary.

- **Global positioning system (GPS) tagging.** Just about any dSLR can be fitted with some sort of external GPS tagging accessory, and an increasing number have the feature built right into the camera. There are so many reasons why marking each photo with data on where and when it was taken is useful (I'll explain some of them later in this book), that GPS tagging should be a standard feature in *all* cameras within five years, as well.

- **Wider Wi-Fi.** Built-in Wi-Fi is becoming standard in mid entry-level cameras (those a notch above the true beginner models). Virtually all of the rest support inexpensive plug-in Wi-Fi add-ons (Nikon has two, but I find them obtrusive and clumsy), or include menu setup options to activate Wi-Fi features included in some SD memory cards (from Eye-Fi, Transcend, and others). Today, you can upload your pictures instantly to Flickr or Facebook (among other sites)

instantly, as you shoot, if you're located near a Wi-Fi hotspot. When "tethering" becomes more widespread, your camera will piggyback onto the instant Wi-Fi hotspots that will be provided by your tablet computer, smartphone, Mi-Fi gadget, or other device no matter where you are. Canon has a cool feature that allows you to link compatible Canon cameras to share images directly.

■ **Storage innovations.** More cameras have dual memory card slots, allowing you to shoot longer (using "overflow" mode); duplicate your images onto two cards for safety or instant sharing (in "backup" mode); or do even more efficient backup by storing RAW files on one card, and a JPEG version on the other. Some cameras allow you to choose which of your two cards will be used for, say, movies, which benefit from storage on "faster" memory cards (if the pair in your camera are unequal in speed). Of course, capacities and speeds of the cards themselves are improving: 64GB Compact Flash and Secure Digital cards have finally become affordable, and new standards with higher capacities and faster speeds, like SDXC, have promise when more cameras (and other devices) support them.

■ **3D photography.** After recent movies—starting with *Avatar* back in 2009 and continuing to *Gravity* in 2013—stunned the viewing public, the comeback of 3D movies gained strength. Now we're seeing 3D television sets, and cameras from vendors like Sony that can produce 3D images using a single optical system (although you may have to view them in the camera, lacking an easy alternative playback system). "Stereo" photography has been with us since 1838, and has come and gone in popularity multiple times since then. As I write this, 3D still photography is starting to wane again. (Sony has dropped the 3D Sweep Panorama feature from several of its amateur cameras.) My opinion is that 3D imaging will peak once again when the next hardware innovation comes along that makes it slightly less clumsy and impractical than today. If you're reading this in the year 2018 on your 3D Kindle, feel free to send me an e-mail (or use whatever medium replaced e-mail) to scold me about the lack of three-dimensional images in this book.

■ **Bits and pieces.** Digital SLRs are becoming smaller in size, with Canon and Nikon both offering some fairly tiny true dSLR cameras. While Sony continues to produce dSLR/SLT models, it's turned to mirrorless models for its truly super-compact high-end cameras (starting with the Alpha A7 and A7r back in 2013). Olympus had some compact dSLR models, but has seemingly abandoned the Four Thirds format and now is producing dSLR-look-alike mirrorless models as its primary focus.

However, more cameras have swiveling LCDs that let you adjust your angle of view for live view shooting, movie making, or image review. LCDs have higher resolution for better detail (although the size seems to have stabilized at about 3.2 inches diagonally). More cameras, primarily EOS Rebels from Canon, feature touch screens that you can use to select menu items, specify the area within a frame where the camera should focus, and even take a photo by tapping the screen. During playback, these cameras allow scrolling among images with a swipe of a finger, and zooming in and out of a display with pinching gestures—just like the typical smart phone.

■ **Rise of the anti-dSLR.** So-called mirrorless interchangeable lens cameras (ILC) use either a back-panel LCD or OLED (organic light emitting diode) screen for composing and reviewing images, or which add an eye-level electronic viewfinder. These are replacing dSLRs for some applications where compact size is prized. Because these cameras do not have a mirror, they can be extra compact and use smaller lenses.

Olympus has been wildly successful with its OM-D lineup of dSLR-lookalikes in the Micro Four Thirds format, with their more compact interchangeable lens PEN cameras not gaining much traction in the marketplace. At their introduction, Sony's Alpha A7 and A7r (the latter with a 36MP sensor) were the smallest full-frame cameras on the market, and the company has done well with its other mirrorless ICL cameras. Panasonic also sells Micro Four Thirds cameras with interchangeable lenses, but the company offers a confusing number of variations on the theme. The Panasonic mirrorless models are known for their excellent movie-making features. The simplified light path of the traditional digital SLR and the new mirrorless cameras is shown in Figure 1.3. I'll explain the other components of the light path in more detail in Chapter 2.

I won't be covering mirrorless cameras in great detail in this book, but did want to give you some perspective about the dSLR's "competition."

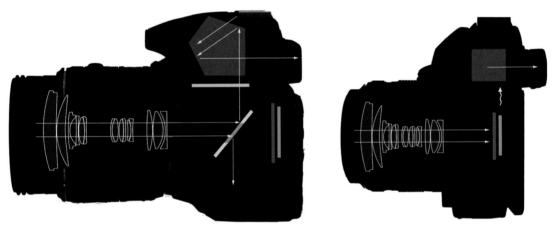

Figure 1.3 In a traditional dSLR (left) light is reflected up to an optical viewing system by a mirror that flips up and out of the light path when an exposure is made. Some mirrorless cameras have an electronic viewfinder (right).

Software Innovations

Software products have seen improvements, too, albeit on a slower schedule, because the impetus among software developers is to bunch upgrades into stable software releases every 12–18 months—just often enough to convince you that you really need to pay up to a third of the original price for your software to gain the new features (whether you really need them or not).

Here are some supposed software innovations—and, what I feel, is the one true breakthrough:

- **Photoshop gets bigger—more expensive.** Photoshop, and its cousins, Photoshop Elements and Lightroom, continue to add sufficient features, some of which are actually needed, to make each, basically, impossible to completely master. The one real breakthrough feature for photographers in recent years has to be Content-Aware Fill, which, if properly used, lets you remove those tiny, inevitable defects that appear in many photos quickly and virtually invisibly. Vexed by a few scraps of paper on the grass, or an ugly, withered leaf or two in your landscape photo? Need to quickly retouch a portrait of someone with a less-than-perfect complexion? Content-Aware Fill can save you hours.

The problem for advanced photographers who are amateurs, or who don't make significant amounts of money from their work, or who are not rich, is that Elements, while automated and easy to use, isn't a true substitute for Photoshop CS6. Neither is Lightroom a good Photoshop replacement. But, unfortunately, Adobe has more or less discontinued its most advanced tool—CS6—in favor of its expensive Creative Cloud subscription model.

Photoshop retouches, color corrects, does an amazing job of compositing, and can tame noise and create animations. Lightroom has some limited image-editing features similar to some of the pixel manipulation tools in Photoshop. However, the intent of Lightroom is to function as a workflow management application. Photoshop can do just about anything, except help you manage 100,000 different images effectively. Lightroom *can't* do everything, but it excels at giving you a way to manage tens or hundreds of thousands of images easily.

Buying both can be expensive, now that Adobe has essentially discontinued the stand-alone licensed version of Photoshop, freezing its feature set at Photoshop CS6. At this writing, all future upgrades will be in the form of Adobe Creative Cloud (CC) subscriptions, for which you will pay a monthly or annual fee to use Photoshop or any of the other applications in the Creative Cloud Suite (such as Adobe InDesign or Adobe Illustrator). The software still physically resides on your computer, but periodically "phones home" to Adobe over the Internet, and if your subscription has expired, so does your access to Photoshop CC and your other tools. For corporations, professional photographers, and avid amateurs who use Photoshop day in and day out, the Creative Cloud subscription is a modest cost. But for those who don't need every single upgraded feature, and who had tended to happily skip Photoshop generations—jumping from CS4 to CS6 for example—the Photoshop CC model is an unnecessary or difficult-to-justify expense.

Adobe has said that Lightroom will retain both stand-alone and CC versions, and remains an option for those who don't like subscribing to software. Photoshop Elements also remains on the stand-alone track, but lacks some of the tools that owners of an advanced camera require.

- **Stop-gap applications.** We've seen remarkable growth of applications that do nothing but fix limitations of the camera. HDR software has become a fad and a cottage industry, and will certainly—in the long run—be much less significant when sensors gain the ability to capture longer dynamic ranges, or HDR is built into more cameras. Other stop-gap applications include resampling software that enables you to make bigger prints (at least until in-camera resolution reaches the point of diminishing returns), and any kind of RAW conversion software.

- **iOS/Android smart device apps.** The true innovation in software has been the growth of photography apps that can be downloaded and run on your phone, tablet, phablet, or other personal device when you're out shooting pictures. Tuck a tiny iPod or phone the size of half a deck of cards in your pocket, and you can pull it out and access any of hundreds of useful utilities and reference guides. You can have depth-of-field or exposure estimator tables at your fingertips, display a level to orient your camera, or keep a digital copy of your camera manual (or this guidebook) at hand. For example, I've developed a few "companion" apps for specific cameras that include settings guides, and videos of myself explaining how to use some of the most under used features, select the best accessories for the job at hand, or how to clean your sensor manually. I also have an absolutely free app, *David Busch's Lens Finder,* to help you decide what optics to add to your collection. (See the screen capture in Figure 1.4 for a shameless plug.) As dSLRs become better able to shoot great pictures in the camera, with less need for image editing, apps like those already available for smart devices will become the most useful software modules for digital photography.

And, many cameras come with their own smart device apps that allow you to operate your camera by remote control (and preview the exact image seen through the camera lens on your phone or tablet). Take time-lapse photos, if you like. Apps allow you to upload photos from your camera to your device through the camera's built-in or add-on Wi-Fi connection. Although some think smart phone cameras will replace digital point-and-shoot cameras, it's becoming obvious that at the higher end, there's no need to beat 'em: join 'em.

Figure 1.4 Portable apps like this one from iTunes provide guidance and enhancements for your dSLR.

The Future

In his 1888 utopian novel *Looking Backward, 2000–1887,* Edward Bellamy made some remarkable predictions—including the first description of what we today call credit and debit cards. But he also predicted that by the turn of the 21st century, music would be available in every household, emanating from speakers connected by telephone lines to live concert halls around the globe. Did he miss the boat, or just leap over phonograph records, CDs, and MP3 players to Pandora? Other seers predicted the automobile, but not one of them foresaw traffic jams, road rage, and smog. It's been said that the chief outcome of predictions has been amusement for our ancestors.

The future of digital photography is equally murky. It seems obvious that, as I mentioned earlier, smart phones will replace low-end digital cameras. They've already supplanted landline phones, stand-alone MP3 players, hand-held video games, many GPS devices, stopwatches, and alarm clocks (as well as wristwatches, for that matter). It's a wonderful technology, the joke goes, that allows us to hold all the knowledge of the world in our hand, look at pictures of cats, and get into arguments with people we don't know.

But, are smart phones, tablets, or phablets a threat to the digital SLR? I think not—at least in the short to medium term—because enthusiasts are willing to give up the small size of the typical smart device in order to gain the versatility that dSLRs (and mirrorless models, too) offer in the way of features and add-ons like interchangeable lenses, electronic flash, and other accessories. The 41MP phones of today still can't do things that the least expensive digital SLR can do.

Still, we can expect dSLRs to get smaller and more compact, even among the professional models. The dramatic rise in popularity of mirrorless cameras demonstrates that, given two cameras with roughly equal capabilities, photographers would like to opt for the smaller one. Other changes outlined in this chapter—higher resolution, better sensors, improved software tools, and enhanced connectivity—are coming, too. While each of these may have points of diminishing returns, we haven't come close to reaching them.

In 2012, the Cleveland Photographic Society, which has been in continuous operation since 1887, "buried" a time capsule destined to be opened in 75 years. It contained an assortment of artifacts from our era, including a copy of one of my books. (I was told that burying it for 75 years was an excellent idea.) The note I enclosed made no predictions of what I thought photography would be like three-quarters of a century hence, lest I be thought a total idiot. Instead, I provided a detailed listing of the state of the technology today, my personal contribution to the amusement of our ancestors. As for the *art* of photography, nothing needed to be said. It's always been that great images don't depend on technology, and the images of the Westons, Cartier-Bressons, Langes, Adamses, and their more recent counterparts, will survive on their own.

2

Inside Your Digital SLR

To belabor my analogy at the beginning of the last chapter, you truly don't need to know anything about internal combustion to operate an automobile, and you really don't need to understand digital technology to use a point-and-shoot digital camera, either. Both devices are so automated these days that there's not a lot for the driver/shooter to do other than point the machinery in the right direction and press the gas pedal or shutter release. Even if you decide to use manual controls on a non-dSLR, the only things you *must* understand are that this button makes the picture lighter or darker, that one helps freeze action, and this other button changes the way the camera focuses.

However, if you really want to master a digital SLR, you can benefit from understanding exactly how the camera's components provide you with a much finer degree of control over your images than the typical point-and-shoot camera. Unlike digital snapshot photography, where it's almost impossible to adjust depth-of-field (the range of acceptable sharpness), and usable ISO ratings range from ISO 100 to ISO 100 (just kidding!), the technology built into a dSLR *does* allow you to make a difference creatively and technically, if you know what you're doing. And for the average serious photographer, that's what taking pictures is all about.

With a digital SLR, it's easy to use depth-of-field to manipulate your images, but you need to understand how digital cameras work with lenses and their apertures. The "graininess" of your pictures is under your control, too, but it depends heavily on things like the size of the sensor, the sensitivity setting you're using, and what kind of noise reduction technology is built into your camera, and how you choose to apply it. If noise is bad, then noise reduction must be good, right? Yet, when you really delve into how your camera works, you'll understand that noise reduction can rob your image of sharpness and detail. There are certain types of pictures in which *less* noise reduction is a better bet, even at a cost of a bit of "grain" in your image.

Or, would you like to take a picture in which a runner is frozen in time, but a streaky blur trails behind him like The Flash in comic books? You'd better understand the difference between front-sync and rear-sync shutter settings. Interested in using a super-long telephoto lens without a tripod or switching to high shutter speeds? Step up and learn about image stabilization.

If you're who I think you are, you don't see understanding digital SLR technology as a daunting task, but as an interesting challenge. By the time someone is ready to use all the features of their digital dSLR, he or she is looking forward to taking greater control over every aspect of the picture-taking process.

The most comforting thing about digital SLR technology is that, for the most part, these cameras were designed by engineers who understand photography. Many of the point-and-shoot digital cameras I have used appear to have been designed by a techie who was creating cell phones last week, and then moved over to digital cameras this week. They operate like computers rather than cameras, have features that nobody in their right mind actually needs, and often are completely impractical for the kinds of photography for which they are intended.

For example, one alarming trend is toward pocket-sized digicams that have *no optical viewfinder at all*. For the majority of the latest models, it's necessary to frame every picture using the LCD, which, unfortunately, washes out in bright sunlight, and often forces you to hold at arm's length, almost guaranteeing that powerful image stabilization features are required to nullify camera shake.

In contrast, digital SLRs are designed by people who understand your needs. They have ple, large bright optical viewfinders (or, in the case of Sony's SLT models, high-resolution viewfinders). These provide a reasonable display of approximate depth-of-field, and su ers can be used under a variety of lighting and viewing conditions. The designers of d have been creating such cameras for many years and know from the feedback they receive what photographers want. So, learning dSLR technology will be rewarding for you, because you'll come to understand exactly how to use features that have been designed to help you be a better and more creative photographer.

This chapter explains that technology, and will help you when you're shopping for your next digital SLR. You'll have a better understanding of the kinds of technology you should be looking for in your camera. If you already own a dSLR, after reading this chapter, you'll know how to put those features to work.

Key Components of Your dSLR

I'm not going to spend a lot of time in this chapter on the mechanical aspects of digital SLRs. If you'll examine Figure 2.1 (with the corresponding numbered list), which shows light entering a lens, evading capture by the diaphragm, bouncing off the reflex mirror up to your eye, and/or wending its way to the sensor, you'll realize that you probably already know that stuff. Here's a quick review

with brief descriptions of the main components (by no means comprehensive; I'll have more detail on some of them later in the book).

1. **Light path.** The yellow arrows represent an overly simplified path for the light entering the lens and making its way to the viewfinder and sensor. In reality, the light is refracted at angles as it passes through the lens elements (2), and is focused on either the autofocus screen (3) and focus screen (4) or the sensor (9).

2. **Lens elements.** Lenses contain a varying number of elements made of glass, plastic, or another material. These elements are fixed in place, or can move in relation to other elements to focus or zoom the image, or, in an image-stabilized lens, shifted to compensate for camera movement.

3. **Mirror.** The mirror is a flip-up partially silvered component that directs most of the light upward toward the viewing system and exposure meters, and some of the light downward toward the autofocus components. (In Sony's SLT cameras, a nonmoving *pellicle* mirror may bounce light upward to an autofocus system, while allowing the rest of the illumination to pass through to the sensor for live viewing in an electronic viewfinder or back-panel LCD.)

4. **Focus screen.** When the mirror is flipped down, light that has passed through the lens is focused on this screen. The screen may have overlays that can be illuminated to provide alignment grids, focus points, or warning messages. In a traditional dSLR, this focus screen clutter is kept to a minimum. With Sony's SLT, the focus screen itself doesn't exist and the electronic viewfinder image may be overlaid with a variety of data, much of which can be turned on or off to reduce untidiness.

Figure 2.1
The light path inside a digital SLR looks something like this, but there's a lot more to know.

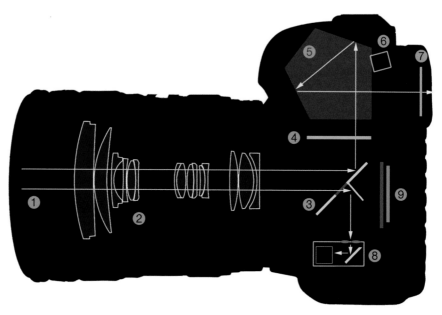

5. **Pentaprism/pentamirror.** This optical component can be a solid glass block, or *pentaprism*, silvered on two surfaces to reflect the light, or a less-efficient (in terms of light transmission) hollow structure, a *pentamirror*, that uses only mirrors. The reflective surfaces reverse the focus screen image received from the lens/lower mirror both laterally and vertically, producing a right-reading view.

6. **Exposure meter.** In the typical dSLR, the exposure meter detects light in the viewing path, using an array of points in the frame that range in number from just a few to more than 2,000, depending on the camera. Readings may involve brightness only, or capture full red/green/blue information to allow the camera to make exposure decisions based on a matrix of points, a small "spot-meter" set of points, or a center-weighted average of the points interpreted.

7. **Viewfinder.** This optical window shows the image as displayed on the focus screen. It includes a *diopter adjustment* that allows fully or partially compensating for the user's eyeglass prescription if the user chooses to shoot without using them, or needs additional correction. Some viewfinders have a shutter that can be closed to keep light from entering the viewing system and affecting the exposure meter (6). Vendors also may provide a rubber or plastic cover to slide over the viewfinder window to block light. Additional accessories, such as a magnifier lens or right-angle viewer, may be offered for the viewfinder.

8. **Autofocus sensor.** Some of the light from the lens is reflected downward to this sensor. It uses pairs of lenses (typically 3 to 61 pairs, depending on the camera) to split off portions of the beam to form *autofocus points* or *zones* that are lined up, in rangefinder fashion, to allow *phase detection* autofocus functions.

9. **Shutter/Sensor.** The shutter can be a physical component, consisting of a pair of vertically traveling curtains (9, left) that open consecutively to create a gap for light from the lens to pass through when the main mirror flips up. Some cameras use an electronic shutter, in which the sensor remains active gathering light (such as for a live view preview), until just before the exposure. Then, the camera "dumps" the image on the sensor electronically and captures a new image for the time specified by the shutter speed. It's possible for a camera to have a traditional physical shutter, an electronic shutter, and a hybrid shutter. The latter speeds the picture-taking process by electronically blanking the sensor at the start of an exposure, then using only the second physical shutter curtain to end the exposure. The process eliminates the need for the first shutter curtain to open and travel across the sensor plane.

The sensor (9, right) contains light-sensitive photosites that record the image and pass it off to the camera's analog-to-digital signal processing chip, and then to a memory card Shutter/Sensor for storage. In live view mode (or, with Sony's SLT cameras, imaging preview mode—which is essentially full-time live view), the sensor provides an image for the LCD/electronic viewfinder, and is used for autofocus.

Sensors Up Close

In the broadest terms, a digital camera sensor is a solid-state device that is sensitive to light. When photons are focused on the sensor by your dSLR's lens, those photons are registered and, if enough accumulate, are translated into digital form to produce an image map you can view on your camera's LCD and transfer to your computer for editing. Capturing the photons efficiently and accurately is the tricky part.

There's a lot more to understand about sensors than the number of megapixels. There are very good reasons why one 20-megapixel sensor and its electronics produce merely good pictures, whereas a different sensor in the same resolution range is capable of sensational results. This section will help you understand why, and how you can use the underlying technology to improve your photos. Figure 2.2 shows a composite image that represents a typical dSLR sensor.

There are two main types of sensors used in digital cameras, called CCD (for charge coupled device) and CMOS (for complementary metal oxide semiconductor), and, fortunately, today there is little need to understand the technical differences between them, or, even which type of sensor resides in your camera. Early in the game, CCDs were the imager of choice for high-quality image capture, while CMOS chips were the "cheapie" alternative used for less critical applications. Today, technology has advanced so that CMOS sensors have overcome virtually all the advantages CCD imagers formerly had, so that CMOS has become the dominant image capture device for dSLRs, with only a very few such cameras using CCDs remaining. (For example, the Nikon D3000, from 2009, was the last Nikon dSLR to use a CCD.) CCDs are still found in non-dSLR models and in electronic movie cameras, because of their ability to capture an entire frame at once (the so-called "global shutter") rather than a line at a time ("rolling shutter") like CMOS sensors.

Figure 2.2
A digital SLR sensor looks something like this.

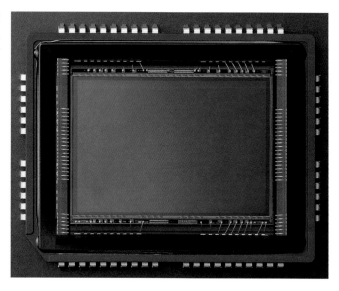

Capturing Light

Each sensor's area is divided up into picture elements (pixels) in the form of individual photo-sensitive sites (photosites) arranged in an array of rows and columns. The number of rows and columns determines the resolution of the sensor. For example, a typical 21-megapixel digital camera might have 5,616 columns of pixels horizontally and 3,744 rows vertically. This produces 3:2 proportions (or *aspect ratio*) that allow printing an entire image on 6 inch × 4 inch (more typically called 4 × 6 inch) prints.

While a 3:2 aspect ratio is most common on digital SLRs, it is by no means the only one used. So-called Four Thirds and Micro Four Thirds cameras from vendors like Olympus and Panasonic, use a 4:3 aspect ratio; the Olympus E-5 dSLR, for example, was a 12.3 megapixel camera with a sensor "laid out" in a 4,032 × 3,024 pixel array. Some dSLRs have a "high-definition" *crop mode* for still photos that uses the same 16:9 aspect ratio as your HDTV. Figure 2.3 shows the difference between these different proportions.

Digital camera sensors use microscopic lenses to focus incoming beams of photons onto the photo-sensitive areas on each individual pixel/photosite on the chip's photodiode grid, as shown in

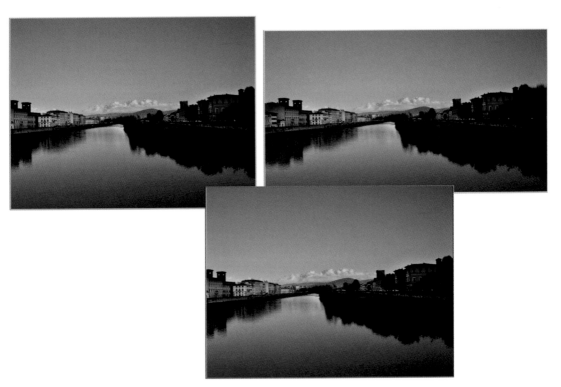

Figure 2.3 Typical sensor aspect ratios include 3:2 (upper left), 16:9 (upper right), and 4:3 (lower right).

Figure 2.4. The microlens performs two functions. First, it concentrates the incoming light onto the photosensitive area, which constitutes only a portion of the photosite's total area. (The rest of the area, in a CMOS sensor, is dedicated to circuitry that processes each pixel of the image individually. In a CCD, the sensitive area of individual photosites relative to the overall size of the photosite itself is larger.) In addition, the microlens corrects the relatively "steep" angle of incidence of incoming photons when the image is captured by lenses originally designed for film cameras. Lenses designed specifically for digital cameras are built to focus the light from the edges of the lens on the photosite; older lenses may direct the light at such a steep angle that it strikes the "sides" of the photosite "bucket" instead of the active area of sensor itself.

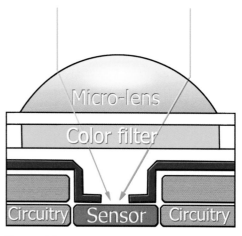

Figure 2.4 A microlens on each photosite focuses incoming light onto the active area of the sensor.

As photons fall into this photosite "bucket," the bucket fills. If, during the length of the exposure, the bucket receives a certain number of photons, called a *threshold*, then that pixel records an image at some value other than pure black. If too few pixels are captured, that pixel registers as black. The more photons that are grabbed, the lighter in color the pixel becomes, until they reach a certain level, at which point the pixel is deemed white (and no amount of additional pixels can make it "whiter"). In-between values produce shades of gray or, because of the filters used, various shades of red, green, and blue. (See Figure 2.5.)

Figure 2.5
Think of a photosite as a bucket that fills up with photons.

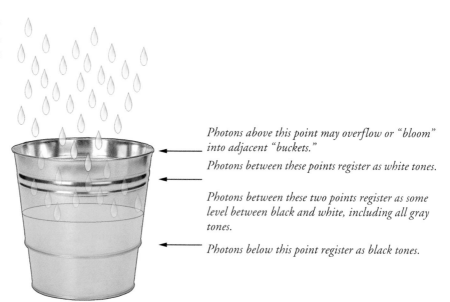

Photons above this point may overflow or "bloom" into adjacent "buckets."

Photons between these points register as white tones.

Photons between these two points register as some level between black and white, including all gray tones.

Photons below this point register as black tones.

If too many pixels fall into a particular bucket, they may actually overflow, just as they might with a real bucket, and pour into the surrounding photosites, producing that unwanted flare known as *blooming*. The only way to prevent this photon from overfilling is to drain off some of the extra photons before the photosite overflows, which is something that CMOS sensors, with individual circuits at each photosite, are able to do.

Of course, now you have a bucket full of photons, all mixed together in analog form like a bucket full of water. What you want though, in computer terms, is a bucket full of ice cubes, because individual cubes (digital values) are easier for a computer to manage than an amorphous mass of liquid. The first step is to convert the photons to something that can be handled electronically, namely electrons. The analog electron values in each row of a sensor array are converted from analog ("liquid") form to digital (the "ice cubes"), either right at the individual photosites or through additional circuitry adjacent to the sensor itself.

Noise and Sensitivity

One undesirable effect common to all sensors is visual noise, that awful graininess that shows up as multicolored specks in images. In some ways, noise is like the excessive grain found in some high-speed photographic films. However, while photographic grain is sometimes used as a special effect, it's rarely desirable in a digital photograph.

Unfortunately, there are several different kinds of noise, and several ways to produce it. The variety you are probably most familiar with is the kind introduced while the electrons are being processed, due to something called a "signal-to-noise" ratio. Analog signals are prone to this defect, as the amount of actual information available is obscured amidst all the background fuzz. When you're listening to a CD in your car, and then roll down all the windows, you're adding noise to the audio signal. Increasing the CD player's volume may help a bit, but you're still contending with an unfavorable signal-to-noise ratio that probably mutes tones (especially higher treble notes) that you really wanted to hear.

The same thing happens during long time exposures, or if you boost the ISO setting of your digital sensor. Longer exposures allow more photons to reach the sensor, increasing your ability to capture a picture under low-light conditions. However, the longer exposures also increase the likelihood that some pixels will register random phantom photons, often because the longer an imager is "hot" the warmer it gets, and that heat can be mistaken for photons. This kind of noise is called *long exposure noise*.

There's a second type of noise, too, so-called *high ISO noise*. Increasing the ISO setting of your camera raises the threshold of sensitivity so that fewer and fewer photons are needed to register as an exposed pixel. Yet, that also increases the chances of one of those phantom photons being counted among the real-life light particles, too. The same thing happens when the analog signal is amplified: You're increasing the image information in the signal but boosting the background fuzziness at the same time. Tune in a very faint or distant AM radio station on your car stereo. Then turn up the volume. After a certain point, turning up the volume further no longer helps you hear

better. There's a similar point of diminishing returns for digital sensor ISO increases and signal amplification, as well.

Regardless of the source, it's all noise to you, and you don't want it. Digital SLRs have noise reduction features you can use to help minimize this problem.

Dynamic Range

The ability of a digital sensor to capture information over the whole range from darkest areas to lightest is called its *dynamic range.* You take many kinds of photos in which an extended dynamic range would be useful. Perhaps you have people dressed in dark clothing standing against a snowy background, or a sunset picture with important detail in the foreground, or simply an image with important detail in the darkest shadow. Or, perhaps you want to capture the snow on mountain peaks in a distant vista that also includes much darker fir trees (see Figure 2.6). If your digital

Figure 2.6
A broad array of tones, such as snow-capped peaks and dark forest foliage, is beyond the capabilities of digital cameras with a narrower dynamic range (top). A wide dynamic range allows you to capture both (bottom).

camera doesn't have sufficient dynamic range or built-in HDR, you won't be able to capture detail in both areas in one shot without resorting to some tricks like Photoshop's Merge to HDR Pro (High Dynamic Range) feature.

Sensors have some difficulty capturing the full range of tones that may be present in an image. Tones that are too dark won't provide enough photons to register in the sensor's photosite "buckets," producing clipped shadows, unless you specify a lower threshold or amplify the signal, increasing noise. Very light tones are likely to provide more photons than the bucket can hold, producing clipped highlights and overflowing to the adjacent photosites to generate blooming. Ideally, you want your sensor to be able to capture very subtle tonal gradations throughout the shadows, mid-tones, and highlight areas.

Dynamic Range and Sensitivity

One way to do this is to give the photosites a larger surface area, which increases the volume of the bucket and allows collecting more photons. In fact, the jumbo photosites in larger dSLR sensors (so-called *full-frame* models) allow greater sensitivity (higher ISO settings), reduced noise, and an expanded dynamic range. In the past few years, a metric called *pixel density* has provided an easy way to compare the size/density of pixels in cameras, even those with different absolute resolutions. For example, consider two cameras from one vendor share the same 24-megapixel resolution, such as the Nikon D610 and Nikon D3300. The former has a full-frame sensor measuring about 24 × 36mm, and roughly 277,778 pixels packed into each square centimeter of sensor area. The latter uses a typical APS-C sensor size (more on that later) measuring about 16mm × 24mm, and with less room on its smaller sensor, has to squeeze 625,000 pixels into each square centimeter of sensor area in order to equal the 24MP resolution of the full-frame camera. Clearly, the camera with the larger sensor has larger pixels that are more sensitive to light, as you can see in Figure 2.7. Those larger pixels can gather more light, allowing better image quality, particularly at higher ISO settings. (I'll explain the reason for those red, green, and blue rectangles later in this chapter.)

Figure 2.7
A full-frame 24mm × 36mm sensor (left) uses larger pixels than an APS-C sensor measuring about 16mm × 24mm (right) of the exact same resolution.

Dynamic Range and Tonal Values

While we're always interested in the amount of detail that can be captured under the dimmest lighting conditions, the *total* dynamic range of tones that can be grabbed is also important. Dynamic range can be described as a ratio that shows the relationship between the lightest image area a digital sensor can record and the darkest image area it can capture. The relationship is logarithmic, like the scales used to measure earthquakes, tornados, and other natural disasters. That is, dynamic range is expressed in density values, D, with a value of, say, 3.0 being ten times as large as 2.0.

As with any ratio, there are two components used in the calculation, the lightest and darkest areas of the image that can be captured. In the photography world (which includes film; the importance of dynamic range is not limited to digital cameras), these components are commonly called Dmin (the minimum density, or brightest areas) and Dmax (the maximum density, or darkest areas).

Dynamic range comes into play when the analog signal is converted to digital form. As you probably know, digital images consist of the three color channels (red, green, and blue), each of which has, by the time we begin working with them in an image editor, tonal values ranging from 0 (black) to 255 (white). Those 256 values are each expressed as one 8-bit byte, and combining the three color channels (8 bits × 3) gives us the 24-bit, full-color image we're most familiar with.

However, when your digital SLR converts the analog files to digital format to create its RAW (unprocessed) image files, it can use more than 8 bits of information per color channel, usually 12 bits, 14 bits, or 16 bits. These extended range channels are usually converted down to 8 bits per channel when the RAW file is transferred to your image editor, although some editors, like Photoshop, can also work with 16-bit and even 32-bits-per-channel images.

The analog to digital converter circuitry itself has a dynamic range that provides an upper limit on the amount of information that can be converted. For example, with a theoretical 8-bit A/D converter, the darkest signal that can be represented is a value of 1, and the brightest has a value of 255. That ends up as the equivalent of a maximum possible dynamic range of 2.4, which is not especially impressive as things go.

On the other hand, a 10-bit A/D converter has 1,024 different tones per channel, and it can produce a maximum dynamic range of 3.0; up the ante to 12 or 16 bits (and 4,094 or 65,535 tones) in the A/D conversion process, and the theoretical top dynamic ranges increase to values of D of 3.6 and 4.8, respectively.

These figures assume that the analog to digital conversion circuitry operates perfectly and that there is no noise in the signal to contend with, so, as I said, those dynamic range figures are only theoretical. What you get is likely to be somewhat less. That's why a 16-bit A/D converter, if your camera had one, would be more desirable than a 12-bit A/D converter. Remember that the scale is logarithmic, so a dynamic range of 4.8 is *many* times larger than one of 3.6.

The brightest tones aren't particularly difficult to capture, as long as they aren't *too* bright. The dark signals are much more difficult to grab, because the weak signals can't simply be boosted by amplifying them, as that increases both the signal as well as the background noise. All sensors produce

some noise, and it varies by the amount of amplification used as well as other factors, such as the temperature of the sensor. (As sensors operate, they heat up, producing more noise.) So, the higher the dynamic range of a digital sensor, the more information you can capture from the darkest parts of a slide or negative. If you shoot low-light photos or images with wide variations in tonal values, make sure your dSLR has an A/D converter and dynamic range that can handle them. Unfortunately, specs alone won't tell you; you'll need to take some pictures and see if the camera is able to deliver. (Which is another good reason to buy your camera locally, even if you have to take your test shots in the store, rather than purchase a pig in a poke from a mail-order or Internet vendor.)

Controlling Exposure Time

This wonderful process of collecting photons and converting them into digital information requires a specific time span for this to happen, known in the photographic realm as *exposure time.* Film cameras have always sliced light into manageable slivers of time using mechanical devices called shutters, which block the film until you're ready to take a picture, and then open to admit light for the period required for (we hope) an optimal exposure. This period is generally very brief, and is measured, for most pictures taken with a hand-held camera, in tiny fractions of a second.

Digital cameras have shutters, too. They can have either a mechanical shutter, which opens and closes to expose the sensor, or an electronic shutter, which simulates the same process. As I mentioned earlier, many digital camera have used *both* types of shutter, relying on a mechanical shutter for relatively longer exposures (usually 1/500th second to more than a second long), plus an electronic shutter for higher shutter speeds that are difficult to attain with mechanical shutters alone. (That's why you'll find a [very] few digital cameras with shutter speeds as high as 1/16,000th second: they're electronic.) Electronic shutters and hybrid electronic/mechanical shutters are also used to speed up a camera's response time in live view mode. These modes avoid the time needed to close the mechanical shutter, dump the image on the sensor, and then re-open the mechanical shutter to begin the actual exposure. Instead, the exposure can commence immediately by blanking the sensor electronically, and then "opening" the electronic shutter.

Shutters can work with any kind of sensor. One important thing to remember about a digital SLR's mechanical shutter is that its briefest speed usually (but not always) determines the highest speed at which an electronic flash can synchronize. That is, if your dSLR syncs with electronic flash at no more than 1/160th second, that may be the highest mechanical shutter speed available. Some special flash systems can synchronize with electronic shutters at higher speeds, but I'll leave a detailed discussion of syncing for Chapter 7.

How We Get Color

So far, I've ignored how sensors produce color. In one sense, digital camera sensors are color blind. They can register the brightness, or *luminance,* of an image, but have no notion of the color of the light at all. To do that, most sensors (excepting a special type called Foveon, used in some Sigma

cameras, and explained below) overlay the photosites with a set of color filters. Each pixel registers red, green, or blue light, and ignores all the others. So, any particular pixel might see red light (only), while the one next to it might see green light (only), and the pixel below it on the next row might be sensitive to blue light (only).

As you might guess, in the normal course of events, a pixel designated as green-sensitive might not be lucky enough to receive much green light. Perhaps it would have been better if that pixel had registered red or blue light instead. Fortunately, over a large pixel array, enough green-filtered pixels will receive green light, red-filtered pixels red light, and blue-filtered pixels blue light that things average out with a fair degree of accuracy. To compensate for this shortcoming, the actual color value of any particular pixel is calculated through a process called *interpolation*. Algorithms built into the camera's circuitry can look at surrounding pixels to see what their color values are, and predict with some precision what each pixel should actually be. For the most part, those guesses are fairly accurate.

For reasons shrouded in the mists of color science, the pixels in a sensor array are not arranged in a strict red-green-blue alternation, as you might expect to be the case. Instead, the pixels are usually laid out in what is called a Bayer pattern (named after Kodak scientist Dr. Bryce Bayer), shown in Figure 2.8, which shows just a small portion of a full sensor array. One row alternates green and red pixels, followed by a row that alternates green and blue filters. Green is "over-represented" because of the way our eyes perceive light: We're most sensitive to green illumination. That's why mono-chrome monitors of the computer dark ages were most often green-on-black displays.

The process of interpreting the pixel values captured and transforming them into a more accurate representation of a scene's colors is called *demosaicing*. With good algorithms, the process is accu-rate, but faulty demosaicing can produce unwanted artifacts in your photo (although, almost by definition, artifacts are generally always unwanted).

Of course, use of a Bayer pattern means that a great deal of the illumination reaching the sensor is wasted. Only about half of the green light is actually captured, because each row consists of half green pixels and half red or blue. Even worse, only 25 percent of the red and blue light is registered.

Figure 2.8
To allow the sensor to capture color, a matrix of red, green, and blue filters is placed over the photosites.

Figure 2.9 provides a representation of what is going on. In our 36-pixel array segment, there are just 18 green-filtered photosites and 9 each of red and blue. Because so much light is not recorded, the sensitivity of the sensor is reduced (requiring that much more light to produce an image), and the true resolution is drastically reduced. Your digital camera, with 10 megapixels of resolution, actually captures three separate images measuring 5 megapixels (of green), 2.5 megapixels (of blue), and 2.5 megapixels (of red).

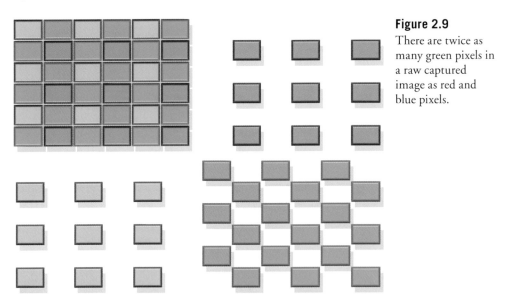

Figure 2.9
There are twice as many green pixels in a raw captured image as red and blue pixels.

FOVEON SENSORS

Foveon sensors are found in several Sigma digital cameras. The Foveon imager works in a quite different way. It's long been known that the various colors of light penetrate silicon to varying depths. So, the Foveon device doesn't use a Bayer filter mosaic like that found in other sensors. Instead, it uses three separate layers of photodetectors, which are shown in Figure 2.10, colored blue, green, and red. All three colors of light strike each pixel in the sensor at the appropriate strength as reflected by or transmitted through the subject. The blue light is absorbed by and registers in the top layer. The green and red light continue through the sensor to the green layer, which absorbs and registers the amount of green light. The remaining red light continues and is captured by the bottom layer.

So, no interpolation (called *demosaicing*) is required. Without the need for this complex processing step, a digital camera can potentially record an image much more quickly. Moreover, the Foveon sensor can have much higher resolution for its pixel dimensions, and, potentially, less light is wasted. The reason why Foveon-style sensors haven't taken over the industry is that technical problems limit the pixel dimensions of this kind of sensor. However, outside the theoretical world, cameras using the Foveon sensor are not yet regarded as the leading edge in sharpness, color fidelity, or much of anything else. However, don't write off this technology until it has been explored fully.

Figure 2.10

The Foveon sensor has three layers, one for each primary color of light. At left, a representation of colored light penetrating the array; at right, a cross section of a typical photosite, measuring about 7 microns wide by 5 microns thick.

Infrared Sensitivity

The final aspect of sensor nuts and bolts that I'm going to mention is infrared sensitivity. Sensors, in particular, are inherently quite sensitive to non-visible, infrared light. Imaging this extra light can produce colors that are not realistic, and therefore inaccurate. For example, a green leaf (which reflects a lot of infrared) might not look the same shade as a non-infrared-reflecting green automobile that, to our eyes, appears to be the exact same hue. So, most camera vendors install infrared blocking filters in front of sensors, or include a component called a *hot mirror* to reflect infrared to provide a more accurate color image. Luckily (for the serious photographer) enough infrared light sneaks through that it's possible to take some stunning infrared photos with many digital cameras. There are easy ways to determine whether your dSLR can shoot infrared photos. Point your TV's remote control at the lens, and take a picture while a button is depressed; if a light dot that represents the invisible infrared beam appears, your camera has some infrared sensitivity.

There are lots of things you can do with infrared, especially if you're willing to manipulate the photo in an image editor. For example, swapping the red and blue channels, as was done for Figure 2.11, can produce an infrared photo in which the sky regains its dark blue appearance for a strange and wonderful effect. If you want to learn more about digital IR photography, you might want to check out my book *David Busch's Digital Infrared Pro Secrets*, from Course Technology/PTR.

Using Interchangeable Lenses

The next most important component of a digital SLR is the lens—or, more properly, lenses—because, unlike other types of digital cameras, which may use add-on lens adapters, the lens of a dSLR is fully interchangeable. I'm not going to tell you much about how lenses work. Most of the rest of this section will deal with practical matters relating to interchangeable lenses on a dSLR.

Figure 2.11 Many digital SLRs can take infrared photos like this one.

The only things you really need to know about lenses are these:

- Lenses consist of precision-crafted pieces of optical glass (or plastic or ceramic material) called *elements*, arranged into *groups* that are moved together to change the magnification or focus. The elements may be based on slices of spheres, or not (in which case they are *aspherical*), and given special coatings to reduce or eliminate unwanted reflections.

- Lenses contain an iris-like opening called a diaphragm that can be changed in size to admit more or less light to the sensor. In addition to adjusting the amount of light that passes through the lens, the diaphragm and its shape affect things like relative overall sharpness of an image, the amount of an image that is in focus, the brightness of your view through the viewfinder, and even the shape and qualities of out-of-focus highlights in your image. I'll describe these aspects in more detail as they come up.

- Lenses are mounted in a housing that keeps the elements from rattling around and provides a way to move them to adjust focus and magnification. The lens housing can include a microprocessor, a tiny motor for adjusting focus (and, in non-dSLR cameras, for zooming), and perhaps a mechanism for neutralizing camera shake (called *vibration reduction*). Also included are threads or a bayonet mount for attaching filters, a fitting that attaches to your camera, and various levers and electronic contacts for communicating with the camera body. You might find a switch or two for changing from autofocus to manual focus, locking a zoom lens so it doesn't extend accidentally while the camera is being carried, and a macro lock/lockout button to limit the seeking range of your autofocus mechanism so your lens won't seek focus from infinity to a few inches away every time you partially depress the shutter release.

Everything else is details, and we'll look at them in this and later chapters of this book.

Lens Interchangeability

The ability to remove a lens and swap it for another is one of the key advantages of the digital SLR. Interchangeable lenses make a very cool tool because they expand the photographer's versatility in several ways:

- Swapping lenses lets you change the "reach" of a lens, from wide-angle to medium telephoto to long telephoto. The zoom lenses on non-SLR cameras provide some of this flexibility, but they can't provide the magnification of the longest telephotos and telephoto zooms, nor the wide-angle perspective of the shortest focal lengths found in some interchangeable lenses and zooms. Figures 2.12, 2.13, and 2.14 illustrate just how much the right lenses can change your view of a single subject.

- Interchangeable lenses let you choose a lens optimized for a particular purpose. Do-everything zooms are necessarily a compromise that may perform fairly well in a broad range of applications, but excel at none of them. Using an SLR lets you choose a lens, whether it's a zoom or a fixed focal length lens (called a *prime* lens), that does a particular thing very well indeed.

Figure 2.12
With the zoom set to 14mm, and with a vertical perspective, the sheer depth of a broad expanse of the Grand Canyon is visible.

Figure 2.13
At 70mm, a lone hiker becomes a point of interest.

Figure 2.14
A 150mm lens crops the image to the hiker and a glimpse of the vista in front of him.

For example, a lens with a zoom range extending from wide-angle to long telephoto may be plagued with distortion at one end of the range or another (or both!). A multi-purpose lens is probably much slower than an optimized optic, perhaps with an f/4.5 or f/5.6 maximum aperture. With the availability of interchangeable lenses, you can select a very fast, f/1.4 lens when you need one, or choose a lens that's particularly good in a given zoom range (say, 12-24mm). Choose another lens for its exquisite sharpness, or because it provides a dreamy blurry effect that's perfect for portraiture. Use zooms when you need them and prime lenses when they are better suited for a job.

■ Lens swaps make it easy for those with extra-special needs to find some glass that fits their specialized requirements. Fisheye lenses, those with perspective control shifts, macro lenses for a bug's-eye view of that prize flower, or hyper-expensive super-long telephoto optics with built-in correction for camera shake are available to anyone who can afford them.

As you know, however, lenses aren't infinitely interchangeable. Lenses designed to fit on one particular vendor's brand of camera probably won't fit on another vendor's camera (although there are exceptions), and it's highly likely that you'll discover that many lenses produced by the manufacturer of your digital SLR can't be used with current camera models. Unfortunately, I can't provide a comprehensive lens compatibility chart here, because there are hundreds of different lenses available, but you might find some of the guidelines in this section useful.

The first thing to realize is that lens compatibility isn't even an issue unless you have older lenses that you want to use with your current digital camera. If you have no lenses to migrate to your new camera body, it makes no difference, from a lens standpoint, whether you choose a Nikon, Canon, Sony, Olympus, Pentax, or another dSLR. You'll want to purchase current lenses made for your camera by the vendor, or by third parties such as Tokina, Sigma, or Tamron, to fit your camera. One exception might be if you had a hankering for an older lens that you could purchase used at an attractive price. In that case, you'll be interested in whether that older lens will fit your new camera.

You also might be interested in backward compatibility if you own a lot of expensive optics that you hope to use with your new camera. That compatibility depends a lot on the design philosophy of the camera vendor. It's easier to design a whole new line of lenses for a new camera system than to figure out how to use older lenses on the latest equipment. Some vendors go for bleeding-edge technology at the expense of compatibility with earlier lenses. Others bend over backward to provide at least a modicum of compatibility.

Viewfinders

The next key component of a digital camera is its viewfinder. The viewfinder is, along with lens interchangeability, one of the distinguishing features between dSLR and non-dSLR cameras. Certainly, other digital cameras provide a form of through-the-lens viewing by displaying the current sensor image on an LCD. But, an LCD display is hardly the same thing as a big, bright SLR

view in terms of composition, ease of focus, amount of information provided, or viewing comfort.

- **View on the back-panel LCD display.** These viewing panels, which operate like miniature laptop display screens, show virtually the exact image seen by the sensor. The LCDs measure roughly 2.7 to 3.2 inches diagonally, and generally display 98 percent or more of the picture view seen by the lens. An LCD may be difficult to view in bright light. Point-and-shoot digital cameras use the LCD display to show the image before the picture is taken, and to review the image after the snapshot has been made. Some of these have no optical viewfinder at all, so the *only* way to compose a shot is on the LCD. There are even fairly advanced mirrorless interchangeable lens cameras available from Canon, Nikon, Sony, Panasonic, and Olympus with no eyelevel viewfinders. In a dSLR, the back-panel LCD is used for reviewing pictures that have been taken and for previewing using the live view features, and for viewing movies as they are taken.

- **View through an optical viewfinder window.** Some non-SLR digital cameras have a glass direct-view system called an optical viewfinder that you can use to frame your photo. Optical viewfinders can be simple window-like devices (with low-end, fixed magnification digital cameras) or more sophisticated systems that zoom in and out to roughly match the view that the sensor sees. The advantage of the optical viewfinder is that you can see the subject at all times (with other systems the view may be blanked out during the exposure). Optical systems may be brighter than electronic viewing, too. A big disadvantage is that an optical viewfinder does not see exactly what the sensor does, so you may end up cutting off someone's head or otherwise do some unintentional trimming of your subject.

- **View through an electronic viewfinder (EVF).** The EVF operates like a little television screen inside the digital camera. You can view an image that closely corresponds to what the sensor sees, and it is easier to view than the LCD display, but until recently, didn't have nearly the quality of an SLR viewfinder. Some of Sony's SLT models have sensational EVFs with 2.4MP of resolution, so the gap is narrowing. Many EVF cameras are more compact than dSLRs, and are available both with interchangeable lenses (such as the Olympus and Panasonic Micro Four Thirds cameras, or E-Mount models in the Sony Alpha series). Others have built-in superzoom lenses that stretch from 12X to 20X or more, thus eliminating some of the need for interchangeable lenses.

- **View an optical image through the camera lens.** Another kind of optical viewfinder is the through-the-lens viewing provided by the SLR camera. With such cameras, an additional component, usually a mirror, reflects light from the taking lens up through an optical system for direct viewing. The mirror reflects virtually all the light up to the viewfinder, except for some illumination that may be siphoned off for use by the automatic exposure and focus mechanisms. The mirror swings out of the way during an exposure to allow the light to reach the sensor instead.

As mentioned earlier, an optical viewfinder's image reflected from the mirror is reversed, of course, so it is bounced around a bit more within the camera to produce an image in the viewfinder window that is oriented properly left to right and vertically. Some digital cameras use a *pentaprism* (see Figure 2.1, earlier), which is a solid piece of glass and generates the brightest, most accurate image. Others use a *pentamirror* system, lighter in weight and cheaper to produce, but which gives you an image that is a little less brilliant than that created by a pentaprism. Olympus has used a swinging sideways mirror viewfinder system it calls a TTL Optical Porro Finder on some of its earlier dSLRs, which has the advantage of allowing a much squatter profile for the camera, because the big lump of a pentaprism/pentamirror needn't inhabit the top of the camera.

There are several other important aspects of SLR viewfinders that you need to keep in mind:

- **Most true dSLRs provide no LCD preview except in live view mode.** Because of the way digital SLRs operate, it is not possible to view the image on the back-panel LCD before the photo is taken. (Of course, Sony's dSLR-like SLT models offer full-time live view.) Lack of live preview doesn't seem like much of a problem at first—after all, the optical view is brighter, easier to focus, and often much larger than an LCD preview—until you go to take an infrared photo or other image using a filter that reduces the visibility of the through-the-lens view, or obscures it entirely. With an SLR, you're shooting blind, so live view can be useful when you want to see the image that the sensor sees, before shooting.

- **Vision correction.** All digital SLRs have diopter correction to allow for near/far sightedness. However, if you have other vision problems that require you to wear glasses while composing photos, make sure your digital camera lets you see the entire image with your eyeglasses pressed up against the viewing window. Sometimes the design of the viewfinder, including rubber bezels around the frame, can limit visibility.

- **Eyepoint.** The distance you can move your eye away from the viewfinder and still see all of the image is called the eyepoint, and it's important to more than just eyeglass wearers, as described above. For example, when shooting sports, you may want to use your other eye to preview the action so you'll know when your subjects are about to move into the frame. Cameras that allow seeing the full image frame even when the eye isn't pressed up tightly to the window make it easy to do this. In the past, manufacturers of SLR cameras have even offered "extended eye-point" accessories for sports photographers and others.

- **Magnification.** The relative size of the viewfinder image affects your ability to see all the details in the frame as you compose an image. It's not something you might think about, but if you compare dSLRs side by side, you'll see that some provide a larger through-the-lens view than others. Bigger is always better, but it is likely to cost more, too.

Working with viewfinders will come up again a few times later in this book, but if you remember the basic information presented in this chapter, you'll understand most of what you need to know.

Storage

Once you've viewed your image through the viewfinder, composed and focused it with your lens, and captured the photons with the sensor, the final step is to store the digital image semi-permanently so it can be transferred to your computer for viewing, editing, or printing. While the kind of storage you use in your camera won't directly affect the quality of your image, it can impact the convenience and versatility of your dSLR, so storage is worth a short discussion.

Once converted to digital form, your images first make their way into a special kind of memory called a buffer, which accepts the signals from the sensor (freeing it to take another picture) and then passes the information along to your removable memory card. The buffer is important because it affects how quickly you can take the next picture. If your camera has a lot of this very fast memory, you'll be able to take several shots in quick succession, and use a burst mode capable of several pictures per second for five or six or ten consecutive exposures. Many digital SLRs provide a viewfinder readout showing either how many pictures can be stored in the remaining buffer or, perhaps, a flashing bar that "fills" as the buffer fills, and gets smaller as more room becomes available for pictures. When your buffer is completely full, your camera stops taking pictures completely until it is able to offload some of the shots to your memory card.

The memory card itself has its own speed, which signifies how quickly it can accept images from the buffer. There's no standard way of expressing this speed. Some card vendors use megabytes per second. Others label their cards as 80X, 120X, 233X, 400X, and so forth. Some vendors prefer to use word descriptions, such as Standard, Ultra II, Ultra III, or Extreme. With Secure Digital cards, the nomenclature Class 4, Class 6, or Class 10 can provide an indication of how quickly the card can move data. I'm not going to tell you which cards are fastest here, because memory card technology and pricing is changing with blinding speed.

For standard shooting, I've never found the speed of my digital film to be much of a constraint, but if you shoot many action photos, sequences, or high-resolution (TIFF or RAW) pictures, you might want to compare write speeds carefully before you buy. A card that's been tested to write more quickly can come in handy when you don't have time to wait for your photos to be written from your camera's buffer to the memory card. What I always recommend is to buy the fastest memory card you can afford in a size that will hold a decent number of pictures. Then, purchase additional cards in larger sizes at bargain prices as your backups.

For example, if you've got a lot of money to spend, you might want to buy a 32GB or "ultra" card as your main memory card for everyday shooting, and stock up on slower, but dirt-cheap 16GB cards to use when your main card fills up. Or, if your budget is limited and you don't need a high-speed card very often, spend your money on a larger standard card, and treat yourself to high-speed media in a more affordable size. That way, if you do need the extra-fast writing speed of an ultra card, you'll have it without spending a bundle on a high-speed/high-capacity memory card. And you'll have plenty of capacity in your standard digital film at an economical price.

In the past we saw marginal use of memory card formats like xD cards or Memory Sticks, and specialized cards like the XQD cards used only in the Nikon D4, D4s, and some video cameras; today, only the two form factors listed below see widespread use in digital SLRs:

- **Secure Digital.** The SD format overtook Compact Flash as the most popular memory card format years ago. Most other vendors had long since converted their non-pro digital cameras to SD card, reserving CF for larger, "pro" cameras. The postage-stamp-sized SD cards allow designing smaller cameras, are available in roughly the same capacities as Compact Flash, and cost about the same. A new specification, SDHC (Secure Digital High Capacity) had to be developed to allow cards larger than 2GB (up to 32GB) to be offered for devices (including cameras) that are compatible with the standard. Today, SDXC offers the potential for memory cards up to 2TB (2000GB) in size.

- **Compact Flash.** Compact Flash is now the second-most-favored format in the United States and first among pro-level digital SLRs. Although larger in size than Secure Digital (SD) cards, Compact Flash cards are still very small and convenient to carry and use. As larger capacities are introduced, they usually appear in CF format first.

Choosing the dSLR That's Right for You

You might have studied the explanations of digital SLR technology in this chapter because you're pondering which dSLR to buy. Because technology changes so rapidly, it's unlikely that the camera you buy today will be your last. On the other hand, even the least expensive dSLR is a major investment for most of us, particularly when you factor in the cost of the lenses and accessories you'll purchase. You want to make the right choice the first time. Digital SLR decision makers often fall into one of five categories:

- **Serious photographers.** These include photo enthusiasts and professionals who may already own lenses and accessories belonging to a particular system, and who need to preserve their investments by choosing, if possible, a dSLR that is compatible with as much of their existing equipment as possible.

- **Professionals.** Pro photographers buy equipment like carpenters buy routers. They want something that will do the job and is rugged enough to work reliably despite heavy use and mistreatment. They don't necessarily care about cost if the gear will do what's needed, because their organizations or clients are ultimately footing the bill. Compatibility may be a good idea if an organization's shooters share a pool of specialized equipment, but a pro choosing to switch to a whole new system probably won't care much if the old stuff has to fall by the wayside.

- **Well-heeled enthusiast photographers.** Many dSLR buyers exhibit a high turnover rate, because they buy equipment primarily for the love of having something new and interesting. Some actually feel that the only way they will be able to take decent (or better) pictures is to own the very latest gear. I'm happy to let these folks have their fun, because they are often a good source of mint used equipment for the rest of us. I purchased several of my favorite lenses

for $900–$1,300 each in mint condition from a "churn"-happy photographer. Each of them sells for $1,500–$2,000 brand new.

- **Serious newcomers.** Many dSLRs are sold to fledgling photographers who are buying their first digital camera or who have been using a point-and-shoot camera model. These buyers don't plan on junking everything and buying into a new system anytime soon, so they are likely to examine all the options and choose the best dSLR system based on as many factors as possible. Indeed, their caution may be why they've waited this long to purchase a digital SLR in the first place.

- **Casual newcomers.** As prices for dSLRs dropped to the $600 level and below, I noticed a new type of buyer emerging, those who might have purchased a point-and-shoot camera at the same price point in the past, but now have the notion that a dSLR would be cool to have and/or might provide them with better photos. Many of these owners aren't serious about *photography*, although they might be serious about getting good pictures of their family, travels, or activities. A large number of them find that a basic dSLR with its kit lens suits them just fine and never buy another lens or accessory. It could be said that a dSLR is overkill for these casual buyers, but most will end up very happy with their purchases, even if they aren't using all the available features.

Questions to Ask Yourself

Once you decide which category you fall into, you need to make a list of your requirements. What kind of pictures will you be taking? How often will you be able to upgrade? What capabilities do you need? Ask yourself the following questions to help pin down your real needs.

How Much Resolution Do You Need?

This is an important question because, at the time I write this, dSLRs are available with resolutions from about 16 megapixels to 24 megapixels (with a small number of high-end models with up to 36MP of resolution). You can buy even more pixels if you turn to exotic (and expensive) *medium-format* cameras. Even more interesting, not all digital SLRs of a particular resolution produce the same results. It's entirely possible to get better photos from a 16-megapixel SLR with a sensor that has low noise and more accurate colors than with a similar 21-megapixel model with an inferior sensor (even when the differences in lens performance is discounted).

Looking at resolution in general, you'll want more megapixels for some types of photography. If you want to create prints larger than 8 × 10 inches, you'll be happier with a camera having 20–24 megapixels of resolution or more. If you want to crop out small sections of an image, you may definitely need a camera with 24MP or more. On the other hand, if your primary application will be taking pictures for display on a web page, or you need thumbnail-sized photos for ID cards or for a catalog with small illustrations, you may get along just fine with the lowest-resolution dSLR camera you can find. However, keep in mind that your needs may change, and you might later regret choosing a camera with lower resolution.

Full Frame or Cropped Frame?

Throughout this chapter I've mentioned some of the differences between *full-frame* sensors and *cropped* sensors. Your choice between them can be one of the most important decisions you make. Even if you're new to the digital SLR world, from time to time you've heard the term *crop factor*, and you've probably also heard the term *lens multiplier factor*. Both are misleading and inaccurate terms used to describe the same phenomenon: the fact that some cameras (generally the most affordable digital SLRs) provide a field of view that's smaller and narrower than that produced by certain other (usually much more expensive) cameras, when fitted with exactly the same lens.

Figure 2.15 quite clearly shows the phenomenon at work. The outer rectangle, marked 1X, shows the field of view you might expect with a 28mm lens mounted on a "full-frame" (non-cropped) camera, like the Nikon D4s or Canon 5D Mark III. The area marked 1.3X shows the field of view you'd get with that 28mm lens installed on a so-called APS-H form factor camera, like the now-defunct Canon 1D series. The area marked 1.5X shows the field of view you'd get with that 28mm lens installed on an APS-C form factor camera, which includes virtually all other non-Four Thirds/ Micro Four Thirds models. Canon's non-full-frame cameras, like the EOS 70D, have a form factor of 1.6X, which is virtually identical and also called by the APS-C nomenclature. All Four-Thirds/ Micro Four Thirds cameras use a 2X crop factor, represented by the innermost rectangle. You can see from the illustration that the 1X rendition provides a wider, more expansive view, while each of the inner fields of view is, in comparison, *cropped*.

The cropping effect is produced because the "cropped" sensors are smaller than the sensors of the full-frame cameras. These sensors do *not* measure 24mm × 36mm; instead, they spec out at roughly 23.6mm × 15.8 mm, or about 66.7 percent of the area of a full-frame sensor, as shown by the black

Figure 2.15

Crop "factors" provide different fields of view.

boxes in the figure. You can calculate the relative field of view by dividing the focal length of the lens by .667. Thus, a 100mm lens mounted on an APS-C camera has the same field of view as a 150mm lens on a full-frame camera. We humans tend to perform multiplication operations in our heads more easily than division, so such field of view comparisons are usually calculated using the reciprocal of .667—1.5—so we can multiply instead. (100 / .667=150; 100 × 1.5=150.)

This translation is generally useful only if you're accustomed to using full-frame cameras (usually of the film variety) and want to know how a familiar lens will perform on a digital camera. I strongly prefer *crop factor* over *lens multiplier*, because nothing is being multiplied; a 100mm lens doesn't "become" a 150mm lens—the depth-of-field and lens aperture remain the same. Only the field of view is cropped. But *crop factor* isn't much better, as it implies that the 24mm × 36mm frame is "full" and anything else is "less." I get e-mails all the time from photographers who point out that they own full-frame cameras with 36mm × 48mm sensors (like the Mamiya 645ZD or Hasselblad H3D-39 medium-format digitals). By their reckoning, the "half-size" sensors found in full-frame cameras are "cropped." Probably a better term is *field of view conversion factor*, but nobody actually uses that one.

If you're accustomed to using full-frame film cameras, you might find it helpful to use the crop factor "multiplier" to translate a lens's real focal length into the full-frame equivalent, even though, as I said, nothing is actually being multiplied.

How Often Do You Want to Upgrade?

Photography is one field populated by large numbers of technomaniacs who simply must have the latest and best equipment at all times. The digital photography realm rarely disappoints these gadget nuts, because newer, more sophisticated models are introduced every few months. If remaining on the bleeding edge of technology is essential to you, a digital SLR *can't* be a long-term investment. You'll have to count on buying a new camera every 18 months to two years, because that's how often the average vendor takes to replace a current model with a newer one. Some upgrades are minor ones.

Fortunately, the typical dSLR replacement cycle is a much longer schedule than you'll find in the digital point-and-shoot world, where a particular top-of-the-line camera may be replaced every six months or more often. Digital SLRs typically are replaced no more often than every 12 to 18 months—12 months for the entry-level models, and 18 months or longer for the intermediate and advanced models.

On the other hand, perhaps you're not on a never-ending quest for a shiny new gadget. You just want great pictures. Once you acquire a camera that does the job, you're not likely to upgrade until you discover there are certain pictures you can't take because of limitations in your current equipment. You'll be happy with a camera that does the job for you at a price you can afford. If your desires are large but your pocketbook is limited, you may want to scale back your purchase to make those inevitable frequent upgrades feasible.

TRADE IN—OR KEEP?

Typically, come upgrade time, your old dSLR will be worth more as a hand-me-down to another user than as a trade-in. That's why I'm already looking forward to using my current favorite dSLR as a second or third camera body when I do upgrade to the next generation. An extra body can come in handy. When I leave town on trips, I generally take one extra body simply as a backup. Still, I end up using the backup more than I expected when I mount, say, a telephoto zoom on my "main" camera and a wide-angle zoom on my backup so I don't have to switch lenses as often.

Is a Compact SLR Important to You?

Compared to point-and-shoot digital cameras, all dSLRs are a bit on the chunky side. A few, particularly pro models with large battery packs and vertical grips, border on the huge. Before you lay down a large hunk of change for a digital camera, play with it to make sure it's a size that you'll be comfortable lugging around with you. The difference in weight alone can be significant if you're walking around all day with a camera strap around your neck. If you're the sort of photographer who would have been happy with a small, lightweight, virtually silent Leica rangefinder camera (which nevertheless produced superb pictures), you might also prefer a smaller dSLR. Heck, you might even want the Leica M9, a non-dSLR that looks and handles like a rangefinder film camera, but produces 18MP digital images (and will set you back up to $7,000, plus lots more for lenses).

In that vein, don't forget to take into account the size of the lenses you'll be using, too. My favorite digital SLR has a 28-200mm zoom lens that was touted, on introduction, as the smallest in the world. I'm very happy I have that compact lens with such an extensive zoom range, because for many photo outings it's all I need, and I can avoid carrying around a weighty camera bag and a half dozen other lenses. I actually went to Europe several years ago carrying only that 28-200mm lens and a 17-35mm wide-angle zoom, and two dSLR bodies. My entire kit fit into a compact shoulder bag that was easy to tote with me everywhere I went.

If you need a compact digital SLR, check out the size and weight of the lenses you are likely to use at the same time you examine the heft of the camera body itself.

Do You Want to Share Lenses and Accessories?

Are you an old-timer who still has lenses left over from the days of film, along with perfectly serviceable flash units and other accessories? Perhaps you own an ancient digital SLR that has seen better days. You may be able to justify a particular digital camera built around a camera body similar to the one used by your previous model. The list of compatible gadgets that can be shared is long, ranging from electronic flash units through filters, close-up attachments, tripods, and so forth. I have a huge stockpile of glass filters and accessories that fit my existing cameras. I'm able to use some of them using step-up and step-down rings in common sizes. Make sure that the adapter rings don't cause vignetting of the corners of your image (common with wide-angle lenses) and that your

filters have both front and back filter threads so you can stack them. (Some filters, particularly polarizers, may not have a front thread.) You'll pay extra for "thin" adapter rings that keep your filters from projecting out too much in front of your lens, but the premium will be worth it. As an alternative, you may be able to simply zoom in a bit to eliminate those vignetted corners.

What Other Features Do You Need?

Once you've chosen your "must have" features for your digital camera, you can also work on those bonus features that are nice to have, but not essential. All digital SLRs share a long list of common features, such as manual, aperture-priority, and shutter-priority exposure modes. All have great autofocus capabilities. Many (but not all) have built-in flash units that couple with the exposure system, and which can control external, off-camera flash units as well (especially useful when using multiple units). Beyond this standard laundry list, you'll find capabilities available in one dSLR that are not found in others. You'll have to decide just how important they are to you as you weigh which system to buy. Here are some of the features that vary the most from camera to camera:

- **Movie making.** The trend today is toward full 1,920 × 1,080 HDTV movie-making capabilities. However, a few non-video-capable models linger on the market. And not all of the current cameras have the same movie-friendly capabilities. If video shooting is important to you, make sure your camera has the ability to plug in a microphone, preferably a stereo microphone. In-camera editing features let you trim clips that run too long, easing the editing process later.

- **Burst mode capabilities.** If you shoot lots of sports, you'll want the ability to shoot as many frames per second as possible for as long as possible. Some cameras shoot more frames per second, and others have larger buffers to let you capture more shots in one burst. For example, one model grabs 4 fps for 32 JPEG images in one burst, or 11 RAW images. Another camera from the same vendor ups the ante to 5 fps, but can capture only 23 JPEG images in one blast. If you've got deep pockets, one top-of-the-line action dSLR blazes through sports photography at a 10 fps clip for 100 or more images.

- **Image stabilization/dust removal.** Some dSLRs may have vibration reduction built into the camera. Other vendors ask you to buy image-stabilized lenses, or may not have that capability at all. If you want to hand-hold your camera at low shutter speeds, or need to take rock-steady telephoto shots without a tripod, regardless of shutter speed, you'll want to consider this capability. Cameras that have internal anti-shake capabilities often use the ability to move the sensor quickly to provide an anti-dust removal system. You'll also find dust cleaning capabilities in virtually all digital cameras these days. But some work better than others, as I'll explain in Chapter 3.

- **Higher and lower ISO ratings.** Some cameras offer sensitivities as low as ISO 50 and as high as ISO 6400 and beyond (ISO 104,600 is not out of the question, and one model puts its upper limit in the ISO 409,600 stratosphere). The need for these depends on what kind of photos you intend to take, and how good the results are at the ISO extremes.

- **Playback/review features.** You'll find used digital SLRs only a few years old with back-panel LCDs as small as 2.7 inches diagonally, but virtually every new model has a 3.0-inch or larger LCD. All same-sized LCDs are not created equal. Some have more pixels and finer detail, and may be brighter and easier to view in direct sunlight or from an angle. Some systems let you zoom in 3X to 4X on your LCD image, while others offer 10X or more zoom. If reviewing your images in the field is critical, take a close look at how a camera's LCD panel performs.

- **Maximum shutter speed.** Some cameras top out at 1/4,000th second; others go as high as 1/16,000th second. In real life, you'll rarely need such brief shutter speeds to freeze action. It's more likely that the high speeds will come in handy when you want to use wider lens openings at your lowest ISO setting. For example, if you want to use f/2.8 on a bright beach or snow scene in full daylight, if your camera's lowest ISO setting is ISO 200, you'll probably need to use a shutter speed of 1/8,000th second. If you don't have such fast shutter speeds, you'd better hope you have a neutral-density filter or two handy. In practice, however, such high shutter speeds aren't really needed; the fastest shutter speed I use regularly is 1/2,000th second, and I don't recall ever using my camera's 1/8,000th second setting, other than to test it.

I'll look into using these and other special features elsewhere in this book.

3

dSLR Foibles

If you're accustomed to working with a point-and-shoot digital, or even with an advanced model using an electronic viewfinder, you'll find that digital single lens reflexes have their own particular set of advantages and quirks that you must learn about. The dSLR is a different type of animal.

While the design of digital SLRs solves many of the problems that may have vexed you with other types of cameras, every silver lining can be cloaked in a troublesome cloud. They are prone to collect dust on their sensors—including stubborn artifacts that the built-in sensor-shaking dust removal systems found in virtually all modern dSLRs can't handle. Your dSLR has some viewfinder anomalies you should know about, and there are some secrets to storing images efficiently and using the various automated exposure modes. This chapter will clear up some of the confusion around dealing with a dSLR's quirks and strengths, and show you how to use them to improve the quality of your picture-taking experience.

It's Done with Mirrors

A key component in any SLR camera is the mirror located immediately behind the lens. This mirror reflects all or part of the light that passes through the lens upward toward the viewing mechanism. In the past there have been some exceptions, as in the case of some odd-ball designs like the old Olympus E-300/EVOLT design, which has a sideways-flipping mirror. Other exceptions include dSLR-like interchangeable lens cameras like the Sony Alpha SLT lineup, which, as I have pointed out from time to time in previous chapters, have semi-transparent mirrors that allow most of the incoming light to continue toward the sensor all the time, but which bounce some illumination upward to an autofocus system (and, as noted, such cameras use electronic viewfinders rather than optical viewfinders like dSLRs).

As you learned in Chapter 1, the traditional dSLR viewing system can consist of a focusing screen that images the picture, plus a prism or set of mirrors that takes the screen's upside-down and reversed view and orients it properly. During exposure, the mirror flips up, allowing the light to continue unimpeded to the sensor. Figure 3.1 shows a highly simplified version of the path of light through a digital single lens reflex. The exposure meters (in the pentaprism/pentamirror housing) and autofocus sensors (on the floor of the mirror box) illustrated in Chapter 1 are not shown in this mirror-centric illustration.

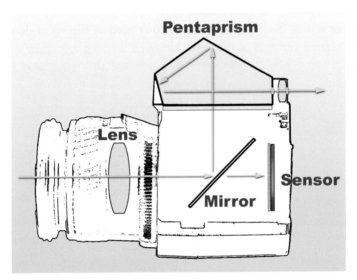

Figure 3.1

Light from the lens bounces off the mirror, through the pentaprism, and out through the viewfinder window.

In practice, there are lots of factors to consider if you want to understand how your SLR viewing system works for you and against you. Let's start with the mirror itself. That little reflective rectangle has to be carefully designed and activated so that the light is reflected toward the viewfinder in precise alignment. Otherwise, your view—particularly your ability to focus—would be inaccurate, and mechanisms within the camera that work with the viewfinder's image, such as the autoexposure and autofocus features, wouldn't work properly.

Mirror Bounce

One thing to keep in mind about the mirror is that, during exposure, its upward travel, brief pause while the picture is made, and then return to the viewing position causes a tiny bit of vibration. Poorly designed mirrors may even "bounce" when they reach their full, upright position. This vibration can, and sometimes does, albeit rarely, affect the sharpness of the photograph, introducing a small amount of "camera shake" during the exposure. Even placing the camera on a tripod and using the self-timer, remote control, or a cable release to trigger the picture can't totally eliminate this effect. You're most likely to see the consequences of mirror slap on exposures that are long

enough for the vibration to have an effect, but not so long that the vibrating portion of the exposure isn't significant.

In other words, an exposure of 1/4 second is more likely to be marred by tiny vibrations than one that's 30 seconds long. The longer exposure will tend to cancel out the effect of any bounce that occurs in the first fraction of a second after the shutter opens. Mirror movement can spoil images made through a microscope or telescope, too, by disturbing the delicate camera/scope setup.

In the past, some camera vendors actually bypassed this problem by using mirrors that were only partially silvered, so that part of the illumination always goes to the viewfinder, and part always continues to the film or sensor. Such *pellicle* mirrors don't need to flip up or down at all. Canon and Nikon have both offered cameras of this type, although in some cases they were special-order or custom-built models. Sony's SLT camera line is a variation on the pellicle concept. With a non-moving mirror, bounce is not a factor.

Of course, the purpose of pellicle-based cameras was not to reduce mirror bounce, but to eliminate the need to flip the mirror up and down at all, allowing faster continuous shooting frame rates. The Sony Alpha SLT cameras, for example, fire off full-resolution captures at up to 10–12 frames per second, depending on the model and shooting mode. Back in the film era, the Canon EOS-1 RS managed 10 fps, while an earlier pellicle-mirrored Canon F-1 was capable of shooting 14 fps. Nikon's two pellicle-based cameras, the Nikon F2H-MD and Nikon F3H could shoot up to 13.5 fps. The speed champ of all was a digital camera, the Olympus E-100RS, capable of 15 fps, but at a paltry 1.5 megapixels of resolution. Current high-speed traditional dSLR models, like the Nikon D4s, top out at 11 fps.

Despite Sony's continuing support for its SLT lineup, I don't expect to see new pellicle dSLRs in the near future, as they have several inherent problems. The most obvious is that with a non-moving mirror, the full amount of light coming from the lens never reaches the viewfinder *or* the film/sensor, so the view is likely to be darker than with a flip-up mirror, and less illumination is available for exposure. In Sony's case, electronics amp up the gain, however, so the image seen through the EVF is still bright and detailed. The second most important drawback is that pellicle mirrors must be kept very, very clean. Although the mirror itself will generally be out of focus from the film or sensor's point of view, any dust or smudges on the mirror can affect the quality of the picture. If you think sensor cleaning is a pain, try keeping a large mirror surface spotless!

Finally, with a partially silvered mirror, it's possible for light from the viewfinder in a true SLR design (but not with SLT models, which use an EVF) to find its way into the camera. With a conventional SLR layout, such illumination can bounce off shiny portions of the rear of the lens and cause ghost images. It's not a good idea to leave the viewfinder window uncovered when shooting with this type of pellicle system. Eyepiece light leak can also affect exposure calculations even on cameras with conventional mirror systems, so some dSLRs have an eye-piece "shutter" to block the light. Or, you can use a clip-on eye-piece light blocker, such as the one offered for most other digital SLR cameras.

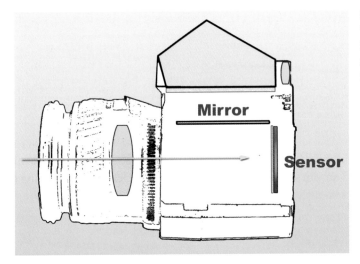

Figure 3.2
With the mirror locked up, one source of vibration is eliminated.

Another way to handle mirror bounce is to lock up the mirror prior to exposure, as shown in Figure 3.2. Because the camera is mounted on a tripod, you can frame your shot before locking up the mirror, then make the exposure free from worries that a pivoting component of your optical system will cause vibration. Unfortunately, not all digital SLRs have mirror lock up that can be triggered prior to an exposure. The mirror lockup may be provided solely to allow cleaning the sensor. You'll know that's the case if you find the mirror lock feature within the "cleaning" options of the menu system, rather than as a separate entry.

However, some dSLRs include a M-Up (Mirror Up) feature that flips up the mirror a fraction of a second before the picture is taken. With several Nikon cameras having this feature, you press the shutter release once to move the mirror out of the way. Then, press the shutter release a second time to actually take the picture. Of course, if you push the shutter release with your finger you're likely to get some vibration from that second shutter press, so M-U is best used with a shutter release cable, infrared remote control, or self-timer. There are also "Quiet Mode" features that separate the mirror flip from shutter opening, in order to reduce the noise caused by the dual action of both operating simultaneously.

FAUX LOCK UP

Terrified that your exposure will be spoiled by mirror vibration? Try holding a black card in front of the lens (but don't touch the lens) as a long manual exposure begins. Remove the card a fraction of a second after the shutter opens (and the mirror is fully flipped up and the vibration has ceased). The exposure will be made exclusively after any mirror-induced shake has been damped.

Mirror Size and Design

There's a lot that goes into the design of an SLR/SLT mirror. They must be light in weight to maximize speed of movement and reduce the wear and tear on the mechanism that raises and lowers the mirror. Unlike a household mirror, in which the silvered surface is protected by the glass in front of it, dSLR mirrors must be front-silvered to avoid the double reflections that occur when light reflects off both the silver and the glass.

Because the silvering is exposed, dSLR mirrors are vulnerable to damage. Even gentle cleaning can scratch their surface if rough particles of dust are present. Because dust on the mirror has no effect on the picture itself, you can safely ignore such particles, or clean them off using blasts of air, using the same tools and cautions you use to clean your sensor.

Every camera with an interchangeable lens and a mirror system includes a mirror that is partially silvered in some way. With SLT models, the entire mirror surface is partially reflective/semi-transparent (*not* translucent; that's Sony's poor choice of nomenclature). Some of the light is reflected upward to the exposure sensors. In true SLR designs almost all the light is reflected upward to the exposure sensors as well as the optical viewing system. But, some portions of the mirror allow light at specific points to pass through and bounce downward toward a set of autofocus sensors. I'll explain how those sensors operate in Chapter 5.

Lens-to-Sensor Distance

While a dSLR mirror must be large enough to reflect the full field of view (or, at least 95 percent of it), it must also be small enough to fit inside the cavity (*mirror box*) behind the lens. Camera lens mounts designed specifically for digital photography with sensors smaller than full frame, such as those with the Canon EF-S lens mount or the Olympus Four Thirds mount, use smaller mirrors that permit lenses to extend closer to the sensor. That kind of design solves a particular problem with wide-angle lenses, which can have a shorter *back focus* distance than normal and telephoto lenses.

As you may know, the focal length of a given lens is the distance from the optical center of the lens to the plane of the film or sensor. With a 20mm lens, that distance would be about 0.75 inches, which is obviously impossible. With the average dSLR, the distance from the lens flange to the sensor is more on the order of 1.5 to 1.75 inches, so with the simplest possible lens design, a wide-angle lens's rear elements would have to extend back *inside* the camera, well beyond where the mirror would sit. I actually own such a lens, an ancient 7.5mm Nikkor Fisheye lens that pokes back into the camera body almost to the film plane, and which requires that the mirror be locked up out of the way before it can be mounted.

No such nonsense is required with today's lenses, which use what is called *retro-focus* designs (also called *inverted telephoto*) to increase the back-focus distance to a reasonable value. Without such designs, the 10-12mm lenses available for digital cameras (or even most lenses shorter than about 40mm) would be impossible. This is especially true with dSLRs that have smaller than full-frame

sensors, because the multiplier factor means that shorter and shorter lenses are required to produce the same wide-angle effect as a full-frame digital or film camera. (There's another advantage to retro-focus design, as you'll see in Chapter 6: The longer back-focus distance allows the light to strike the sensor at a less oblique angle so the photosites are illuminated more directly. You'll find diagrams of retro-focus and conventional lens designs there, too.)

Even with advanced lenses, dSLR camera designers need to do some fancy footwork to create mirrors that accommodate the rear elements of lenses, yet are still able to flip up as needed. A few cameras use a mirror that actually slides backward a bit before it begins to pivot, allowing extra clearance with the rear elements of the lens. I'll explore other lens quirks in Chapter 6.

Focus Screen

The next stop in our optical grand tour is the focus screen, also called a viewing screen, or, in times past, "the ground glass," which is, theoretically, at the exact distance in the optical path as the focal plane of the sensor. Thus, an image that appears to be correctly focused on the viewfinder screen should be in sharp focus when the picture is taken.

Obviously, the screen must be positioned with great accuracy, which is made easier by the fact that in most digital SLRs (at least the non-pro variety), the focus screen is permanently fixed in the camera. Some high-end models offer nine or ten different replaceable focus screens optimized for special applications. These can include screens with matte, split-image rangefinder-type focusing, microprism, cross-hairs, or other types. Specialized screens can provide an extra-bright image for viewing under dim lighting conditions with a central spot area for focusing, grids and cross-hairs for aligning images, and other features.

Custom focus screens are also available from third parties, including Katz Eye Optics (www.katzeyeoptics.com), which supplies a variety of types for Canon, Nikon, Fuji, Kodak, Leica, Olympus, Pentax, and Sigma dSLRs, all priced, roughly, in the $100 range. Installation in your camera is available for $50 more. Katz Eye custom fabricates its screens and can create them with your choice of grid lines, including Rule of Thirds markings for composition, architectural grids, and marks that indicate croppings for 8 × 10, 5 × 7, or square-format prints (useful for portrait photographers). The optical Opti Brite treatment ($55 extra) can be applied to make your view-finder image as much as two stops brighter under some conditions.

While in the past focus screens were usually precision-made chunks of ground glass, today you're likely to find a laser-etched plastic screen in your digital camera. And where such screens were formerly used simply to provide a way for the photographer to view an image and manually focus, today these screens may be used by your camera's exposure system to measure light from a large matrix of points, play a major part in autofocusing the image, or even to measure and set white balance (although at least one camera measures white balance from a sensor area on top of the camera in incident fashion, independent of the light coming through the lens). (Incident light is the light falling on a subject, as opposed to reflected from the subject.)

While EVF cameras can easily fill up the screen to any annoying degree with all kinds of information, you can often disable or minimize the clutter through menu settings. With a traditional digital SLR, the data displayed on the actual focus screen may be rather sparse, as you can see in Figure 3.3. Generally, you'll see little more than the focus-area indicator markings, plus an indicator that shows what area is being measured for spot or center-weighted exposure calculations. Some cameras impose a Low Battery warning or No Memory Card Present display on the actual viewing screen. These areas may be illuminated to show that they're active.

Additional data, which can include the shutter speed, f/stop, exposure mode, exposure number, focus confirmation light, and "flash needed" indicator, most often appears below the focus screen itself, usually as LED indicators.

Figure 3.3
SLR focus screens are relatively uncluttered, with most of the information arrayed at the bottom or (sometimes) sides of the frame, outside the image area.

Pentaprism/Pentamirrors and So Forth

The view of the focus screen looks properly oriented because the light transmitted through the screen is next bounced two more times off the reflective surfaces of a pentaprism, also called a *roof prism*, typically a one-piece optical glass component with silvered surfaces, or a pentamirror or similar system that consists of a hollow glass/plastic roof mirror hybrid. Some cameras, like the old Olympus E-300 I mentioned earlier, used a series of mirrors to produce the same effect, but without the typical pentaprism "hump" on top of the camera. Whichever system is used, these extra bounces are required to rectify the image for normal viewing.

If you've ever seen a traditional view camera at work, you probably noticed that the image on the ground glass was upside-down and reversed left-to-right. Studio photographers learn to work with images presented in this way, but SLR photography is generally a much faster-moving endeavor, so all digital single lens reflex cameras provide a properly oriented view.

The important thing to know about pentaprism/pentamirror systems is that solid-glass systems tend to present a much brighter image than mirror systems. Early in my career, I used a camera with interchangeable finders, and which could be fitted with a waist-level finder (just a hood that protected the viewing screen from light), a pentaprism, or pentamirror, and the reduced brightness of the mirror arrangement was significant.

Eyepiece

At the end of its long journey (which probably took less than a split second, unless you're photographing the moon or stars), the light that entered your lens exits through the eyepiece of your digital camera, ready for viewing by your eye. The eyepiece will usually have a rubber bezel around it so you can comfortably rest your eye against it, even if you're wearing glasses, and will have a diopter correction dial or slider you can use to customize your view for any nearsightedness or farsightedness in your vision. Most digital SLRs also allow adding a prescription lens to the eyepiece if the normal diopter correction isn't strong enough.

There are several factors related to the overall image that emerge from the eyepiece that you need to know about.

Magnification

This is how large the viewfinder image appears to your eye and, up to a point, bigger is better. If your dSLR's viewfinder provides 1X magnification, then your subject as viewed through the finder will appear to be the same size as when you view it with your unaided eye, *when you're using a normal lens focused at infinity.* A normal lens with a full-frame camera is generally defined as around 45mm–50mm. So, if you placed your right eye against the viewfinder and kept your left eye open, as you panned the camera the scene would appear roughly the same with either eye. If your digital camera uses a smaller than full-frame sensor, "normal" will be another focal length, such as 38mm using a camera with a 1.3X multiplier, or 31mm with a camera having a 1.6X multiplier.

If you're using any other lens or zoom setting besides normal, or have focused closer than infinity, the image size will change, even at 1X magnification. That's pretty obvious: zoom a lens from the 38mm "normal" position out to the 114mm telephoto setting, and the subject in the viewfinder will appear to be twice as big. Zoom in to 19mm for a wide-angle shot, and the subject will appear to be half as large.

A 1X magnification factor provides a nice big image for viewing. However, some digital SLRs provide only .80X or .75X magnification. Make sure the dSLR you buy has enough magnification for comfortable viewing.

Coverage

Your viewfinder may not show you 100 percent of what the sensor will see. It's likely that some of the image will be cropped, because it's difficult to design an optical viewing system that shows 100 percent of the available view. Pro cameras do a good job of this, but it's likely that your entry-level

dSLR will show you less, perhaps 95 percent of the true field of view. That shouldn't be a serious problem, because it means your final image will actually include *more* than what you saw.

With a 16 megapixel camera and 95 percent coverage, that's roughly the equivalent of clipping 75 pixels each off the left and right sides of the image area (about 1 percent of the width at either end), and 25 pixels each from the top and bottom lengths of the frame (also about 1 percent at each end). Figure 3.4 shows you roughly how much image you lose in the viewfinder. The purple area represents the portion of the image cropped out with a camera that provides 95 percent coverage. That's not a great deal, as you can see.

You can always crop back to the original viewfinder framing in an image editor if what-you-saw-is-what-you-want happens to be that important. To a certain extent, magnification and coverage work hand-in-hand: If your dSLR provides 100 percent coverage, the magnification may have to be reduced a little to allow room for the other informational displays in the viewfinder. If your camera's viewfinder has 100 percent magnification, it's likely that the coverage is reduced a little, for the same reason. Those pixels clipped at top, bottom, and sides are allocated to the readouts at the bottom of the viewfinder screen.

Eyepoint

This is the distance you can move your eye away from the eyepiece and still see the entire viewfinder, including the focus screen and the informational displays. An extended eyepoint is useful if you wear glasses, because your eyewear might not let you rest your eye right up against the viewfinder. A generous eyepoint figure is also useful when you're shooting sports or action and don't want to have the camera glued to your eye at all times. You might also want to be able to see stuff outside the camera's field of view, so you can monitor how a play is unfolding, or make sure that huge wide receiver who is not currently in the frame isn't headed toward the sidelines and your position! Eyepoint figures are generally given in millimeters, and range from around 12mm (half an inch) to 25mm (a full inch) or more.

Figure 3.4
With 95 percent viewfinder coverage, you'll lose only the portion of the image shaded in purple.

Protecting the Sensor from Dust

Photographers have had to surmount dirt and dust problems for more than 150 years. Dust can settle on film or photographic plates, marring the picture. Dust can reside on the front or back surfaces of lenses and, if the specks are numerous enough, affect the image. Dirt can even get *inside* the lens. It can infest your dSLR's mirror and focusing screen, too, which shouldn't affect the quality of your photos, but can be annoying nevertheless. Dirty electrical contacts could conceivably affect the ability of your flash memory cards to store information or hinder the operation of an external electronic flash.

These ills infected film cameras in the past, and most of them apply to digital cameras as well. However, the dSLR adds a new wrinkle: dirty sensors. In non-dSLRs, the sensor is sealed inside the camera and protected from dust. Unfortunately, your removable-lens digital camera invites the infiltration of dust or worse, every time you swap lenses. Dust will inevitably creep inside and come to rest. Some of it will lie in wait for the shutter protecting your sensor to open for an exposure and then sneak inside to affix itself to the imager's outer surface. No matter how careful you are and how cleanly you work, eventually you will get some dust on your camera's sensor. This section explains the phenomenon and provides some tips on minimizing dust and eliminating it when it begins to affect your shots.

Whither Dust

Like it or not, unless you live in a clean room or one of those plastic bubbles, you're surrounded by dust and dirt. It's in the air around you and settles on your digital camera's works without mercy. When you remove a lens to swap it for another, some of that dust will get trapped inside your camera. Dust can infiltrate even if you *don't* remove the lens; certain lenses are notorious for sucking in dust as their barrels move during zooming or focusing, and then propelling the dust backward toward the lens mount. None of this dust ends up inside the optics of the lens—it's directed toward the interior of your camera. Canon includes soft rubber seals on some of its EF-S lens mounts to prevent dust from sneaking past.

But, in the end, all is for naught. Dust *will* get inside your camera. Most of it will cling to the sides of the mirror box. Some will land on the mirror itself, or stick to the underside of the focus screen. Dust found in any of these locations shouldn't affect your pictures unless enough accumulates to interfere with the autofocus or autoexposure mechanisms, and long before that you'll be seriously distracted by the dust bunnies hopping around in your viewfinder.

The real danger lies in the dust particles that cling to the shutter curtain and rear portions of the mirror box. They're likely to be stirred up by the motion of the curtain and waft their way inside to the sensor. (See Figure 3.5.) Taking a photo with the camera pointed upward will enlist the law of gravity against you. Fortunately for Sony SLT-series users, the non-flipping semi-transparent mirror of those models serves as a partial barrier against dust infiltration.

Figure 3.5
The sensor of a digital SLR is accessible only when the mirror is flipped up and the shutter is open.

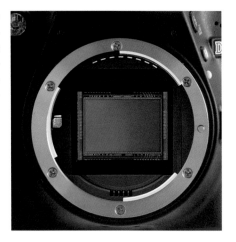

Eventually, though, the dust settles on the outer surface of the sensor, which is a protective filter (often a low-pass, anti-aliasing filter, found in most recent models other than Nikon's latest batch), rather than the sensor itself. Today, all vendors make an effort to ensure that the dust doesn't take up permanent residence. Even so, some digital SLRs are more susceptible to dust on the sensors than others, and some cameras do a better job of removing it than others. Over time, however, most will succumb and exhibit some sensor dust that isn't removed by the camera's self-cleaning features. I owned my latest dSLR for two weeks and had removed the lens perhaps three or four times before I noticed I had my first dust problem.

You may have dust on your sensor right now and not know it. Because the grime settles on a surface that's a tiny fraction of an inch above the actual sensor, it often will not be visible at all at wider lens apertures. If you shoot at f/2.8–f/5.6 most of the time, the dust on your sensor is probably out of focus and not noticeable, particularly if the particles are small. Stop down to f/16 or f/22, and those motes suddenly appear, in sharp relief. (See Figure 3.6 for a set of photos at different lens apertures.) The actual particles may be too small to see with the unaided eye; a dust spot no larger than the period at the end of this sentence (about .33mm in diameter) could obscure a block of pixels 40 pixels wide and 40 pixels tall with a typical dSLR sensor. If a dust spot creates a dark blotch against a light background, a spot as small as 4 pixels wide is likely to stick out like a sore thumb.

Clearly, you do *not* want to have your images suffer from this plague.

Dust vs. Dead Pixels

New dSLR owners who find spots that show up in the same place on a series of images may wonder whether they're looking at a dust spot or a defective pixel in their sensor. Dead pixels aren't as deadly as you might think. A technique called *pixel mapping* can locate non-functioning pixels and permanently lock them out, so the camera will substitute information from surrounding pixels for future images. Some cameras have sensor pixel mapping built into the camera, which can be automatically or manually applied (depending on how the camera is designed).

Figure 3.6
At f/4 (top), the sensor dust on this small portion of a larger image is less visible. At f/22 (bottom), the artifacts are painfully obvious.

You should be aware that some models have a type of pixel mapping the works *only* for the color LCD monitor, removing defective pixels from the display, either during live view or picture review. Those bad pixels reside in the display alone, and are not in the image you captured. This type of pixel mapping does nothing for hot or dead pixels on the *sensor*, which don't show up on the LCD until picture review, after the image has been captured. Other cameras need a firmware upgrade to take care of sensor pixel mapping, or require sending the camera back to the vendor for adjustment. This fix is typically free while the camera is under warranty.

So, how do you tell whether you have a dust bunny or a bad pixel to deal with? Just follow these steps:

1. Shoot several blank frames of both dark- and light-colored backgrounds (so you can see both light and dark pixel anomalies). Do not use a tripod. You do not want the frames to be identical. You want bad pixels, which are always in the same place, to appear regardless of how the subject is framed.

2. Shoot variations of dark and light frames using both your maximum (largest) f/stop and your minimum (smallest) f/stop, such as f/2.8 and f/22.

3. Transfer the images to your computer and then load them into your favorite image editor.

4. Copy one of the dark frames and paste it into another dark frame image as a new layer. Make sure you include frames taken at both minimum and maximum apertures. Repeat for another image containing several light frames.

5. Zoom in and examine the images for dark and light spots.

6. If you locate a suspect spot, make the current layer invisible and see if the spot is in the same position in the other layers (from different shots). If that is the case, then the bad pixel(s) are caused by your imager, and not by your subject matter.

7. Use the guidelines below to determine whether the spots are caused by dust or bad pixels.

Bad pixels may be tricky to track down, because they can mask themselves among other components of an image. A hot pixel may be obvious in a clear blue sky, but scarcely noticeable in an image with lots of detail in the affected area. Figure 3.7 (top) shows a best-case (or worst-case) scenario: a

Figure 3.7
Four bad pixels are lurking here (top). Enlargement reveals their location (bottom).

hot pixel (actually a cluster of *four* pixels) lurking in a speckled image of some crayons. It's lurking in the third row, but you'll never find it with the naked eye. Figure 3.7 (bottom) shows the little devils isolated. They were identified by comparison with a completely different picture, which showed the same hot pixels in the same position. Although the crayons have speckles and dust motes of their own, these hot pixels are objectionable because the crayons in question are supposed to be out of focus, without a razor-sharp hot spot. In Figure 3.8, you can see that the four bad pixels are surrounded by other pixels that are incorrectly rendered because demosaicing was unable to interpolate their proper values correctly due to the hot spot caused by the bad pixel.

Figure 3.8 The bad pixels will cause an ugly blotch like this in every photo taken.

When you've identified spotty areas in your images, figure out their cause by going through this checklist. If you pinpoint a dust spot, use the cleaning methods described later in this chapter. If it's a bad pixel, activate your camera's pixel-mapping feature, if available (either built-in, or through a software utility). If no such remedy is built into your camera or software, you can usually ignore a bad pixel or two. However, if you discover a half-dozen or more, contact your vendor.

Note that if you shoot RAW, the RAW conversion process as you import the image into your image editor may eliminate bad pixels automatically. I discovered this phenomenon when I noticed that when shooting with my camera's RAW+JPEG mode, the errant pixels appeared only in the JPEG version, and not in an image imported from RAW. Bad pixels tend to be most noticeable when they appear within areas of contrasting tone. In an image with many subtle shades, the defective pixel may be massed. I tend to notice them most when shooting concerts, when the vast areas of black surrounding the performers cause anomalous light-colored pixels to stick out like a sore thumb. Finally, bad pixels *can* be intermittent, appearing and disappearing as your sensor heats up or shifts into higher ISO settings that seem to accentuate bad pixels. You can use the remedial methods described in the next section to fix bad spots that appear in existing images.

- **Light pixel.** If the spot is light in color when viewed against an area that is overall dark in color, it's probably caused by one or more pixels that are permanently switched on. This is known as a *stuck* pixel.

- **Dark pixel.** If the spot is dark in color when viewed against an area of lighter pixels, it may be a pixel that is permanently off (known as a *dead* pixel), or it may be a dust spot (if it's fuzzy). A dark pixel that is rectangular (perhaps a black pixel surrounded by pixels of decreasing density) is probably a dead pixel. The additional bad pixels are usually caused by the effects of interpolating surrounding pixels from the dead one.

- **Now-you-see-it/Now-you-don't pixel.** If a spot seems to come and go and you determine that it only happens when using longer exposures, it is likely to be a *hot* pixel, produced when the sensor heats up. You may find that your camera's noise reduction features see hot pixels as noise and remove them for you automatically.

- **Blurry/sharp pixels.** A set of dark pixels that shows up in the frames shot at the smallest f/stop, but which vanishes or becomes out of focus in the wide-open frames is certainly a dust spot, as you can see in Figure 3.6, shown earlier.

Protecting the Sensor from Dust

The easiest way to protect your sensor from dust is to prevent it from entering your camera in the first place. Here are some steps you can take:

- **Keep your camera clean.** Avoid working in dusty areas if you can do so. Make sure you store your camera in a clean environment.

- **Clean your lenses, too.** When swapping lenses, use a blower or brush to dust off the rear lens mount of the replacement lens first, so you won't be introducing dust into your camera simply by attaching a new, dusty lens. Do this before you remove the lens from your camera, and then avoid stirring up dust before making the exchange.

- **Minimize the time your camera is lensless and exposed to dust.** That means having your replacement lens ready and dusted off, and a place to set down the old lens as soon as it is removed, so you can quickly attach the new lens.

- **Face the camera downward.** When the lens is detached, point the camera downward so any dust in the mirror box will tend to fall away from the sensor. Turn your back to any breezes or sources of dust to minimize infiltration. Some camera vendors recommend having the base of the camera downward when *cleaning* the sensor, because their designs employ sticky areas on the floor of the sensor area to grab dust.

- **Protect the detached lens.** Once you've attached the new lens, quickly put the end cap on the one you just removed to reduce the dust that might fall on it.

- **Clean the mirror area.** From time to time, remove the lens while in a relatively dust-free environment and use a blower bulb (*not* compressed air or a vacuum hose) to clean out the mirror box area. A bulb blower is generally safer than a can of compressed air, or a strong positive/negative airflow, which can tend to drive dust further into nooks and crannies.

- **Clean soon and often.** Your camera's built-in sensor cleaning system is not perfect, even if you have set it to clean both when the camera is switched on and powered down. And remember that many cameras allow turning off automatic sensor cleaning (some find the "buzz" annoying, or think they are saving power by disabling the feature). So, manual inspection and cleaning can be important. If you're embarking on an important shooting session, it's a good idea to make sure your sensor is clean *now* using the suggestions you'll find below, rather than coming home with hundreds or thousands of images with dust spots caused by flecks that were sitting on your sensor before you even started.

Fixing Dusty Images

You've taken some shots and notice a dark spot in the same place in every image. It's probably a dust spot (and you can find out for sure using my instructions above), but no matter what the cause, you want to get it out of your photos. There are several ways to do this. Here's a quick checklist:

- **Clone the spots out with your image editor.** Photoshop and other editors have a clone tool or healing brush you can use to copy pixels from surrounding areas over the dust spot or dead pixel. This process can be tedious, especially if you have lots of dust spots and/or lots of images to be corrected. The advantage is that this sort of manual fix-it probably will do the least damage to the rest of your photo. Only the cloned pixels will be affected.

- **Use your image editor's dust and scratches filter.** A semi-intelligent filter like the one in Photoshop can remove dust and other artifacts by selectively blurring areas that the plug-in decides represent dust spots. This method can work well if you have many dust spots, because you won't need to patch them manually. However, any automated method like this has the possibility of blurring areas of your image that you didn't intend to soften.

- **Try your camera's dust reference feature.** Some dSLRs have a dust reference removal tool that compares a blank white reference photo containing dust spots that you shoot for comparison purposes with your images, and uses that information to delete the corresponding spots in your pictures. However, such features generally work only with files you've shot in RAW format, which won't help you fix your JPEG photos. Dust reference subtraction can be a useful after-the-fact remedy if you don't have an overwhelming number of dust spots in your images.

Cleaning the Sensor

Should you clean your sensor? That depends on what kind of cleaning you plan to do, and whose advice you listen to. Some vendors countenance only dust-off cleaning, through the use of reasonably gentle blasts of air, while condemning more serious scrubbing with swabs and cleaning fluids. These same manufacturers sometimes offer the cleaning kits for the exact types of cleaning they recommended against, for sale in Japan only, where, apparently, your average photographer is more dexterous than those of us in the rest of the world. These kits are similar to those used by the vendor's own repair staff to clean your sensor if you decide to send your camera in for a dust cleaning.

Removing dust from a sensor is similar in some ways to cleaning the optical glass of a fine lens. It's usually a good idea to imagine that the exposed surfaces of a lens are made of a relatively soft kind of glass that's easily scratched, which is not far from the truth (although various multi-coatings tend to toughen them up quite a bit). At the same time, imagine that dust particles are tiny, rough-edged boulders that can scratch the glass if dragged carelessly across the dry surface. Liquid lens cleaners can reduce this scratching by lubricating the glass as a lens cloth or paper is used to wipe off the dust, but can leave behind a film of residue that can accumulate and affect the lens' coating in another fashion. Picture the lens wipes as potential havens for dust particles that can apply their own scratches to your lenses.

You can see why photographers who are serious about keeping their lenses new and bright tend to take preventive measures first to keep the glass clean. Those measures often include protective UV or skylight filters that can be cleaned more cavalierly and discarded if they become scratched. If all else fails, the experienced photographer will clean a lens's optical glass carefully and with reverence.

Most of this applies to sensors, with a few differences. Sensors can be affected by dust particles that are much smaller than you might be able to spot visually on the surface of your lens. The filters that cover sensors tend to be fairly hard compared to optical glass. Cleaning a sensor that measures 24mm or less in one dimension within the tight confines behind the mirror can be trickier and require extra coordination. Finally, if your sensor's filter becomes scratched through inept cleaning, you can't simply remove it yourself and replace it with a new one.

In practice, there are three kinds of cleaning processes that can be used to vanquish dust and gunk from your dSLR's sensor, all of which must be performed with the shutter locked open:

- **Air cleaning.** This process involves squirting blasts of air inside your camera with the shutter locked open. This works well for dust that's not clinging stubbornly to your sensor.
- **Brushing.** A soft, very fine brush is passed across the surface of the sensor's filter, dislodging mildly persistent dust particles and sweeping them off the imager.
- **Liquid cleaning.** A soft swab dipped in a cleaning solution such as ethanol is used to wipe the sensor filter, removing more obstinate particles.

The first thing to do is to lock up your camera's mirror so you can gain access to the sensor. You'll probably have to access a menu item in your dSLR's setup page to lock up the mirror. Some vendors recommend locking up the mirror for cleaning only if a camera is powered by an AC adapter, rather than by a battery. The theory is that you don't want your battery to fail while you're poking around inside the camera with tools. A damaged mirror, sensor, or both can easily be the result if the mirror flips down before you're finished.

In practice, my digital camera's battery poops out less frequently than I experience brownouts and AC power blackouts. My recommendation is to charge your camera's battery and use that with confidence to keep your mirror latched up. That recommended AC adapter may be an extra-cost option that you'll buy and then not use for anything else (unless you do a lot of work in a studio).

Once the mirror is up, you should work as quickly as possible to reduce the chance that even more dust will settle inside your camera. Have a strong light ready to illuminate the interior of your camera. If you happen to have one of those headband illuminators that blasts light anywhere you happen to be gazing, so much the better.

The next few sections will describe each of these methods in a little more detail.

Air Cleaning

Cleaning by air is your first line of defense. If you do it properly, it's difficult to overdo. An extra gentle blast of air isn't going to harm your sensor in any way, unless you stir up dust that re-deposits on the sensor.

Of course, the trick is to use air cleaning properly. Here are some tips:

- **Use only bulb cleaners designed for the job.** Good ones, like the Giottos Rocket shown in Figure 3.9, have one-way valves in the base so that air always enters from the rear of the bulb and never the front (which would allow dust from the sensor to be sucked inside, then sprayed out again with the next puff). Smaller bulbs, like those air bulbs with a brush attached sometimes sold for lens cleaning or weak nasal aspirators may not provide sufficient air or a strong enough blast to do much good.

- **Do not use compressed air-in-a-can.** The propellant inside these cans can permanently coat your sensor if you goof.

- **Do not use commercial compressed air compressors.** Super-strong blasts of air are as likely to force dust into places you don't want it to be, including under the sensor filter, as they are to remove it.

- **Hold the camera upside down and look up into the mirror box as you squirt your air blasts**. This increases the odds that gravity will help pull the expelled dust downward, away from the sensor. You may have to use some imagination in positioning yourself. If your vendor recommends holding the camera so the base is downward, try that, too, but I prefer my method. (See Figure 3.10.)

Figure 3.9 Use a robust air bulb like the Giottos Rocket for cleaning your sensor.

Figure 3.10 A few puffs of air should clean your sensor.

Brush Cleaning

If your dust is a little more stubborn and can't be dislodged by air alone, you may want to try a brush, like the Sensor Brush sold at www.visibledust.com. Ordinary brushes are much too coarse and stiff and have fibers that are tangled or can come loose and settle on your sensor. The Sensor Brush's fibers are resilient and described as "thinner than a human hair." Moreover, the brush has a wooden handle that reduces the risk of static sparks.

Another good, if expensive, option is the Arctic Butterfly sold at www.visibledust.com. A motor built into the brush is used to "flutter" the tip for a few seconds prior to cleaning (see Figure 3.11, left), charging the brush's anti-static properties. Then, the motor is turned off (Figure 3.11, right) and the brush tip is passed above the surface of the sensor. (It's not necessary to touch the sensor.) The dust particles are attracted to the brush fibers and cling to them.

The dust is removed by another quick flutter once you've withdrawn the brush from the mirror chamber. A cheaper, inanimate, sensor cleaning brush can be purchased at www.copperhillimages.com. You need a 16mm version. It can be stroked across

Figure 3.11 A proper brush like this Arctic Butterfly is required for dusting off your sensor.

the short dimension of your camera's sensor. You should clean the brush with compressed air before and after each use, and store it in an appropriate air-tight container between applications to keep it clean and dust free. Although these special brushes can be expensive, one should last you a long time. They are offered in various sizes to fit different dSLR sensor widths. You can also use a brush to dust off the surfaces inside the mirror box.

Liquid Cleaning

The most persistent dust spots may be combined with some grease or a liquid that causes them to stick to the sensor filter's surface. In such cases, liquid cleaning with a swab may be necessary. You can make your own swabs out of pieces of plastic (some use fast-food restaurant knives, with the tip cut at an angle to the proper size) covered with a soft cloth. However, I recommend buying commercial sensor cleaning swabs, such as those sold by Photographic Solutions, Inc. (http://photosol.com/product-category/sensor-swabs/) to get the best results. (Some folks get good results using homemade swabs and the Pec-Pad cleaning pads sold by Photographic Solutions, but the company itself does not recommend using these pads for this application.) Vendors selling these swabs will recommend the right size for your particular dSLR.

You want a sturdy swab that won't bend or break so you can apply gentle pressure to the swab as you wipe the sensor surface. Use the swab with methanol (as pure as you can get it; other ingredients can leave a residue), or the Eclipse solution also sold by Photographic Solutions. A couple drops of solution should be enough, unless you have a spot that's extremely difficult to remove. In that case, you may need to use extra solution on the swab to help "soak" the dirt off.

Once you overcome your nervousness at touching your camera's sensor, the process is easy. You'll wipe continuously with the swab in one direction, then flip it over and wipe in the other direction. You need to completely wipe the entire surface; otherwise, you may end up depositing the dust you collect at the far end of your stroke. Wipe; don't rub.

You can make your own swabs out of pieces of plastic (some use fast-food restaurant knives, with the tip cut at an angle to the proper size) covered with a soft cloth or Pec-Pad, as shown in Figure 3.12. However, if you've got the bucks to spend, you can't go wrong with good-quality commercial sensor cleaning swabs, such as those sold by Photographic Solutions, Inc.

If you want a close-up look at your sensor to make sure the dust has been removed, you can pay $50–$100 for a special sensor "microscope" with an illuminator. Or, you can do like I do and work with a plain old Carson MiniBrite PO-55 illuminated 5X magnifier, as seen in Figure 3.13. It has a built-in LED and, held a few inches from the lens mount with the lens removed from your Alpha, provides a sharp, close-up view of the sensor, with enough contrast to reveal any dust that remains. If you want to buy one, you'll find a link at www.dslrguides.com/carson.

Figure 3.12 You can make your own sensor swab from a plastic knife that's been truncated. Carefully wrap a Pec-Pad around the swab.

Figure 3.13 The Carson Mini Brite is an inexpensive illuminated magnifier you can use to examine your sensor.

MIRRORS AND FOCUS SCREENS: HANDLE WITH CAUTION

You won't find many tips for cleaning your dSLR's mirror or focus screens, other than to use a blast of air. That's because a bit of dust on either one of them is unlikely to affect the operation of your camera, and both are easily scratched. If you become obsessed over mirror or screen dust that you can't easily remove, consider sending the camera back to the vendor for cleaning. Wiping with lens paper, swabs, or cleaning liquids is likely to do more harm than good.

Secrets of dSLR Image Storage

Another quirk of the dSLR involves the storage methods you choose and use. You may have more options and a few more pitfalls than your point-and-shoot toting friends. This section will reveal a few of them. Here are the most common memory card configurations found in digital SLRs today:

- **Single memory card.** The majority of dSLRs have a single memory card slot. For entry-level and most mid-level cameras, that slot will accept an SD/SDHC/SDXC (Secure Digital/Secure Digital High Capacity/Secure Digital eXtended Capacity) card. The SD form factor has been the standard for many years now.

 Some older mid-level and a few "pro" cameras have a single slot, too, but instead accept the Compact Flash card preferred by advanced shooters (for reasons I'll explain shortly). If you have an older dSLR it may have one slot for some other memory card type. Sony's original Alpha camera, the DSLR-A100, based on the Konica Minolta MAXXUM 5D digital camera, was introduced at a time when the company was still promoting its doomed Memory Stick technology, and came with a Compact Flash slot, but an adapter that allowed using Memory Stick Pro Duo cards. Today, it's common for Sony cameras to be furnished with just one memory card slot, but that slot will accept both SD and Memory Stick cards.

- **Dual slots/mixed type.** Canon, Nikon, and Sony have all offered cameras with two memory card slots, each for a different type of media. The Canon EOS 5D Mark III, for example, has both Compact Flash and SD slots. (See Figure 3.14, left.) Nikon's top-of-the-line D4/D4s dSLRs have slots for Compact Flash and the newer XQD form-factor cards. Many of Sony's older dSLRs had separate SD/SDHC/SDXC and Memory Stick Pro Duo slots. In its full-frame dSLR models, Sony has also offered cameras with Compact Flash and Memory Stick Pro Duo slots (see Figure 3.14, right). I'll discuss the problems/confusion of mixed slots next.

- **Dual slots/same type.** A few digital SLRs take what I consider to be the best approach and include two memory card slots that are identical. Nikon, for example, offered two Compact Flash slots in its older D3s model, and includes two SD/SDHC/SDXC slots in the Nikon D610 and D7100.

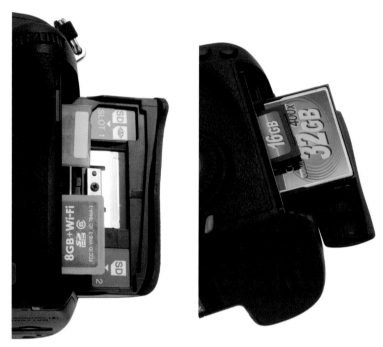

Figure 3.14
Some Sony cameras (left) have two slots: one for Memory Stick Pro cards and one for SD cards, but both can't be used simultaneously. An increasing number of cameras have two functioning slots (right), and allow you to specify how the card in the second slot is used.

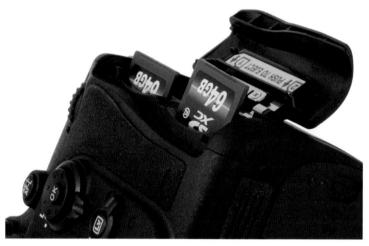

Figure 3.15
The best configuration is to have two identical memory card slots.

ABBREVIATING THE ABBREVIATION

Rather than constantly refer to SD/SDHC/SDXC memory cards, I'm going to lump all of them together as SD cards henceforth. The original SD card format (limited to 2GB or smaller) has, as a practical matter, been replaced by its successors, and all dSLRs on the market today accept SDHC cards. An increasing number will also accept the latest SDXC cards, but I'll use that nomenclature only when it's important to note a difference. Otherwise, it will be SD all the way.

One Slot or Two?

Unless you ranked the number of slots as a critical factor when you chose to purchase your dSLR, the number of memory cards you could use simultaneously was probably not one of your options. However, if you're still deciding what camera to buy for your next upgrade, you'll want to read over the following advantages/disadvantages closely. And, if you already own a camera with two memory card slots, there may be some applications for the feature that you haven't thought of.

The chief (only) advantage of having a camera with a single memory card slot is simplicity. You never have to worry about which type of memory card to put in the camera, whether you've put a card in both slots (your camera will alert you when there is no memory card present), and, unless you own another camera that uses a different kind of memory card, how many of which form factor to include in your bag. One disadvantage of having just one kind of memory card slot is that you can't easily exchange cards with another photographer, which happens more than you might realize on field trips, travel expeditions, or any time you are out shooting with a friend. If you or your friend run out of storage space, you can't share cards unless you both use the same type. I always keep a couple spare cards in my camera bag for sharing, and I end up including *both* Compact Flash and SD cards just to increase my opportunities to be a Good Samaritan. (Altruism aside, it never hurts to have a friend owe you one!)

However, there are other disadvantages to having only one memory card slot, chiefly that you can't do any of the cool things your compatriots with multiple slots can do. To wit:

- **Increase your capacity.** Two identical cards allow you to shoot twice as long without switching, which can be especially critical in photojournalism/sports applications.
- **Shoot to two cards simultaneously.** This gives you an instant backup in case pictures on your primary card become corrupt or are erased. Ideally, your two cards should be equal in size.
- **Make a copy.** Use your camera's copy image(s) facility to make a copy of images you shot on one card to your second card. Instead of shooting on two cards at once (which does slow down the camera a bit), use only one card when you take photos, then make a backup onto a second card at the end of the day. You can copy all or only some of the photos you've shot.
- **Make copies to distribute.** I bought a bunch of 2GB memory cards for $4.98 each, and find it's quick and easy to make multiple copies of photos, not for backup, but for distribution either on the spot, say, to provide models I've hired with some raw (not RAW) images, or to send by snail mail to colleagues, friends, or family. No computer required!
- **Leave your personal storage device at home.** Since I've begun using cameras with dual memory card slots, I leave my hard disk/personal storage device with its built-in reader at home virtually all the time. If I am going to be gone for only a day or two, it's easier to just make copies in the camera, and not bother with another external device.

Most digital SLRs that offer two memory card slots allow you to specify how the second slot is used. One exception is the Sony cameras that have a physical switch that specifies whether the Memory

Stick Pro Duo card, or the alternate memory card (CF or SD) is used. In these Sony cameras, two cards can't be active at once.

For the others, you'll be able to choose whether to use the secondary slot to accept overflow images when the slot 1 card fills up; create a backup of all the files stored on the slot 1 card; or split your RAW+JPEG files between slot 1 and slot 2, with one type on each. Nikon offers a fourth option on some cameras—you can select which slot is used to store your movie clips (and can therefore choose the *largest* memory card or *fastest* memory card for your movies, as you prefer).

Overflow

In this case, when the memory card in slot 1 fills up, the camera automatically switches over to the card in slot 2. The changeover happens quickly, and you're not even likely to notice, unless you have your eye on the camera's status indicators. There are dozens of ways to use this capability:

- **"Limitless" Capacity.** My standard operating procedure is to put one 32GB memory card in each slot. As a practical matter, that means I can shoot all day without changing memory cards, even if I am shooting landscapes and bracketing everything with three- or five-shot sets (either to optimize exposure, or, when the camera is mounted on a tripod, to capture files for later HDR processing). Or, I might be shooting sports/photojournalism, where the practice is to change memory cards when your media is 80 percent full to eliminate the possibility of missing anything important due to a card change at an inopportune time.

- **Small/fast—with backup.** For some sports, if I am shooting at a high frame rate, I may want my fastest memory card in slot 1 to maximize write speed out of the camera's buffer, but the real speed demons in the memory card world can be expensive. So, instead of a 32GB medium-speed card, I may put an 8GB or 16GB UDMA (Ultra Direct Memory Access) or UHS (Ultra High Speed) card in slot 1, and back it up with a slightly slower (and cheaper) 16GB or 32GB card. I can capture images with the fastest card I've got, yet not have to worry about missing shots, because I have an affordable backup card installed in slot 2.

 Canon 5D Mark III owners should note that the camera's SD slot does not conform to the highest speed standards, and stores images and movies at a relatively slow rate. That makes it unsuitable for shooting video. Worse, if you have an SD card mounted, the camera defaults to a slower rate for the CF slot as well. For maximum speed, you really must opt for a single CF card and eschew using an SD card entirely.

- **Put smaller cards to use.** If you don't think you'll need the overflow capacity, but still want to have it just in case, put a smaller card that you don't use much anymore in slot 2. If your large card that you didn't think would fill *does* come up short, you won't lose any shots. They'll be directed to that old 4GB card you put in slot 2 for insurance. I sometimes do this when I am using several cameras and have a limited number of large cards at my disposal. I'll save the big cards for primary use, knowing that any overflow shots will be stored on the small backup cards if necessary.

■ **Stretch your budget.** Your spiffy new 20–24 high-megapixel dSLR produces files that are much larger than your old 12 megapixel model, but after spending an arm and a leg for the camera, you'd like to avoid replacing your fast, but limited-capacity 8GB memory cards for a little while. (Perhaps you're waiting for those new 64GB cards to come down in price.) With one 8GB card in each slot, you can double your shooting before it's time to swap cards.

Backup

When using backup mode, each photograph you take is recorded on the memory cards in both slot 1 and slot 2. The write process takes slightly longer (so it may not be your best option when shooting sports), but it's otherwise a seamless way to create a backup copy of each and every image you take. Here are some of my favorite applications:

■ **Critical shots backed up instantly.** When I was a photojournalist, a lot of the images I took, particularly of spot news events, were literally once-in-a-lifetime shots that couldn't be duplicated under any circumstances. I also shot weddings, and while it was sometimes possible to restage a particular setup or pose, that was never a satisfactory option, even if done on the day of the nuptials. So, there was always a degree of trepidation until the film was processed or digital files backed up. With dual-slot backup capabilities, backup files can be made instantly, as you shoot. What a relief!

■ **Great when there's No-Fi.** Many pros (and more than a few amateurs) rely on in-camera Wi-Fi connectivity to beam backups to a nearby laptop computer for safekeeping, or, at events, so that an assistant can be processing some images while photography continues. But, sometimes that's not possible, or, perhaps, you don't own the necessary equipment. Making a backup in your camera is a great alternative when wireless capabilities are unavailable or impractical. You can even shuttle that slot 2 card to an assistant at intervals while retaining the "main" copy of your images in the camera.

■ **Leave your PSD at home.** When I travel overseas, I like to pack light, with only a carry-on bag that holds my camera gear and some of my clothing, with the rest of my apparel relegated to the second tote that qualifies as a "personal" item. But I've always carried two card reader/personal storage devices so I can make backup copies of my images while I travel. I've found that my dual-card cameras can easily replace the PSD. I can back up each image as it's shot automatically, or shoot on one card (to allow faster capture) and make a duplicate with a card-to-card copy back in my hotel room in the evening. Or I can use my camera's copy image feature to make an extra copy of only the images I want.

■ **Instant copy to share.** Want to give a traveling companion copies of all the images you shoot? Make a backup as you take the photos and hand over the copy on the spot. (Again, if you want to share only *some* of your pictures, you can use the copy image feature instead.)

RAW Slot 1—JPEG Slot 2

If your camera offers this mode, when you're shooting RAW+JPEG, the RAW files are saved to the card in one slot and the JPEG files are saved to the card in the other slot. You'll find this mode useful under the following conditions:

- **Separate RAW and JPEG.** Perhaps you like to store your RAW and JPEG files in separate locations. This mode makes it easy to do that. Copy the card containing the RAW files to one destination on your computer, and the JPEG files from the other card to a second destination. The only complication is that the memory card with the RAW files is likely to fill up more quickly than the card with the smaller JPEG files in the other slot, so if you shoot to the capacity of the card in the RAW slot, you'll need to replace it more often than you will the card with the JPEG files, or start out with a larger capacity card. Or, if you want the two cards to be mirror images of each other (but in different formats), you can swap them both out at the same time, with the JPEG card only partially full.

- **Faster backup of RAW+JPEG.** If you shoot RAW+JPEG, using the backup option (described earlier) means that you're saving *four* files each time you press the shutter release. That can slow you down in some situations if you're rapid-firing a sequence of images. Storing RAW files on one card, and JPEG files on the other is a faster way of capturing a backup, because only two files are saved per click. If you have a problem with one of your JPEG files, you can easily produce a new JPEG from the RAW file. The reverse is not true, however. If your RAW file gets munged, your RAW information is lost forever, even though you still have the JPEG version. So, use this option carefully if your RAW files are especially important for a particular shooting session.

Key Considerations for Choosing a Card

Here are some of the things to consider when choosing memory card storage for your dSLR, assuming you own or plan to buy a camera where such a choice is relevant:

- **Size.** Compact Flash are slightly larger than the alternative media, but probably more rugged, too. The larger size isn't particularly more difficult to tote around (compared to the volume consumed by a brick of film), and not quite as easy to lose. You probably wouldn't choose a dSLR based on what type of memory it used, so this isn't much of an issue for most.

- **Capacity.** Don't expect one format or another to retain a capacity advantage for very long, but at the time I write this, Compact Flash cards that hold 64GB or more are available at reasonable prices, but SD cards of that size are significantly less expensive. If maximum capacity is important to you, keep track of the latest developments among the vendors, realizing that the top-capacity cards are likely to be the most expensive.

- **Form factor.** Compact Flash cards are available in both Type I and Type II configurations. Type II cards are thicker, and won't fit in digital cameras that have only the thinner, Type I slots, which, today, is virtually every CF-using model. Type II cards are effectively obsolete,

unless you own an older camera like the Nikon D3x. CF to SD adapters, in particular, are of the Type II variety. If you have some old Type II cards or an adapter that you want to use, make sure your camera accepts them.

- **Cost.** The secret is to find the "sweet spot" in the pricing, so that you're paying about the same per gigabyte of storage, regardless of the size of the card. That is, a 32GB card should cost about twice as much as a 16GB card of the same speed. If not, you're paying a premium for the extra capacity. Right now, I am still using 32GB cards in my cameras, but I also buy 64GB cards, because some good brands are available at less than twice the cost of two 32GB cards.

- **Speed.** When choosing a card, evaluate your needs and the write speed of the card you're considering. For most kinds of photography, the write speed of the card has little effect on your picture taking. Most memory cards can accept data from single shots as quickly as you can shoot them. An exception might be if you're shooting sports sequences, or if you're shooting RAW files and your camera is particularly slow in saving these files. You'll pay more for the higher-speed cards, perhaps with no discernable benefit during shooting. However, when it comes time to transfer your images from a memory card to your computer, that extra speed can come in handy. If you have a FireWire or fast USB 2.0/USB 3.0 card reader, a slow card can be a bottleneck, and transferring a large number of images can take many minutes. The cards I buy tend to be labeled 600X or 800X, although I do have a few 1000X and 1100X cards for demanding applications.

Large Card or Multiple Smaller Cards?

Opting for large memory cards over several smaller ones does more than reduce your costs on a per-megabyte basis (a 32GB card is usually less expensive than 4 cards of 8GB capacity). You're also increasing your exposure to loss of images if you lose a card or the media becomes unreadable. Some photographers like to pop in a single card and then shoot all day without the need to switch to a different card. Others prefer to swap out cards at intervals, and keep the exposed memory extra safe. (If all your eggs are in one basket, watch that basket very carefully!)

From a security standpoint, there is little difference between using fewer high-capacity cards or a larger number of lower capacity memory, although I tend to see the bigger cards as safer. Working with two 8GB cards instead of a single 16GB card means you double your chances of losing one. You also double your chances of damage to your camera caused by frequent insertions/removals (bending the internal connector pins in a camera that uses Compact Flash cards is far more common than card failure).

True, you could *potentially* lose more pictures if a 16GB card fails, than if an 8GB card fails, but who says that your memory card will become corrupted only when it's full? A 4GB card, 8GB card, or 16GB card could each fail when they had 3GB worth of images on them, costing you the same amount of pain in each case. When you and your family go on vacation by car, do you drive in two separate vehicles? Assuming you don't have a very large family, the answer is probably no. However, auto accidents are much more common than memory card failure, and I imagine you value your family members a lot more than you value the photos you shoot.

Of course, there are other reasons for using multiple memory cards. Using multiple cards is a good way to segregate your images by topic or location. If you're on vacation in Europe, you can use a new card for each city (just as you might shoot one or two rolls of film in each location). Or, photograph cathedrals on one card, castles on a second, landscapes on a third, and native crafts on a fourth.

But, for the most part, I prefer to use larger cards to minimize the number of swaps I need to make while shooting. With a typical dSLR, I can shoot several thousand photos in RAW format per 64G card (a lot more than I got with 36-exposure rolls of film!), and I don't need to swap media very often except when I'm shooting sports, which can eat up an entire 16GB–32GB card in an hour or two. I often segregate several days' shooting by creating new storage folders on the same card. I might put all June 1 images in a folder named 601, and then create a new folder called 602 for the next day. Things get a little more complicated after September each year, but I manage.

Working with RAW and Other File Formats

If you upgraded to a digital SLR from a point-and-shoot camera, you might have been surprised at the new choices you had to make in terms of what file format to select when setting up to take photos. The snapshot crowd generally needs only to choose from among quality settings with names like Super Fine, Fine, or Standard (each step down sacrificing a little quality in order to squeeze more shots on a memory card). Casual photographers may also switch from their camera's maximum resolution to a lower resolution from time to time, usually to produce a more compact image suitable for e-mailing or posting on a web page. For the most part, with a point-and-shoot camera, selecting a file format and resolution is a no-brainer.

That's not quite the case with digital SLR cameras. You, too, get to select a quality level for JPEG images (actually "compression level"—the amount of information discarded in order to make the image file smaller). You can also opt for a different resolution to save some additional storage space with some loss of quality. But you also have other decisions that the majority of point-and-shoot owners don't need to make. Should you shoot only JPEG images, or should you record your photos using the "unprocessed" format known as RAW? Perhaps you'll want to opt for a setting that stores *two* images on your memory card for each shot, one of them JPEG (using one of the three different quality levels available) and the other RAW. A few dSLRs allow you to specify either *compressed* or *uncompressed* RAW, and an even smaller number (generally only the top-of-the-line pro cameras) give you an additional file format option: TIFF.

The most interesting aspect related to the file format dilemma is that dSLR photographers, unlike snapshooters, probably won't select an image format based on how many extra photos can be crammed into a memory card. Any photographer serious enough to purchase a digital SLR has purchased at least enough memory cards to serve most picture-taking situations this side of an extended vacation. Instead of choosing a format solely to save space, the digital SLR shooter often selects one option over another because of the extra quality that might be provided, or the additional

control, or, perhaps, how quickly the format can be stored to the memory card. It's a little like selecting a film that features a particular kind of rendition—saturated and contrasty, or muted and accurate—to produce a particular result. For most dSLR owners, choice of file format is the primary tool for providing as much power over your photos as possible.

Format Proliferation

The universe must love standards, because there are so many of them. It's no secret why formats have proliferated. Vendors always think they can do something better than their competitors, or, at the very least, hope that you'll think so. As a result, they invent a new file format with a few extra features that tweak the capabilities a tad.

Fortunately, JPEG and Adobe's Photoshop-standard PSD formats have become the most common file formats used for image editing. Adobe's DNG is another format that the company is promoting as a standard, but it has been met with less enthusiasm. Of course, your digital camera can't read or produce PSD files at all (nor DNG files, either, except in the case of some oddball cameras from Pentax). PSD can't handle the kinds of information that digital cameras can record, such as a specific white balance, sharpness, variable tonal curves, and other data. When you take a picture, a host of this kind of picture information is captured in a raw form, and then immediately processed using settings you've specified in your camera's menus. After processing, the image is stored on your memory card in a particular format, usually JPEG (TIFF, described later, is also available in some pro cameras). After that's done, any changes must be made to the *processed* data. If you decide you should have used a different white balance, you can no longer modify that directly, even though color balance changes in your image editor might provide a kind of fix.

So, digital camera vendors provide an alternative file format, generically called RAW to encompass them all, but in practice given other names, such as NEF (Nikon), CRW/CR2 (Canon), or ARW (Sony). (I'll explain more about RAW later in this chapter.) The different names reflect the fact that each of these RAW formats is different and not compatible with each other. You'll even find differences between RAW formats used by the same vendor. For example, while the RAW files produced by several Canon dSLRs all have a CR2 extension, they each need their own RAW converter to import the files into a standard format. To date, there are more than 100 different "RAW" formats.

Of course, the reason for individual RAW formats is not to lock you into a particular camera system. The vendor has already done that by using a proprietary lens mount design. Ostensibly, the real reason is the one I outlined earlier: to do the job better than the other folks. Of course, a particular RAW format provides an unadulterated copy of the (relatively) unprocessed data captured by the CCD or CMOS imager. I say *relatively* because the analog information captured by the camera's sensor is certainly processed extensively as it's converted to digital form for storage as a RAW file.

There are advantages to each of the main format types, as well as a few pitfalls to avoid.

WHITHER DNG?

To complicate things, a few years ago Adobe Systems introduced its new DNG (Digital Negative) specification, which purports to translate RAW files from any camera type to a common RAW format compatible with any software. Of course, the specification allows adding what Adobe calls "private metadata" to DNG files, "enabling differentiation," which is another word for non-standard/non-compatible. If DNG is adopted, *most* of the data from your camera's RAW images might be convertible to the new standard, but there's no guarantee that all of it will be. Because Photoshop can already handle the most common types of RAW files we use (although there is a lag between the introduction of a new RAW version and its compatibility with Photoshop), most dSLR owners are likely to be underwhelmed by this initiation for the foreseeable future.

JPEG

JPEG is the most common format used by digital cameras to store their images, as it was designed specifically to reduce the file sizes of photographic-type images. It provides a good compromise between image quality and file size, and it produces images that are suitable for everyday applications. Those who work with point-and-shoot digital cameras may use nothing else but JPEG, and even many dSLR owners find that the default JPEG settings offer quality that's good enough for ordinary use. Indeed, on a sharpness basis, it can be difficult to tell the difference between the best-quality JPEG images and those stored in RAW or TIFF formats. But, as you'll see, there are additional considerations that come into play.

As you probably know, the JPEG format allows dialing in a continuous range of quality/compression factors, even though digital SLRs provide only a fixed number of settings. However, in image editors, you'll find this range shown as a quality spectrum from, say, 0 to 10 or 0 to 15. Sometimes, very simple image editors use sliders labeled with Low, Medium, or High quality settings. Those are just different ways of telling the algorithm how much information to discard.

Digital SLRs, on the other hand, lock you into a limited number of quality settings with names like Super Fine, Extra Fine, Fine, Normal/Standard, or Basic, and don't tell you exactly which JPEG quality settings those correspond to. The names for the quality settings aren't standardized, and a particular setting for one camera doesn't necessarily correspond to the same quality level with another camera.

You'll usually find no more than three JPEG compression choices with any particular digital SLR. Some Nikon cameras, for example, offer Fine, Normal, and Basic. If you're concerned about image quality, and want to use JPEG, you should probably use the best JPEG setting all the time, or alternate between that and RAW setting. Your choice might hinge on how much storage space you have. When I'm photographing around the home where I have easy access to a computer, I use RAW. When I travel away from home, I switch to JPEG if I think I'm going to be taking enough pictures to exceed the capacity of the memory cards I carry around with me at all times.

That might be the case when shooting many sports sequence shots. It's easy to squeeze off a burst of 6 to 8 shots on any given play, and a dozen plays later notice you've exposed gigabytes of RAW photos in a relatively short period of time. Although memory cards are relatively inexpensive, even if you carry a clutch of 4GB or 8GB cards, you'll find that Busch's Corollary to Parkinson's law applies to digital photography: Photos taken expand to fill up the storage space available for them.

Most cameras are able to store photos to the memory card more quickly in JPEG format rather than in RAW, so that is another consideration for sequence shots. If quality isn't critical, then use lower-quality JPEG settings with your camera to fit more images on the available storage.

TIFF

Pure TIFF, one of the original lossless image file formats, is found very seldom in the digital camera world, most often in the higher-end cameras. Most of the non-pro models offer only JPEG and RAW, or, commonly a JPEG+RAW mode that stores the same image in both formats (usually with your choice of JPEG compression ratio). A few still offer TIFF, but their numbers are small.

The original rationale for using TIFF at all was that it provided a higher-quality option in a standard format, without the need for the vendor to develop a proprietary RAW format. Today, the additional advantages of RAW when it comes to tweaking images make RAW well worth the trouble.

TIFF, or Tagged Image File Format, was designed in 1987 by Aldus (later acquired by Adobe along with Aldus's flagship product, PageMaker) to be a standard format for exchange of image files. It's become that, and was at one time supported by virtually all high-end digital cameras as a lossless file option, even though its use has diminished today. However, because TIFF supports many different configurations, you may find that one application can't read a TIFF file created by another. The name itself comes from the *tags* or descriptors that can be included in the header of the file, listing the kinds of data in the image.

TIFF can store files in black/white, grayscale, 24-bit, or 48-bit color modes, and a variety of color gamuts, including RGB, L*a*b, and CMYK. If you've used Photoshop, you know that TIFF can store your levels and selections (alpha channels) just like Photoshop's native PSD format. It uses a variety of compression schemes, or no compression at all. Most applications can read TIFF files stored in any of these compression formats. You might find TIFF useful for image editing, but you'll rarely use it with a digital camera, even if your model offers that option, because storing TIFF files in a camera can take many seconds—per file!

RAW

As applied to digital cameras, RAW, as mentioned earlier in this chapter, is not a standardized file format. RAW is a proprietary format unique to each camera vendor, and, as such, requires special software written for each particular camera. Each RAW format stores the original information captured by the camera, so you can process it externally to arrive at an optimized image.

Some RAW formats, such as those employed by Nikon and Canon for their high-end cameras, are actually a sort of TIFF file with some proprietary extensions. That doesn't mean that an application that can read standard TIFF files can interpret them, unfortunately. Usually, special software is required to manipulate RAW files. If you're lucky, your camera vendor supplies a special RAW processing application that is easy to use and powerful.

But Adobe Camera Raw, available with both Adobe Photoshop and Photoshop Elements, handles RAW files from just about every camera (although in Elements, not all features are available). The problem with Adobe Camera Raw (ACR), is that the latest versions, needed for the newest digital cameras, may not work with your edition of Photoshop. If you're using Adobe Photoshop CS3, for example, and buy a new dSLR, you may find that the most recent version of ACR that works with your image editor doesn't support your camera. Adobe wants you to upgrade to Photoshop CS6 or Photoshop CC to use the ACR version that does work with your camera's RAW files.

Image Size, File Size, Image Quality, and File Compression

One of the original reasons digital cameras offered more than one file format in the first place was to limit the size of the file stored on your memory card. If a digital camera had unlimited memory capacity and file transfers from the camera to your computer were instantaneous, all images would probably be stored in RAW or TIFF format. TIFF might even have gained the nod for convenience and ease of use, and because not all applications can interpret the unprocessed information in RAW files. Both RAW and TIFF provide no noticeable loss in quality, but modern dSLR cameras store RAW files a little more slowly to the memory card, and the few that still support TIFF take a *lot* more time to save image files. So JPEG now gets the nod for most general-purpose applications.

JPEG was invented as a more compact file format that can store most of the information in a digital image, but in a much smaller size. This smaller size is, naturally, quicker to write to a memory card, too. JPEG predates most digital SLRs, and was initially used to squeeze down files for transmission over slow dialup connections. Even if you were using an early dSLR with 1.3 megapixel files for news photography, you didn't want to send them back to the office over a modem at 1200 bps.

Alas, JPEG provides smaller files by compressing the information in a way that loses some information. JPEG remains the most viable digital camera file alternative because it offers several different quality levels. At the highest quality level you might not be able to tell the difference between the original RAW file and the JPEG version, even though the RAW file occupies, say, 14MB on your memory card, while the high-quality JPEG takes up only 4MB of space. You've squeezed the image 3.5X without losing much visual information at all. If you don't mind losing some quality, you can use more aggressive compression with JPEG to store 14 times as many images in the same space as one RAW file.

RAW exists because sometimes we want to have access to all the digital information captured by the camera, before the camera's internal logic has processed it and converted the image to a JPEG. RAW doesn't save as much space as JPEG. What it does is preserve all information captured by your

camera *before* the settings you've made for things like white balance or sharpening have been applied. Think of your camera's RAW format as a photographic negative, ready to be converted by your camera or, at your option, by your RAW-compatible image-editing/processing software.

You can adjust the image size, file size, and image quality of your digital camera images. The guide-books and manuals don't always make it clear that these adjustments are three entirely different things. However, image size affects file size and image quality, and image quality affects file size. File size, while it's dependent on the other two, has no direct effect on image size or quality. No wonder it's confusing! It's a good idea to get these three terms sorted out before we move on so that we're all talking about exactly the same thing. Here's a quick summary:

- **Image size.** This is the dimensions, in pixels, of the image you capture. For example, if you have an 18MP camera, it may offer a choice of 5,184 × 3,456, 3,456 × 2,304, and 2,592 × 1,728 resolutions (or, 18, 13, and 4.5 megapixels, respectively). Each reduction in resolution reduces the size of the file stored on your memory card.

- **File size.** This is the actual space occupied on your memory card, hard disk, or other storage medium, measured in megabytes. The size of the file depends on both the image size (resolution) and image quality (compression) level. You can reduce the file size by reducing the image size or using a lower-quality/higher compression setting.

- **Image quality.** This is the apparent resolution of the image after it's been compressed and then restored in your image editor. The RAW format offers a simple form of compression with no loss of image quality, but JPEG compression reduces the image quality (although the lost quality may be barely visible) for reasons that will become clear shortly.

How JPEG Compression Works

Ordinary compression schemes look for multiple occurrences of strings of numbers in a file, places them in a table, and then provides a pointer to the location of that string of numbers in the table, rather than repeating the numbers each time they appear. With long strings, the savings in file size can be significant. JPEG images also use this kind of encoding to shrink the size of the images. But, as transfer of image files over telecommunications lines became popular (this was even before the public Internet), a consortium called the Joint Photographic Experts Group (JPEG) developed a compression scheme particularly for continuous tone images that is efficient, and still retains the most valuable image information. JPEG uses three different algorithms, a numeric compression method like the one I just described, plus two more schemes with mind-boggling names like "discrete cosine transformation (DCT)" and "quantization."

However, even an ordinary mortal can grasp the basic principles. JPEG first divides an image into larger cells, say 8 × 8 pixels, and divides the image information into two types of data: luminance values (brightness) and chrominance (color) values. In that mode, the JPEG algorithm can provide separate compression of each type of data. Because luminance is more important to our eyes, more compression can be applied to the color values. The human eye finds it easier to detect small changes in brightness than equally small changes in color.

Next, the algorithm performs a discrete cosine transformation on the information. This mathematical mumbo-jumbo simply analyzes the pixels in the 64-pixel cell and looks for similarities. Redundant pixels—those that have the same value as those around them—are discarded.

Next, quantization occurs, which causes some of the pixels that are nearly white to be represented as all white. Then the grayscale and color information is compressed by recording the differences in tone from one pixel to the next, and the resulting string of numbers is encoded using a combination of math routines. In that way, an 8 × 8 block with 24 bits of information per pixel (192 bytes) can often be squeezed down to 10 to 13 or fewer bytes. JPEG allows specifying various compression ratios, in which case larger amounts of information are discarded to produce higher compression ratios.

Finally, the codes that remain are subjected to a numeric compression process. This final step is lossless, as all the information that is going to be discarded from the image has already been shed. Because it discards data, the overall JPEG algorithm is referred to as "lossy." This means that once an image has been compressed and then decompressed, it will not be identical to the original image. In many cases, the difference between the original and compressed version of the image is difficult to see.

Compressed JPEG images are squeezed down by a factor of between 5:1 and 15:1. The kinds of details in an image affect the compression ratio. Large featureless areas such as areas of sky, blank walls, and so forth compress much better than images with a lot of detail. Figure 3.16 shows an image at a low compression setting (top) and high compression (bottom).

Figure 3.16
Low compression (top) produces a smooth look, with artifacts visible only under this high magnification. High compression (bottom) yields a much more blocky appearance.

This kind of compression is particularly useful for digital camera files. Unfortunately, more quality is lost every time the JPEG file is compressed and saved again, so you won't want to keep editing your digital camera's JPEG files. Instead, save the original file as a PSD or another lossless file format, and edit that, reserving the original as just that, an original version you can return to when necessary. In fact, it's a good idea to backup your RAW digital "negative" (say, on a DVD) so you can go back to your original file at any time in the future, no matter how much you've butchered (or improved) the image since.

JPEG, RAW, or TIFF?

Of the three file formats, which should you use? Actually, your choices are just two, because TIFF isn't a practical in-camera option for most people. Between JPEG and RAW, you'll find that JPEG files are the most efficient in terms of use of space, and can be stored in various quality levels, which depend on the amount of compression you elect to use. You can opt for tiny files that sacrifice detail or larger files that preserve most of the information in your original image. JPEG really allows you to tailor your file size for the type of photos you're planning to take.

However, as I noted, JPEG files have had additional processing applied by the camera before they are stored on your memory card. The settings you have made in your camera, in terms of white balance, color, sharpening, and so forth, plus compression, are all applied to the image. You can make some adjustments to the JPEG image later in an image editor like Photoshop, but you are always working with an image that has *already been processed*, sometimes heavily.

The information captured at the moment of exposure can also be stored in a proprietary, native format designed by your camera's manufacturer. These formats differ from camera to camera, but are called RAW. You might think of RAW as a generic designation rather than a specific format, just as the trade name Heinz applies to all 57 varieties instead of just one.

A RAW file can be likened to a digital camera's negative. It contains all the information, stored in 10-bit, 12-bit, 14-bit, or 16-bit channels (depending on your camera), with no compression, no sharpening, no application of any special filters or processing. In essence, a RAW file gives you access to the same information the camera works with in producing a 24-bit JPEG. You can load the RAW file into a viewer or image editor, and then apply essentially the same changes there that you might have specified in your camera's picture-taking options.

Advantages of Shooting RAW+JPEG

My personal preference is to shoot both RAW and my camera's highest quality JPEG setting simultaneously (for example, RAW+JPEG FINE), but, oddly enough, I end up using the JPEG version 80 to 90 percent of the time. If you've made your camera settings intelligently, the JPEG version will not only be good enough for many applications, it can be given minor tweaks in an image editor that will optimize it. Relying on the JPEG file most of the time lets me avoid the need to import the RAW file and perform time-consuming post-processing. Yet, I have the RAW file available if I

need to perform some image-editing magic like fine-tuning white balance or using Photoshop's Merge to HDR Pro command.

Using RAW+JPEG consistently allows some other tricks. You can set your camera to its black-and-white mode when you want to explore the creative possibilities of monochrome images, and thus not need to bother with making tricky color-to-black-and-white conversions in your image editors. You'll shoot black-and-white JPEGs, yet still be able to go back to the RAW image at any time to restore the color if you need it, or want to create a particular monochrome rendition, such as sepia tone or cyanotype.

You can also "miraculously" shoot using two color spaces at once by setting your camera to, say, sRGB (Standard RGB) to produce JPEGs with a color gamut optimized for monitor or web display. Should you find you need an image with the Adobe RGB gamut for printing, you can easily create such a version from your RAW file.

Inexpensive solid-state media make it entirely practical to shoot RAW+JPEG most of the time, particularly if you're staying close to home and will be able to offload your photos to your computer frequently, or you have a backup system, such as a personal storage device (PSD) or a laptop. Of course, shooting both will slow down your camera's continuous shooting capabilities (especially important when shooting sports), and consume more memory card space.

Advantages of Shooting RAW Only

Some photographers shoot RAW exclusively. I do this myself when I am on long trips, in order to maximize my available storage space. I'll shoot RAW, back up my files to one or two PSDs, and be able to make what I think is the best use of my available capacity. I could cram more pictures onto the same storage space if I used JPEG exclusively, but I tend to use my travel photos in my work and want the best possible quality available in every single shot. So, if I have to choose just one format, I end up shooting RAW.

When I get home, there are utilities that will create JPEG files from every single RAW image if I feel I need them. The process is slow when you're creating JPEGs for a lot of files (which is why RAW+JPEG is usually the better choice for dual-format shooting), but I can let a batch run overnight if I need to.

RAW-only is also a good choice for those who plan to do a lot of post-processing and have no significant need for JPEGs produced in the camera.

Advantages of Shooting JPEG Only

I've touted how great RAW is so much in this chapter you might wonder if there are any advantages at all to shooting nothing but JPEG images. Huge numbers of photographers rely on JPEG images for a lot of their work, and there are solid reasons for choosing that format and eschewing the joys of RAW images.

Indeed, many professional photojournalists, sports, wedding, and event photographers shoot nothing but JPEG, and it's not because they want to squeeze every last byte out of their memory cards. Each type of shooter has different reasons for using JPEG exclusively, most of them relating to technical issues or workflow. Here's a quick summary of the rationales:

- **Sheer volume.** Wedding photographers may shoot 1,000 to 1,500 photographs (or even more) during, before, and after the nuptials. Even though a relatively small number of photos are included in bound albums, having alternative images and shots of virtually every guest and relative can lead to additional prints, sales of a DVD, and so forth. Event photographers can easily take thousands of photos in a short period of time. Photojournalists and sports photographers also burn through many pictures. I can't recall a sports event recently at which I didn't take 1,100 to 1,200 photos, many of them with my camera set on 5-to-8 fps continuous bursts. Nobody, especially pros, wants to wade through a thousand pictures doing post-processing on even a small proportion of them. The solution is to make sure the camera settings are optimized, and then produce uniformly good JPEG images that require no twiddling after the dust settles.

- **Sheer speed.** Digital cameras generally take longer to store RAW files, or RAW+JPEG combos to a memory card. For most types of photos, the camera's buffer will absorb those images and dole them out to the card about as fast as you can press the shutter release. But if you're shooting sports or other activities in quick bursts, it's easy for the buffer to become overwhelmed with large files. You may be able to take only 5 or 6 RAW files in a row at 5 fps, but double or triple that number of shots if you're using JPEG exclusively.

- **Faster transfer.** Because they are several times larger, RAW files *will* take longer to transfer from your camera or memory card to your computer. If you're in a big hurry (say, to meet a deadline), the extra wait can be frustrating. So, when time is short, you'll want to use JPEG images and the fastest transfer method available, such as a card reader that is USB 2.0/USB 3.0 or FireWire compatible.

4

Mastering Your Exposure Controls

You may know what all the controls of your digital SLR are, but do you really understand what they are used for, how to select their options, and exactly when to use them? The manual furnished with your digital SLR is not much help. It has a few black-and-white illustrations with labels for every button, dial, and switch on the camera, along with multiple cross-references that force you to jump back and forth to many different pages just to discover what a particular control does. You still have to decide why and when to put them to work.

The various controls that adjust exposure are among the most confusing. This chapter explains the basics for every kind of camera, and when you finish it, you'll have a basic mastery of your digital SLR's exposure controls. If you want to know more, I've written individual camera guides and compact references for most of the major models—but this chapter isn't designed to sell you one of those. I think you'll find a lot of what you need right here. I'm going to answer the most common questions.

You'll learn about automated exposure modes, using histograms, working with f/stops and shutter speeds, and selecting the right "scene" options. I'll also cover some of the quirks of working with automatic focus systems, too. I'm not going to waste pages on some of the easier controls, like the shutter release, or on setup options such as white balance settings you make using your menu system. The emphasis here will be on the most important physical controls you use for everyday shooting.

Exposure Basics

After composition, one of the most important aspects of getting a great photograph is zeroing in on the correct exposure. Your dSLR can take care of exposure for you automatically—most of the time. When exceptions occur, it's time for you to step in and use your camera's controls to fine-tune your images. This section deals with exposure.

Correct exposure is a necessity because, as you'll recall from Chapter 2, no digital camera sensor can capture detail at every possible light level. In very dark portions of a scene, there will be too few photons to register in the individual photosites. Shadows that should have some detail will be rendered as black.

At the other end of the exposure spectrum, if part of the scene is very light, the pixel "wells" will overflow or the excess photons will be drained off, and that photosite will stop collecting additional information. If some of the excess spills over onto adjacent pixels, you'll see an unwanted blooming effect in your image. Having superfluous photons lost or totally ignored renders areas that should be "almost-white" as completely white, and, again, important details can be lost.

Given the fixed limitations of the sensor to record both very dark and very light areas, the goal of setting exposure is to either *increase* the number of photons available to register details in dark areas (by boosting the exposure) or to *decrease* the number of photons flooding the photosites in the light areas (by reducing the exposure). Sensors are unable to handle high-contrast situations in which there is a large variation in brightness between the dark and light areas. The degree to which a sensor can handle such variations is called its *dynamic range* and was explained in Chapter 2. However, even a sensor with a broad dynamic range won't handle the most extreme lighting conditions, so the "correct" exposure is likely to be a compromise that preserves detail at one end of the brightness scale at the expense of detail at the other end.

Generally, that means avoiding the clipping off of highlight detail caused by overexposure. As I noted, once a pixel bucket is "full," that pixel is rendered as pure white with no detail at all. There is no point in collecting additional photons and doing so can spoil the image in surrounding pixels because of spillover. On the other hand, information can often be retrieved from darker areas of an image even if those areas are underexposed, usually by multiplying the data that is there by increasing the ISO sensitivity setting. That's because, even in the darkest areas of the image *some* photons will be collected, even if too few are captured to pass the threshold level where image details start to become visible.

Of course, exposing strictly for the middle tones, while often a good idea, is no panacea; you may still end up with whites that are overexposed, and shadows that lack detail. Nor is exposing for one end or the other of the tonal range the answer, as I am about to show you.

Exposing for Middle Tones

Figure 4.1 shows an example of an image of Michaelangelo's Pietà. Inset at upper right is a set of patches (which I have added and do not actually appear on the wall at St. Peter's Basilica). The left patch is black, the center one a middle gray tone, and the right patch renders as white. The image represents what you'd get if you measured exposure from the middle gray patch, which, for the sake of illustration, we'll assume reflects approximately 12 to 18 percent of the light that strikes it. Lacking a strip of patches, you could also meter from a similar mid-tone area in the scene, in this case one of the shadow areas of the Carrara marble figures.

When you measure exposure using a middle tone, the camera's exposure meter sees an area that it assumes is a middle gray, calculates an exposure based on that, and the patch in the center of the strip is rendered at its proper tonal value. Best of all, because the resulting exposure is correct, the black patch at left and white patch at right are rendered properly as well.

When you're shooting pictures with your camera, and the meter happens to base its exposure on a subject that averages roughly the same as that "ideal" middle gray, then you'll end up with similar (accurate) results. The camera's exposure algorithms are concocted to ensure this kind of result as often as possible, barring any unusual subjects (that is, those that are backlit, or have uneven illumination).

Note that, despite what you may have been taught in photography classes or read in other books, your dSLR is *not* "calibrated" for 18 percent gray. Most digital SLRs are actually calibrated for a value that's closer to 12 to 14 percent gray, depending on the vendor. The 18 percent gray myth is said to have begun after a 1970s-era revision of Kodak's instructions for its E-27Q gray cards (which continue to be sold today by other vendors) omitted the advice to open up an extra half stop from the exposure metered off the card. An entire generation of shooters grew up thinking that a measurement off a gray card could be used as-is. The proviso returned to the instructions by 1987, it's said, but by then it was too late.

HAND-HELD METERS

It's not possible for the user to change the calibration of a dSLR, although, with some cameras it is easy to make a global adjustment so that all images are uniformly "overexposed" or "underexposed" by a set amount. You can also temporarily add or subtract some exposure temporarily using a process called *exposure compensation*, which I will describe later. However, hand-held light meters can be calibrated to a new value, so, if you're still using one of these it may indeed be calibrated to 18 percent gray, or some other value of your choosing.

Figure 4.1
When exposure is calculated based on the middle-gray tone in the center of the card, the black and white patches are rendered accurately, too, and the sculpture is properly exposed.

Figure 4.2
When exposure is calculated based on the black square at upper right, the black patch looks gray, the gray patch appears to be a light gray, and the white square is seriously overexposed.

Figure 4.3
When exposure is calculated based on the white patch on the right, the other two patches, and the photo, are underexposed.

In most cases, the discrepancy is too small to matter much, but if you want to be 100 percent accurate in calculating exposures with a gray card you should do the following:

■ For subjects of normal reflectance, *increase* the indicated exposure by 1/2 stop.

■ For light subjects use the indicated exposure; for very light subjects, *decrease* the exposure by 1/2 stop.

■ If the subject is dark to very dark, *increase* the indicated exposure by 1 to 1 1/2 stops.

Exposing for Dark Tones

Figure 4.2 shows what would happen if the exposure were calculated based on metering the leftmost, black patch. The light meter sees less light reflecting from the black square than it would see from a gray middle-tone subject, and so figures, "Aha! I need to add exposure to brighten this subject up to a middle gray!" That lightens the "black" patch, so it now appears to be gray.

But now the patch in the middle that was *originally* middle gray is overexposed and becomes light gray. And the white square at right is now seriously overexposed and loses detail in the highlights, which have become a featureless white. Our marble sculpture is similarly overexposed, and a lot of detail is lost in the lightest areas.

Exposing for Light Tones

The third possibility in this simplified scenario is that the light meter might measure the illumination bouncing off the white patch, and try to render *that* tone as a middle gray. A lot of light is reflected by the white square, so the exposure is *reduced*, bringing that patch closer to a middle gray tone. The patches that were originally gray and black are now rendered too dark, and Michaelangelo's masterpiece is similarly underexposed. Clearly, measuring the gray card—or a substitute within the scene that reflects about the same amount of light—is the only way to ensure that the exposure is correct. (See Figure 4.3.)

So, as you can see, the ideal way to measure exposure is to meter from a subject that reflects 12 to 18 percent of the light that reaches it. If you want the most precise exposure calculations, the solution is to use a stand-in, such as the evenly illuminated gray card I mentioned earlier. The standard Kodak gray card reflects 18 percent of the light that reaches it, what is considered to be a middle gray. But, as I said earlier, your camera is probably calibrated for a somewhat darker tone than that middle gray, roughly 12 to 14 percent gray, so you would need to *add* about one-half stop *more* exposure than the value metered from the card.

Another substitute for a gray card is the palm of a human hand (the backside of the hand is too variable). But a human palm, regardless of ethnic group, is even brighter than a standard gray card, so instead of one-half stop more exposure, you need to add one additional stop. That is, if your meter reading is 1/500th of a second at f/11, use 1/500th second at f/8 or 1/250th second at f/11 instead. (Both exposures are equivalent.)

If you actually wanted to use a gray card, place it in your frame near your main subject, facing the camera, and with the exact same even illumination falling on it that is falling on your subject. Then, use your camera's Spot metering function to calculate exposure. Of course, in most situations, it's not necessary to do this. Your camera's light meter will do a good job of calculating the right exposure. But, I felt that explaining exactly what is going on during exposure calculation would help you understand how your dSLR's metering system works.

The best exposure may be the one in which some of the white areas lack detail, providing closer to a true white, and some shadow details are lost as a trade-off to allow a better overall tonal range for the image. Image-processing algorithms can often do a good job of making these calculations, using, in some cases, the auto lighting optimizer/dynamic range lighting processing provided by many digital SLR cameras.

If you want to see how this works at a primitive level, load a photo into your image editor and then play with the Brightness control. Moving the Brightness slider to the right lightens shadow areas enough that you may be able to see details that were previously cloaked in darkness. However, moving the same slider to the left to darken overexposed highlight areas won't produce additional detail—it will only turn the white blocks into a featureless gray.

Digital camera autoexposure systems are optimized to attempt to preserve highlight detail (which is otherwise lost forever) at the expense of shadow detail (which can sometimes be retrieved). Any changes in how exposure is made that you make will simply be aimed at improving the relationship between the actual brightness levels in a scene and what is captured by your camera.

Tonal Range

The tonal range of an image is the range of dark to light tones, from a complete absence of brightness (black) to the brightest possible tone (white), and all the middle tones in between. Because all values for tones fall into a continuous spectrum between black and white, it's easiest to think of a photo's tonality in terms of a black-and-white or grayscale image, even though you're capturing tones in three separate color layers of red, green, and blue.

Because your images are digital, the tonal "spectrum" isn't really continuous: it's divided into discrete steps that represent the different tones that can be captured. Figure 4.4 may help you understand this concept. The gray steps shown range from 100 percent gray (black) at the left, to 0 percent gray (white) at the right, with 20 gray steps in all (plus white). The middle tone in the center represents 50 percent gray. I've also marked the approximate gray values of an 18 percent gray card, and the 12–14 percent gray that your camera is calibrated for.

Along the bottom of the chart are the digital values from 0 to 255 recorded by your sensor for an image with 8 bits per channel. (8 bits of red, 8 bits of green, and 8 bits of blue equal a 24-bit, full-color image.) The actual scale may be "finer" and record say, 0 to 4,094 for an image captured using 12 bits per channel. Any black captured would be represented by a value of 0, the brightest white by 255, and the middle gray by 128.

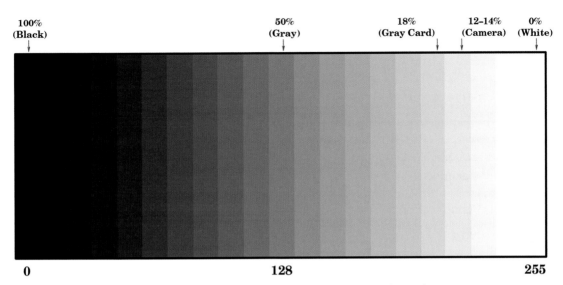

Figure 4.4 A tonal range from black (left) to white (right) and all the gray values in between.

Grayscale images (which we call black-and-white photos) are easy to understand. Or, at least, that's what we think. When we look at a black-and-white image, we think we're seeing a continuous range of tones from black to white, and all the grays in between. But, that's not exactly true. The blackest black in any photo isn't a true black, because *some* light is always reflected from the surface of the print, and if viewed on a screen, the deepest black is only as dark as the least-reflective area a monitor can produce. The whitest white isn't a true white, either, because even the lightest areas of a print absorb some light (only a mirror reflects close to all the light that strikes it), and, when viewing on a monitor, the whites are limited by the brightness of the display's LCD or LED picture elements. Lacking darker blacks and brighter, whiter whites, that continuous set of tones doesn't cover the full grayscale tonal range.

The full scale of tones becomes useful when you have an image that has large expanses of shades that change from one level to the next, such as areas of sky, water, or walls. Consider the image shown at left in Figure 4.5, picturing a man reading a book, in sunlight and partially in shadow. All the tones that make up the details we can see of his face, hands, coat, and slacks are compressed into one end of the brightness spectrum, the lighter end.

Yet, there's more to this scene than the figure of the man. There is a lot of detail cloaked in the shadows of this image. These are illuminated by the softer light that bounces off the surrounding surfaces. If your eyes become accustomed to the reduced illumination, you'll find that there is a wealth of detail in these shadow images, as you can see in the version at right.

This scene would be a nightmare to reproduce faithfully under any circumstances. If you are an experienced photographer, you are probably already wincing at what is called a *high-contrast* lighting situation. (Today, a special kind of processing called *High Dynamic Range* (HDR) imaging—available either in some cameras or by using special software—can be used to produce a final image

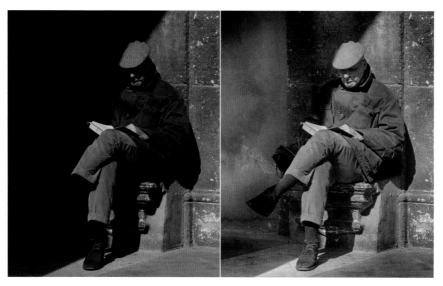

Figure 4.5
Detail exists in the highlights and shadows (left), even though a digital camera isn't always able to capture that information without special techniques like HDR (right).

similar to the one shown at right. I'll explain HDR later on.) Some photos may be high in contrast when there are fewer tones and they are all bunched up at limited points in the scale. In a low-contrast image, there are more tones, but they are spread out so widely that the image looks flat. Your digital camera can show you the relationship between these tones using something called a *histogram.*

Introducing Histograms

Your camera may have "live" histograms available, in live view mode or when using a camera like the Sony SLT models, which *always* shoot in live view mode. Since it's not possible to show a histogram while composing an image using an optical viewfinder, a traditional SLR may present histograms only during image review, where they can be superimposed somewhere next to or overlaid on the image you've already taken. The "live" histogram displayed in shooting mode is probably the most useful, because you can consult it and adjust your exposure before you actually take a shot. A typical histogram is shown in Figure 4.6, which I'll use to show you exactly how they work.

Histograms are simplified displays of the relative numbers of pixels at each of 256 brightness levels, from 0 to 255, producing an interesting mountain range effect. Although separate charts may be provided for brightness (luminance) and the red, green, and blue channels, when you first start using histograms, you'll want to concentrate on the brightness histogram, which represents the tones available in white.

- **Tonal shape.** The white "mountain range" in this brightness/luminance histogram represents the distribution of all the tones in the image, from black on the left (0 brightness) to white (255 maximum brightness) on the right. The vertical axis represents the number of pixels at each point along the brightness scale. The higher the peak at any given point, the more pixels there

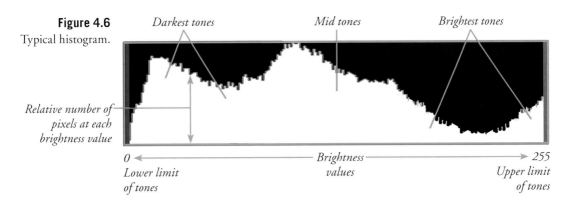

Figure 4.6
Typical histogram.

Darkest tones

Mid tones

Brightest tones

Relative number of
pixels at each
brightness value

0 ← ————————————————— Brightness ————————————————→ 255
Lower limit values Upper limit
of tones of tones

are with that value in an image. Shallow valleys represent a relatively low number of pixels at that particular brightness level.

- **Brightness values.** This scale represents the darkest shadow areas of the image (at the left) to the brightest highlights (on the right). Although traditionally this scale runs from 0 (completely black) to 255 (completely white).

- **Darkest tones.** The darkest pixels are represented at the area at the left in the histogram. Any pixels that venture into the area marked with the blue bar will register as totally black and will be completely lost. By increasing exposure, you can move these pixels toward the right, preserving their detail.

- **Mid tones.** The number of pixels in the middle gray range are represented here. Increasing or decreasing exposure doesn't change the number of these pixels, but, instead moves them to the right or left, making them lighter or darker.

- **Brightest tones.** The lightest pixels are represented at the area at the right in the histogram. Any pixels that venture into the area marked with the red bar will register as totally white and will be lost. Decreasing exposure moves these pixels toward the left, keeping them from becoming "blown out." Optimizing exposure involves arriving at settings that preserve the most important tones in your images, whether they reside in the highlights or shadows.

Many dSLRs can show you a non-live histogram that represents the tonal values of an image that has already been taken, as in Figure 4.7. This histogram shows brightness/luminance values as well as separate values for the red, green, and blue channels of your image.

The sample brightness histogram of the riverside scene of Ft. Matanzas National Monument in Florida at bottom left in Figure 4.7 shows that most of the pixels are spread fairly evenly across the grayscale "spectrum," with some peaks of lighter colored pixels at the right side, representing the brighter clouds, water, and rocks. This histogram represents a fairly good exposure, because only a little image information is being clipped off at either end. With an image of normal contrast and typical subject matter, the bars of the histogram will form a curve of this sort. You can actually compare the curve shapes to evaluate the contrast range of an image.

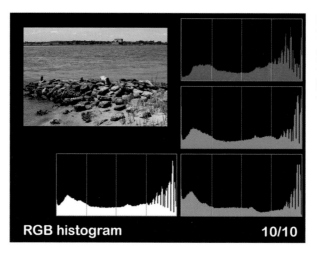

Figure 4.7
Playback Histogram
display with separate
luminance, red,
green, and blue
histograms.

For example, Figure 4.8 shows an image with fairly normal contrast. See how the bars of the histogram create a curve across most of the width of the grayscale? We can see from this histogram that the mask itself has very few black tones. That spike at the left side of the histogram represents the true blacks in the mask. Otherwise, there would be almost no tones at all at the far left.

With a lower-contrast image, like the one shown in Figure 4.9, the basic shape of the histogram will remain recognizable, but gradually will be compressed together to cover a smaller area of the gray spectrum. The squished shape of the histogram is caused by all the grays in the original image being represented by a limited number of gray tones in a smaller range of the scale.

Instead of the darkest tones of the figurine reaching into the black end of the spectrum and the whitest tones extending to the lightest end, the blackest areas of the figurine are now represented by a light gray, and the whites by a somewhat lighter gray. The overall contrast of the image is reduced. Because all the darker tones are actually a middle gray or lighter, the mask in this version of the photo appears lighter as well.

Figure 4.8 This image has fairly
normal contrast, even though,
except for some black features in
the mask, there are few true blacks
showing in the histogram.

Figure 4.9 This low-contrast
image has all the tones squished
into one end of the grayscale.

Figure 4.10 A high-contrast
image produces a histogram in
which the tones are spread out.

Going in the other direction, increasing the contrast of an image produces a histogram like the one shown in Figure 4.10. In this case, the tonal range is now spread over a much larger area. When you stretch the grayscale in both directions like this, the darkest tones become darker (that may not be possible) and the lightest tones become lighter (ditto). In fact, shades that might have been gray before can change to black or white as they are moved toward either end of the scale.

The effect of increasing contrast may be to move some tones off either end of the scale altogether, while spreading the remaining grays over a smaller number of locations on the spectrum. That's exactly the case in the example shown. The number of possible tones is smaller and the image appears harsher.

Understanding Histograms

The important thing to remember when working with the histogram display in your camera is that changing the exposure does *not* change the contrast of an image. The curves illustrated in the previous three examples remain exactly the same shape when you increase or decrease exposure. I repeat: The proportional distribution of grays shown in the histogram doesn't change when exposure changes; it is neither stretched nor compressed. However, the tones as a whole are moved toward one end of the scale or the other, depending on whether you're increasing or decreasing exposure. You'll be able to see that in some illustrations that follow.

So, as you reduce exposure, tones gradually move to the black end (and off the scale), while the reverse is true when you increase exposure. The contrast within the image is changed only to the extent that some of the tones can no longer be represented when they are moved off the scale.

To change the *contrast* of an image, you must do one of four things:

■ **Change your digital camera's contrast setting** using the menu system. You'll find these adjustments in your camera's Picture Controls or Picture Styles menus.

■ **Use your camera's shadow-tone "booster."** Many digital SLRs have a feature, which may be called Automatic Lighting Optimizer, or Active D-Lighting, or some other term. These options use algorithms to process each image (either at the time it is taken, or during in-camera post-processing from a "retouching" menu) to change the relationship between the shadow details and the highlights of a single image. Some dSLR/SLT cameras have an in-camera HDR feature that accomplishes something similar, but by taking two to three or more consecutive different exposures and combining the shadow and highlight details of each. There's a delay while this process is underway, but the results can be excellent.

■ **Alter the contrast of the scene itself,** for example, by using a fill light or reflectors to add illumination to shadows that are too dark.

■ **Attempt to adjust contrast in post-processing** using your image editor or RAW file converter. You may use features such as Levels or Curves (in Photoshop, Photoshop Elements, and many other image editors), or work with HDR software to cherry-pick the best values in shadows and highlights from multiple images.

Of the four of these, the third—changing the contrast of the scene—is the most desirable, because attempting to fix contrast by fiddling with the tonal values is unlikely to be a perfect remedy. However, adding a little contrast can be successful because you can discard some tones to make the image more contrasty. However, the opposite is much more difficult. An overly contrasty image rarely can be fixed, because you can't add information that isn't there in the first place.

What you *can* do is adjust the exposure so that the tones *that are already present in the scene* are captured correctly. Figure 4.11 shows the histogram for an image that is badly underexposed. You can guess from the shape of the histogram that many of the dark tones to the left of the graph have been clipped off. There's plenty of room on the right side for additional pixels to reside without having them become overexposed. So, you can increase the exposure, either by changing the f/stop or shutter speed or by adding an exposure compensation (EV) value to produce the corrected histogram shown in Figure 4.12.

In addition to a histogram, your dSLR may also have an option for color coding the lightest and darkest areas of your photo during playback, so you can see if the areas that are likely to lose detail are important enough to worry about. Usually, such coding will involve flashing colors (often called "blinkies") in the review screen. Areas that are extremely overexposed may flash white, while areas that are very underexposed may flash black. Depending on the importance of this "clipped" detail, you can adjust exposure or leave it alone. For example, if all the dark-coded areas in the review are in a background that you care little about, you can forget about them and not change the exposure, but if such areas appear in facial details of your subject, you may want to make some adjustments.

Alternatively, an image may be overexposed, generating a histogram like the one shown in Figure 4.13. Reducing the exposure a stop or two will create the more optimized histogram you saw in Figure 4.12. One common term for optimizing exposures using a histogram is to "expose to the right." The rule proposes increasing exposure to push your tones to the right side of the histogram, as far as you can without clipping them off (converting the brightest tones to utter white).

The rationale behind this is that once pixels have been exposed to the extent that they become completely white, the information has been lost forever; whereas moving some dark pixels into the dark gray zone during this shift to the right doesn't eliminate picture data. Moreover, visual noise

Figure 4.11 A histogram of an underexposed image may look like this.

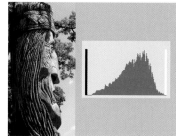

Figure 4.12 Adding exposure will produce a histogram like this one.

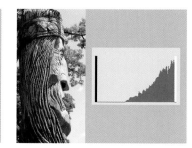

Figure 4.13 A histogram of an overexposed image will show clipping at the right side.

is more easily seen in dark areas, so reducing the amount of dead black can be beneficial if you have a camera that is prone to noise effects. This technique is actually a holdover from the days of color transparencies (positive film/color slides, for those of you who have never seen one). It was better to underexpose a slide, because you could always pump more light through it to retrieve shadow detail (when, say, making a print from that slide), while blown highlights were beyond retrieval.

Of course, digital images aren't like film transparencies. The trailing "toe" of the curve seen in color slides is relatively slow in contrast, while the transition of a digital image from little detail to no detail at all is quite abrupt. So, if you choose to expose to the right, be careful that important highlights don't venture *too* close to the cutoff point at the right side of the histogram (which may be difficult to interpret on a 3.2-inch LCD in any case), and avoid wasting precious tones from your maximum of 256 per channel by leaving the left side of the histogram empty.

WHAT'S EV?

EV stands for Exposure Value, and it is a shortcut for representing changes in exposure regardless of whether they are made using the aperture or shutter speed controls. As you know, changing the settings from 1/125th second at f/8 to 1/60th second at f/8 doubles the exposure because the shutter speed has been made twice as long. Similarly, opening up the f/stop while leaving the shutter speed alone (making the exposure 1/125th second at f/5.6) *also* doubles the exposure. Sometimes you won't care which method is used, because the shutter speed will still be fast enough to freeze whatever action is present, and the aperture will still provide adequate depth-of-field. In those cases, if you're using a programmed exposure mode (in which the camera selects both shutter speed and aperture), you'll find it easiest to use your camera's EV adjustment to add or subtract EV from the exposure. The camera will choose which parameter to change to provide the requested modification. EV values can be added in half-stop or third-stop increments (or some other value, depending on your camera). Dialing in a +1/2 EV change will increase exposure by one-half f/stop/shutter speed value. Setting a −1/2 EV change will reduce exposure by the same amount.

What Affects Exposure

To control exposure, you need to understand what elements affect it. As a photographer, you probably have an innate sense of what these elements are, but the list that follows may bring them into focus, so to speak, for the discussions that follow.

In the most basic sense, exposure is all about light. Exposure can make or break your photo. Correct exposure brings out the detail in the areas you want to picture, providing the range of tones and colors you need to create the desired image. Poor exposure can cloak important details in shadow, or wash them out in glare-filled featureless expanses of white. However, getting the perfect exposure requires some intelligence—either that built into the camera or the smarts in your head—because digital sensors can't capture all the tones we are able to see. If the range of tones in an image is

extensive, embracing both inky black shadows and bright highlights, we often must settle for an exposure that renders most of those tones—but not all—in a way that best suits the photo we want to produce.

You might be aware of the traditional "exposure triangle" of aperture (quantity of light passed by the lens), shutter speed (the amount of time the shutter is open), and the ISO sensitivity of the sensor, which all work proportionately and reciprocally to produce an exposure. The trio is itself affected by the amount of illumination that is available to work with. So, if you double the amount of light, increase the aperture by one stop, make the shutter speed twice as long, or boost the ISO setting 2X, you'll get twice as much exposure. Similarly, you can increase any of these factors while decreasing one of the others by a similar amount to keep the same exposure.

Working with any of the three controls involves trade-offs. Larger f/stops provide less depth-of-field, while smaller f/stops increase depth-of-field and, with higher resolution cameras such as the D5300, can decrease sharpness through a phenomenon called diffraction. Shorter shutter speeds do a better job of reducing the effects of camera/subject motion, while longer shutter speeds make that motion blur more likely. Higher ISO settings increase the amount of visual noise and artifacts in your image, while lower ISO settings reduce the effects of noise. (See Figure 4.14.)

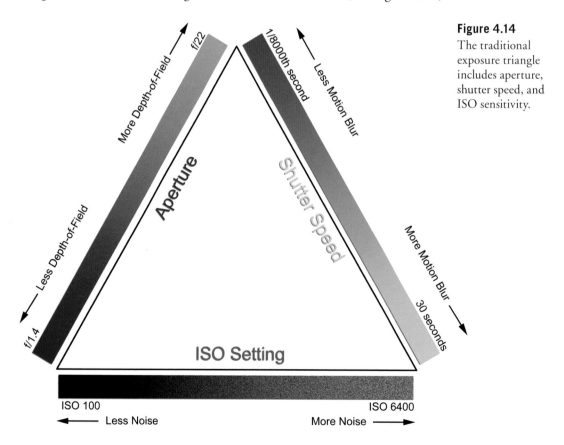

Figure 4.14
The traditional exposure triangle includes aperture, shutter speed, and ISO sensitivity.

F/STOPS AND SHUTTER SPEEDS

Each of my books always has a few readers who are totally new to photography, so it's always necessary to recount how f/stops and shutter speeds are described.

The time-honored way to explain an f/stop or lens aperture is to describe it as a ratio, much like a fraction. That's why f/2 is "larger" than f/4, just as 1/2 is larger than 1/4. However, f/2 is actually *four times* as large as f/4, because the ratio is calculated from the square root of two: 1.4.

Lenses are usually marked with intermediate f/stops that represent a size that's twice as much/half as much as the previous aperture. So, a lens might be marked:

f/2, f/2.8, f/4, f/5.6, f/8, f/11, f/16, f/22, with each larger number representing an aperture that admits half as much light as the one before.

Shutter speeds are actual fractions (of a second), but the numerator is omitted, so that 60, 125, 250, 500, 1,000, and so forth represent 1/60th, 1/125th, 1/250th, 1/500th, and 1/1,000th second. To avoid confusion, virtually all camera vendors use quotation marks to signify longer exposures: 2", 2"5, 4", and so forth representing 2.0-, 2.5-, and 4.0-second exposures, respectively.

You can change from one exposure to an equivalent exposure using a different f/stop and shutter speed, by making one value larger, while reducing the other value by an equivalent amount. So, 1/30th second at f/22 is the same as 1/60th second (half the duration) at f/16 (twice the aperture size).

The factors affecting exposure include:

■ **Intensity of the light.** Indoors, we can turn lights on and off, move them around, and perhaps control their intensity with a dimmer switch. We can add auxiliary lighting equipment. Outdoors, we may have less control over the amount, direction, and quality of the light—although sources like electronic flash, reflectors, and light blockers can add or subtract light from a scene.

■ **Duration.** Light may be continuous during an entire exposure, or, as in the case of an electronic flash, may be intermittent and last for only part of the time the shutter is open.

■ **Amount of light reflected, transmitted, or emitted.** Cameras record only light that bounces off our subjects, or is transmitted through them (say, from translucent objects that are lit from behind), or emitted (perhaps by a campfire or LCD screen).

■ **Light traveling through the camera's lens.** Some of the light from our subject can be filtered out or reduced by the variable-sized lens opening, or aperture of the lens. Changing this *f/stop* provides one of the primary ways we control exposure.

■ **Light admitted by the shutter.** The sensor can capture light only for the duration that the shutter is open, generally from 30 seconds to as fast as 1/8,000th second if we are using the typical camera's automatic shutter speed controls, or for longer if we choose the Bulb setting (which locks the shutter open until we manually release it).

■ **Captured photons.** The discussion of sensors earlier explained how individual photosites either record or do not record the photons that fall into their "buckets."

These six factors all work proportionately and reciprocally to produce an exposure. If you double the *intensity* of the light; lengthen its *duration* by 2X (either at the source or using the shutter); cause twice as much to be *reflected, transmitted,* or *emitted*; or double the number of photons recorded (say, by boosting the ISO setting 2X), you end up with twice as much exposure. Similarly, you can *increase* any one of these factors while *decreasing* one of the others in the same proportion to keep the same exposure.

Choosing an Exposure Mode

Digital SLRs typically have a mixture of fully automated, semi-automated, and manual exposure modes that can choose a correct (or close to correct) exposure for you, or let you have some (or all) control over how the camera exposes the photograph. The ability to choose an exposure mode affects the amount of creativity you can put into the image. You can elect to have the camera make most of the decisions for you, or you can tailor the settings yourself to achieve a particular effect or look.

Programmed and Full Auto Exposures

Digital cameras have modes that select the f/stop and shutter speed for you. Some are fully automatic (you can make few or no adjustments to the settings the camera chooses) or "programmed" (the camera selects settings, but you can modify them for a special effect). Although vendors call these by different names, they generally perform similar functions, as described in this list:

■ **Full Auto.** This mode, usually marked with a green camera or rectangle icon on the selection control (often a *mode dial),* directs the camera to make all the exposure decisions for you, with virtually no options for the photographer. The camera may also choose how to focus the image, whether to pop up the flash, and other parameters. This is the mode you'd use when you stop an honest-looking stranger on the street and ask him to take your picture posing by that big glass pyramid in front of the Louvre.

■ **Full Auto (No Flash).** Once you proceed *inside* the Louvre, you might want to switch to this setting to turn off your electronic flash and work with available light. (Tip: they don't like you to take pictures at all of the Mona Lisa, but there are always about 1,000 tourists doing it anyway at any given time.) This setting, usually marked with a lightning bolt symbol with a diagonal line through it, also works at religious ceremonies, concerts, or any other venue where flash is disruptive or useless.

■ **Creative Auto.** This is a term Canon applies to an automatic mode that allows you to make a few changes. For example, you can turn the flash on or off, but can't adjust the power of the flash nor apply exposure compensation to flash exposures. This mode would be useful for beginners who want the no-brainer qualities of Full Auto, but have learned enough to make some simple adjustments, such as "brighter/darker" or more or less "background blur."

- **Programmed.** With the typical dSLR, Programmed or Programmed Auto is an automatic mode that makes basic settings for you, but allows a great deal of fine-tuning. While in P mode, you can change exposure combinations (switching to a faster or slower shutter speed and letting the camera choose the appropriate aperture—or a different f/stop, with the camera selecting the right shutter speed). P mode also allows adding or subtracting exposure from the calculated reading (*exposure compensation*), switching to a different Picture Control or Picture Style, or performing other adjustments. Many photographers like to use P mode when they encounter a photo-worthy situation and don't have the time to think about what semi-automatic or manual setting to use. Some—even more than a few professional photographers—use P almost all the time, because modern cameras do an excellent job of choosing settings for many typical types of pictures.

- **Scene modes.** These are fully automatic modes (although some may allow a few adjustments) tailored for specific types of shooting, such as Landscapes, Night Portraits, Sports, or Close-Ups. Beginners love these, because they don't require much experience or knowledge. There are dozens of different scene modes, and I'll explain a typical selection of them next.

You can see a quartet of typical dSLR mode dials in Figure 4.15.

Entry-level and intermediate digital SLRs may have from a half-dozen to two dozen scene modes, including some that I consider silly, such as Food (increased saturation to make the food look better) and Museum (locks out the flash even in low light, so you won't get kicked out of the venue), because there are other ways to achieve the same effect. Scene modes generally make some settings for you, and may limit the other settings you can make by blocking out your override capabilities for focus, exposure, brightness, contrast, white balance, or saturation.

Figure 4.15
A dSLR's mode dial offers various exposure options, including priority modes and scene modes. Clockwise, from top left, are typical mode dials from Canon, Nikon, Sony, and Pentax models.

I don't know any advanced dSLR users who work with scene modes regularly, but they're handy if you're a neophyte and fear that the basic programmed exposure modes or semi-automatic/manual modes won't do the job. If a split-second photo opportunity arises, such as a pet unexpectedly doing something cute, if you can't remember what settings you've adjusted on your camera, switch into an appropriate scene mode. You'll get your picture even if it turns out the camera was set in manual mode for a 30-second fireworks exposure the night before.

Note that some digital SLRs may have a basic complement of scene modes on the mode dial, with an additional setting (often called SCN) that provides access to a dozen or more additional scene modes. A few cameras have yet another mode dial setting that provides Special Effects retouching modes, including fisheye effects, that are applied as you take the picture. Here are some of the common scene/effects modes found in digital SLRs, and the typical parameters used by them. No single camera will have all of these; I'm presenting only a selection of some that are offered with some cameras:

- **Portrait.** This scene mode uses a large f/stop to throw the background out of focus and generally sets the flash (if used) for red-eye reduction mode.
- **Night.** Reduces the shutter speed to allow longer exposures without flash, and to allow ambient light to fill in the background when flash is used.
- **Night Portrait.** Uses a long exposure, usually with red-eye flash, so the backgrounds don't sink into inky blackness.
- **Night Vision.** This effect gives you a monochrome image recorded at high ISO under very low light conditions. Because the light is so dim, autofocus is available only in live view mode. You can use manual focus. You'll probably want to use a tripod, because this mode can use longer shutter speeds that accentuate camera movement. (See upper left, Figure 4.16.)
- **Beach/Snow.** May slightly overexpose a scene to counter the tendency of automatic metering systems to overcompensate for very bright settings.
- **Sports.** Uses the highest shutter speed available to freeze action, and may choose spot metering to expose for fast-moving subjects in the center of the frame. This mode may boost the ISO sensitivity to capture more light in dim conditions, or to permit that faster shutter speed.
- **Landscape.** Generally selects a small f/stop to maximize depth-of-field, and may also increase the saturation setting of your camera to make the landscape more vivid.
- **Macro.** Some cameras have a close-up scene mode that shifts over to macro focus mode, which defaults to a smaller f/stop (to provide increased depth-of-field), favors higher shutter speeds to help make close-up photos sharp, and adjusts how your camera selects focus.
- **Kids & Pets.** An "action" scene mode for capturing fast-moving pets and children without subject blur. The camera may boost the ISO to a higher level than normal to allow a fast shutter speed.
- **Silhouette.** Produces silhouettes against bright backgrounds, and flash is disabled. (See Figure 4.16, upper right.)

Figure 4.16

Special effects/scene modes can include Night Vision (upper left); Silhouette (upper right); High Key (lower left); and Low Key (lower right).

- **Super Vivid.** This setting increases the saturation of the colors in a scene, making them appear much richer and more intense than normal. Use it for dramatic effect, but you'll probably want to use this one sparingly, because it could wear out its welcome rapidly.

- **Poster Effect.** This setting, like the previous one, is not intended for a specific type of scene; rather, it imposes a particular type of processing on the image. In this case, it provides a degree of "posterization," increasing contrast with bright color effects.

- **Color Accent.** Creates a special effect: Choose one color on the LCD, and all the other colors in an image are converted to black-and-white.

- **Color Swap.** Changes one color to another. If you want to see Kentucky bluegrass that's *really* blue, this is the mode for you.

- **HDR.** This setting is found on a few cameras, and used for producing in-camera processing of a High Dynamic Range image, by taking three pictures in one sequence at different exposures, and then combining them into a final product that uses the most clearly exposed portions of the different shots to give you better combination of highlights, shadows, and middle tones than you could get with just one exposure.

- **Nostalgic.** This setting lets you ramp down the saturation of the colors in your images, giving the appearance of a faded, antique photograph.

- **Fisheye Effect.** This setting simulates the bulging, distorted view produced by an extreme wide-angle "fisheye" lens.
- **Miniature Effect.** This setting lets you select a portion of the image to be shown clearly, while blurring the top and bottom, resulting in an effect like viewing a miniaturized model.
- **Underwater.** This setting is intended specifically for use under the surface of water (many dSLRs have optional waterproof cases). It removes bluish color casts and reduces the intensity of the flash. The camera may use a high ISO setting to compensate for the reduced amount of light underwater.
- **Foliage.** Another saturation-rich setting for shooting trees and leaves, with emphasis on bright and vivid greens.
- **Fireworks.** Offers vivid photos of fireworks with a longer exposure to capture an entire burst.
- **Selective Color.** This setting creates an image with the selective color effects described previously. As with the other special effects, the built-in flash is disabled.
- **High Key.** Creates bright scenes. This effects tool, like the Low Key effect described next, can't work miracles. It won't produce a high-key image from a low-key subject. But if you have a scene that is filled with bright light, this effect will accentuate that, as seen at lower left in Figure 4.16.
- **Low Key.** Gives you dark, foreboding images. You'll need contrasty lighting to achieve this effect, but given the right subject, you can end up with an image like the one at lower right in Figure 4.16.

Adjusting Exposure with ISO Settings

Most photographers use two primary ways of adjusting exposure: changing the shutter speed or aperture, but may also resort to modifying the amount of light illuminating the scene (most often by adding a source, such as a lamp or electronic flash). However, a less-used way of adjusting exposures is by changing the ISO sensitivity setting. Sometimes photographers forget about this option, because the common practice is to set the ISO once for a particular shooting session (say, at ISO 200 for bright sunlight outdoors, or ISO 800 when shooting indoors) and then forget about ISO. That's because ISOs higher than ISO 200 or 400 are seen as "necessary evils." However, changing the ISO is a valid way of adjusting exposure settings, particularly with cameras that have relatively low light levels at settings as high as ISO 1600, ISO 3200, or higher.

ISO adjustment is a convenient alternate way of adding or subtracting EV when shooting in Manual mode, and as a quick way of choosing equivalent exposures when in Program or Shutter-priority or Aperture-priority modes. For example, select a Manual exposure with suitable f/stop and shutter speed using, say, ISO 200. You can then change the exposure in increments (1/3, 1/2, or whole stops). The difference in image quality/noise at the base setting of ISO 200 can be negligible when you change to ISO 250 or ISO 320 to increase exposure. You end up with your preferred f/stop and shutter speed, but still are able to adjust the exposure.

Or, perhaps, you are using Shutter-priority/Tv mode and the metered exposure at ISO 200 is 1/500th second at f/11. If you decide to use 1/500th second at f/8, you can change the sensitivity to ISO 100. It's a good idea to monitor your ISO changes, so you don't end up at ISO 6400 accidentally.

ISO settings can, of course, also be used to boost or reduce sensitivity in particular shooting situations. Most cameras can also adjust the ISO automatically as appropriate for various lighting conditions. You may even be able to specify the minimum shutter speed where automatic ISO changes kick in. Perhaps you feel you can hand-hold an image at 1/30th second, so you prefer that ISO not be boosted until the camera is forced to use 1/15th second, instead. Most dSLRs also allow you to specify the highest ISO setting that will be used in Auto ISO mode, so, you can "top out" the adjustments at, say, ISO 3200 if your particular model doesn't do a good job at higher sensitivity settings (as described in Chapter 1).

Semi-Automatic and Manual Exposure Modes

All digital SLRs have these, although the names may differ slightly among cameras from various vendors. You'll generally choose the mode you want from a mode dial that also includes the fully automatic and scene modes at other detents. Your choice of which is best for a given shooting situation will depend on things like your need for lots of (or less) depth-of-field, a desire to freeze action or allow motion blur, or how much noise you find acceptable in an image. Each of these exposure methods emphasizes one aspect of image capture or another. This section introduces you to all three.

Aperture-Priority

This setting is called Aperture-priority, aperture preferred, or aperture value mode, depending on the vendor, and is usually abbreviated either A or Av. In Aperture-priority mode, you specify the lens opening used, and the camera selects the shutter speed. This mode is especially good when you want to use a particular lens opening to achieve a desired effect. Perhaps you'd like to use the smallest f/stop possible to maximize depth-of-field in a close-up picture. Or, you might want to use a large f/stop to throw everything except your main subject out of focus, as in Figure 4.17. Maybe you'd just like to "lock in" a particular f/stop because it's the sharpest available aperture with that lens. Or, you might prefer to use, say, f/2.8 on a lens with a maximum aperture of f/1.4, because you want the best compromise between speed and sharpness.

Aperture-priority can even be used to specify a *range* of shutter speeds you want to use under varying lighting conditions, which seems almost contradictory. But think about it. You're shooting a soccer game outdoors with a telephoto lens and want a relatively high shutter speed, but you don't care if the speed changes a little should the sun duck behind a cloud. Set your camera to A or Av, and adjust the aperture until a shutter speed of, say, 1/1,000th second is selected at your current ISO setting. (In bright sunlight at ISO 400, that aperture is likely to be around f/11.) Then, go

Figure 4.17
Use Aperture-priority to "lock in" a large f/stop when you want to blur the background.

ahead and shoot, knowing that your camera will maintain that f/11 aperture (for sufficient DOF as the soccer players move about the field), but will drop down to 1/750th or 1/500th second if necessary should the lighting change a little.

An indicator in the viewfinder or LCD will show when the camera is unable to select an appropriate shutter speed at the selected aperture and that over- and underexposure will occur at the current ISO setting. That's the major pitfall of using Aperture-priority: you might select an f/stop that is too small or too large to allow an optimal exposure with the available shutter speeds. For example, if you choose f/2.8 as your aperture and the illumination is quite bright (say, at the beach or in snow), even your camera's fastest shutter speed might not be able to cut down the amount of light reaching the sensor to provide the right exposure. Or, if you select f/8 in a dimly lit room, you might find yourself shooting with a very slow shutter speed that can cause blurring from subject movement or camera shake. Aperture-priority is best used by those with a bit of experience in choosing settings. Many seasoned photographers leave their cameras set on A/Av all the time. The exposure indicator scale in the status panel and viewfinder typically indicate the amount of under- or over-exposure, so you can make adjustments as required.

When to use Aperture-priority:

■ **General landscape photography.** Aperture-priority is a good tool for ensuring that your landscape is sharp from foreground to infinity, if you select an f/stop that provides maximum depth-of-field.

If you use A mode and select an aperture like f/11 or f/16, it's your responsibility to make sure the shutter speed selected is fast enough to avoid losing detail to camera shake, or that the camera is mounted on a tripod. One thing that new landscape photographers fail to account for is the movement of distant leaves and tree branches. When seeking the ultimate in sharpness, go ahead and use Aperture-priority, but boost ISO sensitivity a bit, if necessary, to provide a sufficiently fast shutter speed, whether shooting hand-held or with a tripod.

■ **Specific landscape situations.** Aperture-priority is also useful when you have no objection to using a long shutter speed, or, particularly, *want* the camera to select one. Waterfalls are a perfect example. You can use A mode, set your camera to ISO 100, use a small f/stop, and let the camera select a longer shutter speed that will allow the water to blur as it flows. Indeed, you might need to use a neutral-density filter to get a sufficiently long shutter speed. But Aperture-priority mode is a good start.

■ **Portrait photography.** Portraits are the most common applications of selective focus. A medium large aperture (say, f/5.6 or f/8) with a longer lens/zoom setting (in the 85mm-150mm range) will allow the background behind your portrait subject to blur. A *very* large aperture (I frequently shoot wide open with my 85mm f/1.4 lens) lets you apply selective focus to your subject's *face*. With a three-quarters view of your subject, as long as their eyes are sharp, it's okay if the far ear or their hair is out of focus.

- **When you want to ensure optimal sharpness.** All lenses have an aperture or two at which they perform best. That's usually about two stops down from wide open, and thus will vary depending on the maximum aperture of the lens. My 45mm f/1.8 is good wide open, but it's even sharper at f/2.8 or f/4; I shoot my 14-40mm f/2.8 wide open at concerts, but, if I can use f/4 instead, I'll get better results. Aperture-priority allows me to use each lens at its very best f/stop.

- **Close-up/Macro photography.** Depth-of-field is typically very shallow when shooting macro photos, and you'll want to choose your f/stop carefully. Perhaps you need the smallest aperture you can get away with to maximize DOF. Or, you might want to use a wider stop to emphasize your subject. A mode comes in very useful when shooting close-up pictures. Because macro work is frequently done with the camera mounted on a tripod, and your close-up subjects, if not living creatures, may not be moving much, a longer shutter speed isn't a problem. Aperture-priority (Av mode) can be your preferred choice.

Shutter-Priority

Shutter-priority/shutter preferred/time value exposure (S or Tv) is the inverse of Aperture-priority: you choose the shutter speed you'd like to use, and the camera's metering system selects the appropriate f/stop. Perhaps you're shooting action photos and you want to use the absolute fastest shutter speed available with your camera; in other cases, you might want to use a slow shutter speed to add some blur to a sports photo that would be mundane if the action were completely frozen. (See Figure 4.18.) Shutter-priority mode gives you some control over how much action-freezing capability your digital camera brings to bear in a particular situation.

Figure 4.18
Lock the shutter at a slow speed to introduce blur into an action shot, as with this panned image of a relay race.

MAKING EV CHANGES

Sometimes you'll want more or less exposure than indicated by the camera's metering system. Perhaps you want to underexpose to create a silhouette effect, or overexpose to produce a high key look. All dSLRs have an exposure compensation system, generally accessible by pressing a button on the camera with a plus/minus mark. Hold down the button and adjust the appropriate dial, wheel, or other control.

The EV change, usually plus or minus three to five stops, remains for the exposures that follow, until you manually zero out the EV setting. An exposure compensation icon or indicator is easy to miss, so don't forget to cancel the change when you're done.

You'll also encounter the same problem as with Aperture-priority when you select a shutter speed that's too long or too short for correct exposure under some conditions. Like A/Av mode, it's possible to choose an inappropriate shutter speed. If that's the case, the displays will show an indicator, which varies depending on the camera model.

When to use Shutter-priority:

- **To reduce blur from subject motion.** Set the shutter speed of the camera to a higher value to reduce the amount of blur from subjects that are moving. The exact speed will vary depending on how fast your subject is moving and how much blur is acceptable. You might want to freeze a basketball player in mid-dunk with a 1/1,000th second shutter speed, or, as I mentioned earlier, use 1/250th second to allow the spinning wheels of a motocross racer to blur a tiny bit to add the feeling of motion.

- **To add blur from subject motion.** There are times when you want a subject to blur, say, when shooting those waterfalls or rivers with the camera set for a one- or two-second exposure in Shutter-priority mode.

- **To add blur from camera motion when *you* are moving.** Say you're panning to follow a relay runner, as illustrated earlier in Figure 4.18. You might want to use Shutter-priority mode and set the camera for 1/60th second, so that the background will blur as you pan with the runner. The shutter speed will be fast enough to provide a sharp image of the athletes.

- **To reduce blur from camera motion when *you* are moving.** In other situations, the camera may be in motion, say, because you're shooting from a moving train or auto, and you want to minimize the amount of blur caused by the motion of the camera. Shutter-priority is a good choice here, too.

- **Landscape photography hand-held.** If you can't use a tripod for your landscape shots, you'll still probably want the sharpest image possible. Shutter-priority can allow you to specify a shutter speed that's fast enough to reduce or eliminate the effects of camera shake. Just make sure that your ISO setting is high enough that the camera will select an aperture with sufficient depth-of-field, too.

- **Concerts, stage performances.** I shoot a lot of concerts with my 50-200mm f/2.8-3.5 lens, and have discovered that, when image stabilization is taken into account, a shutter speed of 1/180th second is fast enough to eliminate the effects of camera shake from hand-holding the camera with this lens, and also to avoid blur from the movement of all but the most energetic performers. I use Shutter-priority and set the ISO so the camera will select an aperture in the f/4-5.6 range.

Program Mode

Program mode/Programmed Auto (P) uses the camera's built-in smarts to select both the correct f/stop and shutter speed using a database of picture information that tells it which combination of shutter speed and aperture will work best for a particular type of photo. If the correct exposure cannot be achieved at the current ISO setting, the shutter speed and/or aperture indicator in the viewfinder will blink, indicating under- or overexposure. You can then boost or reduce the ISO to increase or decrease sensitivity and bring the camera's settings back into "range."

The camera's recommended exposure can be overridden if you want. Use the EV setting feature (also described later, because it also applies to S and A modes) to add or subtract exposure from the metered value. And, as I mentioned earlier in this chapter, you can change from the recommended setting to an equivalent setting that produces the same exposure, but using a different combination of f/stop and shutter speed.

When to use Program mode priority:

- **When you're in a hurry to get a grab shot.** The camera will do a pretty good job of calculating an appropriate exposure for you, without any input from you.

- **When you hand your camera to a novice.** Set the camera to P, hand the camera to your friend, relative, or trustworthy stranger (someone you meet in front of the Eiffel Tower who does not already have three or four cameras and is not wearing track shoes), point to the shutter release button and viewfinder, and say, "Look through here, and press this button." While you can also use the Auto mode found on many cameras as a novice-friendly mode, P gives you the option of making some exposure adjustments before turning your camera over to the other person.

- **When no special shutter speed or aperture settings are needed.** If your subject doesn't require special anti- or pro-blur techniques, and depth-of-field or selective focus aren't important, use P as a general-purpose setting. You can still make adjustments to increase/decrease depth-of-field or add/reduce motion blur with a minimum of fuss.

Manual Exposure

Manual exposure can come in handy in some situations. You might be taking a silhouette photo and find that none of the exposure modes or EV correction features give you exactly the effect you want. Set the exposure manually to use the exact shutter speed and f/stop you need. Or, you might be working in a studio environment using multiple flash units. The additional flash are triggered by slave devices (gadgets that set off the flash when they sense the light from another flash unit, or, perhaps from a radio or infrared remote control). Your camera's exposure meter doesn't compensate for the extra illumination, so you need to set the aperture manually.

Because, depending on your proclivities, you might not need to set exposure manually very often, you should still make sure you understand how it works. Fortunately, most dSLRs make setting exposure manually easy, usually by rotating a main/back panel command dial for shutter speed, and a front/sub-command or other dial for aperture. You might also use the same dial for both, and press a button to switch back and forth.

Manual exposure mode is a popular option among more advanced photographers who know what they want in terms of exposure, and want to make the settings themselves. Manual lets you set both shutter speed and aperture. There are several reasons for using Manual exposure:

- **When you want a specific exposure for a special effect.** Perhaps you'd like to deliberately underexpose an image drastically to produce a shadow or silhouette look. You can fiddle with EV settings or override your camera's exposure controls in other ways, but it's often simpler just to set the exposure manually.

- **When you're using an external light meter in tricky lighting situations or for total control.** Advanced photographers often fall back on their favorite hand-held light meters for very precise exposure calculations. For example, an incident meter, which measures the light that falls on a subject rather than the light reflected from a subject, can be used at the subject position to measure the illumination in the highlights and shadows separately. This is common for portraits, because the photographer can then increase the fill light, reduce the amount of the main light, or perform other adjustments. Those enamored of special exposure systems, like the marvelously effective and complex Zone System of exposure developed by Ansel Adams, might also want the added control an external light meter provides.

- **When you're using an external flash that's not compatible with your camera's TTL (through-the-lens) flash metering system.** You can measure the flash illumination with a flash meter, or simply take a picture and adjust your exposure in Manual mode.

- **When you're using a lens that doesn't couple with your digital camera's exposure system.** Several digital SLR models can use older lenses not designed for the latest modes of operation, although they must be used in Manual focus/exposure mode. I have several specialized older lenses that I use with my dSLR in Manual focus/manual exposure mode. They work great, but I have to calculate exposure by guesstimate or by using an external meter. My camera's exposure system won't meter with these optics under any circumstances.

Exposure Metering

Regardless of whether you're using fully automatic, Programmed, Aperture-/Shutter-priority, or Manual mode using your camera's exposure indicators as a guideline, you'll want to choose a metering method that suits your situation.

Digital SLRs use light-sensitive electronics to measure the light passing through the lens. In the early days of non-digital SLRs, that capability was considered something of a miracle in itself, because cameras of that era frequently captured exposure information through clumsy photocells mounted on the *outside* of the camera body. The alternative was to use a hand-held meter. Such systems were relatively low in sensitivity, and you had to be incredibly lucky or well-seasoned in interpreting meter readings for the light captured by the meter to have some correspondence with the illumination that actually reached the film. Of course, if you used a filter or other add-on, all bets were off. Photographers were delighted when cameras were introduced that actually measured light destined for the film itself.

Of course, we now take TTL (through-the-lens) metering for granted. Digital SLRs use much more refined methods of metering light, too, compared to the earliest through-the-lens models that captured an amorphous blob of light without much regard to where it originated in the image. Modern metering systems can be divided into several categories:

- **Center-weighting.** While early cameras had a form of averaging metering, in which light from all portions of the viewfinder was captured, in truth they tended to emphasize the center portion of the frame. This bug was turned into a feature and center-weighted averaging was born. Most of the exposure information is derived from the middle of the frame. Figure 4.19 shows, roughly, the typical area emphasized by a center-weighted metering system. (The blue shading does *not* appear in the viewfinder!)

- **Spot metering.** This method gathers exposure information only from a central portion of the frame. You may be able to choose from a 6mm or 8mm spot, or larger. Light outside the spot area is ignored. Figure 4.20 shows a typical center spot arrangement, with the sensitive area in blue. Some cameras allow you to change the spot metered area from the center, usually to one of the locations indicated by the focus area brackets (in red in the figure). Some Canon cameras have a partial spot metering system called, logically enough, Partial, that measures an area that is somewhat larger.

- **Matrix/Evaluative metering.** Exposure information is collected from many different positions in the frame, and then used to calculate the settings using one of several calculation routines. Figure 4.21 shows the matrix/evaluative metering zones used by Canon for one of its intermediate models.

Once the camera's metering system has captured the amount of illumination passing through the lens, the information is evaluated and the correct exposure determined. How that exposure is calculated can vary from camera to camera. One vendor's camera may calculate center-weighted exposure based on an average of all the light falling on a frame, but with extra weight given to the center.

Figure 4.19 Center-weighting gathers most of its exposure information from the center of the frame, but it also includes data from the rest of the image.

Figure 4.20 Spot metering collects exposure information only from the center of the frame.

Figure 4.21 Matrix/evaluative metering gathers exposure information from an array of areas within the frame.

Others may use a modified spot system with a really large, fuzzy spot, so that light at the periphery of the frame is virtually ignored, even though the system is *called* center-weighting.

Similarly, spot metering can vary depending on the size of the spot, and what the camera elects to do with the spot of information, and how much flexibility the photographer is given over the process. For example, as I mentioned, you might be able to choose the size of the spot. Or, you may be allowed to move the spot around in the viewfinder using your camera's cursor controls, so that you meter the subject area of your choice, rather than a central area forced on you by the camera. You'll find this option especially useful for backlit subjects or macro photography.

In modern multipoint matrix metering systems, hundreds or thousands of different points might be measured. Various Nikon models, for example, use anything from a 420- to 2,016-cell CCD in the viewfinder to collect individual pieces of exposure data.

Matrix metering enables the camera to make some educated guesses about the type of picture you are taking, and choose an exposure appropriately. For example, if the camera detects that the upper half of the frame is brighter than the bottom half, it may make a reasonable assumption that the image is a landscape photo and calculate exposure accordingly.

Brightness patterns from a large number of metering zones in the frame are collected, and then compared against a large database of sample pictures compiled by the camera manufacturer. Your camera is not only capable of figuring out that you're shooting a landscape photo, it can probably identify portraits, moon shots, snow scenes, and dozens of other situations with a high degree of accuracy.

These highly sophisticated evaluation systems use a broad spectrum of information to make exposure decisions. In addition to overall brightness of the scene, the system may make changes based on the focus distance (if focus is set on infinity, the image is more likely to be a landscape photo); focus or metering area (if you've chosen a particular part of the frame for focus or metering, that's probably the center of interest and should be given additional weight from an exposure standpoint);

the difference in light values throughout the frame (effectively, the contrast of the image); and, finally, the actual brightness values encountered.

It's often smart to build in some bias toward underexposure, because incorrectly exposed shadows are easier to retrieve than blown highlights. Evaluative metering systems use that kind of bias and other factors to calculate your exposure. For example, in dark scenes, the tendency is to favor the center of the photo. In scenes with many bright values, extra attention is given to the brightest portions, especially if the overall contrast of the image is relatively low. Your best bet is to become familiar with how your own camera's exposure systems work in the kinds of photo situations you favor.

EXPOSURE LOCK

Digital SLRs include an exposure lock/focus lock button you can use to capture the current exposure settings without the need to continuously hold down the shutter release. The exposure and/or focus remains locked until you take the next picture, allowing you to reframe or do other things before you actually depress the shutter release to capture the image.

Bracketing

Another control you might find handy is the bracketing option, which automatically provides settings with less and additional exposure (clustered around your base exposure), using an increment (such as 1/3 or 1/2 stop) that you select. More advanced systems can bracket conventional exposure, flash exposure, or both, and perhaps other values, such as white balance. By using bracketing to shoot several consecutive exposures at different settings, you can improve the odds that one will be exactly correct, or that one will be "better" from a creative standpoint. For example, bracketing can supply you with a normal exposure of a backlit subject, one that's "underexposed," producing a silhouette effect, and a third that's "overexposed" to create yet another look. (See Figure 4.22.) Not all cameras have built-in bracketing in any form, but you can always shoot successive images at different exposures with manual adjustments.

I use bracketing a great deal, not because I lack confidence in my camera's exposure metering or my ability to fine-tune it. Some pictures just can't be reshot if the exposure is not exactly right, and under conditions where lighting is constantly changing, or a scene has a mixture of bright sunny areas and dusky shadows, a range of exposures can be useful. So, I'll set the camera to shoot in three-shot brackets, either with a 1/3 stop or 2/3 stop increment, depending on how widely the lighting conditions vary. (With a broader range of lighting, I'll use a larger increment to increase the chances that *one* of my shots will be spot-on.) Then, I'll use continuous shooting mode and bang off a triplet of shots with one press of the shutter button.

Figure 4.22
Bracketing can give you three different exposures of the same subject.

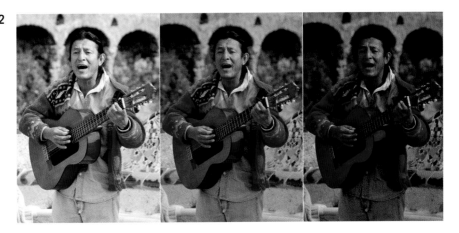

Depending on the type of dSLR you are using, you might have some decisions to make in setting up bracketing:

- **Choose type of bracketing.** Your camera may allow you to bracket exposure only, flash exposure only, or both, plus white balance only. Nikon cameras also allow bracketing the Active D-Lighting feature to boost detail in highlights.

- **Select number of bracketed exposures.** Some cameras, particularly entry-level models, shoot a fixed number of bracketed shots (say, three); Nikon cameras may allow you to choose from 0 (which turns bracketing off), or 2, 3, 5, 7, or 9 bracketed shots. You'll find a higher number of shots useful when shooting images for later HDR processing, as more images provide a larger span of exposures on which the HDR software can perform its magic, as explained next.

- **Choose bracket increment.** You can select 1/3 stop brackets (for minor fine-tuning), as well as 2/3 or 1 stop adjustments for a broader range of exposures. Some cameras may allow you to choose even larger bracket increments.

- **Set zero point.** Canon cameras allow you to move the zero point for bracketing from the metered exposure to a higher or lower value. That way, you can create a set of bracketed exposures that are clustered around the metered exposure, or which are all underexposures or overexposures.

- **Frame and shoot.** As you take your photos the camera will vary exposure, flash level, white balance, or other setting for each image. In single shot mode for exposure bracketing, you'll need to press the shutter release button the number of pictures in your bracketed set. In continuous shooting mode, all will be taken in one burst if you continue to hold down the shutter release.

- **Turn bracketing off.** When you're finished bracketing shots, remember to cancel bracketing. If you've been using single shot mode and forget you're still bracketing, you may be puzzled why your exposures differ from shot to shot.

Bracketing and Merge to HDR

HDR (High Dynamic Range) photography is all the rage right now, with entire books devoted to telling you how, using software, you can partially correct for your sensor's inability to record an unrealistically long dynamic range. I'm joking, in part, because the most common use for HDR seems to be to produce fantasy-world images that couldn't possibly be seen by the eyes of humans. They're most often vertically oriented landscapes (so as to encompass the maximum amount of sky and foreground in the same image), shot with ultra-wide-angle lenses (for the same reason), with dramatic skies and fine details stretching from immediately in front of the photographer to infinity. Enjoy viewing and taking these images while you can, because, like cross-processing techniques (if you'll recall those weird colors that dominated fashion photography five to ten years ago), they will soon fall from favor.

Yet, HDR does have uses for improving images in less extreme ways, providing a photo that looks more like the scene did to your unaided eye. High dynamic range photography involves shooting two or three or more images at different manually or automatically bracketed exposures, giving you an "underexposed" version with lots of detail in highlights that would otherwise be washed out, an "overexposed" rendition that preserves detail in the shadows, and several intermediate shots. These are combined to produce a single image that has an amazing amount of detail throughout the scene's entire tonal range.

Figure 4.23 Exposing for the foreground overexposes the area seen through the columns.

Figure 4.24 Adjust the exposure for the far background, and everything else is underexposed.

Suppose you encountered a colonnaded structure such as the one in the Gaudí-designed Park Güell in Barcelona. Exposing for the foreground columns leaves the open park area at the end overexposed, as you can see in Figure 4.23. If you expose for the park seen through the columns—a difference of more than 7 f/stops—the columns themselves appear dark and dingy. (See Figure 4.24.) But taking several exposures and combining them into one shot gives you an image like the one in Figure 4.25, which more or less resembles what the scene actually looks like to the eye.

Figure 4.25
Combining several exposures using HDR techniques yields one optimized image.

When you're using Merge to HDR, a feature found in Adobe Photoshop (similar functions are available in other programs, including Photomatix [www.hdrsoft.com; free to try, $99 to buy]), you'd take several pictures. As I mentioned earlier, one would be exposed for the shadows, one for the highlights, and perhaps several more for the midtones. Then, you'd use the Merge to HDR Pro command (or the equivalent in other software) to combine all of the images into one HDR image that integrates the well-exposed sections of each version.

The images should be as identical as possible, except for exposure. So, it's a good idea to mount the camera on a tripod, use a remote release, and take all the exposures in one burst. You should use Aperture-priority to fix the aperture at a single f/stop—otherwise the focus and depth-of-field will change and make merging the photos more difficult. Or, you can bracket manually and remember to change only the shutter speed.

If you don't have the opportunity or inclination, or skills to create several images at different exposures of the original scene, you may still be able to create an HDR photo. If you shoot in RAW format, import the image into your image editor several times, using the RAW import utility (such as Adobe Camera Raw) to create multiple copies of the file at different exposure levels. For example, you'd create one copy that's too dark, so the shadows lose detail, but the highlights are preserved. Create another copy with the shadows intact and allow the highlights to wash out. A third copy would optimize the middle tones. Then, you can use your HDR software to combine the three and end up with a finished image that has the extended dynamic range you're looking for.

5

Mastering the Mysteries of Focus

Correct focus is another critical aspect of taking a technically optimized photograph. You want your main subject to be in sharp focus generally (there are exceptions), and may want other parts of the image to be equally as sharp, or you may want to let them become blurry to use selective focus techniques.

If you're coming from the point-and-shoot camera world, focus was probably no big deal for you. These models have tiny sensors and short focal length lenses, with, say, a 6-36mm true zoom range (but billed as a 28-168mm "equivalent"). So, virtually everything may be in sharp focus, except when shooting macro (close-up) photos. That extensive depth-of-field can be either a good thing or a bad thing, depending on whether you wanted to use focus creatively.

Digital SLRs, on the other hand, have larger sensors, use lenses with longer focal lengths, and aren't necessarily susceptible to this problem/advantage. Focus really matters. You can choose to focus the image yourself, manually, let the camera focus for you, or step in and fine-tune focus after the camera has done its best. There are advantages and disadvantages to each approach. To help you understand your focusing options, this chapter will first explain the basics of focus, to help you understand what the focus controls and settings available on your camera do. Then, I'll dive a little more deeply into exactly how focusing works, which will enable you to fine-tune how you choose to put your dSLR's focusing capabilities to work.

Manual Focus

Manual focus, activated with an AF/M switch on the lens or camera body, or, sometimes through a menu setting, allows you to twist the focus ring on your lens until the image you want pops into sharp focus. For some who are new to digital photography, this may be an almost forgotten skill, because most cameras have had autofocusing capabilities built in for at least 20 years. However, manual focusing is a skill that's easy to learn. Many dSLRs have a cool feature to help you: Even if you're focusing manually, a focus indicator LED may illuminate or stop blinking when you've achieved correct focus, giving you some helpful extra confirmation. A few cameras have a range-finder feature, shown in Figure 5.1, that helps you gauge just how far out of focus an image is.

Some points to consider about manual focus are these:

- **Speed.** Manual focus takes more time, compared to the speedy operation of autofocus systems. If you're shooting contemplative works of art, portraits in which your subjects will generally stay put for a period of time, or close-up pictures, the speed of manual focus may be no consideration at all. For action photography, however, you may not be able to change focus quickly enough to keep up.

- **Your bad memory.** The eye (the brain actually) doesn't remember focus very well. That's why you must jiggle the focus ring back and forth a few times using smaller and smaller movements until you're certain the image is sharply focused. You never really know if optimal focus is achieved until the lens starts to de-focus. So, manual focus may actually be a trial-and-error experience.

- **Difficulty.** Focusing is most easily done when the image is bright and clear, the depth-of-field of the image being viewed is shallow, and there is sufficient contrast in the image to make out details that can be brought in and out of focus. Unfortunately, you'll frequently encounter scenes that are dim and murky, with little contrast, and be using a slow lens that compounds the problem.

- **Accuracy.** Only you—not the camera—know precisely which subject in the frame you want to be in sharpest focus. So, tweaking focus manually is the best way to ensure that the exact portion of the image you want to be sharp and clear *is* sharp and clear. If you're using selective focus creatively, manual focus is the only way to go.

Figure 5.1

With an automatic rangefinder feature, a display appears indicating: correct focus (upper left); focus is grossly incorrect (upper right); focus slightly in front of the subject (center left); focus slightly behind the subject (center right); focus significantly in front of the subject (bottom left); focus significantly behind the subject (bottom right).

■ **Following action.** Today's autofocus systems are sophisticated enough that they can use *predictive focus* to track moving subjects and keep them in focus as they traverse the frame. Even so, it may be easier to manually focus on a point where you know the action is going to be, and trip the shutter at the exact right moment. The human brain still has some applications.

THE GLASS CEILING

Manual focus is especially helpful if you're shooting through glass. Some autofocus mechanisms focus on the glass pane instead of the subject behind it. That's not a problem if you focus manually.

Autofocus

When your camera is set in autofocus mode, it will use one of several different methods to collect focus information and then evaluate it to adjust the correct focus for your image. These generally work by examining the image as the lens elements are moved back and forth to change focus. The image will be in sharp focus when the camera "lines up" matching portions of the image as seen through the optical viewfinder (called *phase detection* and explained later in this chapter); or when the image has its highest contrast (when using live view in *contrast detection* mode, also explained later). (Some dSLRs have the ability to flip out of live view for a short period of time, autofocus using phase detection, and then return to live view mode.) An autofocus system may rely on the ambient illumination on the subject, or use a special autofocus assist light source built into the camera to improve the lighting under dim conditions.

Autofocus Considerations

No matter how autofocus is accomplished, there are a host of things to keep in mind when using this feature. I outlined a few of them in the section on manual focus. Here are some more points to ponder:

■ **Autofocus speed.** The speed at which your autofocus mechanism operates can be critical. With many digital SLR systems, the autofocus motor is built into the lens itself, which makes focusing dependent on the type of miniature motor used. Canon, for example, uses several different types of motors, including relatively slow AFD (arc-form drive) and MM (micromotor) types, as well as several types of superior USM (ultrasonic motor) mechanisms. Although newer Nikon lenses (designated AF-S) have a motor built into the lens itself, Nikon's older AF lenses use a slower-acting motor in the camera body, rather than in the lens. You may want to check the specifications of any lens you buy to see if it has a fast USM motor (for Canon lenses) or AF-S motor (for Nikon optics). Other camera vendors don't have as much variation in the types of autofocus their lenses use, so that won't be a consideration.

- **Autofocus technology.** Different digital SLRs use different autofocus systems, even among systems offered by the same vendor. These differences can involve the type and number of sensors used to calculate focus. Sensors can consist of lines of pixels that are evaluated, or cross-hatched sections (called *cross-type* focus sensors, described later in this chapter) that cover more area. Focus systems might have as few as 3 or as many as 61 different sensor areas, concentrated in different parts of the view screen area. Different sensors may be used in bright light than in dim light. Plus, you may be able to specify which sensor within the frame is used to calculate focus, using your camera's cursor keys or other controls.

- **Autofocus evaluation.** How and when your camera applies the autofocus information it calculates can affect how well your camera responds to changing focusing situations. As with exposure metering systems, your camera may use the focus data from the various sensors differently, depending on other factors and settings. For example, the camera may be set to focus priority on the *nearest* subject to the camera, or may use a pattern of focus sensors to choose the correct point. More sophisticated cameras offer more autofocus evaluation options, but also make it more complicated for you to choose which settings to use in a given situation.

Autofocus Modes

To save battery power, your dSLR doesn't start to focus the lens until you partially depress the shutter release. But, autofocus isn't some mindless beast out there snapping your pictures in and out of focus with no feedback from you after you press that button. There are several settings you can make that return at least a modicum of control to you. The three basic parameters to be concerned about are as follows:

- **When does the camera lock in focus?** That is, does the camera focus once and then ignore any additional movement in the frame? Or does the camera continually re-focus if your subject moves? Each approach has advantages and disadvantages, listed in the next section.

- **What portions of the frame are used to determine focus?** Does the camera focus on the subject in the center of the frame, or does it choose another portion of the image to evaluate? Can you change from one focus zone to another? I'll explain that in the following sections.

- **What takes priority?** Under certain autofocus conditions, your camera may refuse to take a picture until sharp focus has been achieved. This is called *focus priority,* and is often a good idea for everyday shooting, because it eliminates taking an out-of-focus picture. Focus priority can also be extremely frustrating if an important moment (say, a game-winning touchdown) is unfolding in front of you and your camera is still seeking focus at the exact moment you want to take a picture. In such situations, an option called *release priority* may be preferable. You can take a picture a fraction of a second before perfect focus is achieved, at a point when focus may well be good enough, at the exact moment you prefer, rather than when the camera decides it's ready. Some dSLRs allow you to specify focus priority or release priority for particular autofocus modes. If yours doesn't allow setting this parameter, it's a good idea to learn which priority it uses, anyway, to avoid unexpected disappointment.

When to Focus

The *when to focus* question is answered by your choice of *autofocus mode*. The three main modes are as follows:

- **Single autofocus (AF-S).** This mode is also called Single Focus, Single Servo, or One-Shot AF, depending on the vendor. In this mode, once you begin to press the shutter release, focus is set once, and remains at that setting until the button is depressed, taking the picture, or you release the shutter button without taking a shot. For non-action photography, this setting is usually your best choice, as it minimizes out-of-focus pictures (at the expense of spontaneity). The drawback here is that you might not be able to take a picture at all while the camera is seeking focus; you're locked out until the autofocus mechanism is happy with the current setting.

- **Continuous autofocus (AF-C).** This mode is also called Continuous AF or AI Servo by some vendors. Once the shutter release is partially depressed, the camera sets the focus, but continues to monitor the subject, so that if it moves or you move, the lens will be refocused to suit. This setting may be your best bet for fast-moving subjects and sports. The chief drawbacks of this system are that it's possible to take an out-of-focus picture if your subject is moving faster than the focus mechanism can follow, it uses more power, and makes a distracting noise.

 One important consideration in using continuous autofocus is the system's *lock on* timing. That is, how quickly does the focus change when a moving subject is detected. You might assume that a quick reaction time is preferable, but that's not always so. What if you're on the sidelines at a football game and focusing on a receiver who is ready to catch a pass. Another player or a referee runs in front of the camera momentarily. In that case, you'd want the camera to ignore the interloper for a brief period, and not change focus. The very best dSLRs allow you to set the lock on timing so that the system quickly refocuses on the new movement (if that's what you want) or ignores the movement for a short period so you can shoot your original subject.

- **Automatic autofocus (AF-A).** This mode is also called AI Focus AF, and is found on an increasing number of cameras. It offers the best compromise between the two previous modes. The camera alternates between AF-C and AF-S modes, depending on whether the subject remains stationary or it begins moving.

Where to Focus

Your camera will choose a focus zone to evaluate in one of two ways: by selecting a zone automatically and dynamically, or by using a particular focus area that you specify. All digital SLRs will give you these two options. Most common is a switch or menu setting that sets either automatic zone selection or manual zone selection. In manual selection mode, you will be able to change from among the available focus points using a dial, cursor keys, or other control. Some entry-level cameras have as few as three focus zones in a horizontal row roughly in the center of the screen. Intermediate cameras usually have 7 to 11 different focus zones, while pro cameras can have 45 to 61 different focus zones. When using a camera with a large number of focus zones, you may be able to specify how many of the zones are active at any time (say, 21 or 11 zones instead of the full 51).

That's because more focus areas is not always better. You (or the camera's automatic zone system) can waste a lot of time shifting from one zone to another. Indeed, when shooting action and sports with relatively large subjects darting around the frame, I switch to automatic focus zone selection using just 11 focus zones, to reduce the amount of time my camera spends switching around among available focus areas.

There are other settings you can use to adjust how your dSLR focuses. Not all of these are available on every camera, but the most common parameters include:

- **Dynamic focus area.** Because your dSLR has more than one focus sensor checking your frame, it may shift among them as focus is calculated. With dynamic area autofocus, the camera may automatically switch from using one sensor to a different sensor if it detects subject motion.

- **User-selected focus area.** You switch from one focus area to another using the camera's cursor pad or directional keys, as shown in Figure 5.2. Autofocus systems frequently use the same general zones applied by the autoexposure system, and use a single on-screen set of indicators to show them. The focus area in use will often be indicated by a glowing red light, as you can see in the figure. (I've filled in the other autofocus zones to make them easier to see; in your viewfinder they are less obtrusive.)

- **Nearest subject.** In this mode, the autofocus system looks for the subject matter that's closest to the camera, no matter where it is located in the frame, and focuses on that.

- **Focus lock.** Your digital SLR has a focus locking button that lets you fix the focus at the current point until you take a picture. With most cameras, you can also press the shutter release halfway to lock focus.

- **Focus override.** Cameras and lenses generally have an AF/M or similar button you can use to switch between autofocus and manual. Some let you use a mode that focuses automatically, but which can be fine-tuned manually with no danger of grinding gears or gnashing teeth.

Figure 5.2
When you switch from one autofocus zone to another, the focus priority area often will be indicated with a green or red glow.

- **Macro lock/lockout.** Some cameras and lenses have a provision for locking the lens into macro position so focus can be achieved only within the narrower close-up range. Or, you might find a macro lockout feature, which keeps the autofocus mechanism from trying to focus closer than a given distance. That can come in handy when you're shooting distant subjects, because the lens won't bother seeking close focus, which can be time-consuming.

- **Autofocus assist lamp.** This is an optional feature that can improve autofocus operation in low-light situations. The light, which is most often either white or red, is rarely strong enough to be of much help beyond a few feet, tends to be annoying to your human or animal subjects, and uses enough power to drain your battery a bit.

How Focus Works

Although autofocus has been with us since the 1980s (this was when images were captured on film, not solid-state sensors), prior to that breakthrough focusing was always done manually. Even though viewfinders were bigger and brighter than they are today, special focusing screens, magnifiers, and other gadgets were often used to help the photographer achieve correct focus. Imagine what it must have been like to focus manually under demanding, fast-moving conditions such as sports photography.

I don't have to imagine it. I did it for many years. I started my career as a sports photographer, and then traveled the country as a roving photojournalist for more years than I like to admit. Indeed, I was a hold-out for manual focus right through the film era, even as AF lenses became the norm and autofocus systems in cameras were (gradually) perfected. I purchased my first autofocus lens back in 2004, at the same time I switched from non-SLR digital cameras and my film cameras to digital SLR models.

Manual focusing was problematic because our eyes and brains have poor memory for correct focus, which is why your eye doctor must shift back and forth between sets of lenses and ask "Does that look sharper—or was it sharper before?" in determining your correct prescription. Similarly, manual focusing involves jogging the focus ring back and forth as you go from almost in focus, to sharp focus, to almost focused again. The little clockwise and counterclockwise arcs decrease in size until you've zeroed in on the point of correct focus. What you're looking for is the image with the most contrast between the edges of elements in the image.

The camera also looks for these contrast differences among pixels to determine relative sharpness. There are two ways that sharp focus is determined, phase detection and contrast detection.

Phase Detection

Digital SLRs use an optical viewfinder and mirror system to preview an image (that is, when not in live view mode). In that mode, the camera calculates focus using what is called a *passive phase detection* system. It's passive in the sense that the ambient illumination in a scene (or that

illumination augmented with a focus-assist beam) is used to determine correct focus. (An *active* phase detection system might use a laser, sonar, or other special signal, as a few cameras did back in the prehistoric era.)

Parts of the image from two opposite sides of the lens are directed down to the floor of the camera's mirror box, where an autofocus sensor array resides; the rest of the illumination from the lens bounces upward toward the optical viewfinder system and the autoexposure sensors. With Sony's SLT lineup of cameras, the lightpath is somewhat different. Some 30 percent of the illumination is reflected upward to the autofocus sensors, and the remaining 70 percent continues through the mirror to the sensor, where the exposure is calculated.

With either dSLR or SLT models, a portion of the illumination is reflected downward or upward (respectively) to the autofocus sensor array, which includes separate autofocus "detectors." A single detector for a single focus "zone" is shown in Figure 5.3. (Keep in mind that your camera may have 3 to 61 of these detectors, one for each focus zone.)

A condenser lens directs the image from that focus zone's region through a set of two apertures where a pair of reconverging lenses focus the images onto a matching set of light-receiving sections in the focus sensor. As the lens is focused, the pair of images gradually converges, as you can see in Figure 5.4, until they merge when the subject (in this case, Chief Pontiac) is in sharp focus. When the image is out of focus—or out of phase—the two images, each representing a slightly different view from opposite sides of the lens, don't line up. Sharp focus is achieved when the images are "in phase," and aligned.

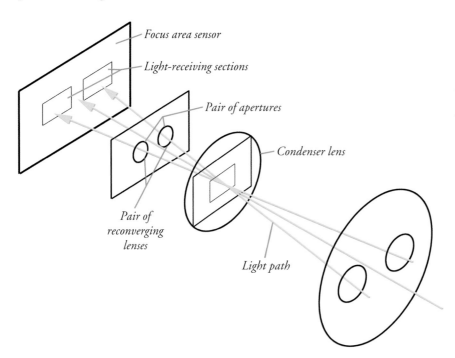

Figure 5.3

Part of the light is bounced downward to the autofocus sensor array, and split into two images, which are compared and aligned to create a sharply focused image.

As with any rangefinder-like function, accuracy is better when the "base length" between the two images is larger, so the two split images have greater separation. (Think back to your high school trigonometry; you could calculate a distance more accurately when the separation between the two points where the angles were measured was greater.) For that reason, phase detection autofocus is more accurate with larger (wider) lens openings than with smaller lens openings, and may not work at all when the f/stop is smaller than f/5.6. Obviously, the "opposite" edges of the lens opening are farther apart with a lens having an f/2.8 maximum aperture than with one that has a smaller, f/5.6 maximum f/stop, and the base line is much longer. The camera is able to perform these comparisons and then move the lens elements directly to the point of correct focus very quickly, in milliseconds.

Figure 5.4 shows what happens with a horizontally oriented focus sensor. In an actual dSLR, some sensors may be horizontal, some may be vertically oriented, and some (or all) may be of the "cross" type. You can understand why focus sensor orientation is important if you visualize a particular subject not as a Native American chief, but as a series of vertical lines, as shown in Figure 5.5. With a horizontal sensor, it's easy to match up the vertical lines so they are in phase, as seen in the figure.

However, if, in an absolutely worst-case scenario, a subject happened to consist entirely of horizontal lines, you can see that a horizontally oriented sensor would find it almost impossible to detect when the two images are in phase, as you can see in Figure 5.6. Of course, in the real world, even a subject with predominant horizontal lines would have some vertical information that could be used to achieve focus.

Figure 5.4
In phase detection, parts of an image are split in two and compared. When the image is in focus, the two halves of the image align, or are in phase, as with a rangefinder.

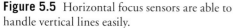

Figure 5.5 Horizontal focus sensors are able to handle vertical lines easily.

Figure 5.6 Horizontal focus sensors are confused by horizontal lines.

A partial solution is to include some vertically oriented focus sensors, which have the opposite characteristics: they are able to handle subjects with horizontal lines with aplomb, and stumble over vertical lines.

Cross-Type Focus Points

So far, we've only looked at focus sensors that calculate focus in a single direction. But what does such a sensor do when it encounters a subject that isn't conveniently aligned at right-angles to the sensor array? In the past, the "solution" was to include a sprinkling of vertically oriented AF sensors in with the horizontally oriented sensors. The vertical sensors could detect differences in horizontal lines, while the horizontal sensors took care of the vertical lines. Both types were equally adept at handling *diagonal* lines, which crossed each type at a 45-degree angle. Today, however, most digital SLRs use at least one "multi-function" sensor (often in the center of the array) that has a cross-type arrangement.

The value of a cross-type focus sensor in phase detection is that such sensors can line up edges and interpret image contrast in both horizontal and vertical directions. The horizontal lines are still more difficult to interpret with the horizontal arm of the cross, but they stand out in sharp contrast in the vertical arms, and allow the camera to align the edges and snap the image into focus easily. In lower light levels, with subjects that were moving, or with subjects that have no pattern and less contrast to begin with, the cross-type sensor not only works faster but can focus subjects that a horizontal- or vertical-only sensor can't handle at all.

Contrast Detection

Contrast detection is a slower mode and used by digital cameras in live view modes, because, to allow live viewing of the sensor image, the camera's mirror has to be flipped up out of the way so that the illumination from the lens can continue through the open shutter to the sensor. Your view through the viewfinder is obstructed, of course, and there is no partially silvered mirror to reflect some light down to the autofocus sensors. So, an alternate means of autofocus must be used, and

that method is *contrast detection*. Some cameras do have a mode—usually called quick mode or hand-held mode—that temporarily flips the mirror back down to allow phase detection autofocus, but unless you use that mode, focus must be achieved either manually (with the color LCD live view as a focusing screen), or by contrast detection.

Contrast detection is a bit easier to understand and is illustrated by Figure 5.7. When the image is brought into focus (top), the transitions are sharp and clear. At the bottom of the image, the transitions between pixels are soft and blurred. Although this example is a bit exaggerated so you can see the results on the printed page, it's easy to understand that when maximum contrast in a subject is achieved, it can be deemed to be in sharp focus.

Contrast detection is used in live view mode, and may be the only focus mode possible with point-and-shoot cameras that don't offer a through-the-lens optical viewfinder as found in a digital SLR. Contrast detection works best with static subjects, because it is inherently slower and not well-suited for tracking moving objects. Contrast detection works less well than phase detection in dim light, because its accuracy is determined not by the length of the baseline of a rangefinder focus system, but by its ability to detect variations in brightness and contrast. You'll find that contrast detection works better with faster lenses, too, not as with phase detection (which gains accuracy because the diameter of the lens is simply wider), but because larger lens openings admit more light that can be used by the sensor to measure contrast.

We'll look at contrast detection again when we explore live view modes.

Figure 5.7 Focus in contrast detection mode evaluates the increase in contrast in the edges of subjects, producing a sharp, contrasty image (top) from a soft, blurry, low-contrast image (bottom).

Other Focus Options

Some cameras have additional focusing options. Here's a quick summary:

- **Avoiding endless focus hunting.** If you frequently photograph subjects that don't have a lot of detail (which complicates focus) or use very long telephoto lenses (which may be difficult to autofocus because of their shallow depth-of-field and smaller maximum apertures), you may find the camera constantly seeking focus unsuccessfully. Some cameras have a function that tells the camera what to do when it is having difficulty focusing. You can order the camera to keep trying (if that's what you really want), or instruct the camera to give up when the autofocus system becomes "lost," giving you the opportunity to go ahead and focus manually.

- **Show/hide AF points in the viewfinder.** If the camera is selecting the focus zones, you may find the constant display of the selected zone distracting. Some cameras allow you to specify whether the AF points, the grid, and other elements are illuminated in the viewfinder with red highlighting under low light levels. Some people find the glowing red elements distracting and like to disable the function. You can select Auto (highlighting is used in low light levels), Enable (highlighting is used at all times), or Disable (red highlighting is never used).

- **Activate/deactivate the autofocus assist lamp.** The autofocus assist lamp may be useless in some cases (when your subject is more than about six feet from the camera) or distracting in others (say, at a concert or religious ceremony). Your camera probably has a feature that determines when the AF assist lamp or bursts from an electronic flash are used to emit a pulse of light that helps provide enough contrast for the camera to focus on a subject. You can select Enable to use an attached electronic flash to produce a focus assist beam. Use Disable to turn this feature off if you find it distracting. (Keep in mind that some cameras use the same lamp or a flash burst for red-eye reduction.)

- **Manual focus peaking.** Focus peaking is an additional manual focusing feature available with some cameras (chiefly Sony models) when focusing in live view mode. When you activate this feature, the edges of objects in your scene are highlighted in your choice of a color, with the hue at its most vivid when that area of the subject is in sharp focus. Don't worry—the color edges do not show up in your final image; they are strictly a focusing aid.

Face Detection and Focus Tracking

Some dSLRs are able to find faces in your scene and lock focus in on them. They also may allow you to select a subject, press a button, and then have the camera continue tracking that subject as it moves around the screen. Generally, this capability is most often available when using live view mode (and, of course, Sony's SLT cameras are in live view all the time), but some high-end cameras use high-resolution exposure arrays within the optical viewfinding system to provide similar features when not in live view.

Figure 5.8
With manual focus peaking, the edges of objects are accentuated with color, which becomes most vivid when that area is in sharp focus.

Face Detection

In this mode, the camera will try to identify any human faces in the scene. If it does, it will surround each one (from 8 to 35, depending on the camera model) with a white frame. If it judges that autofocus is possible for one or more faces, it will create the frames around those faces. When you press the shutter button halfway down to autofocus, the frames will turn green or yellow once they are in focus. The camera will also attempt to adjust exposure (including flash, if activated) as appropriate for the scene.

These cameras may allow you to register certain faces so they will be more quickly recognized the next time the camera encounters them, and you may be able to assign a priority to them. That is, if your spouse or child's face is found, the camera will give preference to that face over, say, your brother-in-law. (See Figure 5.9.)

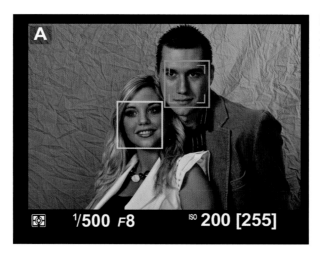

Figure 5.9
Face detection in
live view mode.

Tracking Focus

Another AF magic trick is called *tracking focus.* You can choose a moving subject to lock focus on, and as it moves around the frame, the camera will attempt to retain focus on that subject. Changes in lighting, lack of contrast with the background, extra-small or extra-large subjects, and anything moving very rapidly can confuse tracking focus, but it generally does a good job. In either face detection or tracking focus modes, your camera may be able to "remember" the subject selected, so if the subject disappears from the frame and then returns, the camera locks in on that object again. (See Figure 5.10.)

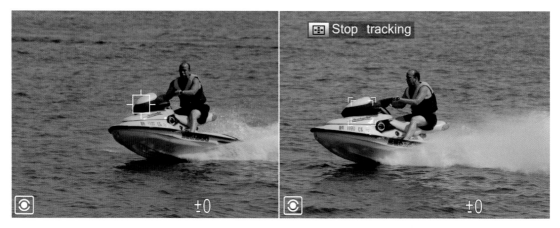

Figure 5.10 Focus tracking.

Phase Detection Comes to Live View

Several manufacturers have been experimenting with providing faster phase detection in live view mode, which is particularly useful for movie shooting, in which conventional phase detection is impossible. Canon currently has the most sophisticated technology, which it dubs Dual Pixel CMOS AF system. Used in live view mode while shooting stills and movies, it works much more quickly than the camera's more traditional contrast detection system in those two modes.

An array of special pixels, which cover 80 percent of the frame horizontally and vertically, provide the same type of split-image rangefinder phase detection AF that is available when using the optical viewfinder. The most important aspect of the system is that it doesn't rob the camera of any imaging resolution. It would have been possible to place AF sensors *between* the pixels used to capture the image, but that would leave the sensor with less area with which to capture light. Keep in mind that CMOS sensors, unlike earlier CCD sensors, have more on-board circuitry which already consumes some of the light-gathering area. Microlenses are placed above each photosensitive site to focus incoming illumination on the sensor and to correct for the oblique angles from which some photons may approach the imager. (Older lenses, designed for film, are the worst offenders in terms of emitting light at severely oblique angles; newer "digital" lenses do a better job of directing photons onto the sensor plane with a less "slanted" approach.)

With the Dual Pixel CMOS AF system, the same photosites capture both image and autofocus information. Each pixel is divided into two photodiodes, facing left and right when the camera is held in horizontal orientation (or above and below each other in vertical orientation; either works fine for autofocus purposes). Each pair functions as a separate AF sensor, allowing a special integrated circuit to process the raw autofocus information before sending it on to the Canon camera's digital image processor, which handles both AF and image capture. For the latter, the information grabbed by *both* photodiodes is combined, so that the full photosensitive area of the sensor pixel is used to capture the image.

While traditional contrast detection frequently involves frustrating "hunting" as the camera continually readjusts the focus plane trying to find the position of maximum contrast, adding Dual Pixel CMOS AF phase detection allows the Canon camera to focus smoothly, which is important for speed, and essential when shooting movies (where all that hunting is unfortunately captured for posterity). Movie Servo AF tracking is improved, allowing shooting movies of subjects in motion. The system works with (at this writing) 103 different lenses, both current and previously available optics, and works especially well with lenses that have speedy USM or STM motors.

Fine-Tuning the Focus of Your Lenses

Several mid-level and pro cameras have a feature called Autofocus Fine Tuning or AF Microadjustment, which I hope you never need to use, because it is applied only when you find that a particular lens is not focusing properly. If the lens happens to focus a bit ahead or a bit behind the

actual point of sharp focus, and it does that consistently, you can use the adjustment feature that can "calibrate" the lens's focus.

Why is the focus "off" for some lenses in the first place? There are lots of factors, including the age of the lens (an older lens may focus slightly differently), temperature effects on certain types of glass, humidity, and tolerances built into a lens's design that all add up to a slight misadjustment, even though the components themselves are, strictly speaking, within specs. A very slight variation in your lens's mount can cause focus to vary slightly. With any luck (if you can call it that), a lens that doesn't focus exactly right will at least be consistent. If a lens always focuses a bit behind the subject, the symptom is *back focus*. If it focuses in front of the subject, it's called *front focus*.

You're almost always better off sending such a lens in to the vendor to have them make it right. But that's not always possible. Perhaps you need your lens recalibrated right now, or you purchased a used lens that is long out of warranty. If you want to do it yourself, the first thing to do is determine whether your lens has a back focus or front focus problem.

For a quick-and-dirty diagnosis (*not* a calibration; you'll use a different target for that), lay down a piece of graph paper on a flat surface, and place an object on the line at the middle, which will represent the point of focus (we hope). Then, shoot the target at an angle using your lens's widest aperture and the autofocus mode you want to test. Mount the camera on a tripod so you can get accurate, repeatable results.

If your camera/lens combination doesn't suffer from front or back focus, the point of sharpest focus will be the center line of the chart. If you do have a problem, one of the other lines will be sharply focused instead. Should you discover that your lens consistently front or back focuses, it needs to be recalibrated. Unfortunately, it's only possible to calibrate a lens for a single focusing distance. So, if you use a particular lens (such as a macro lens) for close focusing, calibrate for that. If you use a lens primarily for middle distances, calibrate for that. Close-to-middle distances are most likely to cause focus problems, anyway, because as you get closer to infinity, small changes in focus are less likely to have an effect.

Focus calibration is done differently for each different type and brand of camera, so it's not possible to outline the methods in this book. I provide more specific directions in my comprehensive guides to particular cameras that have that feature. If you want to attempt calibration on your own, you can obtain a focus test chart (you can download your own copy of my chart from www.dslrguides.com/FocusChart.pdf). (The URL is case sensitive.) Then print out a copy on the largest paper your printer can handle. (I don't recommend just displaying the file on your monitor and focusing on that; it's unlikely you'll have the monitor screen lined up perfectly perpendicular to the camera sensor.) Then, place your camera on a tripod, level it, and take several photographs at slightly different focus distances. Then follow the directions for your camera to fine-tune your camera for that lens.

6

Working with Lenses

Camera bodies come and go; lenses are forever.

Well, to a certain extent. Most digital photographers upgrade to new camera bodies every four to five years (or so) to take advantage of improvements like more resolution and built-in HDR or Wi-Fi. That was not the case in the film era, when incremental improvements were rather small and a particular camera body could easily compete with vendors' most recent offerings for eight or ten years, or much longer. Indeed, even classic cameras like certain Leica or Nikon 35mm models were much more than collectibles: photographers frequently prized particular models for daily shooting for decades.

It is also true that in any photographic era, past or present, lenses have always tended to outlive the camera bodies for which they were originally purchased. In today's digital age, you may change cameras from time to time, but it's likely—if you purchased wisely when you acquired your current set of lenses—that you migrated many of the optics from your last camera to your latest model. Unless you switch vendors (from Nikon to Sony or Canon), or change form factors (from APS-C to full frame) or seriously need to upgrade a particular focal length to increase versatility/sharpness/maximum f/stop, a particular lens can be usable for a long, long time.

For example, any Nikon lens built after 1977 can be mounted on any Nikon single lens reflex camera—film or digital—ever built. Earlier lenses dating back as far as 1959 may require a simple modification (costing about $35) to be usable on some models. But not all Nikon autofocus lenses will autofocus on all camera models (and I'll explain why later in this chapter).

Similarly, virtually any Canon lens designed for full-frame cameras produced since 1987 can be used in full autofocus/autoexposure mode on any Canon digital camera, and the company's lenses designed for its APS-C models (which aren't compatible with earlier or current full-frame cameras) operate with aplomb on any Canon APS-C camera since the introduction of the original Digital Rebel in 2003. (I'll explain what APS-C is, too, later in this chapter.) Sony digital SLR and SLT

models can use all A-mount lenses dating back to before there were Sony interchangeable lens cameras; the current A-mount was originally introduced for the Minolta Maxxum 7000 film SLR in 1985.

This rich heritage of legacy lenses for all three camera types is a treasure trove for those who want to add to their lens collection at reasonable cost. I've purchased dozens of lenses for my Nikon, Canon, and Sony cameras from KEH (www.keh.com), which has a seemingly unending supply of mint lenses that are like new despite being older than some of the readers of this book.

Welcome to Lens Lust

Despite the vast array of lenses to choose from, believe it or not, there are large numbers of casual photographers who purchase a digital SLR with versatile kit optics and then never, ever buy another lens. I won't say anything bad about these snapshooters, who are obviously deliriously happy with the camera they bought. But, my guess is that most of the readers of this book suffer from a singular disease: Lens Lust, defined as the urge to add just one more interchangeable lens to your repertoire in order to make it possible to shoot wider, longer, closer, sharper, or in less available illumination.

I didn't make that term up. You'll find references to Lens Lust all over the Internet, in user groups, and any gathering that includes two or more photographers. Lens Lust isn't a new phenomenon, nor is it limited to digital SLRs; it infects anyone who owns a camera with removable lenses, including those of the film SLR and rangefinder persuasions.

I've fallen victim to it myself. I worked for two years as the manager of a camera store, and a hefty chunk of what I earned was diverted to my favorite vendor's dealer personal purchase program, as well as to acquiring good used equipment brought to me for trade-in. I ended up with 16 different lenses, including *two* fisheye lenses, a perspective-control lens, and other specialized optics. Of course, all but one of those lenses were fixed focal length (prime) lenses, so I wound up "upgrading" when I began accumulating zoom lenses.

If the symptoms are familiar, you should read this chapter. It will tell you more than you need to know about lenses, but, then, you're probably going to acquire more lenses than you need anyway. There's a little bit more detail on how lenses work (which will help you in selecting your next optics) and some advice for choosing the right lens for the job.

I can't promise a remedy for Lens Lust. I can promise you that I will *not* refer to lenses in this book as "glass," as in "I'm really loaded up on Nikon glass" or "I find Sigma glass to be better than Tamron glass." Using that term as a generic substitute for "lens" is probably confusing and potentially inaccurate. Lens elements aren't necessarily glass, in any case, as very good lens elements can be made using other materials, including quartz and plastic (although the manufacturers will probably call it "optical resin" instead of plastic), and at least one vendor has introduced a point-and-shoot camera with a transparent ceramic lens. If I happen to mention "glass" in this book, I'll be

referring to amorphous silica, not a lens. If I need a synonym to keep from using the word *lens* three times in one sentence, I'll substitute *optics*.

Lenses and dSLRs

As recently as ten years ago, there were many photographers making the transition from film-based SLR cameras to digital SLRs, and these migratory shooters often wanted to bring the lenses they used to shoot film with them to the digital realm. Today, virtually everyone who has planned to make the transition has already done so, and most today have either converted from film to digital or started out using digital cameras in the first place and never used a film SLR. That greatly simplifies the question of lens selection.

Or does it? Even in an all (or mostly) digital world, there still exists a dichotomy between *full-frame* digital cameras (the "successors" of the film camera in terms of their 24mm × 36mm image capture size) and *cropped sensor* cameras, which use a sensor that is smaller than 24mm × 36mm (most commonly *APS-C* models with sensors that measure about 16mm × 24mm). The complication exists because lenses specifically designed for cropped sensors probably aren't able to cover the full traditional frame—at least, with zoom lenses, at all focal lengths. I'll explain why that is true shortly.

Many newly introduced lenses are being designed for digital cameras only, especially among vendors that don't offer a full-frame camera, such as Olympus (which now offers only a single Four Thirds format dSLR, plus their Micro Four Thirds non-SLR models). Other vendors, particularly Canon, Nikon, and Sony (who all offer full-frame cameras) produce lenses for both full-frame and cropped sensor models. All full-frame lenses from a vendor will work just fine on a cropped sensor camera, but not vice versa.

For example, as I hinted earlier, Canon offers its EF series of lenses, designed for full frame, and which can be used on any Canon SLR. It also markets its EF-S optics, which must be used only on Canon's 1.6X APS-C crop models, which all have sensors smaller than the "full-frame" 24mm × 36mm format, as I mentioned in Chapter 1.

Nikon's digital-only lenses are marked with the DX designation; the other lenses currently in its product line are considered "FX" lenses (although not specifically marked as such), and can be used on any Nikon SLR, although newer lenses with a G in the product name lack an aperture ring and can be used only on film and digital cameras that can set the f/stop electronically (that is, all those produced in the last 25 years). Sony marks its cropped-only A-mount lenses with a DT (Digital Technology) designation. All its other lenses, including those the company inherited from Konica Minolta, and those produced for the company by Carl Zeiss, can be used with full-frame or cropped cameras. Sony full-frame cameras can use lenses designed for APS-C models; however, their full-frame dSLRs and SLT models automatically detect such lenses and crop the image area to conform (more on that later). Note that Sony also sells E-Mount APS-C and full-frame lenses for its mirrorless camera models, including the original NEX cameras, more recent Alpha A*xxxx* models, and full-frame mirrorless models like the Alpha A7/A7r.

Third-party vendors use their own nomenclature to differentiate between full-frame capable and cropped sensor dSLR lenses. Table 6.1 will help clear up the confusion.

Examples of both types of lenses are shown in Figure 6.1. In the future, you can expect these leading vendors to introduce only lenses that have been optimized for digital photography in some way.

Table 6.1 Lens coverage designations

Vendor	Full-Frame Lenses	Cropped Sensor Lenses
Nikon	FX or no designation	DX
Canon	EF	EF-S
Sony	No designation	DT
Sigma	DG	DC
Tamron	Di	Di-II
Tokina	D or FX	DX

Figure 6.1 Canon's EF-S series (left) and Nikon's DX lenses (middle) can be used only on their digital SLRs with sensors smaller than 24mm × 36mm. The Sony lens (right) can be used on any 1980s–present Sony or Minolta/Konica Minolta SLR/SLT camera.

Digital Differences

Vendors claim that some of their lenses are "optimized" for digital photography. Exactly what kind of optimization is possible for "digital only" lenses? The answer is interesting. Although lenses designed for film and digital use all operate on the same basic principles, sensors react to the light transmitted by those lenses in different ways than film does. Digital lens designs need to take those differences into account. Here are some of the key digital differences.

Some Sensors Are Smaller Than Traditional "Full" Frame

You should remember this difference from the brief discussion in Chapter 2. As I noted, many sensors are smaller than the 24mm × 36mm standard frame that digital systems inherited from the film era. When mounted on a camera with a smaller sensor, lenses of a particular focal length produce what is actually just a cropped version of the same image. No "magnification" takes place; you're just using less than the full amount of optical information captured by the lens.

The most obvious result is the infamous *lens multiplier factor*. Fortunately, this incorrect term is dying out, and it is being replaced by the more accurate and descriptive *crop factor*. The "multiplication" concept came into play because the easiest way to calculate how much a given lens was cropped in relation to the same lens on a full-frame camera is to multiply the lens's focal length by the factor, so that a 100mm lens mounted on a camera with a 1.5X crop factor "becomes" a 150mm lens in terms of field of view.

There are actually five formats that have been commonly used with digital SLR/SLT cameras: 1X, 1.3X, 1.5X, 1.6X, and 2X. Some of these are no longer in use. The 1X "crop" is, of course, the full-frame mode, found in several Nikon, Canon, and Sony cameras, and is shown as the outer rectangle in Figure 6.2. The 1.3X crop was used in Canon's 1D model line, which is no longer being produced. A 1.5X/1.6X crop, which for all practical purposes provide identical image fields of view, are used in the vast majority of dSLR/SLT designs, including cameras from Nikon, Sony, Pentax, and Canon. Vendors who produced Four Thirds–format digital SLRs, including Olympus and Panasonic, worked with sensors that provided slightly different proportions (4:3, versus the 3:2 aspect ratio used by most other digital SLRs). The Four Thirds sensor *size* (which is now used primarily in Micro Four Thirds mirrorless cameras), produces a 2X crop.

To make things even more interesting, Leica has used a 2X crop in the past, and the Nikon D2x and D2xs were 1.5X models that had an additional 2X crop mode that enabled high-speed continuous bursts. The Nikon D7100 (and presumably some other, similar cameras introduced after this book was written) have a 2X crop mode, as well, which, unfortunately, Nikon dubs a 1.3X crop because it is applied to the 1.5X cropping already used, yielding an effective 2X "multiplier." (The actual math is way beyond me.)

While this crop factor can be, seemingly, a boon to those needing longer lenses, transforming a 200mm f/4 lens into a 320mm f/4 medium-long telephoto (at a 1.6X crop), it's a hindrance in the wide-angle realm. A decently wide 28mm full-frame lens becomes the equivalent of a 45mm normal

Canon, Nikon, Sony full frame models (1X)

Canon 1D Mark IV, etc. (1.3X)

Nikon, Sony, Pentax (1.5X), Canon (1.6X)

Olympus, Panasonic, Leica, Nikon D2Xs (2X)

Figure 6.2
Cameras with sensors smaller than 24mm × 36mm provide cropped views.

lens when mounted on a camera with a 1.6X multiplier. Figure 6.2, like the similar illustration in Chapter 2, gives you a graphic representation of how the crop affects your image.

There are other ramifications. Because a smaller portion of the lens coverage area is used, the smaller sensor effectively crops out the edges and corners of the image, where aberrations and other defects traditionally hide. If you use a full-frame lens on a dSLR with a smaller sensor, you may be using the best part of the lens. This is nothing new; users of pro film cameras have a much more intimate knowledge of coverage circles. They know that, say, a 200mm telephoto lens for a 2 1/4 × 2 1/4 film SLR like a Hasselblad may actually cover a square no larger than 3 × 3 inches, whereas a 200mm lens for a view camera may have an image circle that's 11 to 20 inches in diameter.

Still, you'd probably be surprised to realize that an inexpensive 200mm lens originally developed for a 35mm film camera is a great deal sharper within its 24mm × 36mm image area than a mondo-expensive 200mm "normal" lens for a 4 × 5 view camera *cropped to the same size and image area.* Because 4 × 5 film is rarely enlarged as much as a 35mm film image—or equivalent digital camera image—lenses produced for that format don't need to be as sharp, overall. Instead, they need to be built to cover *larger areas.*

Conversely, when creating a lens that's designed to cover *only* the smaller sensor, the vendor must make the lens sharper to concentrate its resolution on the area to be covered. Olympus claims that its Four Thirds lenses have double the resolution of similar lenses it builds for its 35mm cameras of a past era. Indeed, Four Thirds lenses are so sharp that, even though Olympus is no longer promoting true digital SLRs using Four Thirds lenses, their legacy optics are extremely popular on the company's mirrorless models (with an appropriate Four Thirds to Micro Four Thirds adapter).

Of course, if the coverage area is made smaller, that can re-introduce distortion problems at the periphery of the coverage circle. This is particularly true of ultra-wide-angle lenses, which are difficult to produce in short focal lengths anyway, including the 10mm-24mm zoom I favor for one of my cropped sensor cameras.

Figures 6.3, 6.4, and 6.5 illustrate the coverage circle and cropping concepts more visually. Imagine three different 50mm lenses, each designed for a different kind of SLR camera. The fuzzy circle at left in each figure represents the coverage circle of each 50mm lens, while the green inset

Figure 6.3
A 50mm lens on a 6cm × 6cm film SLR produces a wide-angle view from its generous coverage circle.

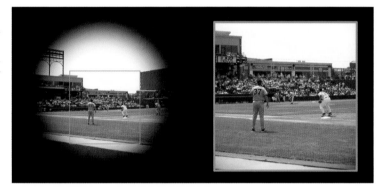

Figure 6.4
The same 50mm focal length creates a "normal" viewpoint on a full-frame SLR, and requires less of a coverage circle.

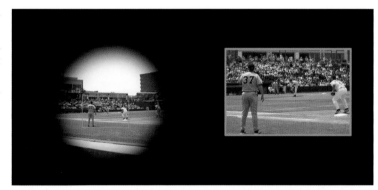

Figure 6.5
Lenses for digital SLRs with smaller sensors can be smaller and more compact, as with this 50mm lens that is the equivalent of a short telephoto.

box represents the frame area for the camera for which the lens was designed. You'll note that the magnification of each lens (at left in the figures) is identical, but the coverage area is different in each case.

For example, Figure 6.3 represents a 50mm lens used as a wide-angle optic on a 6cm × 6cm single lens reflex. The coverage area is just a little larger than necessary to cover the full frame. If it were any smaller, you can see that vignetting in the corners would result. At the right side of the illustration is the image that the camera crops out of the lens's coverage area to produce a slightly wide-angle view.

Figure 6.4 might be a full-frame SLR, with a slightly smaller coverage area to produce a "normal" view from the 50mm lens. Figure 6.5 would correspond to a 50mm lens designed for a smaller sensor, and would have a commensurately smaller coverage area. The 1.5X crop factor, compared to the full-frame image in Figure 6.4, results in a short telephoto effect, roughly the same as if a 75mm lens were used on the full-frame camera.

While lenses intended for full-frame cameras benefit from having a smaller portion of their coverage angle used when mounted on digital cameras with smaller-size sensors, lenses *specifically* designed for cropped sensors deliberately take advantage of this effect. A digital-only wide-angle lens with a 10mm focal length would need to be huge to cover the full 35mm frame, but it can be much smaller if it only has to provide an image to a smaller sensor. Figure 6.6 shows a typical 1.5X crop imager (called an APS-C sized sensor) superimposed on a full-frame sensor. The illuminated area represents the image area of a carefully designed digital-only lens. (This figure also provides another illustration of *pixel density*, first shown in Figure 2.7 in Chapter 2, as you can see that the faux pixels in Figure 6.6 are smaller and more tightly packed in the APS-C sensor.)

The image circle in the figure doesn't cover the full frame area, and badly vignettes the corners and edges. In fact, there is even a tiny amount of vignetting in the corners of the APS-C sensor with this lens (which sometimes happens with wide-angle optics), but the smaller frame is, by and large, sufficiently covered.

Figure 6.6
A lens designed for a smaller sensor probably won't fill the entire frame of a camera with a 24mm × 36mm sensor.

Zoom lenses complicate things a little, as their coverage area can vary with the focal length being used. That's why certain digital-only lenses vignette at the wide-angle position when used on a full-frame camera (or, as I mentioned, they may even vignette slightly when mounted on a camera with a sensor size for which they were designed). But, as you zoom in with that lens, the coverage circle may enlarge enough to fill the full 24mm × 36mm frame acceptably. So, some digital-only lenses work fine on full-frame cameras, but only at their longer focal lengths.

If you think you might buy a camera in the future with a full-frame sensor, you'll want to make sure the lenses you buy now are compatible.

Extreme Angles

Another difference in how digital cameras work with lenses derives from dissimilar ways film and silicon capture photons. Film's "sensors" consist of tiny light-sensitive grains embedded in several different layers. These grains respond in roughly the same way, whether the light strikes them head on or from a slight or extreme angle. The angle makes a small difference, but not enough to degrade the image.

As you learned in Chapter 2, sensors consist of little pixel-catching wells in a single layer. Light that approaches the wells from too steep an angle can strike the side of the well, missing the photosensitive portion, or stray over to adjacent photosites. This is potentially not good, and can produce light fall-off in areas of the image where the incoming angles are steepest, as well as moiré patterns with wide-angle lenses.

Fortunately, the camera vendors have taken steps to minimize these problems. The phenomenon is more acute with lenses with shorter distances between the back of the lens and the sensor, such as wide angles. Because the rear element of the lens is so close to the sensor, the light must necessarily converge as a much sharper angle. Lens designs that increase the back-focal distance (more on this later) alleviate the problem. With normal and telephoto lenses that have a much deeper back-focal distance anyway, the problem is further reduced.

Another solution, discussed earlier in this book, is to add a microlens atop each photosite to straighten out the optical path, reducing these severe angles. Figure 6.7 shows how such a microlens operates. Newer cameras employ such a system, which do a good enough job that you can use modern lenses designed for either film or digital use without much worry.

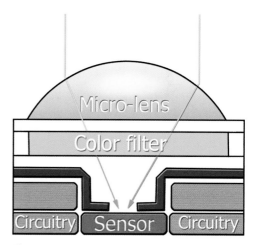

Figure 6.7 A pattern of microlenses above each photosite corrects the path of the incoming photons.

Reflections

If you've ever looked at film (your local camera club may have some samples in their archives or museum), you noticed that the "dull" emulsion side—the side that is exposed to light—has a relatively matte surface, due to the nature of the top antiabrasion coating and the underlying dyes, and a light-catching anti-halation layer at the bottom. Take a glance at your sensor, and you'll see a much shinier surface. It's entirely possible for light to reflect off the sensor, strike the back of the lens, and end up bouncing back to the sensor to produce ghost images, flare, or other distortions. While lens coatings can control this bounce-back to a certain extent, digital camera lenses are more prone to the effect than lenses used on film cameras.

Lens Designs

In the "more than you probably wanted to know" department, you can understand why designing lenses for digital SLRs can become extremely complex if you investigate how lenses are created. Although typical interchangeable lenses contain many elements in several groups, I'm going to explain some basic principles using a minimal number of pieces of glass. Bear with me: someday you can amaze all your friends with this arcane knowledge.

Figure 6.8 shows a simple lens with one positive element. This is known as a *symmetrical* lens design because both halves of the lens system are mirror images. The optical center of this lens is in the center of the single element, and the distance from the center to the focal plane (in this case, the sensor) is the same as the focal length of the lens. Assuming it's a 75mm lens, that distance, the back-focus distance, would be 75mm, or about 3 inches. All you'd need to do to use this configuration would be to design a lens that positioned the single lens element at 75mm to bring the lens into sharp focus.

Things get more complicated when you start designing a longer lens. With a 500mm optic, you'd need to design the lens so the optical center was 20 inches from the sensor. That would be quite a long lens! Indeed, so-called *mirror lenses* exist that use a series of reflecting surfaces to fold this long optical path to produce a lens that is much shorter for its particular focal length.

But there's another way, through the use of an *asymmetrical* lens design. Place a negative lens element *behind* the positive element, spreading the incoming light farther apart again, causing the photons to converge farther from the optical center than they would otherwise, as you can see in Figure 6.9. The negative element has the effect of lengthening the effective focal length and moving the optical center in front of the front element of the lens. The result: a "shorter" telephoto lens.

With wide-angle lenses, we have the reverse problem. The photons focus too close to the rear of the lens, creating a back-focus distance that's so short it doesn't allow room for the mirror. Without the mirror to worry about, it wouldn't matter if some of the elements of a wide-angle lens extended far into the camera body, very close to the focal plane itself. Indeed, that's the arrangement found in non-dSLR cameras that lack mirrors, including the digital rangefinder camera, the Leica M9, and with some lenses from the dark ages (like my 7.5mm fish-eye), which was viable on an SLR only if the mirror was locked up out of the way.

The solution here is to create an inverted telephoto lens, usually called *retro-focus*, which inserts the negative lens element ahead of the positive element, spreading the beam of light so that when the positive lens element focuses it again on the sensor, the focal point is much farther back than it would be otherwise. The optical center has been moved *behind* the center of the lens, as you can see in Figure 6.10.

You can see that an inverted telephoto design helps digital camera lens designers produce wide-angles that are physically "longer" than their focal lengths, just as the traditional telephoto configuration produced lenses that were physically "shorter" than their focal lengths. Unfortunately, these more complex lens designs lead to undesired effects in both telephoto and wide-angle lenses. A primary symptom is *chromatic aberration*, or the inability of a lens to focus all the colors of light at the same point, producing a color fringing effect. This color effect is caused by the glass's tendency to refract different colors of light in different ways, much like a prism. There are actually two types of chromatic aberration: *axial* (in which the colors don't focus in the same plane) and *transverse*, in which the colors are shifted to one side. The partial cure is the use of low diffraction index glass (given an ED code by Nikon and Sony, and UD by Canon), which minimizes the effect.

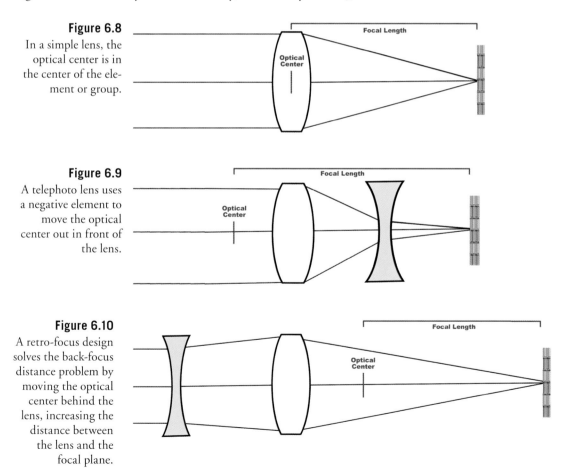

Figure 6.8
In a simple lens, the optical center is in the center of the element or group.

Figure 6.9
A telephoto lens uses a negative element to move the optical center out in front of the lens.

Figure 6.10
A retro-focus design solves the back-focus distance problem by moving the optical center behind the lens, increasing the distance between the lens and the focal plane.

Other ailments include barrel distortion, which is a tendency for straight lines to bow outward, and various spherical aberrations. Lens designers have countered with *aspherical* lens elements. As you might guess, aspherical optics are lenses with a surface that is not a cross-section of a sphere. These lenses are precisely ground or molded to the required shape, and do a good job of correcting certain kinds of distortion.

Note that none of the lens designs I've cited are exclusive to digital SLR cameras. Such lenses can be developed for any sort of camera, but some of their characteristics come in particularly handy in the dSLR realm.

If It Ain't Bokeh, Don't Fix It

Lens Lust isn't the only malady that can befall a new dSLR owner. Another illness is the search for the perfect bokeh. The term has almost become a buzzword, and it is used to describe the aesthetic qualities of the out-of-focus parts of an image, with some lenses producing "good" bokeh and others offering "bad" bokeh. *Boke* is a Japanese word for "blur," and the h was added to keep English speakers from rhyming it with *broke*.

You've probably noticed that out-of-focus points of light become disks, which are called *circles of confusion*. These fuzzy discs are produced when a point of light is outside the range of an image's depth-of-field. Often, circles of confusion appear most vividly in close-up images, particularly those with bright backgrounds, as shown at left in Figure 6.11. The circle of confusion is not a fixed size, nor is it necessarily always a perfect circle. The viewing distance and amount of enlargement of the image determine whether we see a particular spot on the image as a point or as a disc. The shape of the lens's diaphragm can determine whether the circle is round, nonagonal, or some other configuration.

Figure 6.11 Out-of-focus areas produce noticeable blobs of light with lenses that have poor bokeh characteristics (left). At right, the unfocused areas are less noticeable.

Evenly illuminated discs, or, worst of all, those with lighter edges, are undesirable. The bokeh characteristics of a lens are most important when you are using selective focus (say, when shooting a portrait) to de-emphasize the background, or when shallow depth-of-field is a given because you're working with a macro lens, long telephoto, or with a wide-open aperture. Figure 6.11, right, shows improved bokeh. There are fewer bright highlights in the image to begin with, so the circles of confusion are smaller and less numerous. The out-of-focus discs blend together to form an unobtrusive background.

Good bokeh and bad bokeh derive from the fact that some of these circles are more distracting than others. Some lenses produce a uniformly illuminated disc. Others, most notably *mirror* or *catadioptic* lenses, produce a disc that has a bright edge and a dark center, producing a "doughnut" effect, which is the worst from a bokeh standpoint, as shown in Figure 6.12. Lenses that generate a bright center that fades to a darker edge are favored because their bokeh allows the circle of confusion to blend more smoothly with the surroundings. In Figure 6.13, I've isolated three typical circles of confusion to show you what good, neutral, and bad discs look like.

Figure 6.12
Specular highlights exhibit the donut-shaped bokeh typical of the 500mm f/8 mirror lens used for this shot.

Figure 6.13
Discs that create good bokeh (left), neutral bokeh (middle), and bad bokeh (right).

Understanding Lens Requirements

You've got a little background in lenses now, and you're ready to learn exactly what you should be looking for when choosing lenses for your digital SLR. After all, the lenses you own affect the quality of your images as well as the kinds of pictures you can take. The most important factors in choosing a lens are the quality of the lens, the resolution of the images it produces, the amount of light it can transmit (that is, its maximum lens opening), its focusing range (how close you can be to your subject), and the amount of magnification (or zooming, in a zoom lens) that it provides. Here are some of the things you should consider.

Image Quality

If you're graduating from a digital point-and-shoot camera, one of the first things you notice is how concerned your colleagues are over lens sharpness. Most point-and-shooters don't worry about it that much because there is little they can do about it, anyway, other than purchasing another camera. The lens on a non-interchangeable lens camera is what it is; it may be sharp or it may be less sharp, and that's it. The situation is similar to the horsepower question in an econobox automobile. You didn't purchase the vehicle for its horsepower. You'd be more interested in engine power if you had a sports car that, perhaps, could be souped up a little with some aftermarket components.

Lenses are the dSLR's primary aftermarket component. If you frequent the dSLR newsgroups and forums, you'll notice the attention paid to how sharp a particular lens is. Visit any such venue and you'll find multiple postings inquiring about the resolution of this lens or that lens, and whether it has good or bad bokeh. A good rule of thumb is that most general-purpose lenses produce good enough image quality for general-purpose shooting. When you start to get into specialized areas— ultra-wide lenses, extra long telephotos, super-fast optics with large f/stops—the compromises necessary to produce those expensive toys sometimes involve compromises in image quality. If you're contemplating one of these lenses, it's a good idea to read the magazines and websites that have formalized, standard testing, and check around among your friends, colleagues, and others who can provide you with tips and advice.

The traditional ploy of shooting a brick wall or a newspaper pinned up on a bulletin board probably won't work reliably. There are too many variables, even if you use a tripod to steady the camera. For example, you may or may not set up your camera properly with the sensor plane parallel to the plane of your target. It's unlikely you'll be able to tell the difference in sharpness among several pictures at different f/stops. Can you focus repeatedly on the same spot? Do you know a sharp picture when you see one? If so, where is it sharp—in the center, at the edges, corners? Can you differentiate between different types of lens defects, including several varieties of chromatic aberration? You're almost better off just going with the reputation that a particular lens has established, based on reviews and comments in user groups, rather than trying to do your own tests for image quality.

Variability

One thing to keep in mind is lens variability from sample to sample within a particular lens model. When you peruse For Sale listings of lenses, you'll frequently see the note that this is "a good copy." That generally means that the previous owner has found the lens to be more than satisfactorily sharp, and may imply that other samples of this lens have been found lacking by others. Variability becomes a concern because not all examples of a particular lens model are created equal, both in terms of sharpness as well as *build quality*, which I discuss later.

One on-going debate you'll discover as you attempt to cure your Lens Lust is whether this vendor or that makes the "best" lenses. It's easiest to stick with the lenses produced by the maker of your camera, as Nikon, Canon, and Sony all have rigorous standards that each and every lens they offer for sale must meet. You'll find that the optical and mechanical variability of camera maker lenses is very slight. However, even among the Big Three you'll find slight variations in quality from sample to sample. Moreover, not every lens a camera manufacturer produces is the absolute best in its focal length range for a particular camera.

You'll discover this phenomenon most often among "do-everything" lenses. Nikon makes an affordable, versatile 18-300mm f/3.5-5.6 zoom that I owned for a time. It is indeed versatile, but tends to be very soft (in all samples I've seen) at the long end of its range. When I purchase a lens with a 300mm maximum zoom (rather than, say, an 18-200mm lens), I expect it to perform well at 300mm. So, I sold my copy. I was probably unrealistic in expecting a do-everything lens to, in fact, do everything.

I've found that variability between samples most often comes into play with third-party lenses, such as those from Sigma, Tamron, Tokina, and Vivitar (although Sigma has considerably upped its game in recent years). You're most often likely to find "good copy" notations for lenses from these vendors. I've run into this myself: my old Sigma 170-500mm f/5-6.3 APO was not highly regarded by the photographic community, especially when stacked up against its 50-500mm f/4-6.3 "Bigma" stablemate, or the later Sigma 150-500mm f/5-6.3 lens (with optical image stabilization; more on that later). Yet, my own 170-500mm lens was wicked sharp, and I've never hesitated to use it for anything.

My advice is to take pictures with any lens you plan to purchase, or ask for return privileges (widely available from online retailers), and then keep only the lenses you are well satisfied with.

Construction/Build Quality

A related consideration when choosing a lens is the quality of its construction, also called *build*. See if the key lens components are made of metal or plastic. Believe it or not, an increasing number of lower-cost lenses have mounts that are made of non-metallic components. They're less sturdy, and more likely to wear if you attach and detach them from your camera often, but they'll perform perfectly well under moderate use by the average non-professional photographer.

Also check for play in the focusing and zooming mechanisms. You don't want any looseness, stickiness, odd noises, or other qualities that signify cheap or poor construction. Your investment in lenses will probably exceed your cost for your digital camera body after a few months, so you want your lenses to hold up under the kind of use and abuse you'll subject them to.

Remember that, most likely, the lenses you purchase after each bout with Lens Lust will probably work just as well with your *next* dSLR as with your current model, so you can consider them a long-term investment. I have lenses that I purchased early in my career that are still in use a dozen camera bodies later. So, don't be afraid to spend a little more for lenses that are constructed well and have all the features you need. I own more than one lens that originally cost more than my dSLR body, and I don't consider the expenditure extravagant.

Zoom Lenses

A zoom lens is a convenience for enlarging or reducing an image without the need to get closer or farther away. You'll find it an especially useful tool for sports and scenic photography or other situations where your movement is restricted. Only the least-expensive digital non-SLR cameras lack a zoom lens. Some offer only small enlargement ratios, 4:1, in which zooming in closer produces an image that is four times as big as one produced when the camera is zoomed out. More-expensive cameras have longer zoom ranges, from 12:1 to 18:1 and beyond.

Digital SLRs, of course, can be fitted with any zoom lens that is compatible with your particular camera, and you'll find a huge number of them in all focal length ranges and zoom ratios. There are wide-angle and wide-angle-to-short telephoto zooms, which cover the range of about 18mm to 105mm, short telephoto zooms from around 70mm to 200mm, high-power zooms in the 80mm to 400mm range, and lenses that confine their magnifications to the long telephoto territories from about 200mm to 600mm or more.

Lens "Speed"

If you're a veteran dSLR user, you know all about lens apertures. If not, you need to know that the lens aperture is the size of the opening that admits light to the sensor, relative to the magnification or focal length of the lens. A wider aperture lets in more light, allowing you to take pictures in

dimmer light. A narrower aperture limits the amount of light that can reach your sensor, which may be useful in very bright light. A good lens will have an ample range of lens openings (called f/stops) to allow for many different picture-taking situations.

You generally don't need to bother with f/stops when taking pictures in automatic mode, but we'll get into apertures from time to time in this book. For now, the best thing to keep in mind is that for digital photography a lens with a maximum (largest) aperture of f/2 to f/2.8 is "fast" while a lens with a maximum aperture of f/6.3 is "slow." If you take many pictures in dim light, you'll want a camera that has a fast lens.

Zoom lenses tend to be slower than their prime lens (non-zooming) counterparts. The most commonly used digital optics are almost always zoom lenses, and zoom lenses tend to have smaller maximum apertures at a given focal length than a prime lens. For example, a 28mm non-zoom lens might have an f/2 or f/1.4 maximum aperture. Your digital camera's zoom lens will probably admit only the equivalent of f/2.8 to f/3.5, or less, when set for the comparable wide-angle field of view.

The shorter actual focal length of digital camera lenses when used with cameras that have a lens crop factor also makes it difficult to produce effectively large maximum apertures. For example, the equivalent of a 28mm lens on a full-frame camera with a camera having a smaller 1.6X multiplier sensor is an 18mm lens. There's a double-whammy at work here. Although providing the same field of view as a 28mm wide-angle, the 18mm optic has the same depth-of-field as any 18mm lens (much more than you'd get with a 28mm lens). Worse, the mechanics of creating this lens complicates producing a correspondingly wide maximum f/stop. So, while you might have used a 28mm f/2 lens with your film camera with a workable amount (or lack) of depth-of-field wide open, you'll be lucky if your 28mm (equivalent) digital camera lens has an f/stop as wide as f/4. That increases your depth-of-field at the same time that the actual focal length of your wide-angle (remember, it's really an 18mm lens) is piling on even *more* DOF.

What about the minimum aperture? The smallest aperture determines how much light you can block from the sensor, which comes into play when photographing under very bright lighting conditions (such as at the beach or in snow) or when you want to use a long shutter speed to produce a creative blurring effect.

Digital cameras don't have as much flexibility in minimum aperture as film cameras, partly because of lens design considerations and partly because the ISO 100 speed of most sensors is slow enough that apertures smaller than f/22 or f/32 are rarely needed. A digital camera's shutter can generally reduce the amount of exposure enough. So, your lens probably won't have small f/stops because you wouldn't get much chance to use them anyway. If you do need less light, there are always neutral-density filters.

Of course, while smaller apertures increase depth-of-field, there are some limitations. In practice, a phenomenon known as *diffraction* reduces the effective sharpness of lenses at smaller apertures. A particular lens set at f/22 may offer significantly less overall resolution than the same lens set at f/5.6, even though that sharpness is spread over a larger area.

Constant Aperture

You'll note that in describing various zoom lenses in this book, I've often referred to their apertures using terms like "f/2.8-4.0" or "f/4-5.6." The "range" specification is required because the effective aperture (and sometimes even the focus plane) of a lens may vary as the zoom setting/magnification changes, because the elements of a lens are moving around in strange and mysterious ways. A lens that has an f/2.8 maximum aperture at its wide-angle setting may provide only the amount of light admitted by an f/4.5 lens at the tele position. Lenses that keep the same aperture regardless of zoom setting are called *constant aperture* lenses, and generally are larger and more expensive than their counterparts with varying maximum apertures.

Aperture change is likely to be a factor while you're shooting. Suppose you're taking photos with a 55-250mm f/4-5.6 zoom lens, with the zoom set to 55mm and using an exposure of 1/125th second at f/4. Then, you zoom in to the 250mm setting, and because the camera adjusts exposure automatically, you may be unaware that you're now taking photos at the *equivalent* (technically) exposure of 1/60th second at f/5.6. Unfortunately, while a shutter speed of 1/125th second is likely to be fine with a 55mm focal length (even accounting for the fact that you may be using a front-heavy zoom lens), it's unlikely that 1/60th second will be fast enough to account for camera shake magnified by the 4.5X zoom factor at 250mm. The result (even if you have image stabilization in the lens) is likely to be an image suffering from camera/lens shake.

Video Considerations

Focus can change, too, so when you focus at, say, the wide-angle position and then zoom in to a telephoto view, the original subject may not technically still be in sharpest focus (although the huge amount of depth-of-field provided by digital camera lenses at smaller f/stops may make the difference more difficult to detect). When shooting stills, you'd notice the differences only when using the camera in manual exposure or focusing mode, anyway. When set to autofocus and autoexposure, your camera will provide the optimum setting regardless of zoom magnification.

However, that's not the case when shooting video. Zooming while capturing a clip is not generally a good idea (unless you're working on a kung-fu movie), but it can be used artistically, if done carefully. Constant and linear automatic focus is a good idea in such situations. But wait, there's more. Sophisticated video shooters may want to *follow focus* to track a subject as it moves closer to or farther from the camera during a shot. Or, it may be desirable to quickly switch selective focus from a nearby subject to the background, or vice versa, again for artistic reasons. (We've all seen these techniques used in movies and TV shows, whether we're aware of them or not.)

A new generation of video-friendly lenses have been created by some manufacturers that include linear focus (and zoom) characteristics, so that when you zoom in or out, or change focus, the shifts are smooth rather than jerky. Such lenses may also have ultra-quiet autofocus motors, and built-in near-silent power zooming (available at the press of a button or switch) to minimize sound

disruptions that can occur when the camera's microphone picks up noises emanating from the lens. Such sounds are most pronounced when using a camera's built-in microphone(s), but can also be obtrusive when using an external microphone that's physically attached to the camera.

Focusing Distance/Speed

The ability to focus close is an important feature for many digital camera owners. One of the basic rules of photography is to get as close as possible and crop out extraneous material. That's particularly important with digital cameras because any wasted subject area translates into fewer pixels available when you start cropping and enlarging your image. So, if you like taking pictures of flowers or insects, plan to photograph your collection of Lladró porcelain on a tabletop, or if you just want some cool pictures of your model airplane or stamp collections, you'll want to be able to focus up close and personal.

What's considered close can vary from model to model; anything from 12 inches to less than an inch can be considered "close-up," depending on the vendor. Fortunately, those short focal length lenses found on digital cameras come to the rescue again. Close focusing is achieved by moving the lens farther away from the sensor (or film) and an 18mm wide-angle lens doesn't have to be moved very far to produce an image of a tiny object that fills the viewfinder. You'll find more about macrophotography in Chapter 17.

Autofocus speed is another important factor. Some lenses focus noticeably faster than others, which can be important when tracking fast-moving subjects for sports photography, or shots of young children. Most of the difference can be traced to the focusing mechanism used by the lens.

Nikon, for example, offers lenses that have internal motors (these are marked with an AF-S designation), which are able to focus the lens more quickly than the AF variety that use a motor built into the camera to push a pin in the lens mount and move the lens's focusing mechanism that way. (The Nikon D5xxx series, D3xxx series, and some earlier models lack this motor, and thus cannot use non-AF-S lenses, which include both older Nikon optics as well as most lenses offered by third parties.)

All Canon lenses sold since the current lens EF and EF-S lens mounts were developed include a motor built right into the lens. (The EF stands for Electronic Focus.) However, several different types of motors are incorporated in these lenses, ranging from a relatively inexpensive and relatively slow AFD (arc-form drive) and MM (micromotor) types to more advanced USM drives using high-speed vibrating rings to adjust focus.

Because not all autofocus systems are created equal, you may need to do a little homework before buying a lens to make sure its focus speed will meet your requirements.

Add-On Attachments

Photographers have been hanging stuff on the front of their lenses to create special effects for a hundred years or more. These include filters to correct colors or provide odd looks, diffraction gratings and prisms to split an image into pieces, pieces of glass with Vaseline smeared on them to provide a soft-focus effect, and dozens of other devices. These range from close-up lenses to microscope attachments to infrared filters that let you take pictures beyond the visible spectrum. Add-on wide-angle and telephoto attachments are also available, along with slide-copy accessories and other goodies. If you're serious about photography, you'll want to explore these options.

Unfortunately, dSLRs come with lenses that have all different sizes of filter threads. One of Nikon's strong selling points in olden times was that virtually all its general-purpose lenses used a 52mm filter thread, so you could invest hundreds of dollars in filters and add-ons and be able to use them with a whole range of optics. Of course, a 52mm thread size is hardly practical for modern dSLR lens designs. You're more likely to need 62mm accessories for many of your lenses, probably will require 67mm add-ons for many of them, and needn't be surprised if your faster lenses, longer zooms, and widest optics require 72mm or 77mm filters. Some vendors have standardized as much as possible; my own lenses fall into two groups: the least expensive consumer-type zooms that use 62mm or 67mm filters, and my "pro" lenses that all require 77mm filters.

Of course, you won't want to choose a lens based on its filter thread, but it's a good idea to look at how you plan to use your lenses before purchasing filters. If only one of your lenses requires a 72mm filter, but the lenses you use most use 62mm and 67mm filters, you might want to standardize on 67mm filters and use a step-down ring to mount those same filters on the lenses that accept 62mm accessories. (A set of stepping rings is shown in Figure 6.14.) Buy only those 72mm filters you actually need. Filters are so much more expensive in the larger sizes that you probably won't need much prompting to make your plans carefully.

Figure 6.14 Step-up and step-down rings allow you to use filters on lenses with several different thread sizes.

What Lenses Can Do for You

No one can afford to buy even a percentage of the lenses available. The sanest approach to expanding your lens collection is to consider what each of your options can do for you and then choose the type of lens and specific model that will really boost your creative opportunities.

- **Wider perspective.** Your mild wide-angle lens has served you well for moderate wide-angle shots. Now you find your back is up against a wall and you *can't* take a step backward to take in more subject matter. You need an ultra-wide lens or zoom with a broader view.

- **Bring objects closer.** A long lens brings distant subjects closer to you, offers better control over depth-of-field, and avoids the perspective distortion that wide-angle lenses provide. They compress the apparent distance between objects in your frame.

- **Bring your camera closer.** Macro lenses allow you to focus to within an inch or two of your subject, as I'll explain in Chapter 17.

- **Look sharp.** Many lenses are prized for their sharpness and overall image quality. While your run-of-the-mill lens is likely to be plenty sharp for most applications, the very best optics are even better over their entire field of view (which means no fuzzy corners), are sharper at a wider range of focal lengths (in the case of zooms), and have better correction for various types of distortion.

- **More speed.** Your inexpensive 70-300mm f/4.5-5.6 telephoto zoom lens might have the perfect focal length and sharpness for sports photography, but the maximum aperture won't cut it for night baseball or football games, or, even, any sports shooting in daylight if the weather is cloudy or you need to use some ungodly fast shutter speed, such as 1/4,000th second. You might be happier to gain a full f/stop with a (non-zooming) prime lens or faster zoom.

Zoom or Prime?

When selecting between zoom and prime lenses, there are several considerations to ponder. Here's a checklist of some important factors:

- **Logistics.** As prime lenses offer just a single focal length, you'll need more of them to encompass the full range offered by a single zoom. More lenses mean additional slots in your camera bag, and extra weight to carry.

- **Image quality.** Prime lenses usually produce better image quality at their fixed focal length than even the most sophisticated zoom lenses at the same magnification.

- **Maximum aperture.** Because of the same design constraints, zoom lenses usually have smaller maximum apertures than prime lenses, and, as mentioned previously, the most affordable zooms have a lens opening that grows effectively smaller as you zoom in.

- **Working speed.** Using prime lenses takes time and slows you down. It takes a few seconds to remove your current lens and mount a new one, and the more often you need to do that, the more time is wasted.

Wide-Angle/Wide-Zoom Lenses

Wide-angle lens considerations:

- **More depth-of-field.** Practically speaking, wide-angle lenses offer more depth-of-field at a particular subject distance and aperture. You'll find that helpful when you want to maximize sharpness of a large zone, but not very useful when you'd rather isolate your subject using selective focus (telephoto lenses are better for that).

- **Stepping back.** Wide-angle lenses have the effect of making it seem that you are standing farther from your subject than you really are. They're helpful when you don't want to back up, or can't because there are impediments in your way.

- **Wider field of view.** While making your subject seem farther away, as implied above, a wide-angle lens also provides a larger field of view, including more of the subject in your photos.

- **More foreground.** As background objects retreat, more of the foreground is brought into view by a wide-angle lens. That gives you extra emphasis on the area that's closest to the camera.

- **Super-sized subjects.** The tendency of a wide-angle lens to emphasize objects in the foreground, while de-emphasizing objects in the background can lead to a kind of size distortion that may be more objectionable for some types of subjects than others. Very wide-angle lenses, like the fisheye used to capture the black-and-white shot in Figure 6.15, make this effect even more dramatic.

- **Perspective distortion.** When you tilt the camera so the plane of the sensor is no longer perpendicular to the vertical plane of your subject, some parts of the subject are now closer to the sensor than they were before, while other parts are farther away. So, buildings, flagpoles, or NBA players appear to be falling backward.

Figure 6.15 A fisheye wide-angle lens produces dramatic distortions.

- **Steady cam.** You'll find that you can hand-hold a wide-angle lens at slower shutter speeds, without need for vibration reduction, than you can with a telephoto lens. The reduced magnification of the wide-lens or wide-zoom setting doesn't emphasize camera shake like a telephoto lens does.

- **Interesting angles.** Many of the factors already listed combine to produce more interesting angles when shooting with wide-angle lenses. Raising or lowering a telephoto lens a few feet probably will have little effect on the appearance of the distant subjects you're shooting. The same change in elevation can produce a dramatic effect for the much-closer subjects typically captured with a wide-angle lens or wide-zoom setting.

Using Telephoto and Tele-Zoom Lenses

Telephoto lenses also can have a dramatic effect on your photography.

- **Selective focus.** Long lenses have reduced depth-of-field within the frame, allowing you to use selective focus to isolate your subject. You can open the lens up wide to create shallow depth-of-field, or close it down a bit to allow more to be in focus. The flip side of the coin is that when you *want* to make a range of objects sharp, you'll need to use a smaller f/stop to get the depth-of-field you need. Like fire, the depth-of-field of a telephoto lens can be friend or foe.

- **Getting closer.** Telephoto lenses bring you closer to wildlife, sports action, and candid subjects, allowing you to capture memorable moments while retaining enough distance to stay out of the way of events as they transpire.

- **Reduced foreground/increased compression.** Telephoto lenses have the opposite effect of wide angles: they reduce the importance of things in the foreground by squeezing everything together. This compression even makes distant objects appear to be closer to subjects in the foreground and middle ranges. The photographer in Figure 6.16 was on a hill almost 25 yards from the breaking waves in the background.

- **Accentuates camera shakiness.** Telephoto focal lengths hit you with a double whammy in terms of camera/photographer shake. The lenses themselves are bulkier, more difficult to hold steady, and may even produce a barely perceptible see-saw rocking effect when you support them with one hand halfway down the lens barrel. Telephotos also magnify any camera shake. It's no wonder that vibration reduction is popular in longer lenses.

- **Interesting angles require creativity.** Telephoto lenses require more imagination in selecting interesting angles, because the "angle" you do get on your subjects is so narrow. Moving from side to side or a bit higher or lower can make a dramatic difference in a wide-angle shot, but raising or lowering a telephoto lens a few feet probably will have little effect on the appearance of the distant subjects you're shooting.

Figure 6.16 Telephoto lenses provide a compression effect, making elements seem closer together.

Typical Upgrade Paths

Many digital SLRs are purchased with a lens, either because the buyer doesn't already own a suitable lens or because the particular camera is available only in a "kit" that includes a basic zoom lens. So, the humble kit lens may be the start of a great collection of lenses. But, to paraphrase Malvolio, reading Maria's letter aloud in *Twelfth Night*, "Some collections are born great, some achieve greatness, and some have greatness thrust upon them."

However, even if that starter lens in your collection is thrust upon you, it's likely you'll have choices in your mandatory kit lens. Virtually all non-professional digital SLRs today can be purchased with a basic 18-55mm f/3.5-5.6 lens that's wide enough at the wide end (the equivalent of 27mm on a "full-frame" 35mm film camera) and long enough at the telephoto end (82.5mm—both after calculating a 1.5X "crop" factor) to be useful for anything short of architecture (wide) or field sports (long). However, other lenses in other kits are also available.

For example, Canon dSLR cameras can often be purchased with a 17-85mm f/4-5.6 lens, a great 24-105mm f/4, or a 18-135mm f/3.5-5.6 lens, all with built-in image stabilization (anti-shake) technology. (More on that later.) Nikon digital SLRs can be found in kits that include 18-55mm, 18-140mm, or 18-200mm lenses. Sony has a very nice 16-50mm f/2.8 lens and 18-135mm f/3.5-5.6 in its kit lens lineup, in addition to the traditional 18-55mm zoom. It offers a 28-75mm f/2.8 zoom lens for its full-frame SLT cameras as a good starter lens. The "pro" cameras in each vendor's line are usually sold as a camera body, without lens, on the theory that buyers either already have suitable optics or will be buying a specific lens along with their camera.

Unless you have specific reasons for not wanting it, the basic kit lens is often a wise purchase. The 18-55mm versions usually add less than $100 to the price of the camera body (if it's available) and so are very economical even if you don't plan to use them much. When I recently bought a super-compact entry-level dSLR for family use, I went ahead and purchased the 18-55mm kit lens, too, even though I had a better 18-70mm lens already in my collection. The kit price was only $70 more than the camera body alone and, equipped with a "protective" glass filter (which I don't normally use), it could be entrusted to the hands of the youngest budding photographer.

These basic lenses are likely to be very sharp for their price, too, because the vendors crank out hundreds of thousands of them and are able to give you a very high-quality optic for not very much money. Back in the film era, the 50mm lens furnished with a camera was likely to be dollar for dollar, the sharpest, most versatile, and least expensive lens a camera owner had. The same is true with most kit lenses. They have a useful zoom range (at least for a beginning photographer), an adequate aperture speed of f/3.5 at the wide-angle end and acceptable f/5.6 at the telephoto setting, compact size, and fast autofocusing.

The next step on the upgrade path will depend on the kind of photography you want to do. Someone interested in sports may decide they need a 55-200mm zoom lens to pull in distant action. Those with a hankering to shoot landscapes or architecture may be interested in a 12-24mm or 10-20mm wide-angle. Bug or wildflower photographers may want a close-up, or *macro*, lens to provide more magnification of tiny subjects. One, or, maybe, two more lenses may be all you need.

That is, until Lens Lust raises to a fever pitch and you find that there is *always* one more lens you must have—not to make you a better photographer, of course; lenses and gadgets won't improve your skills and creativity.

But, that extra lens will let you shoot a particular picture that just can't be captured with your existing optics. For example, I shoot concert photos with an 85mm f/1.4 lens at 1/160th second and ISO 800 using a monopod to steady the camera. Such photos simply wouldn't be the same with a 55-200mm zoom set at 85mm and f/4.5 and 1/30th second—even with the monopod: the performers move too quickly, and a faster shutter speed at ISO 3200 would dissolve my crisp image in grainy noise.

You'll want to plan your upgrades and additions carefully, using the tips I provide in this chapter, because you don't want to end up upgrading *twice*, as I did. My first upgrade was from my original array of fixed focal length prime lenses to a useful complement of affordable, convenient zooms. My initial collection consisted of the 18-70mm kit lens that came with the camera, a 12-24mm wide-angle zoom, a 28-200mm zoom, and a 105mm macro close-up lens. I added a 170-500mm zoom to pull in distant subject matter.

But all these lenses were slow and not especially sharp when wide open, which made their limited maximum apertures even more painful: an f/4.5 or f/5.6 lens that must be used at f/8 or f/11 to gain real sharpness is slow, indeed. So, I methodically, and at more expense than I like to think about, upgraded again to bigger, heavier, sharper, and more costly optics. I ended up with 17-35mm f/2.8, a 28-70mm f2.8, and 70-200mm f/2.8 zooms (the longest of the three had built-in image stabilization/vibration reduction). These are used for 90 percent of my work. I use my older lenses chiefly when I want to travel light, or when I need something slightly wider (the 12-24mm lens) or a bit longer (the 170-500mm zoom). While your mileage (and upgrade path) may vary, it's likely that, if you're careful, you can limit the Lens Lust enough to acquiring only the optics you really, really need (or think you do).

Image Stabilization

Image stabilization, which counteracts camera shake, is a feature built into some lenses. It's also built into the bodies of many dSLR cameras, but I'm going to cover it in this chapter, because the intent and effect is the same: to reduce the blurring in photographs caused by camera motion during exposure.

There are actually three types of image stabilization, and it goes by many names. Vibration reduction. Anti-shake. Optical image stabilization. All these describe several types of technology that help eliminate blur from camera and photographer movement during an exposure. Camera waver is probably the number one cause of blurry photos, and one of the banes of photography at all levels. It doesn't matter whether you're a tyro, a serious photo enthusiast looking to express bottled-up creativity with photography, or a seasoned pro who should know better: Over the entire spectrum of users, as many images are "lost" through camera-induced blur as through poor exposure or bad focus.

The many names applied to image stabilization all fit, because there are many causes of camera shake, and several different technologies used to counter that movement. The three main types of IS are as follows:

■ **Electronic image stabilization.** This type is most often used in video cameras. It's applied using a simple trick. The image captured by the sensor is slightly larger than the image stored as part of a continuous video of 24/25 or 30 frames per second (depending on the video system you use). So, if the camera moves slightly between frames, shifting, say, the equivalent of three pixels to the left and two pixels down, compared to the previous frame, the camera's electronics detect that and grab an image that's in "register" from the sensor, three pixels to the right and two pixels up, and stores that instead of the shifted frame.

■ **Optical image stabilization.** Tiny motors built into the lens shift lens elements at high speed to compensate for the motion that detectors in the lens measure in real time as you shoot. This type of IS is commonly used by Canon and Nikon in select lenses, but it is also applied by Panasonic and Sony for some lenses used on their interchangeable lens cameras.

■ **In-camera image stabilization.** The entire sensor is shifted slightly to adjust for motion that occurs during exposure. This system is used by Olympus, Sony, and Pentax.

The Bane of Image Blur

Amateurs bring me their photographs asking how they can make them "sharp and clear" and a quick evaluation of their shooting technique is enough for me to tell them not to "punch" the shutter button. I've seen examples of camera shake so egregious it was impossible to tell whether an aggressive downward stroke on the shutter release was vertical or slightly diagonal. You'd think automated cameras would set a shutter speed high enough to prevent these blurry pictures, but, as you'll see, that's not always possible. As light levels drop, so do shutter speeds, and blur is an inevitable result.

Camera shake can result from a combination of a too-slow shutter speed and something as mundane as the photographer breathing, from attempting to shoot from a moving vehicle even at higher shutter speeds, or from using long lenses that are "front-heavy" and cause camera wobble. There are several different ways of counter-acting this movement, ranging from putting certain elements of the lens in motion to stabilize the optical path to moving the sensor in sync with the camera jitter. Some video cameras even provide stabilization electronically.

Photographers who don't have access to any of these image stabilization technologies, and who can't switch to a higher shutter speed, often rely on their imagined ability to hand-hold their cameras and get sharp images at 1/30th second or slower. But even the steadiest hand is sometimes shocked at how much sharpness is actually lost when they compare their hand-held shots with those taken at the same settings using a tripod or other steadying aid. Of course, a hand-held shot may be good enough for its intended use, or even *better* for artistic or practical reasons than one taken with a tripod.

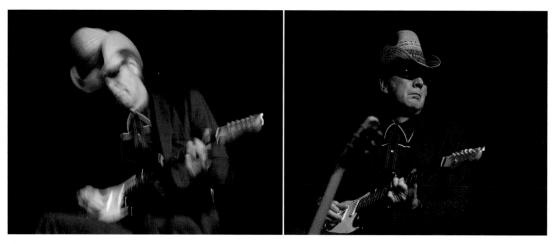

Figure 6.17 Left: With an exposure of 1/2 second, this image is very blurry, but still an interesting portrait of the guitarist. Right: An image taken a few seconds later using a shutter speed of 1/200th second and a high ISO setting shows the guitarist's attitude, but little of the excitement of his playing.

For example, Figure 6.17, left, was taken hand-held at 1/2 second, producing a blurred rendition that captures the movement of the energetic blues guitarist. There are many reasons to prefer this shot over the more static one shown in Figure 6.17, right, taken a few seconds later at 1/200th second, with the sensor's sensitivity cranked up to a noise-inducing ISO 1600. Most creative efforts reside somewhere between the very blurry and the very sharp, and image stabilization gives you the option to choose your techniques to suit the photograph you want to take.

Camera and lens manufacturers are starting to come to the aid of all of us by producing products with shake-canceling features under various names that make themselves known in product names by acronymic appendages like IS (image stabilization), VR (vibration reduction), or AS (anti-shake). No insult is intended toward Nikon, Sony, and other vendors of these anti-blur technologies, but for the purposes of this chapter I'm going to adopt Canon's terminology and call it image stabilization, or IS. In any case, Canon was the first to introduce this feature, back in the 1990s. Some form of IS is now found in many lenses, built right into cameras, and into other kinds of products, including video cameras and binoculars.

Causes of Camera Shake

Sharpness-robbing camera shake is insidious because it can come from so many sources. As I mentioned earlier, punching the shutter release, as rank amateurs (as well as careless photographers with more experience) do, can jar the entire camera, often producing motion in a downward or diagonal direction sufficient to blur the image when slow shutter speeds are used. A more gentle finger on the release can eliminate some of the worst problems.

The normal, inevitable motion of the hand during a longer exposure can also produce camera shake. Some people have an almost imperceptible amount of tremor in their grips that is not caused by serious problems in the brain, my neurologist assures me. But the steadiest hands will tremble slightly, and the results will show in photographs taken with a normal or wide-angle lens at 1/30th second, or even, amazingly, at 1/125th second.

Shakiness can be exacerbated by several other factors. A camera or camera/lens combination that is poorly balanced is prone to additional camera shake. Turning the camera from a horizontal to a vertical orientation can produce more shake if the rotated grip is uncomfortable, or if there is no second "vertical" shutter release and the photographer's hand is forced into an awkward position.

Camera shake is magnified by longer focal lengths. It's bad enough that a long telephoto will induce vibration by making the camera front-heavy. But vibrations that are almost imperceptible when shooting photos with a 25mm lens will be seemingly magnified 10X at 250mm. The rule of thumb that suggests using a minimum shutter speed that's the reciprocal of the focal length of the lens (e.g., 1/250th second with a 250mm lens) is a good one, even if it doesn't go far enough. Enlarging a small section of a photo in an image editor, or the magnification produced by a non-full-frame camera's crop factor can also magnify the effects of camera shake.

One final cause of camera shake is the internal motion of the camera's innards as the photograph is taken. For digital SLRs, the one source that's a proven culprit is the slapping of the mirror as it flips up out of the way prior to the opening of the shutter. This kind of vibration can happen even when the camera is firmly mounted on a tripod, and the photographer takes himself out of the movement equation by using a shutter release or remote control to trigger the exposure. The solution here is to lock the mirror up before taking the picture. Not all dSLRs offer mirror lock-up, however, but, fortunately, mirror vibration is not a concern in most picture-taking situations. It's likely to cause some effects under extreme magnifications (with very long lenses), or for close-up pictures with longer exposures.

Diagnosing Camera Shake

The big shocker for many experienced photographers is that the "recommended" minimum shutter speed suggested by the popular rules of thumb is not a panacea. The only true way to eliminate camera shake is to prevent the camera from shaking. If that's not possible, one of the image stabilization technologies available from camera vendors will probably help.

Most photographers are surprised to learn just how much camera shake they fall victim to even at "high" shutter speeds. Even the steadiest hands are likely to see some camera shake in their photos at 1/125th second, or even higher, if only under extreme magnification. It may be virtually invisible in normal picture-taking circumstances, but it's there.

Very serious camera shake is easy to diagnose. There are four possible causes for a blurry photo (and don't forget that some pictures can contain elements of all four causes):

- **The picture is out of focus.** If you or your camera's autofocus mechanism goofed, some of your subject matter, or in the worst cases *all* of it, will be out of focus and blurry. You can spot this kind of blur by looking at pinpoints of light in your image. Absent camera shake or subject movement, fixed spots of light will be enlarged and blurry, but will maintain their shape. Figure 6.18 shows an image that is simply out of focus. The camera had been manually focused on an object fairly close to the camera, and not adjusted when the lens was pointed at the Ferris wheel that was, effectively, at infinity.

- **The subject was moving.** You can tell if subject movement is the main cause of image blur if the subject itself is blurry, but the background and surroundings are not. Figure 6.19 shows the same Ferris wheel, this time with the camera on a tripod and the wheel is moving. Spots of light in the image will be blurred in the direction of the subject's travel, in this case producing an interesting blur effect.

- **You zoomed during the exposure.** Racking the zoom lens in or out during a long exposure is a time-honored special effect, but it's easy to do it accidentally. You're zooming in on an interesting subject and happen to press the shutter release on impulse before the zoom is finished. If your zoom movement is fast enough, you can see this effect in exposures as long as 1/60th second. Points of light will move inward toward the center of the image or outward as the magnification decreases or increases while you zoom. Figure 6.20 shows an intentional zoom during exposure. The Ferris wheel was also moving, so a combination of zoom and movement blurs result.

- **Your camera shook.** The final primary cause of a blurry photo is camera shake. You can spot this kind of blur by looking at spots of light or other objects in the picture. They'll be deformed in the direction of the camera shake: up and down, diagonally, or, in the worst cases, in little squiggles that show that the camera was positively trembling. Figure 6.21 shows an example of camera shake.

Figure 6.18 Blur caused by an out-of-focus image.

Figure 6.19 Blur caused by subject movement.

Figure 6.20 Light trails caused by zooming during exposure.

Figure 6.21 Camera shake causes distinctive blur patterns.

If you want a measurable way of seeing just how badly camera shake affects your own photos, it's easy to construct a diagnostic tool. Get yourself a large piece of aluminum (aluminum foil will do in a pinch) and poke some tiny holes in it using a pattern of your choice. I prefer a cross shape because that simplifies seeing blurs in horizontal, vertical, and diagonal directions; the cross pattern doesn't interfere with the blurs you produce.

Then mount the sheet 10 to 20 feet away and back-illuminate it so the tiny holes will form little dots of light. The correct distance will depend on the focal length of the lens or zoom you'll be testing. You want to fill the frame with the testing sheet. Focus carefully on the sheet, and then take a series of exposures at various shutter speeds, from 1/1,000th second down to 1 full second. Repeat your test shots using various methods of steadying yourself. Brace the camera against your body with your arms. Take a deep breath and partially release it before taking the photo. Try different ways of holding the camera.

Then, examine your test shots. As the shutter speed lengthens, you'll notice that the tiny circles in the aluminum sheet will become elongated in the vertical, horizontal, or diagonal directions, depending on your particular brand of shakiness. You may even notice little wavering trails of light that indicate that you weren't merely shaking but were more or less quivering during the exposure.

You'll probably be shocked to discover some discernable camera shake at shutter speeds you thought were immune. With a normal lens, you might find some blur with hand-held shots at 1/125th second; with short telephotos, blur can be produced at 1/250th second or shorter exposures. Figure 6.22 shows some typical results.

Figure 6.22 These backlit test patterns were photographed at 1/1,000th second (upper left); 1/30th second (upper right); 1/4th second (lower left); and 1 second (lower right).

Preventing Camera Shake

The least expensive way of countering camera shake is to hold your camera steady. You probably don't want to carry a tripod around with you everywhere, but there are alternative devices that are easier to transport, ranging from monopods to the C-clamp devices that fasten to any convenient stationary object. I carry mine with me everywhere; it fits in an outside pocket of my camera bag and can be used to convert anything from a fence post to a parking meter into a tripod-like support. It even has a sturdy screw fitting so you can attach it to utility posts or other wooden objects. (Please don't kill trees!) Once, when I was nursing a gimpy hip, I coupled this clamp with a walking cane to create a handy instant monopod. Most of the Ferris wheel photos earlier in this chapter were all taken with this clamp and a handy railing.

Lacking any special gear, you can simply set your camera on any available surface and use your self-timer to take a shake-free picture. The two versions shown in Figure 6.23 were taken with the camera hand-held (top) and with the camera resting on top of a trash receptacle (bottom). Sometimes you can rest a long lens on a steadying surface to reduce the front-heavy effect. Veteran photographers carry around beanbags they can place on an object and

Figure 6.23 Steady a hand-held shot by placing the camera on a handy object.

use to cradle their long lens. Another trick is to attach a strong cord to the tripod socket of your lens (most telephotos have them) with a tripod fitting, loop the other end of the cord around your foot, and pull it taut, adding some stability to your camera/lens combination.

You can also follow any of the well-known prescriptions for holding your body more steady, such as regulating your breathing, bracing yourself, and, above all, *not punching the shutter release.*

Using Image Stabilization

Your camera may be able to help stabilize your images. One of the most popular features of some current cameras and lenses is hardware stabilization of the image. By countering the natural (or unnatural) motion of your camera and lens, IS can provide you with the equivalent of a shutter speed that is at least four times faster, effectively giving you two extra stops to work with. That can be important under dim lighting conditions.

For example, suppose you're shooting in a situation with a 400mm lens that calls for a shutter speed of 1/500th second at f/2.8 for acceptable sharpness. Unfortunately, you're using a zoom lens with a maximum aperture at that particular focal length of only f/5.6. Assume that you've already increased the ISO rating as much as possible, and that a higher ISO either isn't available or would produce too much noise. Do you have to forego the shot?

Not if you're using a camera or lens with IS. Turn on your IS feature, and shoot away at the equivalent exposure of 1/125th second at f/5.6. If the image stabilizer works as it should, blur caused by camera shake should be no worse than what you would have seen at 1/500th second. Your picture may even be a little sharper if your lens happens to perform better at f/5.6 than at f/2.8 (which isn't uncommon).

There are some things to keep in mind when using image stabilization:

- **IS doesn't stop action.** Image stabilization mimics the higher shutter speed *only* as it applies to camera shake. It will neutralize a wobbly camera, but it won't allow you to capture faster-moving objects at a slower shutter speed. If you're shooting sports with IS-enabled gear, you'll still need a shutter speed that's fast enough to freeze the action. Figure 6.24 shows a concert photo of a fiddler in Celtic rock band Enter the Haggis. It was taken hand-held with a Nikon 70-200mm VR lens at the 200mm zoom setting and a 1/60th second shutter speed. The vibration reduction feature stopped camera shake just fine, but the slow shutter speed still allowed the animated musician's hands (especially) to blur.

Figure 6.24

Image stabilization neutralized camera shake, but the performer was moving too fast for the 1/60th second shutter speed used.

■ **IS can degrade tripod shots.** Some older image stabilizers produce *worse* results if used while you're panning or using a tripod. The intentional camera movement of panning may confuse the IS, or provide only partial compensation, so you'll end up with a picture that is not as good as if IS were switched off. Use of image stabilization when the camera is on a tripod leads to wasted use of the feature, or, worse, unneeded compensation that adds to the blur. Not all equipment suffers from this problem, however. Newer image stabilization systems can recognize horizontal motion as panning, and interpret extraordinarily low levels of camera movement as tripod use, and disable themselves when appropriate. Your camera or lens may have a special "active" mode that can be selected when shooting from a moving car or other vibration-heavy environments.

■ **IS slows camera response.** Image stabilization can slow down your camera a little. The IS process takes some time, just as your autofocus and autoexposure do, but unlike either of those, does not necessarily cease when you partially depress the shutter release. Image stabilization can produce the equivalent of shutter lag, and, oddly enough, may not work as well as you think for sports photography. IS is great for nature photography, long-range portraits, close-ups, and other work with subjects that aren't moving at a high rate of speed, but less suitable for fast action.

■ **IS not limited to telephoto or close-up applications.** Remember that image stabilization can be used for applications besides long-range telephoto or close-up photography, and it doesn't require macro or tele settings to be of benefit. For example, if you find yourself in an environment where flash photography is not allowed, such as a museum or concert, IS can be a life-saver, letting you shoot with normal or wide-angle settings at shutter speeds as slow as 1/4th second. I bought the Canon EF-S 17-85mm f/4-5.6 IS USM lens for my Canon camera as a "walking around" lens that's ideal for many ordinary picture-taking situations in which a slower than optimum shutter speed is desirable. I've found its image stabilization features helpful even when using the wide-angle range of the zoom. Many vendors now offer IS lenses in the wide-angle zoom range and, of course, IS is available at any focal length for cameras with the feature built into the body.

Despite my final caveat, image stabilization can be used effectively for sports photography, particularly if you're careful to catch peak moments. Figures 6.25 and 6.26 show two different shots of a base runner diving back to first base, both taken with 400mm long lenses at about 1/500th second. In both pictures, subject motion isn't really a problem. The sliding base runner has already skidded to a halt, and the first basewoman has caught the ball and prepares to make the tag (too late), in Figure 6.25, or is waiting for the ball to arrive (in Figure 6.26). The 1/500th second shutter speed was sufficient to stop the action in either case.

However, camera shake proved to be the undoing in the first example, but image stabilization saved the day in the second photo.

Figure 6.25
No vibration reduction and a long lens leads to visible camera shake, even at 1/500th second.

Figure 6.26
The same shutter speed works fine with image stabilization.

How It Works

As I mentioned earlier, there are several ways of achieving image stabilization. Some electronic video cameras use an electronic form of IS by capturing an image that's slightly larger than the final frame and shifting the pixels in the proper direction to counter the motion of the camera, then saving the displaced pixels as the final image for that frame, repeating the process many times each second. This works, but it is not the ideal method.

Optical image stabilization built into the lens is better. Several piezoelectric angular velocity sensors operate like tiny gyroscopes to detect horizontal and vertical movement, which are the usual sort of camera shake you'll experience—up-and-down or side-to-side shaking, rather than rotation around the optical axis, which is difficult to do accidentally while taking an ordinary photo. Once motion is detected, the optical system uses prisms or adjustments in several "floating" lens elements to compensate. The glass can be shifted along the optical axis to cancel undesired lens movement and vibration. Lenses that can be adjusted to compensate only for up and down motion can successfully use image stabilization even when you're panning.

The now-defunct Konica Minolta company pioneered a system built into the camera, rather than the lens, in which the *sensor* is moved in response to camera motion. The advantage of this method, carried over by Sony with its Super SteadyShot system in Sony Alpha dSLRs, and the systems found in some other cameras, is that you don't have to purchase a special lens that incorporates IS; the anti-shake technology is in the camera and therefore works with virtually any lens you use. Other vendors, including Pentax, Panasonic, and Olympus, also have in-camera image stabilization. If you like working with lots of different lenses and don't want to purchase an array of IS-enabled optics, this approach has its advantages.

There are also some disadvantages to either type of image stabilization. When IS is built into each and every lens, you must purchase special image-stabilization-capable optics to get this feature. Canon offers its most popular zoom lens types both with and without IS, and Nikon seems to be on a campaign to convert just about all of its zoom lenses—both professional and consumer grade—to their vibration reduction features. Building IS into lenses allows vendors to offer new and improved technology simply by upgrading the capabilities of their lenses.

While you don't have to purchase special IS lenses for your Sony or other camera with internal image stabilization, you do have to contend with a single point of failure: if the anti-shake feature of your camera breaks, you have to send the entire camera in for repair, which is likely to be less convenient and more expensive than if you were able to ship off just a lens. Many photographers who have tried both types of systems like being able to see lens-based IS at work; you can see the image being stabilized right through the viewfinder as you partially depress the shutter release to lock in focus. In-camera IS provides no such feedback, so you need to trust your camera and hope that the feature is doing its job.

It's safe to say that image stabilization is a technology that's destined to become a standard feature on all lenses and/or digital SLR cameras within the lifespan of this book.

7

Working with Light

Photography, like all forms of visual art, uses light to create shape and form. But, unlike artists who create drawings and paintings, photographers have less control over the direction, quality, and effects of light. Some artists may paint from life and may prefer to choose a setting like the portraitists' legendary "northlight studio," but others are free to paint from their imaginations, and maintain absolute control over the attributes of the illumination that fills their canvases.

For the photographer, even awesome Photoshop skills won't be able to fix an image captured under poor, difficult, or unflattering lighting conditions. Photographers need to learn how to use the qualities of light to shape their pictures, and how to adapt and modify the light that's available to achieve the image they are trying to capture.

Two Types of Light

There are two main categories of illumination available to photographers: continuous lighting, such as daylight, moonlight, and artificial lighting indoors or outdoors; as well as electronic flash, supplied by the camera's built-in electronic flash unit, or external units that are generally triggered by the camera at the moment of exposure.

Table 7.1 compares the two forms of illumination. Some points in the table will receive some additional explanation later in the chapter.

Table 7.1 Attributes of Light Sources

Attribute	Continuous Illumination	Electronic Flash
Intensity	Plentiful in full daylight; generally less early or late in the day, or at night, or indoors, unless strong supplemental lighting is used.	Often stronger than continuous light sources at a location, and intensity can be increased by adding stronger or multiple units.
Range	Daylight fills a scene, but with less illumination in shade. Supplemental continuous light sources can be limited in range.	Particularly vulnerable to the *inverse square* law. A flash unit that is twice as far away from a subject provides only one-quarter the illumination, for example.
Exposure calculation	The camera's metering system easily can measure the illumination in a scene, even when different areas have differing levels of light. Spot metering can zero in on a specific zone, if desired.	The camera can measure and adjust exposure only for the camera's built-in flash, and dedicated flash units designed for metering by the camera. Exposure for other types of flash must be calculated using a flash exposure meter, or by estimate when viewing test images or histograms.
Lighting preview	What you see is what you get.	For the most precise preview of lighting, the flash must have a *modeling light* or function that provides continuous illumination for a short period.
Action stopping	Your shutter speed determines whether action is frozen, so there must be sufficient illumination to allow using the shutter speed you need.	The slice of time captured is generally determined by the duration of the flash, which is usually in the 1/1000th second range, or briefer. However, the actual camera shutter speed may be slow enough to allow a secondary, "ghost" image.
Cost	Daylight is free; supplementary lights (except for professional studio lighting equipment) are relatively inexpensive.	Most dSLRs have a flash built in. Supplementary external flash units can cost $150–$500 (or more) each, depending on their power and features.

Continuous Lighting Essentials

While continuous lighting and its effects are generally much easier to visualize and use than electronic flash, there are some factors you need to take into account, particularly the color temperature of the light. (Color temperature concerns aren't exclusive to continuous light sources, of course, but the variations tend to be more extreme and less predictable than those of electronic flash.)

Color temperature, in practical terms, is how "bluish" or how "reddish" the light appears to be to the digital camera's sensor, and is measured using the *Kelvin* scale, on which the light we see in our illumination generally ranges from 2,800K to around 6,000K. Indoor illumination is quite warm, at 2,800K to about 3,400K, comparatively, and appears reddish to the sensor. Dawn and dusk can also venture into this warm range.

Full daylight, from about 5,000K to 6,000K, in contrast, seems much bluer to the sensor. Our eyes (our brains, actually) are quite adaptable to these variations, so white objects don't appear to have an orange tinge when viewed indoors, nor do they seem excessively blue outdoors in full daylight. Yet, these color temperature variations are real and the sensor is not fooled. To capture the most accurate colors, we need to take the color temperature into account in setting the color balance (or *white balance*) of the camera—either automatically using the camera's features or manually, using our own knowledge and experience. The chief types of light you'll be working with include:

- **Daylight.** Outdoors, daylight is pervasive (even at night, when light bounced off the sun may be called *moonlight*)—direct, bright, and harsh, or indirect, soft, and diffused (by clouds or bouncing of objects like walls or filtered by shade). Under these varied conditions, daylight's color temperature can vary quite widely. It is highest (most blue) at noon when the sun is directly overhead, because the light is traveling through a minimum amount of the filtering layer we call the atmosphere. The color temperature at high noon may be 6,000K. At other times of day, the sun is lower in the sky and the particles in the air provide a filtering effect that warms the illumination to about 5,500K for most of the day. Starting an hour before dusk and for an hour after sunrise, the warm appearance of the sunlight is even visible to our eyes when the color temperature may dip below 4,500K. Figure 7.1 shows an image shot outdoors at midday. It has a slight bluish cast, but it's really barely noticeable, because this rendition is what we expect to see at this time of day.

- **Incandescent/Tungsten light.** These lights consist of a glass bulb that contains a vacuum, or is filled with a halogen gas, and contains a tungsten filament that is heated by an electrical current, producing photons and heat. Although the exact color temperature of this type of illumination varies, it can be precisely calculated and used for photography without concerns about color variation (at least, until the very end of the lamp's life). Figure 7.2 shows an outdoors shot from a wedding shoot in Valencia, Spain. The camera's white balance was set for the incandescent lights that were used, so the bride and groom appear with very little color cast. However, the other illumination in the plaza was quite a bit warmer, giving an orange tint to the fountain and background.

■ **Fluorescent light/Other light sources.** Fluorescent light has some advantages in terms of illumination, but some disadvantages from a photographic standpoint. This type of lamp generates light through an electro-chemical reaction that emits most of its energy as visible light, rather than heat, which is why the bulbs don't get as hot. The type of light produced varies depending on the phosphor coatings and type of gas in the tube. So, the illumination fluorescent bulbs produce can vary widely in its characteristics. Different types of lamps have different "color temperatures" and fluorescent lamps have a discontinuous spectrum of light that can have some colors missing entirely. A particular type of fluorescent tube can lack certain shades of red or other colors, and other alternative technologies such as sodium-vapor illumination can produce truly ghastly looking human skin tones. Their spectra can lack the reddish tones we associate with healthy skin and emphasize the blues and greens popular in horror movies. Your camera probably has several different fluorescent color balance settings to choose from. Figure 7.3 shows an image taken in a college gym under fluorescent lighting, with the camera's color balance set to correct for the color rendition.

Figure 7.1
This shot in full daylight has the rich colors and slight blue cast we expect at midday.

Figure 7.2
Although the white balance was set correctly for the incandescent lighting illuminating the bride and groom, the warmer incandescent lights that lit the rest of the plaza produced a warmer rendition.

Figure 7.3 If you choose the right fluorescent color balance setting, colors will look natural.

Electronic Flash Essentials

Electronic flash illumination is produced by a burst of photons generated by an electrical charge that is accumulated in a component called a *capacitor* and then directed through a glass tube containing xenon gas, which absorbs the energy and emits the brief flash. The typical electronic flash provides a burst of light that lasts about 1/1,000th second.

An electronic flash is triggered at the instant of exposure, during a period when the sensor is fully exposed by the shutter's pair of curtains. When the exposure begins, the first curtain opens and moves to the opposite side of the frame, at which point the shutter is completely open. The flash can be triggered at this point (so-called *1st curtain sync*), making the flash exposure. Then, after a delay that can vary from 30 seconds to 1/250th second for most modern cameras (depending on the camera's fastest *sync speed*), a second curtain begins moving across the sensor plane, covering up the sensor again. If the flash is triggered just before the second curtain starts to close, then *2nd curtain sync* is used. In both cases, though, the sync speed is the fastest shutter speed that can be used to take a photo. I'll explain flash sync in a little more detail later in this chapter.

If you're using your camera's built-in flash or a compatible dedicated flash, the camera will automatically adjust the shutter speed downward to the sync speed if you accidentally set it higher. The exception is when you're using high-speed sync, described in the sidebar that follows.

CUT-OFF IMAGES

Shutter speeds briefer than the top sync speed are produced by launching the second curtain before the first curtain has finished its journey, so the second curtain chasing the first creates a slit that's narrower than the full frame, and thus exposes only part of the sensor at a time as the opening moves. If you use a faster shutter speed (say, because you're using a non-dedicated or studio flash unit that doesn't communicate with your camera), only part of the image—corresponding to the width of the slit—will be exposed during the moment the flash fires. (See Figure 7.4.) Some camera/flash unit combinations offer a *high-speed sync* option, in which the electronic flash fires at a reduced output level for the entire duration of the moving slit's travel across the sensor surface. All of the sensor is exposed to the flash illumination, but at a much lower level. Thus, high-speed sync is best reserved for close-up photos, where the weaker flash output is still sufficient to make an exposure.

Understanding Flash Sync

Perhaps you haven't fiddled much with your dSLR's flash sync settings, because the default setting probably works well for most photos. That's not necessarily true with action photography, particularly if you're looking to reduce or enhance the ghosting effect produced by intentional/unintentional double exposures from flash and ambient light. Now's a good time to learn just how flash sync settings can affect you.

As you learned earlier in this book, dSLRs generally have two kinds of shutters, a mechanical shutter that physically opens and closes, much like the focal plane shutter on a film camera, and an electronic shutter, which controls exposure duration by limiting the time during which the sensor can capture pixels. It's often most efficient to use a mechanical shutter for "slower" shutter speeds (from 30 seconds up to around 1/250th–1/500th second) and switch to an electronic shutter for the really fast speeds (up to 1/16,000th second on a very few models).

An electronic flash unit's duration is often much briefer than any of these, typically 1/1,000th second to as short as 1/50,000th second with some models at some power settings. So, as far as the electronic flash is concerned, the shutter speed of your camera is irrelevant as long as the shutter is completely open during the time the flash fires. If you've used flash with a camera at a shutter speed that was too high, you probably noticed that your exposed image was only one-quarter, one-eighth, or some other fraction of the full frame. That's because the focal plane shutter (which moves immediately above the film plane) was open only partially as it traveled across the film, and that opening was exposed by the flash, as described in the sidebar and shown in Figure 7.4.

Your digital camera has a maximum flash sync speed, which can be as slow as 1/125th second or as fast as 1/500th second (with some older cameras). Even higher speeds can be used when working with high-speed sync, mentioned in the sidebar, because that interval is the shutter speed at which the sensor is fully exposed and ready to capture a brief flash.

The next fly in the ointment is the ghost image mentioned earlier in this chapter. Because the shutter is open for a longer period than is needed to record the flash alone, you'll end up with that ghost image caused by a secondary exposure from ambient light. If the subject is moving, the ghost will

Figure 7.4
With a non-dedicated flash unit connected, it's possible to use a shutter speed that's higher than a camera's fastest sync speed, producing a "shadow" of the shutter on the frame.

trail or precede the flash image. If you're holding the camera unsteadily, the ghost image may even be jerky due to camera movement.

If you don't want ghost images, use the highest shutter speed practical to reduce the impact of ambient light, without producing a completely black background. Experiment until you find a shutter speed that eliminates ghosting, but still allows the background to be illuminated a bit.

Here are the most common synchronization options found on digital cameras:

- **Front sync.** In this mode (also called *front-curtain sync*), the flash fires at the beginning of the exposure. If the exposure is long enough to allow an image to register by existing light as well as the flash, and if your subject is moving, you'll end up with a streak that's in front of the subject, as if the subject were preceded by a ghost. Usually, that's an undesirable effect. Unfortunately, front-curtain sync is generally the default mode for most dSLRs. You can be suckered into producing confusing ghost images without knowing the reason why. Figure 7.5 shows an example of a photograph taken using front-sync flash.

 In the figure, the dancer is moving from the right side of the frame to the left. The flash, located to the left and slightly in front of her, was triggered as soon as the shutter opened. The shutter remained open for about 1/30th second, so the ambient light on the stage produced a ghost image in front of her as she moved to the left. The ghost partially obscured the dancer—which is not what I wanted.

Figure 7.5 With front-curtain sync, the blur precedes the sharp flash image.

Figure 7.6 With rear-curtain sync, the blur trails the sharp flash image and looks more natural.

- **Rear sync.** In this mode (also known as *rear-curtain sync*), the flash doesn't fire until the *end* of the exposure, so the ghost image is registered first, and terminates with a sharp image at your subject's end position, with the well-known streak (like that which followed The Flash everywhere) trailing behind. That can be a bad thing or a good thing, depending on whether you want to use the ghost image as a special effect. Figure 7.6 shows the improved effect you get when you switch to rear sync when using a slow shutter speed. In this shot, the dancer was swiveling her body and leg, and the ghost image was recorded as she made this movement. Then, the flash was triggered, creating a sharp image at the end of the movement. That rendition looks much more natural to the eye.

- **Slow sync.** This mode sets your camera to use a slow shutter speed automatically, to record background detail that the flash, used to expose a subject closer to the camera, fails to illuminate. This mode can improve your flash images if you hold the camera steady and the subject is not moving. So, slow sync is best reserved for non-sports images, non-moving subjects, or photographs in which the subject is approaching the camera. Otherwise, you can almost guarantee ghost images.

On one trip, I wanted to take a black-and-white photo of the cathedral in Segovia, Spain, but the foreground was too dark. Mounting my camera on a tripod, I used slow sync and an external flash, ending up with an exposure of 1/15th second at f/16. Because the image was captured in monochrome, the mixed lighting—warm incandescent background and cool foreground illuminated by the flash—was not a problem. (See Figure 7.7, top.) The original mixed lighting version is shown at bottom.

Calculating Exposure

As I noted earlier, digital SLRs can calculate exposure for electronic flash automatically when you're using the built-in flash or a dedicated flash designed for that camera. This is accomplished by firing the flash twice. The initial burst is a *pre-flash* that can be measured by the camera and used to adjust the intensity of the main flash that fires a split-second later. If you're using one or more dedicated flash units, the camera is able to calculate the total exposure for a scene from the pre-flashes that all of them emit when directed to do so by the main or "commander" flash. The commander can be your camera's built-in flash, an auxiliary flash unit, or a special triggering device specifically used to set off your strobes (often using infrared signals rather than a visible flash).

Manual flash exposure can also be calculated, roughly, using the guide number (GN) supplied for that flash unit. Just take the GN for that flash at the ISO setting you are using, and divide by the approximate distance to your subject. For example, if your camera were set at ISO 100 and a particular flash has a GN of 80 for that ISO, with a subject at 10 feet, you'd use f/8 (80 divided by 10=8). At 14 feet, you'd use f/5.6 (80 divided by 14=5.6). Because there are other, more accurate options today (primarily your camera's flash metering capabilities), guide numbers are used chiefly to compare the relative power of two flash units. One with a GN of 110 would be twice as powerful as one with a GN of 80, for example.

Figure 7.7 Slow sync allows mixing flash (in the foreground) with ambient light (the background) using slow shutter speeds when the camera is mounted on a tripod. Top, monochrome version; bottom, original mixed-lighting color version.

Flash meters are a third alternative for calculating flash exposure. These can be used with dedicated or non-dedicated flash alike; they are pointed at the subject (in reflective mode) or, more commonly, held at the subject and pointed toward the light source (this is called incident mode) and the light measured when the flash unit(s) are triggered. One advantage of using a flash meter is that in studio and other situations where multiple flash is used, each unit can be fired individually and the illumination measured to help you evaluate or set lighting ratios.

Choosing a Flash Exposure Mode

Digital SLR vendors apply fancy names to their dedicated flash units, such as d-TTL, or i-TTL, or Creative Lighting System, so you'll know that your camera contains massive technology innovation. However, this nomenclature can be confusing. Learn what your flash unit's most common exposure modes do, and how they can help you. Here are some typical options:

- **TTL (through the lens) metering.** With this type of exposure, the camera measures the flash illumination that reaches the sensor (often by diverting some of the light elsewhere) and adjusts the exposure to suit. If you're photographing a subject that reflects or absorbs a lot of light, the exposure setting may not be accurate.

- **Pre-flash metering.** The camera fires a pre-flash and uses that information only to calculate exposure. This is the best mode to use when your exposure is "non-standard" in some way, as when you put a diffuser on the flash, a darkening filter on your lens, or use an external flash unit.

- **Integrated metering.** The camera triggers a pre-flash just before the exposure, measures the light that reflects back, and then integrates that information with distance data supplied by your camera's focus mechanism. The camera knows roughly how far away the subject is and how much light it reflects, and can calculate a more accurate exposure from that.

- **Manual control.** In this mode, the flash fires at whatever power setting you specify for the flash (full power, half power, and so forth) and you calculate the manual exposure yourself, using a flash meter or various formulas using guide numbers (values that can be used to calculate exposure by dividing them by the distance to the subject).

Electronic flash units may have firing modes, too, in addition to exposure modes. The most common modes you'll encounter are these (not all are available with every digital SLR camera, and some models may have additional modes):

- **Always flash.** Any time you flip up the electronic flash on your camera, or connect an external flash, the flash will fire as the exposure is made.

- **Autoflash.** The flash fires only when there isn't enough light for an exposure by available light.

- **Fill flash.** The flash fires in low light levels to provide the main source of illumination, and in brighter conditions such as full sunlight or backlighting, to fill in dark shadows.

- **Red-eye flash.** With some dSLR models, a pre-flash fires before the main flash, contracting the pupils of your human or animal subjects, and reducing the chance of red-eye effects. (Others use an AF-assist lamp on the camera itself.)

- **Rear sync/front sync.** As described earlier, these options control whether the flash fires at the beginning or end of an exposure.

- **Wireless/remote sync.** In this mode, the camera triggers an external flash unit using a wireless sync unit. As with all such remote controls, a selection of perhaps four or more channels are available so you can choose one that's not in use by another nearby photographer who also happens to be using wireless control. Unless you're covering a major event, you probably won't experience many conflicts when using wireless control. Some remote control/slave flash setups trigger by optical means: the camera's flash is detected and sets off the remote flash. You may be able to set the camera flash to low power so the main illumination comes from the remote.

Lighting Equipment

You can choose from the existing light (modified with reflectors if need be), electronic flash units (or incandescent illumination such as photoflood lights), high-intensity lamps, or other auxiliary lighting. If you want to be pedantic, you can also shoot close-ups with light emitted by the subject itself, so if you have some lighted candles or lightning bugs to capture, knock yourself out.

Working with Existing Light

The existing light that already illuminates your subject may be the most realistic and easy-to-use option for close-up photos, as long as you're prepared to manipulate the light a bit to achieve the best effect. That's particularly true when you're shooting on location or outdoors. Making the most of the existing light means not having to set up special light sources or possibly locating a source of electrical power (not always an option outdoors).

Available light can be contrasty, providing enough illumination for the highlights of your subject, but with not enough light to open up the shadows. It might also be too dim overall, or too bright. You can usually fix these failings with a variety of reflectors and light blockers. You can buy these tools if you like, but it's often just as easy to make your own in the exact shape and size that you need. As a bonus, you can use reflectors and light attenuating accessories with your electronic flash units, too.

The next sections detail some recommended tools and what you can do with them.

White Cardboard

The best and most versatile light tool is a piece of white posterboard. It's cheap, disposable, and you can do dozens of things with it. Here are a few ideas on using white cardboard:

- **Portability.** Fold it up into quarters to make it more compact. Having a few creases won't hinder your cardboard's utility as a reflector in the least. You can unfold only as much as you need for your photograph.

- **Go colorful.** Use white shades, but mix in some colors. Most of the time you'll want a neutral white board, but you can carry orange and light-blue versions to warm up or cool down the shadows of your picture. You might find, for example, that the highlights of an object are illuminated by diffuse sunlight, but the shadows are filled in by reflections off a bluish object. An orange reflector can balance the color quickly. Poster boards can double as a background, too.

- **Block the light.** Use the cardboard to block light, too. While you'll generally use the cardboard to reflect light onto your subject, you'll find you can use it to block direct sunlight and create soft shadows where none existed before.

- **Use your cookies.** Cut holes in the cardboard for special effects. Motion-picture lighting often uses "cookies" to create special lighting shapes and effects. What? You thought those shadows on the wall were cast by *real* Venetian blinds? Use your imagination and cut some holes in your cardboard to create a halo around your subject or some other effect. Move the cardboard closer to the subject to make the highlight harder, and farther away to soften it.

Foamboard

Foamboard can make a great soft-light reflector, especially when you're shooting in your home studio. Those ultra-light boards of plastic foam sandwiched between paper or plastic sheets are commonly used to mount photos or to construct exhibits. They make great reflectors, too, especially if you need larger sizes that are rigid but also light in weight. They don't fold easily, and are probably more useful for portraits and group pictures, but if you have a small hunk of foamboard, keep it handy.

Aluminum Foil

Aluminum foil provides a bright, contrasty reflection that can sharpen up soft lighting (if that's what you need). Tape aluminum foil to a piece of white cardboard (use the reverse side of your main cardboard reflector if you want). If you need lighting with a little less snap, just reverse the cardboard to expose the non-aluminum side. Be sure to crinkle the aluminum foil so it will reflect the light evenly; you don't want shiny hot spots.

Mylar Sheets

Those space blankets can do more than keep you warm at your campsite or in an emergency. They can be used as a handy high-contrast reflector, yet still folded up and carried in a pocket of your gadget bag. Every photographer should get two: one for the emergency kit in the trunk of your car, and another for photographic purposes. Windshield sun shades make good reflectors, too. They usually have a silver reflective side, a darker/matte side, and fold up for portability.

Umbrellas

Photographic umbrellas are used in the studio, and available in white, gold, or silver surfaces. You can buy them with a black outer covering, which keeps light from being "wasted" by passing through the umbrella, away from your subject. However, the translucent type, often called "shoot

Figure 7.8 Purse- or pocket-sized umbrellas are perfect for macro shooting in the field.

Figure 7.9 Tents are great for photographing shiny objects, like this glazed ceramic container.

through" umbrellas, are useful, too, as you can turn them around to serve as an extra-soft diffuser. While conventional photographic umbrellas are compact enough to carry with you on outside close-up shooting expeditions, outside the studio environment I favor white purse-sized rain umbrellas, like the one shown in Figure 7.8, that telescope down to six or eight inches in length, yet unfold to a respectable size. You can use these as a reflector to bounce light onto your subject, or as a translucent diffuser to soften the light that passes through them (perfect for use in bright sunlight when you can't find any open shade). And if it rains, you won't get wet!

Tents

If you're photographing a very shiny object, a light tent may be the best tool to even out your lighting. Photographic tents are usually made of a translucent material and are placed right over the object you're photographing. Illuminate the tent from all sides, shoot through a hole in the tent provided for that purpose, and you can get soft, even lighting without bright spots, even with relatively shiny subjects. Figure 7.9 shows the view inside a typical small lighting tent.

Black Cardboard or Cloth

Sometimes you need to block light from a glaring source to produce softer illumination. A sheet of black poster board works, although even black board reflects some light. For extra light absorption, consider a small piece of black velour. If you're trying to take photos of seashells in their natural habitat, a black cloth will help.

Working with Electronic Flash

The electronic flash built into your digital camera may work fine for quick and dirty pictures, but sometimes it will provide illumination that is too bright, too harsh, and might not cover your subject completely. This is because built-in flash is typically "aimed" to light subjects that are at least a few feet away from the camera. It's more difficult to visualize how electronic flash illumination

will look in the finished picture. While available light provides an automatic "preview," with electronic flash, what you get may be a total surprise. On the plus side, the short duration of electronic flash will freeze any moving subject this side of a hummingbird if it is the predominant light source and you are close enough to the subject to minimize lighting from other sources.

Electronic flash is most applicable to macro work indoors, especially if you plan to work with several lights and set them up on stands. Outdoors, you might be limited to one or two battery-operated flash units. Here are your choices for electronic flash used for close-up photography:

- **Built-in flash.** This is the flash unit built into your digital camera. You'll find that in extreme close-ups, the light it produces will look unnatural and may not illuminate your subject evenly. You probably can't aim the built-in flash in any meaningful way, and you may find that the lens casts a shadow on your close-up subject.

- **External flash units.** Many digital cameras have a connector for attaching an external flash unit. These can be inexpensive flash units designed for conventional film cameras, or more elaborate (and more costly) studio flash devices with modeling lights, which are extra incandescent lamps that mimic the light that will be emitted by the flash. These external flash units don't have to be physically connected to the camera; Canon, Nikon, and Sony all offer wireless operation, either using a camera's built-in flash (if it has one) to trigger off-camera units, or with an external flash mounted on or connected to the camera and then used to trigger the additional flash. Wireless flash works differently for each brand, but you'll find information to get you started in each of my guidebooks written for your specific camera.

- **Slave flash.** These are electronic flash units with light-detecting circuitry that automatically trigger them when another flash goes off. You can also purchase add-on slave detectors that set off any flash. Slaves are useful when you want to use two or more electronic flash. Keep in mind that you may need to disable your main flash's pre-flash feature to avoid tripping the slave too early. Some slave triggers have a so-called "digital" mode, which tells them to wait for the main flash burst before firing, and to ignore the pre-flash.

- **Ringlights.** These are specialized electronic flash units made especially for close-up photography. They have circular tubes that fit around the outside of a camera lens, providing very even lighting for close-ups. Ringlights are generally a professional tool used by those who take many close-ups, particularly with interchangeable lens cameras. If you can afford an SLR digital camera, and do enough close-up work to justify a ringlight, they make a great accessory.

REFLECTORS

If you're forced to use your camera's built-in flash, you still may be able to achieve acceptable lighting. Try placing a reflector or two just outside the picture area at the back and sides of the subject. A piece of white cardboard or even a handkerchief might be enough. The reflector bounces light from the camera's flash back onto the subject, providing a more even, softer light than you'd get with the main flash alone.

Painting with Light

I think you'll find this project a lot of fun, because there are lots of different effects you can achieve. You can use either electronic flash for this (probably best for "large" paintings) or an incandescent source as small as a flashlight (better for painting smaller subjects and scenes).

Painting with light is just that: using a light source to daub illumination over a dark subject during a time exposure. You can use this technique to provide good lighting for architectural subjects that are too large or too dark even for a long exposure with your camera mounted on a tripod.

Here's a quick description of how to paint with light:

1. **Select a suitable subject in a dark environment.** Choose a subject that has insufficient illumination, or which is illuminated unevenly. If possible, select an environment that has few, if any, strong lights pointed directly at the camera. External security lights on the building, for example, should be doused if they're pointing toward the lens. Some light sources, such as city lights in the background, won't hurt anything and may even add interest. For the photo shown in Figure 7.10, I didn't have any choice; the lights illuminating the county courthouse weren't under my control. My main problem was that the lights illuminated only the middle portion of the building. The two ends were rather dimly lit. It helped that there was no breeze, too, so the flags in the photo weren't blurred during the long exposure.

Figure 7.10 Painting with light can evenly illuminate a photo that would otherwise be murky in spots.

2. **Set up on a tripod.** I mounted my camera on a tripod and composed the photograph.

3. **Shoot some test exposures.** You don't want to have to repeat the "painting" step too many times! After some tests, I set the aperture of the lens so it was appropriate for a two-minute time exposure. Make sure your camera has this capability! In my case, the maximum preset time exposure my camera allows is 30 seconds, so I had to use the locking capability of a plug-in remote control. Your camera may have an infrared remote control, which allows clicking once to open the shutter, which then remains open until you click the remote control a second time. (This is called a "bulb" exposure in photo parlance.) You may have to experiment with the right f/stop, but you'll want a fairly long exposure in order to give you time to do your painting. Ten to 20 seconds to a minute or two is the exposure to shoot for. I used two minutes. Setting your camera to a lower ISO rating (ISO 64 to 100) will let you use longer exposures but, of course, will reduce the amount of exposure from your external flash units.

4. **Begin the time exposure.** When everything was set, I started the time exposure. I had waited until the dead of night, minimizing the chance of passing car headlights intruding on the painting procedure.

5. **Begin painting.** Then, I had an assistant move into the scene. Because the light from the building's main illumination was relatively bright, my helper had to move quickly and *keep* moving. Otherwise, his body would have been imaged in the photo just from the available light. You'll find that with a two-minute time exposure, a rapidly moving person won't register at all as long as you keep spill light from your electronic flash from hitting the person.

6. **Use repeated flashes.** Keeping the photo "painter's" body between the camera and external electronic flash, I had the assistant trip the flash to expose the left part of the building for several flashes, then race over to the other side to add another flash to the right side. If you try this, move around and expose other parts with additional flash exposures. Because your camera's lens is open, it will register each of these exposures.

7. When the painting was finished, I closed the shutter, ending the time exposure.

8. Check your results on your camera's LCD screen and repeat the process, making appropriate changes to improve your photo. You might want to use a longer exposure, more flashes, or work harder to keep yourself or your assistant from showing up in the picture.

TIP FROM THE PROS: HANDLING MIXED COLORS

Because part of the exposure was made from the existing illumination, which is considerably warmer in color than the illumination from the electronic flash, I had to use a special orange filter over the flash head. You can buy these ready-made for some electronic flash units, or you can make one of your own using orange filter material. If you can find a filter equivalent to a Wratten #85B filter, you're all set. If you can reduce the ambient illumination so it doesn't contribute to the exposure at all, you won't need the orange filter. Or, you can even go for an interesting mixed-light effect with both the bluish flash and orange-tinted incandescent lighting in the same image.

There are many variations on this theme. Here are a few to play with:

- Alternate flashes using multi-colored gels over your unit, painting your building with a rainbow of different colored lights.

- Paint only part of the structure, allowing the rest to remain in shadow. This is a good way of disguising the less-photogenic portions of a building.

- Instead of an electronic flash pointed *away* from the camera, use a flashlight pointed *toward* the camera, and "write" with it. Small beams, such as those provided by penlights, work best. Trace the outline of a portion of the building, draw a human figure, or create any other kind of light writing you want.

Part II

Exploring
New Tools

No feature discussed in the next three chapters even existed in a form the average photographer could use five years ago. Live previewing of images on the back-panel LCD was something that point-and-shoot cameras did routinely, but was impossible with any camera in the dSLR world. If you wanted movies, you tucked a camcorder in your camera bag alongside your digital SLR, and both Wi-Fi and GPS tagging were pro features that required specialized equipment. If you had a particular application that helped you with your photography, you had to lug a laptop computer and endure the slow boot-up process each time you wanted to use it.

Those days are long past. In this next part, I'm going to devote a trio of very short chapters to introducing these new features. In Chapter 8, you'll discover some things about live view and movie making that you might not have thought of. Chapter 9 introduces you to some of the things you can do with Wi-Fi and GPS, while Chapter 10 concentrates on the newest technologies of all—smartphone/tablet computer apps that can travel with you anywhere. In Chapter 11, you'll find information about some great gadgets that expand the capabilities of your dSLR.

8

Live View and Movies

Digital point-and-shoot cameras have always had live preview to accompany their (generally) poor optical viewfinders—and today, many of these cameras offer only the live view option and lack an optical viewfinder entirely. Initially, live view was slow to catch on among experienced SLR users (especially those dating from the film era). While at first dSLR veterans didn't really miss live view, it was at least, in part, because they didn't have it and couldn't miss what they never had. After all, why would you eschew a big, bright, magnified through-the-lens optical view that showed depth-of-field fairly well, and which was easily visible under virtually all ambient light conditions? LCD displays, after all, were small, tended to wash out in bright light, and didn't really provide you with an accurate view of what your picture was going to look like.

There were technical problems, as well. Real-time previews theoretically disabled a dSLR's autofocus system, as focus was achieved by measuring contrast through the optical viewfinder, which is blocked when the mirror is flipped up for a live view. Extensive previewing had the same effect on the sensor as long exposures: the sensor heated up, producing excess noise. Pointing the camera at a bright light source when using a real-time view could damage the sensor. The list of potential problems goes on and on.

But all those problems have been conquered. All dSLRs introduced in the last few years have back-panel LCDs that can be viewed under a variety of lighting conditions and from wide-ranging angles, so you don't have to be exactly behind the display to see it clearly. (See Figure 8.1.) They offer a 100 percent view of the sensor's capture area (optical viewfinders may show as little as 95 percent of the sensor's field of view). Large LCDs are big enough to allow manual focusing—but, with many cameras, if you want to use automatic focus instead, there's an option that allows briefly flipping the mirror back down for autofocusing, interrupting live view, and then restoring the sensor preview image after focus is achieved. Some dSLRs have sensors with special pixels embedded that allow fast phase detect focusing when using live view for stills or movies, as described in

Figure 8.1
Live view really shines on the large LCD of modern dSLRs.

Chapter 5. You still have to avoid pointing your dSLR at bright light sources (especially the sun) when using live view, but the real-time preview can be used for fairly long periods—up to half an hour—without frying the sensor. (Most cameras issue a warning when the sensor starts to overheat.)

Live View Features

You may not have considered just what you can do with live view, if you've been letting this feature lie fallow in your digital SLR. But once you've played with it, you'll discover dozens of applications for this capability, as well as a few things that you can't do. Here's a list of live view considerations:

- **Preview your images on a TV.** Connect your digital SLR to a television using the video cable, and you can preview your image on a large screen.

- **Preview remotely.** Extend the cable between the camera and TV screen, and you can preview your images some distance away from the camera.

- **Shoot from your computer.** You may be able to use software to control your camera from your computer, so you can preview images and take pictures without physically touching the digital SLR.

- **Continuous shooting.** You can shoot bursts of images using live view, but, with some cameras, all shots will use the focus and exposure setting established for the first picture in the series.

- **Shoot from tripod or hand-held.** Of course, holding the camera out at arm's length to preview an image is poor technique, and will introduce a lot of camera shake. If you want to use live view for hand-held images, use an image-stabilized lens and/or a high shutter speed. A tripod is a better choice if you can use one.

Figure 8.2
Live view and swiv-
eling/tilting LCDs
allow shooting from
multiple viewpoints.

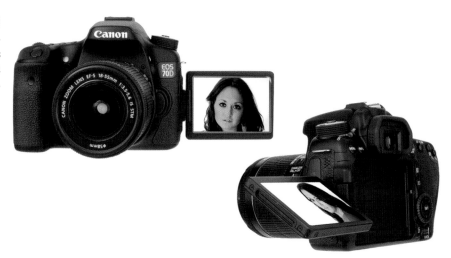

■ **Choice of angles.** When you're shooting stills through your digital SLR's optical viewfinder, the camera must generally be held up to your eye, so your viewpoint is limited to perspectives you can physically manage. In live view mode, you can see the preview image or movie capture on the back-panel LCD, and can position the camera higher, lower, or in any location where you can still see the LCD. Cameras with adjustable LCD panels (see Figure 8.2) let you shoot at waist level, elevate it to shoot as if you were using a periscope, or reverse the LCD entirely for self-portraits.

■ **Watch your power.** Live view uses a lot of juice and will deplete your battery rapidly. One vendor (Canon) estimates that you can get 130 to 170 shots per battery when using live view, depending on the temperature. The optional AC adapter is a useful accessory.

Shooting Movies

The most recent digital SLRs can shoot full HDTV movies with monaural sound at 1,920 × 1,080 resolution. Your camera may also be able to shoot stereo sound using built-in stereo microphones, or, if only a monaural mic is built in, cameras may allow you to plug in an accessory stereo microphone. In some ways, the camera's movie mode is closely related to the digital SLR's live view still mode. In fact, digital SLRs use live view type imaging to show you the video clip on the LCD as it is captured. Many of the functions and setting options are the same, so the functions and setting options discussed elsewhere in this book will serve you well as you branch out into shooting movies with your camera.

You'll want to keep the following things in mind before you start:

■ **Choose your resolution.** The typical movie-capable digital SLR can capture movies in Full High Definition (1,920 × 1,080 pixel) resolution, Standard HD (1,080 × 720 pixel) resolution, and, sometimes, other resolutions such as 720 × 480 pixel resolution.

■ **You can still shoot stills.** With most cameras, you can press the shutter release all the way down at any time while filming movies in order to capture a still photo. Still photos are usually stored as separate files from the movie clips.

■ **Use the right card.** You'll want to use a fast memory card to store your clips; slower cards may not work properly. Chose a memory card with at least 4GB capacity (8GB or 16GB are even better). If the card you are working with is too slow, a five-level thermometer-like "buffer" indicator may appear at the right side of the LCD, showing the status of your camera's internal memory. If the indicator reaches the top level because the buffer is full, movie shooting will stop automatically.

■ **Use a fully charged battery.** Typically, a fresh battery will allow about one hour of filming at normal (non-winter) temperatures.

■ **Image stabilizer uses extra power.** If your lens has an image stabilizer, it will operate at all times (not just when the shutter button is pressed halfway, which is the case with still photography) and use a considerable amount of power, reducing battery life. You can switch the IS feature off to conserve power. Mount your camera on a tripod or monopod, and you don't need IS anyway.

■ **Silent running.** You can connect your digital SLR to a television or video monitor while shooting movies, and see the video portion on the bigger screen as you shoot. However, the sound will not play—that's a good idea, because, otherwise, you could likely get a feedback loop of sound going. The sound will be recorded properly and will magically appear during playback once shooting has concluded.

MOVIE TIME

I've standardized on 16GB memory cards when I'm shooting movies; these cards will give you 49 minutes of recording at 1,920 × 1,080 Full HD resolution. (Figure 330MB per minute of capture.) A 4GB card, in contrast, offers just 12 minutes of shooting at the Full HD setting. With many cameras, the actual size of a single video clip may be limited to 2GB and 29 minutes, 59 seconds, for technical reasons.

Capturing Video/Sound

To shoot movies with your camera, just follow these typical steps:

1. **Set Movie Recording Size.** Choose 1,920 × 1,080 (Full HD) quality, or another resolution.

2. **Activate live view.** Press the button or control on your camera to start live view mode.

3. **Focus.** Use the autofocus or manual focus techniques for your camera to achieve focus on your subject.

4. **Begin filming.** Press the Movie button or other control to begin shooting. A red dot or similar indicator will appear on the LCD screen to show that video/sound are being captured. (See Figure 8.3.) The memory card access lamp also flashes during shooting.

5. **Stop filming.** Press the Movie control again to stop filming.

6. **Start Playback.** Press the Playback button to review thumbnails of the stills and movies you've captured. Movie clips show up the same as still photos, but with an icon to indicate that it is a video clip. With most cameras, a series of video controls appear at the bottom of the frame. You can choose options like Play, Slow Motion, First Frame, Previous Frame, Next Frame, Last Frame, or Exit.

7. **View your clip.** Once you've highlighted a clip you'd like to review, press your camera's movie activation button and the clip begins. An indicator will show the progress/time elapsed for the clip. Press the activation button again to stop at any time.

Figure 8.3
A lot of information is shown on the screen as you begin shooting a movie clip.

More on Video Resolution

As I noted earlier, there are three key resolutions for video:

■ **HD Video 720.** This is a high-definition video standard that has dimensions of 720 × 1,280 pixels. This is approximately equivalent to a one-megapixel still photo in resolution, and produces smaller video files.

■ **HD Video 1080.** This is a high-definition video standard that has dimensions of 1,080 × 1,920 pixels. This is approximately equivalent to a two-megapixel still photo in resolution. You will not see a huge difference between 1080 and 720 resolutions on a standard HD television set.

■ **SD Video.** Standard definition video was the traditional video before high-definition video. SD video has a resolution of 720 × 480 pixels in the U.S. and other countries that use what is called the NTSC standard. Other countries use slightly different standards, such as PAL, that may include a slight increase in resolution.

Selecting a Frame Rate

Frame rate refers to how many frames or fields per second are captured while you are recording video. The common standard for video in the United States is 30 frames/fields per second (fps), although the European standard is 25 frames/fields per second. Because of this difference, people sometimes refer to the U.S. standard as NTSC high-definition video and the European standard as PAL high-definition video, but this is incorrect as those standards only refer to standard definition video and technically don't apply to HD.

You will typically find up to three different frame rates for shooting video:

- **30 fps.** This has long been a standard for video. Technically, broadcast video is at 29.97 fps, and many cameras will give precisely that. For the average photographer shooting video, that technicality is not going to make much of a difference. A rate of 30 frames per second is exactly that, 30 individual frames shot per second of video. A rate of 30 frames per second gives you an appearance that definitely looks like video that you would see on television.

- **24 fps.** Theatrical movies are shot both with film and video typically at 24 frames per second. This has long been a standard for the film that was used for movies. This has a slightly different look than 30 fps, and many people feel this tends to give video more of the look of a movie. Where you will see this is in the way that motion is recorded. Higher frame rates record motion more smoothly, but it is that less smooth recording of movement of movies that some people like and so choose 24 fps.

- **60 fps.** The higher frames per second of 60 fps gives an even smoother movement to video, but it comes at a cost. Remember that this means 60 individual little pictures are being shot and recorded per second which is a lot of data to go through the camera and record to the memory card. Because of this, 60 fps is often only available at 720 HD resolution. Some people like to shoot 60 fps and then use it at 30 fps when they edit the video. This creates a bit of a slow-motion effect because it shows everything at half speed.

Progressive Scan vs. Interlaced Scan

As you probably know, video images as you see them on your TV or monitor consist of a series of lines which are displayed, or *scanned*, at a fixed rate. When captured by your camera, the images are also grabbed, using what is called a *rolling shutter*, which simply means that the image is grabbed one line at a time at the same fixed rate that will be used during playback. (There is a more expensive option, not used in the camera, called a *global shutter* that captures all the lines at one time.)

Line-by-line scanning during capture and playback can be done in one of two ways. With *interlaced scanning*, odd-numbered lines (lines 1, 3, 5, 7,... and so forth) are captured with one pass, and then the even-numbered lines (2, 4, 6, 8,... and so forth) are grabbed. With the AVCHD 60i format, roughly 60 pairs of odd/even line scans, or 60 *fields* are captured each second. (The actual number is 59.94 fields per second.) Interlaced scanning was developed for and works best with analog display systems such as older television sets. It was originally created as a way to reduce the amount of

bandwidth required to transmit television pictures over the air. Modern LCD, LED, and plasma-based HDTV displays must de-interlace a 1080i image to display it. (See Figure 8.4.)

Newer displays work better with a second method, called *progressive scanning* or *sequential scanning.* Instead of two interlaced fields, the entire image is scanned as consecutive lines (lines 1, 2, 3, 4,… and so forth). This happens at a rate of about 60 frames per second (not fields). (All these numbers apply to the NTSC television system used in the United States, Canada, Japan, and some other countries; other places use systems like PAL, where the nominal scanning figures are 50 fps.)

One problem with interlaced scanning appears when capturing video of moving subjects. Half of the image (one set of interlaced lines) will change to keep up with the movement of the subject while the other interlaced half retains the "old" image as it waits to be refreshed. Flicker or *interline twitter* results. That makes your progressive scan options of 60p or 24p a better choice for action photography.

Which to Choose?

If you're shooting a relatively static image, you can choose 60p 28M for the best combination of resolution and image quality, if you can accept the high demands of a 28 Mbps transfer rate, and have a TV that can display 60p video (otherwise the video will be converted before output to the television). Use 60i 24M or 60i 17M if you know you'll be mixing your video with existing 60i footage, or if you happen to be shooting for NBC, CBS, or The CW. (Ha!)

Figure 8.4
The inset shows how lines of the image alternate between odd and even in an interlaced video capture.

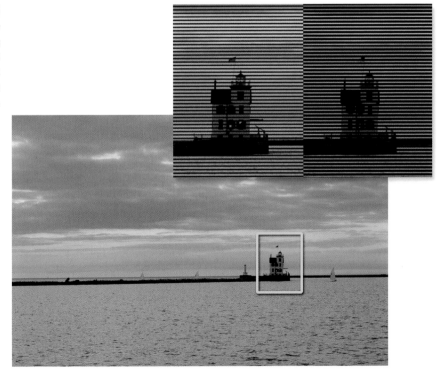

Tips for Shooting Better Video

Producing good-quality video is more complicated than just buying and using good equipment. There are techniques that make for gripping storytelling and a visual language the average person is very used to, but also pretty unaware of. While this book can't make you a professional videographer in half a chapter, there is some advice I can give you that will help you improve your results with the camera.

Depth-of-Field and Video

Have you wondered why professional videographers have gone nuts over still cameras that can also shoot video? The producers of *Saturday Night Live* could afford to have Alex Buono, their director of photography, use the niftiest, most expensive high-resolution video cameras to shoot the opening sequences of the program. Instead, Buono opted for a pair of digital SLR cameras. One thing that makes digital still cameras so attractive for video is that they have relatively large sensors, which provide improved low-light performance and results in the oddly attractive reduced depth-of-field, compared with most professional video cameras.

Figure 8.5 provides a comparison of the relative size of sensors. The typical size of a professional video camera sensor is shown at lower left. The APS-C sensor used in many digital SLRs is shown just northeast of it. You can see that it is much larger, especially when compared with the sensor found in the typical point-and-shoot camera shown at right. Compared with the sensors used in

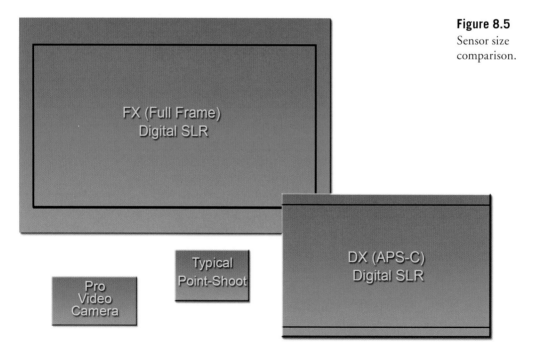

Figure 8.5

Sensor size comparison.

many pro video cameras and the even smaller sensors found in the typical consumer camcorder, the typical dSLR's image-grabber is much larger.

A larger sensor calls for the use of longer focal lengths to produce the same field of view, so, in effect, a larger sensor has reduced depth-of-field. And *that's* what makes these cameras attractive from a creative standpoint. Less depth-of-field means greater control over the range of what's in focus. Your dSLR, with its larger sensor, has a distinct advantage over consumer camcorders in this regard, and even does a better job than many professional video cameras.

Zooming and Video

When shooting still photos, a zoom is a zoom is a zoom. The key considerations for a zoom lens used only for still photography are the maximum aperture available at each focal length ("How *fast* is this lens?"), the zoom range ("How far can I zoom in or out?"), and its sharpness at any given f/stop ("Do I lose sharpness when I shoot wide open?").

When shooting video, the priorities may change, and there are two additional parameters to consider. The first two I listed, lens speed and zoom range, have roughly the same importance in both still and video photography. Zoom range gains a bit of importance in videography, because you can always/usually move closer to shoot a still photograph, but when you're zooming during a shot, most of us don't have that option (or the funds to buy/rent a dolly to smoothly move the camera during capture). But, oddly enough, overall sharpness may have slightly less importance under certain conditions when shooting video. That's because the image changes in some way many times per second (24/30/60 times per second), so any given frame doesn't hang around long enough for our eyes to pick out every single detail. You want a sharp image, of course, but your standards don't need to be quite as high when shooting video.

Here are the remaining considerations:

- **Zoom lens maximum aperture.** The speed of the lens matters in several ways. A zoom with a relatively large maximum aperture lets you shoot in lower light levels, and a big f/stop allows you to minimize depth-of-field for selective focus. Keep in mind that the maximum aperture may change during zooming. A lens that offers an f/3.5 maximum aperture at its widest focal length, may provide only f/5.6 worth of light at the telephoto position.

- **Zoom range.** Use of zoom during actual capture should not be an everyday thing, unless you're shooting a kung-fu movie. However, there are effective uses for a zoom shot, particularly if it's a "long" one from extreme wide angle to extreme close-up (or vice versa). Most of the time, you'll use the zoom range to adjust the perspective of the camera *between* shots, and a longer zoom range can mean less trotting back and forth to adjust the field of view. Zoom range also comes into play when you're working with selective focus (longer focal lengths have less depth-of-field), or want to expand or compress the apparent distance between foreground and background subjects. A longer range gives you more flexibility.

- **Linearity.** Interchangeable lenses may have some drawbacks, as many photographers who have been using the video features of their digital SLRs have discovered. That's because, unless a lens is optimized for video shooting, zooming with a particular lens may not necessarily be linear. Rotating the zoom collar manually at a constant speed doesn't always produce a smooth zoom. There may be "jumps" as the elements of the lens shift around during the zoom. Keep that in mind if you plan to zoom during a shot, and are using a lens that has proved, from experience, to provide a non-linear zoom. (Unfortunately, there's no easy way to tell ahead of time whether you own a lens that is well-suited for zooming during a shot.)

Keep Things Stable and on the Level

Camera shake's enough of a problem with still photography, but it becomes even more of a nuisance when you're shooting video. While an in-camera or in-lens image-stabilization feature can help minimize this, it can't work miracles. Placing your camera on a sturdy tripod will work much better than trying to hand-hold it while shooting.

Shooting Script

A shooting script is nothing more than a coordinated plan that covers both audio and video and provides order and structure for your video. A detailed script will cover what types of shots you're going after, what dialogue you're going to use, audio effects, transitions, and graphics.

Storyboards

A storyboard is a series of panels providing visuals of what each scene should look like. While the ones produced by Hollywood are generally of very high quality, there's nothing that says drawing skills are important for this step. Stick figures work just fine if that's the best you can do. The storyboard just helps you visualize locations, placement of actors/actresses, props and furniture, and also helps everyone involved get an idea of what you're trying to show. It also helps show how you want to frame or compose a shot. You can even shoot a series of still photos and transform them into a "storyboard" if you want, such as in Figure 8.6.

Storytelling in Video

Today's audience is used to fast-paced, short-scene storytelling. In order to produce interesting video for such viewers, it's important to view video storytelling as a kind of shorthand code for the more leisurely efforts print media offers. Audio and video should always be advancing the story. While it's okay to let the camera linger from time to time, it should only be for a compelling reason and only briefly.

It only takes a second or two for an establishing shot to impart the necessary information. For example, many of the scenes for a video documenting a model being photographed in a Rock and Roll music setting might be close-ups and talking heads, but an establishing shot showing the studio where the video was captured helps set the scene.

Figure 8.6
A storyboard is a series of simple sketches or photos to help visualize a segment of video.

Provide variety too. Change camera angles and perspectives often and never leave a static scene on the screen for a long period of time. (You can record a static scene for a reasonably long period and then edit in other shots that cut away and back to the longer scene with close-ups that show each person talking.)

When editing, keep transitions basic! I can't stress this one enough. Watch a television program or movie. The action "jumps" from one scene or person to the next. Fancy transitions that involve exotic "wipes," dissolves, or cross fades take too long for the average viewer and make your video ponderous.

Composition

In movie shooting, several factors restrict your composition, and impose requirements you just don't always have in still photography (although other rules of good composition do apply). Here are some of the key differences to keep in mind when composing movie frames:

- **Horizontal compositions only.** Some subjects, such as basketball players and tall buildings, just lend themselves to vertical compositions. But movies are shown in horizontal format only. If you want to show how tall your subject is, it's often impractical to move back far enough to show him full-length. You really can't capture a vertical composition. Tricks like getting down on the floor and shooting up at your subject can exaggerate the perspective, but aren't a perfect solution.

- **Wasted space at the sides.** What do you do when you want to capture the 2,080-foot Tokyo Sky Tree, the world's second-tallest structure (behind the 2,717-foot Burj Kalifa in Dubai)? If you zoom in as outlined by the yellow box in Figure 8.7 you're still forced to leave a lot of empty space on either side. Even zooming out a bit doesn't do justice to the enormous tower. You have to be creative, back off even further, or pan to capture really tall subjects.

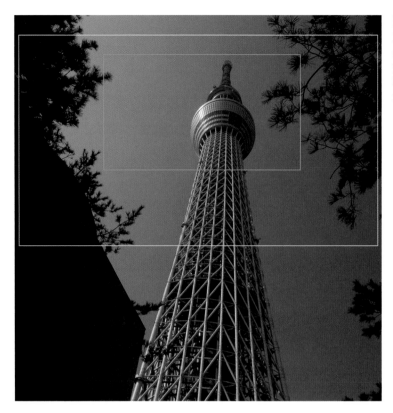

Figure 8.7
Movie shooting requires you to fit all your subjects into a horizontally oriented frame.

- **Seamless (or seamed) transitions.** Unless you're telling a picture story with a photo essay, still pictures often stand alone. But with movies, each of your compositions must relate to the shot that preceded it, and the one that follows. It can be jarring to jump from a long shot to a tight close-up unless the director—you—is very creative. Another common error is the "jump cut" in which successive shots vary only slightly in camera angle, making it appear that the main subject has "jumped" from one place to another. (Although everyone from French New Wave director Jean-Luc Goddard to Guy Ritchie—Madonna's ex—have used jump cuts effectively in their films.) The rule of thumb is to vary the camera angle by at least 30 degrees between shots to make it appear to be seamless. Unless you prefer that your images flaunt convention and appear to be "seamy."

- **The time dimension.** Unlike still photography, with motion pictures there's a lot more emphasis on using a series of images to build on each other to tell a story. Static shots where the camera is mounted on a tripod and everything is shot from the same distance are a recipe for dull videos. Watch a television program sometime and notice how often camera shots change distances and directions. Viewers are used to this variety and have come to expect it. Professional video productions are often done with multiple cameras shooting from different angles and positions. But many professional productions are shot with just one camera and careful planning. You can do just fine with your dSLR.

Here's a look at the different types of commonly used compositional tools:

- **Establishing shot.** Much like it sounds, this type of composition, as shown in Figure 8.8, establishes the scene and tells the viewer where the action is taking place. Let's say you're shooting a video of your offspring's move to college; the establishing shot could be a wide shot of the campus with a sign welcoming you to the school in the foreground. Another example would be for a child's birthday party; the establishing shot could be the front of the house decorated with birthday signs and streamers or a shot of the dining room table decked out with party favors and a candle-covered birthday cake. Or, in Figure 8.8, I wanted to show the studio where the video was shot.

- **Medium shot.** This shot is composed from about waist to head room (some space above the subject's head). It's useful for providing variety from a series of close-ups and also makes for a useful first look at a speaker. (See Figure 8.9.)

- **Close-up.** The close-up, usually described as "from shirt pocket to head room," provides a good composition for someone talking directly to the camera. Although it's common to have your talking head centered in the shot, that's not a requirement. In Figure 8.10 the subject was offset to the right. This would allow other images, especially graphics or titles, to be superimposed in the frame in a "real" (professional) production. But the compositional technique can be used with videos, too, even if special effects are not going to be added.

- **Extreme close-up.** When I went through broadcast training, this shot was described as the "big talking face" shot and we were actively discouraged from employing it. Styles and tastes change over the years and now the big talking face is much more commonly used (maybe people are better looking these days?) and so this view may be appropriate. Just remember, your dSLR is capable of shooting in high-definition video and you may be playing the video on a high-def TV; be careful that you use this composition on a face that can stand up to high definition. (See Figure 8.11.)

- **"Two" shot.** A two shot shows a pair of subjects in one frame. They can be side by side or one in the foreground and one in the background. (See Figure 8.12.) This does not have to be a head-to-ground composition. Subjects can be standing or seated. A "three shot" is the same principle except that three people are in the frame.

- **Over-the-shoulder shot.** Long a composition of interview programs, the "over-the-shoulder shot" uses the rear of one person's head and shoulder to serve as a frame for the other person. This puts the viewer's perspective as that of the person facing away from the camera. (See Figure 8.13.)

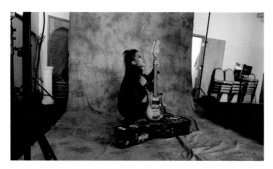

Figure 8.8 An establishing shot sets the stage for your video scene.

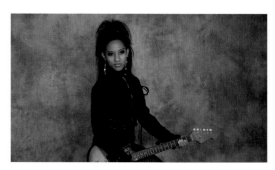

Figure 8.9 A medium shot is used to bring the viewer into a scene without shocking them. It can be used to introduce a character and provide context via their surroundings.

Figure 8.10 A close-up generally shows the full face with a little head room at the top and down to the shoulders at the bottom of the frame.

Figure 8.11 An extreme close-up is a very tight shot that cuts off everything above the top of the head and below the chin (or even closer!). Be careful using this shot since many of us look better from a distance!

Figure 8.12 A "two-shot" features two people in the frame. This version can be framed at various distances such as medium or close up.

Figure 8.13 An "over-the-shoulder" shot is a popular shot for interview programs. It helps make the viewers feel like they're the one asking the questions.

Lighting for Video

Much like in still photography, how you handle light pretty much can make or break your videography. Lighting for video can be more complicated than lighting for still photography, since both subject and camera movement is often part of the process.

Lighting for video presents several concerns. First off, you want enough illumination to create a useable video. Beyond that, you want to use light to help tell your story or increase drama. Let's take a better look at both.

Illumination

You can significantly improve the quality of your video by increasing the light falling in the scene. This is true indoors or out, by the way. While it may seem like sunlight is more than enough, it depends on how much contrast you're dealing with. If your subject is in shadow (which can help them from squinting) or wearing a ball cap, a video light can help make them look a lot better.

Figure 8.14 Inexpensive LED video lights can provide fill-in illumination.

Lighting choices for amateur videographers are a lot better these days than they were a decade or two ago. An inexpensive incandescent video light, which will easily fit in a camera bag, can be found for $15 or $20. You can even get a good-quality LED video light like the one shown in Figure 8.14, for less than $100. Some electronic flashes have built-in video lights, like the Canon flash shown in Figure 8.15. Work lights sold at many home improvement stores can also serve as video lights since you can set the camera's white balance to correct for any color casts. You'll need to mount these lights on a tripod or other support, or, perhaps, to a bracket that fastens to the tripod socket on the bottom of the camera.

Much of the challenge depends upon whether you're just trying to add some fill-light on your subject versus trying to boost the light on an entire scene. A small video light will do just fine for the former. It won't handle the latter.

Creative Lighting

While ramping up the light intensity will produce better technical quality in your video, it won't necessarily improve the artistic quality of it. Whether we're outdoors or indoors, we're used to seeing light come from above. Videographers need to consider how they position their lights to provide even illumination while up high enough to angle shadows down low and out of sight of the camera.

Figure 8.15 Some electronic flash units have LED video lights built-in.

When considering lighting for video, there are several factors. One is the quality of the light. It can either be hard (direct) light or soft (diffused). Hard light is good for showing detail, but can also be very harsh and unforgiving. "Softening" the light, but diffusing it somehow, can reduce the intensity of the light but make for a kinder, gentler light as well.

While mixing light sources isn't always a good idea, one approach is to combine window light with supplemental lighting. Position your subject with the window to one side and bring in either a supplemental light or a reflector to the other side for reasonably even lighting.

Lighting Styles

Some lighting styles are more heavily used than others. Some forms are used for special effects, while others are designed to be invisible. At its most basic, lighting just illuminates the scene, but when used properly it can also create drama. Let's look at some types of lighting styles:

- **Three-point lighting.** This is a basic lighting setup for one person. A main light illuminates the strong side of a person's face, while a fill light lights up the other side. A third light is then positioned above and behind the subject to light the back of the head and shoulders.

- **Flat lighting.** Use this type of lighting to provide illumination and nothing more. It calls for a variety of lights and diffusers set to raise the light level in a space enough for good video reproduction, but not to create a particular mood or emphasize a particular scene or individual. With flat lighting, you're trying to create even lighting levels throughout the video space and minimize any shadows. Generally, the lights are placed up high and angled downward (or possibly pointed straight up to bounce off of a white ceiling).

- **"Ghoul lighting."** This is the style of lighting used for old horror movies. The idea is to position the light down low, pointed upward. It's such an unnatural style of lighting that it makes its targets seem weird and "ghoulish."

- **Outdoor lighting.** While shooting outdoors may seem easier because the sun provides more light, it also presents its own problems. As a general rule of thumb, keep the sun behind you when you're shooting video outdoors, except when shooting faces (anything from a medium shot and closer) since the viewer won't want to see a squinting subject. When shooting another human this way, put the sun behind her and use a video light to balance light levels between the foreground and background. If the sun is simply too bright, position the subject in the shade and use the video light for your main illumination. Using reflectors (white board panels or aluminum foil-covered cardboard panels are cheap options) can also help balance light effectively.

Audio

When it comes to making a successful video, audio quality is one of those things that separates the professionals from the amateurs. We're used to watching top-quality productions on television and in the movies, yet the average person has no idea how much effort goes in to producing what seems to be "natural" sound. Much of the sound you hear in such productions is actually recorded on carefully controlled sound stages and "sweetened" with a variety of sound effects and other recordings of "natural" sound.

Tips for Better Audio

Since recording high-quality audio is such a challenge, it's a good idea to do everything possible to maximize recording quality. Here are some ideas for improving the quality of the audio your camera records:

- **Get the camera and its microphone close to the speaker.** The farther the microphone is from the audio source, the less effective it will be in picking up that sound. While having to position the camera and microphone closer to the subject affects your lens choices and lens perspective options, it will make the most of your audio source. Of course, if you're using a very wide-angle lens, getting too close to your subject can have unflattering results, so don't take this advice too far.

- **Use an external microphone.** Many dSLRs have an external microphone port that accepts a stereo mini-plug from a standard external microphone, allowing you to achieve considerably higher audio quality for your movies than is possible with the camera's built-in microphones (which are disabled when an external mic is plugged in). An external microphone reduces the amount of camera-induced noise that is picked up and recorded on your audio track (The action of the lens as it focuses can be audible when the built-in microphones are active.) (See Figure 8.16.)

 The external microphone port can provide plug-in power for microphones that can take their power from this sort of outlet rather than from a battery in the microphone. Sony provides optional compatible microphones such as the ECM-ALST1 and the ECM-CG50; you also may find suitable microphones from companies such as Shure and Audio-Technica.

- **Turn off any sound makers you can.** Little things like fans and air handling units aren't obvious to the human ear, but will be picked up by the microphone. Turn off any machinery or devices that you can plus make sure cell phones are set to silent mode. Also, do what you can to minimize sounds such as wind, radio, television, or people talking in the background.

- **Make sure to record some "natural" sound.** If you're shooting video at an event of some kind, make sure you get some background sound that you can add to your audio as desired in post-production.

Figure 8.16
External microphones can be used hand-held, mounted near your subject, or clipped on top of the camera, as shown.

■ **Consider recording audio separately.** Lip-syncing is probably beyond most of the people you're going to be shooting, but there's nothing that says you can't record narration separately and add it later. It's relatively easy if you learn how to use simple software video-editing programs like iMovie (for the Macintosh) or Windows Movie Maker (for Windows PCs). Any time the speaker is off-camera, you can work with separately recorded narration rather than recording the speaker on-camera. This can produce much cleaner sound.

External Microphones

The single most important thing you can do to improve your audio quality is to use an external microphone. Most internal stereo microphones mounted on the front or top of the camera will do a decent job, but have some significant drawbacks, partially spelled out in the previous section:

■ **Camera noise.** There are plenty of noise sources emanating from the camera, including your own breathing and rustling around as the camera shifts in your hand. Manual zooming is bound to affect your sound, and your fingers will fall directly in front of the built-in mics as you change focal lengths. An external microphone isolates the sound recording from camera noise.

■ **Distance.** Anytime your camera is located more than 6–8 feet from your subjects or sound source, the audio will suffer. An external unit allows you to place the mic right next to your subject.

■ **Improved quality.** Obviously, a camera manufacturer isn't going to install a super-high-quality microphone on a (relatively) budget-priced camera. An external microphone will almost always be of better quality.

■ **Directionality.** The camera's internal microphone generally records only sounds directly in front of it. An external microphone can be either of the directional type or omnidirectional, depending on whether you want to "shotgun" your sound or record more ambient sound.

You can choose from several different types of microphones, each of which has its own advantages and disadvantages. If you're serious about movie making with your camera, you might want to own more than one. Common configurations include:

■ **Shotgun microphones.** These can be mounted directly on your camera, although, if the mic uses an accessory shoe mount, you'll need the optional adapter to convert the camera's shoe to a standard hot shoe. I prefer to use a bracket, which further isolates the microphone from any camera noise.

■ **Lapel microphones.** Also called *lavalieres*, these microphones attach to the subject's clothing and pick up their voice with the best quality. You'll need a long enough cord or a wireless mic (described later). These are especially good for video interviews, so whether you're producing a documentary or grilling relatives for a family history, you'll want one of these.

■ **Hand-held microphones.** If you're capturing a singer crooning a tune, or want your subject to mimic famed faux newscaster Wally Ballou, a hand-held mic may be your best choice. They serve much the same purpose as a lapel microphone, and they're more intrusive—but that may be the point. A hand-held microphone can make a great prop for your fake newscast! The speaker can talk right into the microphone, point it at another person, or use it to record ambient sound. If your narrator is not going to appear on-camera, one of these can be an inexpensive way to improve sound.

■ **Wired and wireless external microphones.** This option is the most expensive, but you get a receiver and a transmitter (both battery-powered, so you'll need to make sure you have enough batteries). The transmitter is connected to the microphone, and the receiver is connected to your camera. In addition to being less klutzy and enabling you to avoid having wires on view in your scene, wireless mics let you record sounds that are physically located some distance from your camera. Of course, you need to keep in mind the range of your device, and be aware of possible signal interference from other electronic components in the vicinity.

WIND NOISE REDUCTION

Always use the wind screen provided with an external microphone to reduce the effect of noise produced by even light breezes blowing over the microphone. Both the camera and many mics include a low-cut filter to further reduce wind noise. However, these can also affect other sounds. With many cameras, you can disable the low-cut filters for the camera's internal microphones. Some external mics have their own low-cut filter switch.

9

Exploring GPS and Wi-Fi

When you think of GPS and Wi-Fi, you may be thinking of using your vehicle's GPS system to help you find the nearest coffee shop where you can connect your laptop to the Internet. But, today, both GPS and Wi-Fi have many more applications. You can mark your photographs with location information, so you don't have to guess where a picture was taken. And, you can upload your photos directly to your computer or—if you're in that coffee shop or another Wi-Fi hotspot—to online picture sharing services like Facebook and Flickr. This chapter will help you discover some of the things you can do with these tools, which have been available as add-on accessories for some time, and which now are built right into an increasing number of dSLRs.

What's Geotagging?

For photographers, geotagging is most important as a way to associate the geographical location where the photographer was when a picture was taken, with the actual photograph itself. This is done using a GPS (global positioning system) device that calculates the latitude and longitude, and, optionally, the altitude, compass bearing, and other location information. Geotagging can be done automatically, through a device built into the camera (or your smartphone or other gadget) or manually, by attaching geographic information to the photo after it's already been taken.

Automatic geotagging is the most convenient. Many point-and-shoot cameras and smartphone cameras have included built-in geotagging for some time. The feature has more recently become available for dSLRs through add-on gadgets like the Nikon GP-1a, shown in Figure 9.1, or built into the camera itself in models like the Nikon D5300 or Canon EOS 70D. Canon also uses the USB socket on the wireless file transmitter unit (WFT) as a GPS interface, so if you own that Wi-Fi device you can add GPS features to Canon cameras that don't have it built in. Sony has begun including GPS built-into a number of its SLT models, such as the SLT-A99.

A swarm of satellites in geosynchronous orbits above the Earth became a big part of my life even before I purchased a GPS-capable dSLR. I use the GPS features of my iPhone and iPad and the GPS device in my car to track and plan my movements. When family members travel without me—most recently to Europe—I can use the Find my iPhone feature to see where they are roaming and vicariously accompany them with Google Maps' Street View features. And, since the introduction of GPS accessories and built-in features, GPS has become an integral part of my shooting regimen, too. I use both the external and internal GPS capabilities. If you already own an external GPS adapter (see Figure 9.1), you can use that with a camera that has an internal global positioning system, as the external unit's "exposed" location on top of the camera can sometimes snag satellite radio signals more easily than the GPS receiver built into the camera. However, I think you'll usually find the camera's own GPS features more convenient.

Any GPS device makes it easy to tag your images with the same kind of longitude, latitude, altitude, and time stamp information that is supplied by the GPS unit you use in your car. (Don't have a GPS? Photographers who get lost in the boonies as easily as I do *must* have one of these!) The geotagging information is stored in the metadata space within your image files, and can be accessed by software that comes with the camera or GPS unit, or by online photo services such as mypicturetown.com and Flickr.

Geotagging can also be done by attaching geographic information to the photo after it's already been taken. This is often done with online sharing services, such as Flickr, which allow you to associate your uploaded photographs with a map, city, street address, or postal code. When properly geotagged and uploaded to sites like Flickr, users can browse through your photos using a map, finding pictures you've taken in a given area, or even searching through photos taken at the same location by other users. Of course, in this day and age it's probably wise not to include GPS information in photos of your home, especially if your photos can be viewed by an unrestricted audience.

Having this information available makes it easier to track where your pictures are taken. That can be essential, as I learned from a trip out west, where I found the red rocks, canyons, and arroyos of

Figure 9.1
Add-on gadgets like the Nikon GP-1a bring geotagging to compatible dSLRs.

Nevada, Utah, Arizona, and Colorado all pretty much look alike to my untrained eye. I find the capability especially useful when I want to return to a spot I've photographed in the past and am not sure how to get there. I can enter the coordinates shown into my hand-held or auto GPS (or an app in my iPad or iPhone) and receive instructions on how to get there. That's handy if you're returning to a spot later in the same day, or months later.

All operate on the same principle: using the network of GPS satellites to determine the position of the photographer. (Some mobile phones also use the location of the cell phone network towers to help collect location data.) As mentioned earlier, the GPS data is automatically stored in the photo's EXIF information when the photo is taken. A connected GPS will generally remain switched on continuously, requiring power, and will then have location information available immediately when the camera is switched on.

Most dSLR cameras don't contain a built-in GPS receiver, but you can still use them to tag photos by using an external GPS device. You can take the picture normally, without GPS data, and then special software can match up the time stamps on the images with times stamps recorded by an external GPS device, and then add the coordinates to the EXIF information for that photo. (Obviously, your camera's date/time settings must be synchronized with that of the GPS for this to work.) This method is time consuming, because the GPS data is added to the photograph through post-processing.

You can also add location information to your photographs manually. This is often done with online sharing services, such as Flickr, which allow you to associate your uploaded photographs with a map, city, street address, or postal code.

Using GPS

External GPS units usually slip onto the accessory shoe on top of the camera, and connect to a USB or GPS/accessory port using a cable. Nikon configures its external GPS units with a pass-through connector, so you can plug a remote control into a port on the GPS, which is then connected directly to the accessory port of the camera. Once attached, the device is very easy to use. You need to activate the camera's GPS capabilities in the GPS choice within its setup menu. An internal GPS can be activated in much the same way.

The next step is to allow the GPS unit to acquire signals from at least three satellites. If you've used a GPS in your car, you'll know that satellite acquisition works best outdoors under a clear sky and out of the "shadow" of tall buildings. It may take about 40–60 seconds for the camera GPS to "connect." A blinking LED, viewfinder/LCD indicator or other signal means that GPS data is not being recorded; a green blinking LED or similar acknowledgement in the viewfinder or on the LCD signifies that the unit has acquired three satellites and is recording data. With Nikon's external unit, when the LED is solid green and has stopped blinking, the unit has connected to four or more satellites, and is recording data with optimum accuracy.

You may have the option to run the GPS unit all the time, or only when you manually turn it off. Always On assures that the camera doesn't go to sleep while you're using the GPS unit. Of course, in this mode the camera will use more power (the meters never go off, and the GPS draws power constantly), but you don't want to go through the 40–60-second satellite acquisition step each time you take a picture.

You're all set. Once the unit is up and running, you can view GPS information using photo information screens available on the color LCD with most cameras offering GPS features. The Nikon GPS screen, which appears only when a photo has been taken using the GPS unit, looks like Figure 9.2.

Nikon cameras with GPS support include a menu that appears only when the device is attached. It has several options, none of which turn GPS features on or off, despite the misleading "Enable" and "Disable" nomenclature (what you're enabling and disabling is the automatic exposure meter turn-off):

- **Enable.** Reduces battery drain by turning off exposure meters while using the GP-1 after the time you specify has elapsed. When the meters turn off, the GP-1 becomes inactive and must reacquire at least three satellite signals before it can begin recording GPS data once more.

- **Disable.** Causes exposure meters to remain on while using the GP-1, so that GPS data can be recorded at any time, despite increased battery drain.

- **Position.** This is an information display, rather than a selectable option. It appears when the GP-1 is connected and receiving satellite positioning data. It shows the latitude, longitude, altitude, and Coordinated Universal Time (UTC) values.

- **Set Clock from Satellite.** Select Yes or No. When enabled, your internal camera clock will be set using UTC values obtained whenever the GPS is activated. If you use the device frequently, this will ensure that your camera's clock is always set accurately, and won't require a manual update periodically.

Figure 9.2
Captured GPS information can be displayed when you review the image.

When your GPS is active, you'll see indicators on the LCD screen (see Figure 9.3) or through the viewfinder (the electronic viewfinder of a Sony SLT model is shown in Figure 9.4). Although GPS is still in its infancy in the dSLR world, we can expect exciting new devices and applications for the technology in the future.

Figure 9.3

Indicators on the LCD…

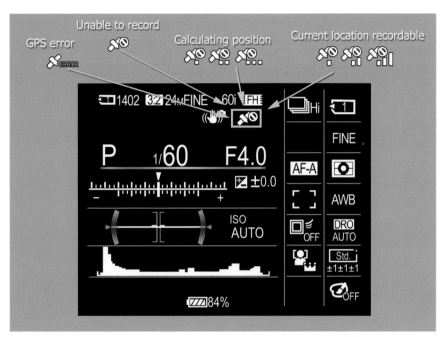

Figure 9.4

…or in the viewfinder/electronic viewfinder show when GPS data is being captured.

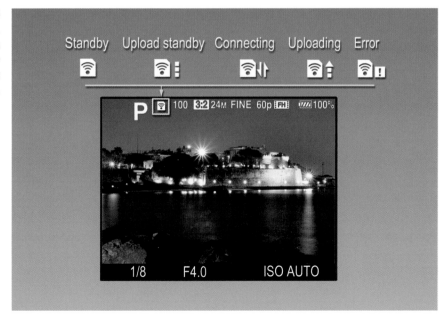

Tracking Logs

Some internal or external GPS units have the capability of recording the camera's position at preset intervals and saving that information to a track log file that can be viewed using software. This capability can be useful in tracking your wanderings separately from the actual pictures you take. You can turn the log on and off, and the camera will continue to access satellite data when available and will continue logging *even if the camera has been powered off.* Logging will stop when the battery is depleted, so make sure your battery is fully charged, and it's smart to have an extra one available because your battery will run out more quickly than if you hadn't been using GPS or logging. In Nikon's case, the camera creates a folder on your memory card. These logs can be copied to your computer just like image or movie files. Their format conforms to the NMEA (National Marine Electronics Association) protocols, but may not be compatible with all utilities or devices.

Assisted GPS

If you want to increase the speed with which your camera's built-in GPS determines position, cameras including Nikon and Sony let you use an optional feature called *assisted GPS*. GPS Assist (also known as A-GPS) services use network data connections to improve accuracy and shortens what is called "time to first fix" (which can be slow if the unit has difficulty accessing satellite data). To use this feature, download the latest A-GPS file according to the instructions supplied by your camera vendor, copy the data to a memory card, insert in the camera, and load the data into your camera's GPS memory. The file you've downloaded will be valid for about two weeks, at which point the camera will ignore it. If you try to update using an outdated A-GPS file, an error message will be displayed. If you elect to continue using assisted GPS, you'll need to update the camera's files at intervals to maintain valid data.

Eye-Fi Upload

Affordable Wi-Fi connectivity has to be one of the most exciting options to come to digital SLR photography in years. It's been available for some time, but only through expensive add-on devices for pro cameras from Canon and Nikon, typically at costs of $700 or more for the transmitter. I'm not even going to discuss those pricey devices in this book—the professionals who need them already know about them. Normal people like you and me need an affordable solution, like the built-in Wi-Fi found in an increasing number of dSLRs, and memory card–based solutions that add Wi-Fi to other cameras, like the cards offered by Eye-Fi (www.eye.fi).

The Eye-Fi card is an SDHC memory card with a wireless transmitter built in. You insert it in your camera just as with any ordinary card (see Figure 9.5), and then specify which networks to use. You can add as many as 32 different networks. The next time your camera is on within range of a specified network, your photos and videos can be uploaded to your computer and/or to your favorite sharing site. During setup, you can customize where you want your images uploaded. The Eye-Fi card will only send them to the computer and to the sharing site you choose. Upload to many

popular sharing websites, including Flickr, Facebook, Picasa, MobileMe, Costco, Adorama, Smugmug, YouTube, Shutterfly, or Walmart. Online Sharing is included as a lifetime, unlimited service with all X2 cards.

Newer dSLR cameras have a menu option for enabling or disabling Wi-Fi access, but I've found that the card works with cameras that don't have direct support for Wi-Fi—the Eye-Fi card, in effect, is "on" all the time. You control its behavior, such as which Wi-Fi networks to use, from the Eye-Fi Center software.

When uploading to online sites, you can specify not just where your images are sent, but how they are organized, by specifying preset album names, tags, descriptions, and even privacy preferences on certain sharing sites.

Figure 9.5
Just insert the Eye-Fi card in an SD slot.

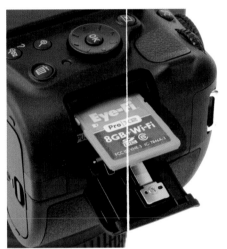
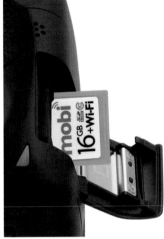

Figure 9.6
Your camera may include Eye-Fi support, but the card works with cameras that don't have it.

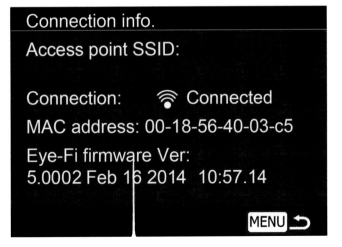

If you frequently travel outside the range of your home (or business) Wi-Fi network, an optional service called Hotspot Access is available, allowing you to connect to any AT&T Wi-Fi hotspot in the USA. In addition, you can use your own Wi-Fi accounts from commercial network providers, your city, even organizations you belong to such as your university.

The card has another interesting feature called Endless Memory. When pictures have been safely uploaded to an external site, the card can be set to automatically erase the oldest images to free up space for new pictures. You choose the threshold where the card starts zapping your old pictures to make room. Eye-Fi currently offers a number of different models, in both the latest Mobi and Pro X2 models, in 8GB–32GB capacities, ranging in price from around $50 to about $150. Some versions can add geographic location labels to your photo (so you'll know where you took it), and frees you from your own computer network by allowing uploads from more than 10,000 Wi-Fi hotspots around the USA. Very cool, and the ultimate in picture backup. The company also offers an Eye-Fi app for the iPhone that allows you to upload your photos directly to your computer or websites.

Built-in Wi-Fi

These days, built-in GPS and Wi-Fi capabilities work together with your camera in interesting new ways. Wireless capabilities allow you to upload photos directly from your camera to your computer at home or in your studio, or, through a hotspot at your hotel or coffee shop back to your home computer or to a photo sharing service like Facebook or Flickr. You can use your smart phone as a remote control for your camera, and preview your live view images right on your Android or iOS phone's screen. Your Wi-Fi-compatible camera has its own Wi-Fi capabilities, and works in conjunction with a Wi-Fi app for your smart phone or tablet (using either iOS or Android operating systems). (See Figure 9.7.)

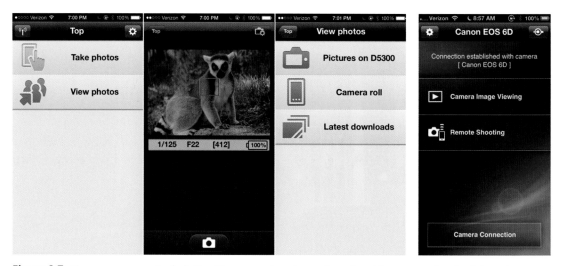

Figure 9.7 Your camera may include Eye-Fi support, but the card works with cameras that don't have it.

The traditional methods for transferring photos and videos to a computer work well and they're familiar to most everyone, but in this high-tech era there are wireless alternatives. Your camera may be equipped with a built-in Wi-Fi system that can be used for transferring files to a networked computer or to a networked HDTV or to a smartphone or tablet computer. There's also an option (with an app) to use the smart device as a remote controller for the camera.

These aspects of Wi-Fi are available with an increasing number of digital cameras but some cameras pile on additional features. For example, after making Wi-Fi connectivity from the camera to a network or hotspot, you can instruct the camera to download apps (free or for $4.99 or $9.99 in the U.S.) from a website for increased versatility. An app can expand existing features with extra options or add entirely new functions. For example, one app enables you to retouch JPEGs to improve them while two others allow for direct uploading (via Wi-Fi) from the camera to certain social media sites on the Internet.

Depending on your camera model, you may be able to link to other Wi-Fi-compatible cameras (Canon Wi-Fi models introduced since 2012 are especially adapt at this), connect directly to a smartphone or tablet, link to your computer, print directly to a wireless printer, or view your images on an intelligent high-definition television (see Figure 9.8).

Figure 9.8
Communicate with multiple devices.

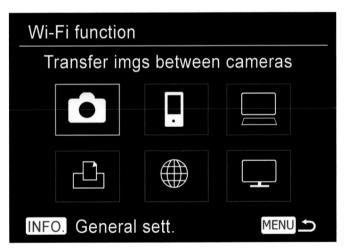

Printing from your camera is particularly convenient. Canon EOS models, for example, show you a screen you can use to select, resize, transmit, or print images one at a time or in batches. (See Figure 9.9.)

Figure 9.9 Upload or print directly from your camera.

10

Using Apps

In the past, the most important add-on accessory for your digital SLR was probably your second lens, a tool that, as you learned in Chapter 6, expands your perspective, brings you closer to your subject, or allows you to shoot in more challenging environments. Of course, depending on the type of subjects you shoot, that MVP (most valuable purchase) might be a tripod or close-up accessory. By the time the next edition of this book is published, however, the hands-down winner for most useful accessory will be your smart device (phone, tablet, phablet, or other portable gadget), and the apps it can run. That's because, of all the technologies discussed in this book, that of the portable application—or app—is the one that is still truly in its infancy, and which will grow dramatically in importance. Quite simply, in the future, smart devices and related electronics will be one of the most important accessories you can have for your digital SLR, if it isn't already. We're only now seeing the beginnings of the trend.

Think of all the products that have effectively been made obsolete by a device that's small enough to slip into a pocket or purse:

- **Point-and-shoot cameras.** Millions of pocket cameras are still sold each year, primarily because they have a few features that are not yet universal in smart phones, such as zoom lenses. Yet, the adage goes, "The best camera is the one you have in your hand" and while even the most avid snapshooter doesn't tote their P & S camera everywhere they go, when they venture out they're more likely to forget a wallet than a smart phone. When phone cameras catch up to the best point-and-shoots in terms of features, the latter will become an endangered species.

- **GPS.** It's true, as I explained in Chapter 9, that GPS built into cameras is becoming an important technology for photographers. However, other types of global positioning system units will eventually join the endangered species list along with point-and-shoot cameras. Many people are already using their smart device GPS for route information and finding particular points of interest (i.e., where's the nearest gas station?). Hand-held GPS, used by hikers, and in-vehicle

GPS units are less crucial. Did you think it was cool that your latest automobile had an in-dash GPS system? How thrilled will you be in five years when you still own that car and realize your obsolete GPS unit can't be updated every two years like your phone.

- **Landlines.** People started phasing out home landlines when they disconnected their fax machines and dial-up Internet connections a decade ago. I don't even *know* anybody who has an actual landline, unless you consider one of those Internet-based voice over IP (VOIP) systems that use a standard telephone. They may be magic, Jack, but we use our mobile phone a lot more.

- **Wrist watches.** Today, most wrist watches are a fashion accessory rather than a useful device. If you really need to know the time, glancing at your phone's screen takes only a second longer than looking at your wrist—and the display will likely tell you about the weather, too.

- **Voice calls.** A lot of people, especially the younger set, don't even make many voice calls with their phones. Texting can be faster, can be responded to (or not) at your convenience without interrupting what you're doing, and provides a non-paper trail of a conversation so you don't have to take notes. If you really need to communicate with someone in real time, Skype or FaceTime are frequently more useful.

And I didn't even include standalone MP3 players or pocket calculators in this list. The next sections will look at how electronic accessories—including smart devices—are becoming essential tools for the digital SLR photographer.

Smart Platforms

In the past, wireless carriers have subsidized the cost of the smart device in order to attract your business and tie you to their mobile system. Because we're paying only $200 or less for a phone that costs, in reality, $600, the tendency is to upgrade to the latest and greatest models as often as every two years. Some carriers have even eliminated long-term contracts and allow you to purchase your devices on an installment plan. In some ways, committing to a given operating system/platform is a lot like choosing a camera brand. Once you've select Nikon, Canon, Sony, or some other vendor, and start investing in lenses and accessories, you're locked in until you decide to jump ship and re-invest in an entirely new platform/brand. So, as in choosing a camera brand, it's important to select your platform carefully. The relevant platforms are these (see Figure 10.1):

- **Old-style smart phones.** Cell carriers call these "Basic Phones," and they are only *somewhat* smart. They can run apps designed specifically for them, and have a few features beyond making phone calls. With Blackberry increasingly out of the picture, I include in this category all smart phones that are *not* based on Apple's iOS, Microsoft's Windows Phone, or Google's Android operating systems. You can buy lots of interesting apps for these non-iOS/Windows/Android phones, although not many applications specifically for photography. This type of phone should be on its way out, too, simply because it's easier to write applications for the iPhone's iOS and Android than to create them for multiple "old" smart phone platforms. Carriers keep selling them because there are people who basically use their phones primarily for making phone calls.

Figure 10.1 The iPad, iPod, and other devices open a whole world of useful apps to the photographer.

- **Android smart phones.** There are already more Android-based smart phones on the market than for all other types, including iOS. Although Apple had a head start, the number of Android applications is rapidly catching up. You'll find lots of photo applications, GPS apps, and other great utilities.

- **iPhones.** The sale of iPhones took off once Apple stopped supplying them exclusively to AT&T, and began offering them through dozens of carriers, including all the majors in the United States, including Verizon, T-Mobile, and Virgin Mobile. The iPhone is supported in Canada, too, through carriers like Rogers, and throughout Europe and Asia. Apple's iOS leads in number of applications, especially for photography apps. When my first camera-specific app was developed, it appeared for the iOS platform first, and my free *David Busch's Lens Finder* app remains available only through the Apple App Store. Apps from camera vendors like Nikon, Canon, and Sony are always available for iOS.

- **iPod Touch.** The main reason why Apple is able to continue to sell iPods is that, in the case of the iPod Touch, the product is basically just an iPhone that can't make phone calls. (Although there are some hacks around that limitation.) Virtually all of the apps that run on the iPhone under iOS also run on the iPod Touch. You need a Wi-Fi connection to access features that use network capabilities, but, these days, Wi-Fi hot spots aren't that difficult to find. Tethering and Mi-Fi (which allow another device to serve as a hot spot for non-connected gadgets like the Touch), and *automobiles* that include built-in Wi-Fi (!) make connectivity almost universal. In my travels through Europe in the last year, I found free Wi-Fi connections in the smallest towns. (Indeed, the only time I was asked to pay for it was when staying in an upscale hotel.) So, for many who are tied to a non-iPhone cell phone, the iPod Touch is a viable alternative.

■ **iOS tablets.** I was welded to my iPad since I bought it the first day they became available in January, 2010. I resisted Apple's annual upgrades until Apple's lack of OS support for their original model nudged me into my current iPad Air and iPad Mini models. Because of the large number of iOS apps I have, and my preference for some of the features found in the various iPads, I'll continue using them as a key tool for photographic and personal use.

However, iPad tablets are far from the perfect tool for photographers. As I write this, they lack memory card slots or any way to plug in additional external storage (other than through clever wireless add-on hard drives), so you're stuck with no more than 128GB of storage. Loading your images onto the iPad is best done with Apple's Camera Connection Kit, or third-party clones, or by connecting the iPad to your computer through a USB cable.

■ **Android Tablets/Phablets.** The range of tablets and combined phone/tablet products ("phablets") is amazing, and spans the gamut from $79 basic models to the higher-end devices like the Samsung Galaxy and Amazon Kindle models priced in the $500 range once dominated by Apple's pricey iPads.

Depending on the model you select, you can find Android devices with memory card slots, USB ports, and other hardware upgrades, including a selection of different screen sizes. Like iPad models, these are available with internal 3G/4G support, or can rely solely on Wi-Fi connections. Of course, different vendors install slightly different "flavors" of the Android OS on their tablets, so not every app runs on every device. I've been using a Kindle Fire for some time, but not for photography, for the most part. The Kindle Fire interfaces more smoothly than my iPads with Amazon's Prime movie streaming service, and is more convenient for downloading and reading books (compared to the full-size iPad Air).

An Android phablet proved especially useful during a six-week visit to Asia. A kiosk at Bangkok's international airport sold SIM (mobile connection) cards with one month's unlimited use for a modest amount, allowing uploading and e-mailing many photos without worrying about the meter ticking.

■ **Windows Phone/Surface Tablets.** Microsoft continues to try to break into the phone/tablet market, but has a lot of catching up to do to overtake iOS or Android. I tend to lag behind Microsoft's technological "breakthroughs" until it becomes obvious that they've put together a winner (Windows 7) or a loser (Microsoft Zune). I must admit that I do have heavily customized versions of Windows 8 smoothly running on my laptop (which I used in Florida to write the first half of this book), and one desktop computer, but my "main" desktop (that I'm using right now) relies on a mature copy of Windows 7.

Should you try out Windows Phone or Surface products? Microsoft and Nokia have given the photography aspects of the Windows Phones a priority, so, if you want to use your phone as a camera, you'll be pleasantly surprised. If you like Windows (i.e., you're not a Mac user), the Windows Phone and Surface operating systems will seem familiar to you. However, the number of apps designed specifically to take advantage of these products lags behind. For example, while Windows Phone has come with basic Microsoft Office applications, in early 2014 a version for iPads was made available, too.

What Can They Do?

Many of these devices can serve as a backup for your memory cards. I've got Apple's camera connection kit, and can offload my pictures to my iPad's 64GB of memory, then upload them to Flickr or Facebook, or send to anyone through e-mail. (I'll show you a way to transmit your images directly to your home television from a distant vacation spot later in this chapter.) My iPad also makes a perfect portable portfolio, too. I have hundreds of photos stored on mine, arranged into albums (see Figure 10.2) ready for instant display, either individually or in slide shows. I have the same photo library on my iPod Touch, and more than a few pictures available for showing on my smart phone.

But the real potential for using these devices comes from specialized apps written specifically to serve photographic needs. Here are some of the kinds of apps you can expect in the future. (I'm working on more than a few of them myself.) Google any of these topics to locate current apps that perform these functions.

- **Camera guides.** Even the inadequate manual that came with your camera is too large to carry around in your camera bag all day. I'm converting many of my own camera-specific guides to app form, while adding interactive elements, including hyperlinks and videos. You can already put a PDF version of your camera manual on your portable device and read it, if you like. You should be able to read any of the more useful third-party guides anywhere, anytime.

- **Photo editors.** In these days of Instagram, there are literally hundreds of apps that manipulate your photos to provide a retro look, correct color balance, bend pixels, make stereoscopic images, convert shots to high dynamic range (HDR) versions, add text, or compile collages.

- **Lens selector.** Wonder what's the best lens to use in a specific situation? Enter information about your scene, and your app will advise you. Or, you can use my *Lens Finder* app, currently available for iOS.

Figure 10.2
Display your photos in albums, anywhere.

- **How a dSLR works.** Curious about how your camera works? Find an app with a 3D model of your dSLR with internal components labeled and captioned with their functions.

- **Exposure estimator.** Choose a situation and the estimated exposure will be provided. Useful as a reality check and in difficult situations, such as fireworks, where the camera's meters may falter.

- **Shutter speed advisor.** The correct shutter speed for a scene varies depending on whether you want to freeze action, or add a little blur to express motion. Other variables include whether the subject is crossing the frame, moving diagonally, or headed toward you. The photographer also needs to consider the focal length of the lens, and presence/absence of image stabilization features, tripod, monopod, etc. This app will allow you to tap in all the factors and receive advice about what shutter speed to use.

- **Hyperfocal length calculator.** In any given situation, set the focus point at the distance specified for your lens's current focal length setting, and everything from half that distance to infinity will be in focus. But the right setting differs at various focal lengths. This app tells you, and is a great tool for grab shots.

- **Accessory selector.** Confused about what flash, remote control, battery grip, lens hood, filter, or other accessory to use with your camera or lens? This selector lists the key gadgets, which ones fit which cameras, and explains how to use them.

- **Before and after.** Images showing before/after versions of dozens of situations with and without corrective/in-camera special effects applied.

- **Fill light.** Pesky shadows on faces from overhead lighting indoors? This turns your iPod/iPhone or (best of all) iPad into a bright, diffuse fill light panel. Choose from white fill light, or *colors* for special effects. Makes good illumination for viewing your camera's buttons and dials in dark locations, too.

- **Level.** Set your device on top of your camera and use it to level the camera, with or without a tripod.

- **Gray card.** Turn your i-device into an 18 percent gray card for metering and color balance.

- **Super links.** If you don't find your answer in the Toolkit, you can link to websites with more information.

- **How It's Made.** A collection of inspiring photos, with details on how they were taken in camera—or manipulated in Photoshop (if that's your thing).

- **Quickie guides.** Small apps that lead you, step-by-step, through everything you need to photograph lots of different types of scenes (similar to what I have for you in Part III of this book). Typical subjects would be sports, landscape photography, macro work, portraits, concerts/performances, flowers, wildlife, and nature.

As you can see, the potential for apps is virtually unlimited. You can expect your smart phone, tablet computer, or other device to be a mainstay in your camera bag within a very short time. Although point-and-shoot cameras are on the way out, dSLRs will benefit from these applications.

Camera-Specific Apps

Canon offers its EOS Remote and Camera Window apps for its cameras; Nikon has its Wireless Remote Utility; and Sony makes its PlayMemories software available for download. All these run on smart devices. You can also find camera control software that runs on your desktop or laptop computer, too, such as Canon's EOS Utility or Nikon's Camera Control Pro. Several third-party companies, such as Breeze Systems (www.breezesys.com) produce similar software at reasonable prices, such as NikonRemote or DSLRRemote.

With any of these, you can use your computer (linked to the camera wirelessly or over a USB cable) or smart device (connected wirelessly) to make camera settings, adjust picture styles, upload firmware updates, or, most importantly, operate the camera remotely. You can preview the live view image on your monitor or device's LCD, change exposures or just about any other setting, and actually take a picture in single shot, continuous, or time-lapse mode. The image you've just shot is transferred directly to your computer or phone/tablet, and you can then upload it to a destination of your choice. I explained the various options of wireless connectivity in Chapter 9.

Another Great Device

Imagine shooting pictures on vacation (or on assignment) and having them show up immediately on the television in your home or office—thousands of miles away. All you need is a smart device (phone, tablet, phablet) connected to a Wi-Fi or cellular network; or, a Wi-Fi-equipped camera like the Canon EOS 70D. Then, use a connecting box like the new Amazon Fire TV ($99) to link your device to any high-definition television with a spare HDMI port. Introduced in April, 2014, the Amazon Fire TV is an alternative to Google Chromecast/Roku/Apple TV devices, with a couple features photographers will love.

I love the ability to remotely view images, as they are shot. The first step is to set your camera to upload pictures to your Amazon Cloud Drive over any available Wi-Fi network. Amazon gives you 5GB of cloud storage for free, but you can upgrade to 20GB to 1TB at extra cost. ($20 to $500 a year as I write this.) Alternatively, if a Wi-Fi network isn't available, you can upload from your camera to your smart device (phone, etc.) and use the device's connection to upload the images to the Amazon Cloud Drive.

Once in cloud-land, your shots are immediately available for viewing on your Fire TV–equipped television. Friends/colleagues can view what you shoot as quickly as you can upload the images, even if you're thousands of miles away. Or, you can view your own shots in your home, office, or studio. Any photos in the cloud can be viewed on your television using this device.

As a bonus, Fire TV also does television! And games. My HDTV already has built-in connectivity to YouTube, Netflix (so I was able to watch *House of Cards* non-stop on a big screen) and a few other services. The Fire TV lets me view my Amazon Prime videos as well (I binged on 10 episodes of *Orphan Black* over two nights), Hulu Plus for current TV shows, and can be used to play games with an optional controller. We've gone from game consoles that let you watch Netflix and other streaming video to video links that let you play games—and share your photos automatically.

11

Great Gadgets

Don't fret if your dream digital SLR is something that you can only dream about. The camera you own right now may be capable of doing a lot more than you think, with the addition of just a few accessories. It's easy to get excited over a newly introduced model with killer features, until you realize that there are very, very few pictures that the most advanced camera can take that are beyond the reach of an unadorned basic entry-level dSLR. Other than higher resolution (and do any of us really *need* 36MP or so?) and better performance at lofty ISO sensitivity settings (how much available darkness photography do you do?), the only thing a fancier camera is likely to give you is *convenience.* Built-in HDR, Wi-Fi, or GPS, as well as features like sophisticated multiple exposure capabilities or lightning-fast autofocus are all conveniences, and most of them can be replaced by external tools or clever shooting techniques.

And, most important of all, you can often add these nifty features to your existing camera with a few well-selected accessories or add-ons. In this chapter, I'm going to summarize a few of the most popular.

Taking Pictures by Remote Control

Sometimes you want to trip your shutter without being anywhere near your camera. It's not out of laziness; sometimes you just don't want to be anywhere near what you're photographing because it's scared of you (small birds and animals) or you're scared of it (big animals, your in-laws). While you can set the self-timer and run, that only gets you one shot, or, perhaps, a short series with most cameras and doesn't really work when you're trying to capture wildlife (see Figure 11.1).

A wireless triggering system is simpler to rig and easier to use. Cheaper systems are available for specific camera lines for less than $100 (sometimes a lot less) and often rely on infrared light to signal the camera to fire. While pro versions will cost a good deal more, the good news is a pro

Figure 11.1
Remote control shot
of a butterfly.

wireless triggering system can also be used for firing a flash wirelessly, too. The systems that provide the greatest range use radio waves, which are stronger than infrared, not prone to failure in bright sunshine, and bounce around enough to transmit through obstacles. The cheap ones are good for about 150 feet or so, while the pro setups can be good for well over a thousand feet. A cable-based approach can only manage about 100 feet at best, and only if you have an expensive, long cable.

- **At the cheap end.** There are several low-cost camera remote systems available these days from $30 and up. An extension cable adds to the cost. Phottix (www.phottix.com) makes one for Nikon, Canon, and most other camera systems. (See Figure 11.2.)

- **Pro versions.** Higher-end remote transmitters can trigger their receiver longer distances of more than a thousand feet and send their signals through walls and around corners. They can also be used to fire remote flashes as well. Pocket Wizard makes a variety of transmitters and receivers (including units that can do both). You need two units plus a cord to plug into the camera's digital connection. Setting up the pair would run you from $300 to close to $600 (the company offers several different units, hence the price range). The accessory cable for the camera would add from $20 to $60 or more. You'd need another cord to hook up the receiver with the strobe (more on this in the section on working with flash units).

- **Infrared remotes.** At the low end of the price range ($29.99) are infrared remotes. These will trigger the camera but may not have the range of radio signal–based devices. Higher-end versions such as the Argraph twin1 R3 can cost upward of $100 but offer more features and greater range (more than 300 feet). These are line-of-sight remotes, meaning you can't have anything blocking the signal for them to work.

Time-Lapse Remotes and Intervalometers

Sometimes you need a series of photographs taken over a long period of time at regular intervals. Time-lapse photography, nature photography, and stop-motion animation are just a few forms of photography that take advantage of this technique. It can also be useful for creating multiple exposure sequences at precise intervals, say, to document construction progress. If your camera doesn't have a built-in intervalometer feature, you can add that capability.

- **Remote cable release with intervalometer.** Camera makers such as Canon and Nikon offer a basic cable release that just trips the shutter and locks it open if need be (about $45). On the high end they offer a unit such as the Canon TC-80N3, which can be set to fire the camera at regular intervals from one second to 99 hours, 59 minutes, and 59 seconds, or anywhere in between, making it a perfect device for sequences that need to be captured at regular intervals. Remote cable releases that offer this function cost about $180.

- **Mumford Time Machine.** This is a programmable device that can be used to trigger the camera at regular intervals or set it to fire in response to another action such as a sound, light, or motion. The company also offers an accessory table that can be used for time-lapse movies that pan across a scene. The device is also useful for high-speed time-lapse photography. Depending on how it's configured, the Time Machine (see Figure 11.3) runs between $325 and $400 or slightly more. It can produce stunning results, as shown in Figure 11.4.

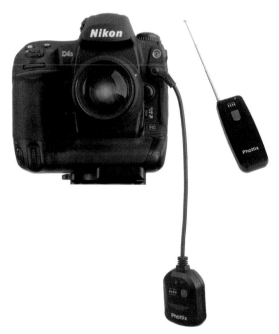

Figure 11.2 Wireless remotes let you keep some distance between you and your camera while still being able to keep shooting.

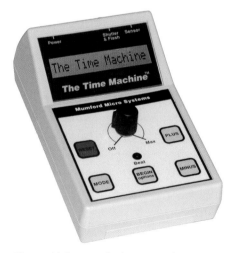

Figure 11.3 Mumford time machine.

Figure 11.4
An intervalometer can trigger your camera to fire at specific intervals making it useful for stop-motion photography.

- **Zigview.** The Zigview is an electronic viewfinder that mounts on to the eyepiece of the camera and then provides a larger LCD view. It also has the ability to trigger the shutter release based on your settings. The Zigview can be set to work as an intervalometer, a remote cable release, or—and this is really cool—a nine-area motion sensor that triggers the camera when variations in the brightness level indicate that there is movement in the image. Zigview electronic finders that offer this capability (the R and the S2 models) range in price from $279 (plus additional cost for an adapter to fit your camera's eyepiece) to $399.

Underwater Housings

Underwater photography is both challenging and rewarding. Once you slip below the water's surface, a wide range of opportunities and problems greet you. Most pressing of course is how to keep your valuable camera equipment safe and dry. If you're operating a camera just a foot or two under the surface, the main problems facing underwater photography—water pressure and loss of certain color wavelengths—are minimized. Even light falloff is inconsequential at that depth, so all you really have to worry about is safety, protecting your camera from moisture.

It's a different story when you put on scuba gear or try to take your camera deeper than 5 or 10 feet. As you descend deeper into the water, the pressures that build up on whatever's protecting your camera increase drastically and the consequences of even a tiny leak become magnified under the greater pressure. The amount of light penetrating the water decreases significantly the farther down you go and certain color wavelengths also become weaker, meaning your photos take on a pronounced bluish cast.

This is expensive gear, but there are good reasons for it. Once you're at depth, you can't just make a quick run to the surface if something goes wrong (at least not if you're diving to a depth that requires decompression stops on the way back up). Equipment failures when you're diving past snorkeling depths risk your equipment and can blow your shoot.

Right now we're going to take a look at protecting your camera and keeping it safe and operational while it's underwater.

Let's take a look at what options exist for underwater photography:

- **Ewa-Marine.** Ewa-Marine has been making underwater camera housings for a long time now. The company offers a soft, baglike housing. These housings offer certain advantages over the hard housing approach. They pack smaller for travel, cost less, and can be a little more adaptable when it comes to using different lenses. For instance, the company makes an extra-large body housing that can handle a professional dSLR with up to a 300mm lens, making it a good choice for photography from a small boat or kayak as well as for use underwater. This unit (the U-BZ) costs under $370. A similar model (for use with shorter lenses) costs a bit less.

- **Ikelite.** Ikelite is another company that has specialized in underwater housings (see Figure 11.5). This company offers a variety of units including polycarbonate models designed for specific cameras. These are more expensive (up to $1,600 or more suggested U.S. retail price) but are fully functional to a depth of 200 feet. The company also offers strobes specifically designed to attach to and work with the housing. Ikelite also offers a variety of accessories to work with its housings.

Figure 11.5
Underwater camera housings require strength and functionality. If problems arise when you're at depth, you're in a tough spot. There's no such thing as rushing to the surface when you're deep enough to require decompression stops on your return. If the housing's controls won't operate your camera, you're not much better off either.

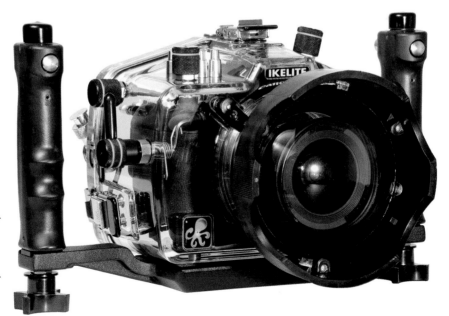

■ **Sea&Sea.** Sea&Sea offers both its own underwater digital camera and an assortment of hard camera housings. Its flagship model uses an aluminum body designed to withstand severe shooting environments. The housing can handle even a pro dSLR as big as the Canon EOS 1D X and still provide use of almost all the camera's controls. It has a depth rating of 200 feet. Specific housings are designed for specific cameras so I can only give a broad sense of pricing. A top-of-the-line dSLR housing for a pro dSLR at Canon or Nikon's top end can cost as much as $4,000 and you may still need a couple of accessories to complete the unit. As you drop down to smaller dSLRs the prices lower too, but not that much. These are high prices, but this is an all-or-nothing situation. At a depth of 200 feet, any malfunction is likely to result in a wrecked camera and a missed opportunity.

Improving Your View

Let's face it. Your connection with your camera gets pretty intimate, particularly when it comes to bringing your eye up to the viewfinder. It sounds like a simple thing, unless of course you wear eyeglasses or need to achieve critical focus or need a stronger diopter power than what's built into the camera viewfinder. Eyepiece accessories can improve the quality of your photographic experience in many ways and at least a few of these may merit inclusion in your camera bag.

Figure 11.6 Eyepiece extenders let you back off from the camera.

Let's take a look at some of the choices you have:

■ **Eyepiece extender.** These are inexpensive accessories (less than $20) that bring the eye farther from the camera. (See Figure 11.6.) This can make the photographer more comfortable and help keep your nose off the back of camera. They also reduce magnification by about 30 percent.

■ **Eyepiece magnifier.** Sometimes you need to achieve critical focus (particularly with macrophotography). This is one of those times where even professional-quality autofocus may not be enough. Eyepiece magnifiers help you zoom in so you can focus as precisely as possible. (See Figure 11.7.)

■ **Eyepiece cup.** This is a rubber eyecup designed to block intermittent light from bothering you while you're looking through the viewfinder. These cost anywhere from $10 to $30 depending on the quality of the eyepiece and whether you're buying the manufacturer's version or a larger heavy-duty option such as the one Hoodman offers.

Figure 11.7 An eyepiece magnifier makes it easy to check focus.

- **Correction diopters.** While most dSLRs already have diopter correction built in, it's not always enough. If your eyesight needs more help than your camera's diopter correction can deliver, then one of these might be the answer for you. They usually aren't very expensive (less than $20).

- **Right-angle finders.** Right-angle finders are useful accessories. They're great for times when you've got the camera mounted on a tripod and it's low enough that bending down to look through the viewfinder would be uncomfortable. They're also useful for ground-level photography where you'd rather not lie flat on the ground. Camera makers usually offer some kind of right-angle finder for their cameras and there's a third-party manufacturer or two as well. Prices can run from $70 for a third-party version to more than $200 for a camera-maker's version. Some offer magnification choices too.

Vertical Grips

Vertical grips offer several important advantages. First, many of them make it easier to use your camera in vertical orientation because they have a shutter button conveniently placed at the base of the grip. This means you don't have to bend your wrist over to reach the normal shutter button. When you have long sessions shooting in vertical orientation (in my case, that's portraits, fashion, and basketball photography), a vertical grip is much more comfortable to use.

These grips typically contain one or two batteries, providing extra juice for your camera. You can shoot longer before having to change batteries. Vertical grips also balance the camera better, offer more weight (which can add enough inertia to reduce camera shake), and provide a more secure grip on the camera when you're carrying it one-handed. Camera vendors who supply these grips for their own cameras frequently keep the same camera base configuration when they upgrade models, so a single grip can be used on several cameras.

Of course, top-of-the-line pro cameras from Canon and Nikon come with a vertical grip as part of the camera. This is because such cameras are designed for the abuse working pros deliver and camera makers can build stronger cameras if they can design the body out of a single piece of metal rather than connecting separate pieces the way they'd have to if building a separate camera/grip combination. For cameras that are sealed to provide some measure of protection against the weather, such a connection would be another place where moisture, sand, or dust could get in, another reason to avoid that kind of construction. These cameras also frequently offer a high frames-per-second rate shooting capability, which also requires the additional battery power accessory grips can provide.

Mid-range cameras and lower models on the other hand, aren't built to the same standards. Camera makers know that not every buyer wants the power grip or can afford the extra cost, so it's better to design the camera to accept an optional grip and leave the decision up to the buyer whether to add one or not. The owner can always decide to add the grip later on if they want to.

It used to be only camera makers who offered accessory grips, but that's not the case anymore. Let's see what's out there:

- **Manufacturer's grip.** The power grips offered by the manufacturer are usually the safest and most expensive options available. On the one hand, they offer security that they will work as well with the camera as any vertical grip on the market can. On the other hand, their cost is usually upward of $150 and may approach $300 for some cameras. (See Figure 11.8.)

- **Third-party grip makers.** It's now possible to buy a vertical grip from one of several third-party manufacturers. (Often in such cases there's only one or two companies making the item, but more selling it as the manufacturer will label it for another seller.) These units tend to be considerably cheaper (under $100) but the reviews I'm seeing for them aren't good. Users are reporting problems with fit and connection with these units no matter what name they're sold under. My advice if you're considering one of these would be to take your camera to a camera store that sells the grip and actually test the grip you want to buy in your camera. Once you get one that fits and works properly in your camera, buy that specific grip. It might cost you a few dollars more, but the added cost will be worth it. Many users have been pleased with the Opteka grips (www.opteka.com).

- **Satechi LCD Timer Vertical Battery Grip.** I'm singling this one out because it's quite different from the other vertical grips on the market. This unit has a built-in intervalometer and a small LCD screen that provides a variety of useful information. Its somewhere between the manufacturer's grip and the other third-party grips when it comes to price (about $129) but offers functionality that few other vertical grips do. If you need both a power grip and an intervalometer, this can be a cost-effective way of getting both. A separate battery powers the LCD screen, so using it won't drain your regular camera batteries.

Figure 11.8
Vertical grips help provide better balance for your camera, extra battery power, and a more ergonomic grip for you to hold.

Light and Measuring Aids

Digital photography has made photography easier in many ways. Savvy photographers can glean a lot of information from the feedback the camera's LCD screen provides. From being able to see the image itself and judge its exposure and color to being able to read the histogram, this information is incredibly valuable.

Even so, as important as it is, such feedback alone doesn't guarantee the results you need. For critical exposure and for color accuracy, there are certain accessories that help you achieve the quality you need. It sounds kind of old fashioned to be carrying a hand-held light meter or color meter, but there's nothing old fashioned about the modern versions of these tools.

Color meters can provide precise color information, and gray cards and tools such as the Expo disc can help photographers make sure they get the most accurate color possible. While Photoshop can fix a lot of problems, it's still easier to get it right in the camera than it is to fix it later. Plus, if you're running or thinking about running an event photography business (which produces a high volume of images), having to spend a lot of time working in Photoshop is time that can be better spent doing other things.

- **Light meters.** While your camera comes with a built-in light meter, it's not as accurate as a hand-held unit, many of which can also double as flash meters. Light meters are particularly important when you have unusual conditions. Remember, camera light meters are calibrated to roughly 13–18 percent gray. If you're shooting a lighter or darker scene, you camera meter can be thrown off. With a hand-held light meter you can measure the light falling on the scene rather than the light reflected off the scene, a more accurate method under such conditions. Light meters can cost from about $100 to more than $1,400. The difference in price reflects things such as digital versus analog technology, and additional capabilities such as being able to measure flash output, and control wireless remotes such as Pocket Wizards.

- **Spot meters.** These are light meters with a very narrow field of view so you can take readings from a distance. You use this to take several light meter readings of the scene to determine the best overall exposure. Zone System proponents in particular find spot meters useful (the Zone System is a very precise exposure control system made famous by Ansel Adams), but landscape photographers in general like them. Spot meters generally cost between $300 and $800 but often you can find a hand-held light meter that has a spot meter attachment ($100 or more as an add-on accessory) so you don't have to buy both.

- **Color meters.** Similar to a light meter, but it measures color temperature instead (generally in degrees Kelvin). As long as your camera can accept input in degrees Kelvin, it provides for very accurate color. Color meters cost from $1,200 to $1,400.

- **Flash meters.** Usually better quality light meters can also trigger flash units (either via PC cord or Pocket Wizard) and read their light output, but if you don't need a multi-purpose light meter or yours doesn't have a flash meter capability, you might consider a flash meter. Flash meters run about $100 to $800.

- **Gray cards.** Since camera light meters are theoretically calibrated to 18 percent gray (it's actually closer to 13–14 percent gray), using a gray card to help achieve correct exposure and color works fairly well. You hold the gray card under the light your subject is under and activate the camera's light meter. This gives you the best exposure as long as you've got the card under the same light as your subject. You might want to use about one-half stop *more* exposure, because your camera is probably calibrated for a slightly lighter tone. You can also use the gray card to set your white balance under the camera's custom white balance feature (the method varies from camera to camera so check your owner's manual to see how). These run from $5 to $50, but the more expensive versions are usually made from plastic or resin rather than cardboard and may include a color chart or some other color correction tool.

- **Expo Disc.** The Expo Disc is a white diffuser-like dome that fits over your camera lens. You point it at your subject area and create an exposure. You then load the image into your custom white balance setting and as long as your lighting conditions don't change, you can then work from that white balance. If your lighting conditions change (or you move to an area with different lighting conditions, such as indoors from the outside or vice versa) then you need to create another Expo Disc exposure. If you're shooting at this location on a repeat basis, you can always use the Expo Disc exposure all over again, but you should be sure the lighting conditions haven't actually changed. Expo Disc prices are based on filter size for your camera and cost from $70 to $170.

The Three Qs of Filter Buying: Quality, Quality, Quality

Filters come in two varieties: cheap and fairly expensive. The cheap filters are the ones that you receive for free from your grateful photo dealer, or as part of a "bargain" bundle (which is likely to include a cheap tripod and some other useless gear). You may also *buy* cheap filters for prices of $5 to about $20. Bargain-basement filters are not a total waste of money. They make great lens caps. You can smear them with petroleum jelly to create a dreamy soft-focus effect.

But for serious applications, I use serious filters. If you buy a decent one in the first place, you'll have little need to replace it over the next few decades—until you reach a point that you no longer own a lens that fits that particular filter size. Or, if you shoot in sandstorms a lot or your filter encounters an unidentified flying object, it's possible that the filter will be damaged and need replacement. But, in most cases, spending a few extra dollars to get a good filter will pay off, because your filter will last a long, long, time. If you're interested in experimenting with things like infrared photography, a good IR filter, such as the one shown in Figure 11.9, is essential to achieve effects like you see in Figure 11.10.

Figure 11.9 Infrared photography is one pursuit that absolutely demands the use of a filter.

Figure 11.10 High-quality infrared filters aren't cheap, but they can be your gateway to a new outlet for your creativity.

Here are some things to think about when considering buying filters:

■ **Good filters filter what they are supposed to—and nothing else.** Filters are intended to *remove* something from the light path, unless they are clear glass filters designed for "protection" (more on that later). The best filters are made from high-quality glass or resin and should be either completely neutral in color or precisely the exact color they're supposed to be. Inexpensive filters may have a slight color-cast, and may cause unwanted optical effects, such as flare.

■ **Glass or gels.** Glass is generally better, but there are a couple of ways that glass filters are constructed. The better way is for the glass to be made with the ingredients that give it its effect added while the glass is still molten. The other approach, sandwiching multiple pieces of glass around a colored gel and then fusing the sandwich together makes for cheaper, less durable glass filters. Gels are flimsy; in fact, they're usually used in special mounts at the rear of certain lenses (usually extreme wide-angle lenses or very long telephotos) instead of the front of the lens.

■ **Larger filters cost more.** One type of filter I prefer costs $35 in a 52mm screw-in mount (that is, the filter has male threads that screw into matching female threads around the perimeter of a camera lens). I use that size on a 105mm macro lens, several 50mm f/1.8 lenses, and some older optics that I still use. Most of my best lenses use a 77mm thread, standardized by the lens manufacturer as a mercy to us cash-strapped photographers. The exact same brand and model filter costs $85 in the 77mm size. You'll want to keep that in mind when planning your own filter arsenal. If all your lenses use the same size filter (so you don't have to duplicate your set), and that size is modest (say, 62mm or 67mm), you can afford more filters, and will have fewer to carry around.

- **Brass or aluminum frame.** Circular filters are usually made with either a brass or aluminum frame. In this case there are advantages and disadvantages to each material. Brass is harder, so it's less likely to lock to your lens, but it's also more likely to break a glass filter because it won't absorb shock. Aluminum, on the other hand, isn't as hard as brass, so it's more likely to bind to your lens. It won't transmit shock to the filter as readily though, so it's less likely to cause your filter to crack if it receives a hard tap. I tend to panic at the thought of my lens or filter receiving a "hard tap," so I may be more careful than most, as well as insistent on always having a protective lens hood mounted to my lens.

- **Thickness.** Another reason I prefer my brass filters (B+W brand, the version made in Germany) is that these particular filters are a bit thinner than any aluminum filters I've used. They can be mounted on fairly wide-angle lenses without the filters themselves intruding into the picture area (as described shortly). You may be able to "stack" several thinner filters together, so you can use more than one at once. (However, not all filters, especially the very thinnest ones, have a front female thread to allow attaching additional filters.) I don't recommend stacking filters, because additional layers of glass will eventually affect your images, no matter how good the filter is, but it's a useful creative option nevertheless.

- **Coating.** Ideally, a filter will remove only the photons it is supposed to, and won't add any. But when light strikes the front surface of a filter, it's possible that some of those photons will go awry, and bounce around on their way to the sensor, causing a phenomenon known as *flare*. Flare robs your image of sharpness while reducing contrast. It can cause those little globs of light, distracting "rays," and other visual artifacts that nobody wants (unless they *do* want it, for "effect," and add using an image editor's Lens Flare filter). Fortunately, many filters (and virtually all lenses) receive one or more coating layers that greatly reduce unwanted reflections. More expensive filters usually have the most effective coatings. Coatings can also be used to make an optical surface harder and more scratch resistant, which is one reason why you can carefully clean filters and lenses with the right kind of cloth, tissues, or other tools.

- **Square or round.** Filters can be mounted to your camera several ways. Most common are round filters that screw into the front of your lens; also popular are rectangular filters, like the Cokin System, which slide into an adapter mounted on the front of your lens.

Once you've chosen the brand, type, and size filter you want, there are even more things to watch out for:

- **One size does not fit all.** Attachments designed with a specific diameter won't fit lenses with other diameters without use of a step-up or step-down ring. For example, to mount a 67mm filter on a lens with a 62mm filter thread, you'd need to use a 62mm-to-67mm adapter ring. Step-up and step-down adapter rings can allow you to use the same filter on multiple lenses with different diameter threads. They have a male thread of one size to screw into a specific lens diameter, and a female thread of a different size to accept a filter of another diameter. These adapters can cost $10–$20 and are well worth the cost.

- **Vignetting.** As I noted earlier, a filter or other add-on may intrude into the picture area, particularly when used with wide-angle lenses, at smaller apertures (which have greater depth-of-field), and when shooting close-ups (which brings the plane of focus closer to the front of the lens). The result is darkened corners.

- **Lens/filter conflicts.** Some lens barrels *rotate* during focusing (while others use *internal focusing* and may not change length or rotate). This rotation can cause problems when using a filter that needs to be used in a specific orientation, such as a polarizer (which is rotated until the desired degree of reflection-removal is achieved), gradient filters (which have a particular density and/or color in one portion, and a different density/color in another), and when using certain special effects attachments (such as "kaleidoscope" lenses that change rendition as they are rotated).

- **Lens/lens hood conflicts.** If you're using a lens hood that fastens to the filter thread rather than to a bayonet on the lens barrel, certain unpleasantries can occur. One of them is vignetting (described above), which is almost inevitable with wide-angle lenses when you attach the filter first and then screw in the lens hood (which is now moved farther away from the front element of the lens, and potentially visible in the picture area). A lens hood may interfere with your ability to adjust a filter, such as a polarizer or star filter, which must be rotated to the orientation you want. Another drawback of this configuration is that each time you decide to switch filters, you must remove the lens hood first. It's also easy to screw a lens hood into a filter thread too tightly, making it difficult to remove. Some attachments have no matching filter thread on their front rim (polarizers frequently don't) so you have no way of attaching a lens hood in the first place.

Filters to Protect Your Lenses

Do you need to use a filter to protect your lens? I have a definitive answer: yes, no, and maybe. There are three schools of thought when it comes to using filters to help protect your lenses. The first says it's smart to use an inexpensive filter to help protect your expensive glass from dust and scratches. The second says why stick a cheap filter in front of an expensive piece of glass? I subscribe to the third school of thought: I put an *expensive* filter in front of an expensive piece of glass, but virtually always remove it before shooting. Five of my best lenses each have an $85 B+W UV filter on the front, and, as I mentioned earlier in the chapter, I can snap off the lens cap and shoot a grab shot with the filter in place if I need to. And if an evil wind, misty rain, or a gritty sandstorm is afoot, I can still fire away. (Although, when I am not doing photojournalism, wind, rain, and sand usually are enough to send me packing.) The second and third alternatives don't put much stock in the "protective" qualities of filters, except when shooting under dire environmental conditions.

Each of the three sides' arguments can be persuasive. No matter how careful you are, if you're not using a filter, some dust, mist, or other foreign substances can get on your lens. If you know how to clean your lens properly, that's not a problem. But, if you don't know how to clean a lens, or don't

have the proper tools, the more often you have to clean your lenses, the greater the likelihood of leaving cleaning marks or clumsily rubbing off some of the vital multi-coating that helps prevent lens flare. Yet, there are other ways to protect your lens. First off, a good quality lens shade, properly matched to a particular lens, will help protect your expensive glass. Coupled with a lens cap and reasonable care when shooting, you can minimize the risk of dust and accidents.

I suppose it comes down to what your shooting style is like. Are you a careful and deliberate photographer who can take the time to set up each shot and treat your equipment as carefully as possible or are you more frenetic? I'm cautious when I am shooting landscapes, wildlife, and architecture, and almost never need a protective filter under favorable environmental conditions.

As with most controversies, there are pros and cons for each side. You'll find many photographers who have never used a protective filter and who have suffered no mishaps in 30 to 40 years that a lens hood wouldn't counter. A significant percentage of those who are most adamant about using a protective filter have tales of woe about smacking or dropping a lens or two that was "saved" by the filter. I don't know if the non-filter users are more careful and/or lucky, or whether the filter proponents are clumsy, careless, or unfortunate. The real bottom line: if you're convinced you need a filter to protect your lens, you *really* need one. Otherwise, you're sure to have an accident and regret it for the rest of your life.

Here are the relevant pros and cons. First, the no-filter-required arguments:

- **No filtering required.** It's known that general-purpose UV and skylight filters have no effect in the digital world. However, strongly yellow UV filters, such as a Haze2A or UV17 can reduce chromatic aberration. If you're not using a lens plagued with this defect, you really don't need to be filtering anything. A piece of clear glass (an "optical flat") would provide the same effect—good or bad.

- **Varying performance.** Lower-quality filters can cause problems with autofocus and can degrade the image. That means if you use a protective filter at all, you should use one of high quality. A $20 filter might do more harm than good. A very good filter, on the other hand, can cost $70 to $100 or more in larger filter sizes (and don't forget you'll need one of these for each and every lens).

- **Cost.** If you are using a $1,500 lens, an $85 filter might make sense to you. But an $85 filter for a $180 lens makes little sense. But, oddly enough, that cheap lens might have little quality to spare and would, ironically, benefit more from a pricey filter than the expensive lens that is so sharp you won't notice a little degradation.

- **Softer images.** Adding another element can degrade image quality due to aberrations and flare. Why reduce the quality of every image you take to guard against an accident that may never happen?

- **Damage from a broken filter.** A badly broken filter can scratch the optical glass element behind it. For every lens "saved" by a protective filter, you may find one that's really been

whacked, sufficiently that the filter is cracked, crushed, and the pieces driven into the glass behind it. In some cases, the damage might have been less had the protective filter not been in place.

- **Lens hoods provide better protection.** I don't use protective filters most of the time, and have never had an accident where one would have helped. However, I've gently bumped the front of my lens up against objects, and my lens hood prevented any damage every time. The insidious thing about filters is that when one is being used, the camera owner may actually be less likely to use a lens hood—which should always be your first line of defense.

And on the other side of the fence:

- **Protection from small sharp and blunt objects and falls.** If the lens is dropped, the filter may well suffer scratches or breakage instead of the front lens element. Small pointy things can sneak past a lens hood and strike the front of your lens. A lens hood is great at blocking a door that opens unexpectedly, but will not help if the first thing that hits your lens is a doorknob.

- **Reduced cleaning.** One can clean the filter frequently without having to worry about damaging the lens coatings; a filter scratched by cleaning is much less expensive to replace than a lens. I must admit, though, that this rationale applies most to those who don't know how to clean their lenses properly.

- **Makes a good lens cap.** I keep mentioning this, because most people tend to forget about this alternative. A protective filter can do its job and still not interfere with image quality. Keep a screw-on filter mounted on your lens at all times—without a lens cap protecting the filter. Then, if an impromptu opportunity for a picture appears without warning, you can flip your camera on (if necessary), sight through your viewfinder, and take a picture. There is no time lost fumbling for the lens cap. If you have more time, *take the filter off.* I usually don't care if one of my "grab" shots with filter in place is not as sharp as it could have been. It's a grab shot, an opportunity that would have been lost entirely.

Polarizing Filters

Polarizing filters are useful in many ways—most of which are impossible to recreate in Photoshop. Light becomes polarized (and therefore susceptible to the effects of a polarizing filter) when it is scattered by passing through a translucent medium. So, light from a clear-blue sky becomes polarized when it passes through the dust-laden atmosphere. Light striking, passing through, and reflecting off water also becomes polarized. The same is true of many other types of objects, including foliage, and the partially transparent paint on an automobile body (think about it: that's why cars need several coats of paint). Nontransparent or translucent objects, like the chrome *trim* on the automobile, aren't transparent, and don't polarize the light. *However,* if the light reflecting from the metal has already been partially polarized (that is, it is reflected skylight), you still might be able to see a reduced amount of glare reduction with a polarizing filter.

How does it work? A polarizer contains what you can think of as a tiny set of parallel louvers that filter out all the light waves except for those vibrating in a direction parallel to the louvers. The polarizer itself consists of two rings; one is attached to the lens, while the outer ring rotates the polarizing glass. This lets you change the angle of the louvers and selectively filter out different light waves. You can rotate the ring until the effect you want is visible. The amount of glare reduction depends heavily on the angle from which you take the photograph, and the amounts of scattered light in the reflections (which is determined by the composition of the subject). Polarizers work best when the sun is low in the sky and at a 90-degree angle from the camera and subject (that is, off to your left or right shoulder). Blue sky and water, which can contain high amounts of scattered light, can be made darker and more vibrant as glare is reduced. You can also reduce or eliminate reflections from windows and other nonmetallic surfaces.

As you might expect, polarizing filters solve problems and enhance images in several ways. Let's look at them:

- **Reduce or eliminate reflections.** Polarizing filters can reduce or eliminate reflections in glass, water, lacquer-coated objects, non-conducting surfaces, and plastic. They don't have any effect on reflections on metallic surfaces.

- **Increase contrast.** A polarizing filter is the only filter that can increase contrast in color imagery by eliminating those pesky reflections.

- **Darken pale skies.** Polarizing filters block a lot of light (as much as two f/stops), and because the effect is strongest when dealing with polarized light (such as light in the sky), this can help darken pale skies considerably. At the same time, it will also make clouds stand out more strongly, as you can see in Figure 11.11.

Figure 11.11
Using polarizing filters can get rid of reflections, increase contrast, and turn pale skies bluer.

When considering a polarizer, there are some important considerations. First off—linear or circular? This one's easy: if you're using an autofocus camera, you want a *circular polarizer*, usually abbreviated CPL. Now, keep in mind, when we're talking about linear and circular, we're not talking about the shape of the filter. All polarizers are furnished in a circular frame for easy rotation. While both types transmit linearly polarized light that is aligned in only one orientation, a circular polarizer has an additional layer that converts the light that remains into circularly polarized light that doesn't confuse the metering and autofocus sensors in digital SLRs.

The second thing to watch out for is the use of polarizers with wide-angle lenses. Such filters produce uneven results across the field of view when using lenses wider than the equivalent of about 28mm (which would be a 17-18mm lens on a camera with a 1.5X to 1.6X crop factor). Polarizers work best when the camera is pointed 90 degrees away from the light source, and provides the least effect when the camera is directed 180 degrees from the light source, as when the light source is behind you. The field of view of normal and telephoto lenses is narrow enough that the difference in angle between the light source and your subject is roughly the same across the image field.

But an extra-wide-angle lens may have a field of view of about 90 degrees. It's possible for subjects at one side of the frame to be oriented exactly perpendicular to the light source, while subject matter at the opposite side of the frame will actually face the light source (at a 0-degree angle). Everything in between will have an intermediate angle. In this extreme case, you'll get maximum polarization at one side of your image, and a greatly reduced polarization effect at the opposite edge. Use caution when using a polarizer with a very wide lens. This phenomenon may not even be a consideration for you: many polarizers will intrude into the picture area of wide-angle lenses, causing vignetting, so photographers tend to avoid using them entirely with the very widest lenses.

Neutral Density Filters

There are times when you can have too much light. When reducing ISO and closing down the aperture aren't enough to get the desired shutter speed, you need a neutral density filter to block additional light. *ND* filters, as they're known, come in a variety of "strengths," and vendors use somewhat confusing nomenclature to define how much of the light is blocked. You'll see neutral density filters from one manufacturer labeled according to something called a *filter factor*, while others, from different vendors, are labeled according to their *optical density*. There are actually no less than *four* variations of naming schemes, all equally cryptic; and even if you understand the difference you still probably won't know which is which, or why.

For example, one of the ND filters I own of a particular value is labeled, by different manufacturers, with the following names: ND8, 8X, ND 0.9, and "Three Stop." All four monikers mean that the filter reduces the amount of illumination by three full f/stops. If the correct exposure were 1/500th second at f/8 without any filter at all, you'd need an exposure of 1/60th second at f/8 with the filter in place. (Or, if your goal were to use a larger f/stop instead, you could shoot at 1/500th second at f/2.8 with the filter attached.) Only the last term ("Three Stop") actually explicitly tells you what you want to know.

While you might see stronger or weaker neutral density filters available, the basic ND2, ND4, and ND8 set will handle most situations, because they can be stacked and used together to provide higher light-stopping values. Stacking filters does increase the chances of noticeable image degradation, color shift (because neutral density filters are rarely 100% color-neutral, despite their name), and/or vignetting.

Here are some of the things you can use neutral density filters for:

- **Slower shutter speeds.** Many digital SLRs have ISO 200 as their lowest ISO setting; others have a minimum of ISO 100, and only a very few go as low as ISO 50. The average lens has f/22 as its smallest f/stop. So, outdoors in bright daylight you may find it impossible to use a shutter speed longer than 1/50th or even 1/100th second. If your mountain stream is not in bright sunlight, it's still unlikely you'll be able to use a shutter speed any longer than about 1/30th to 1/15th second. That's a shame when you have a beautiful waterfall or crashing ocean waves in your viewfinder and want to add a little creative motion blur. An ND8 filter can give you the 1/2 second to several-second exposures you'll need for truly ethereal water effects, as shown in Figure 11.12.

- **Larger f/stops.** Frequently there is too much light to use the large f/stop you want to apply to reduce depth-of-field. The wide-open f/stop you prefer for selective focus applications might demand shutter speeds of 1/4,000th second or higher. With a 2X or 4X ND filter, the apertures f/2.8 or f/2 are available to you. ND filters are often used to avoid a phenomenon called *diffraction*, which is the tendency of lenses to provide images that are less sharp at very small

Figure 11.12 Neutral density filters reduce light striking the lens making it possible to use slower shutters speeds and get much longer exposures.

f/stops, such as f/22 or f/32. If the shutter speed you want to use calls for such a small f/stop, you can add a neutral density filter and shoot the same image at f/16 or f/11.

- **Split the difference.** If creative or practical needs dictate, you can *split* the effects among all the exposure factors: an ND8 filter's three-stop light-blocking power will let you use a shutter speed that is half as fast, an f/stop that is twice as large, and an ISO setting that is twice as sensitive, all in the same photograph if that's what you want.

- **Countering overwhelming electronic flash.** I have several older manual studio flash units that are simply too powerful for *both* my available range of f/stops and ISO settings, even when switched from full power to half power. Newer units generally offer 1/4, 1/8, 1/16, and 1/32 power options and may be continuously variable over that or an even larger range. But lower power may not be the ideal solution. It's common for the color temperature of electronic flashes to change as the power is cranked way down. An ND filter, instead, allows me to shoot flash pictures with these strobes at my camera's lowest ISO setting and apertures larger than f/22, reducing the need to shoot at a lower power setting.

- **Vanishing act.** Create your own ghost town despite a fully-populated image by using a longer shutter speed. With an ND8 filter and shutter speeds of 15 to 30 seconds, moving vehicular and pedestrian traffic doesn't remain in one place long enough to register in your image. With enough neutral density, you can even make people and things vanish in full daylight.

- **Sky and foreground balance.** A special kind of neutral density—the split ND or graduated ND filter, is a unique tool for landscape photographers. In the average scene, the sky is significantly brighter than the foreground and well beyond the ability of most digital camera sensors to capture detail in both. An ND filter that is dark at the top and clear at the bottom can even out the exposure, restoring the puffy white clouds and clear blue sky to your images. There are other types of split and graduated filters available, as you'll learn from the next section.

Graduated Neutral Density Filters

Graduated neutral density filters are a special type of ND filter, one that's almost indispensable for landscape photography. They are particularly important in digital photography for a couple of reasons. The first is that digital cameras often have trouble capturing high-contrast light. The second is that they can have difficulty recording detail with overcast skies.

Digital imaging sensors have gotten a lot better at handling high-contrast light than they were just a few years ago, but they're still not capable of handling typically contrasty conditions you frequently run into when shooting under extreme lighting conditions. That's one reason for the current High Dynamic Range (HDR) photography fad among avid users of image editors and utilities like Adobe Photoshop and Photomatix.

Graduated neutral density filters come in a variety of shapes, sizes, densities, and even area of coverage. These filters are so useful that pro landscape photographers may own a half dozen or more. You can find round ones and square ones, but rectangular ones that are longer than they are wide are the best choice.

Here's what you need to know about them:

- **Soft edge or hard.** You can find these filters transitioning from dark to light ending in either a soft transition to a clear area (as shown top left in Figure 11.13) or ending in a hard transition to clear area (shown at top right in Figure 11.13). The center bottom filter is a split-color filter, discussed in the next section.

- **Reverse graduated neutral density filters.** The typical graduated neutral density filter is darkest at one of the outside edges and gradually gets lighter. The folks at Singh Ray responding to requests from landscape photographers created a filter where the transition moves from clear at the outer edge to darker in the middle of the filter then back to clear at the other edge. This filter is a good choice for sunset and sunrise photography when the brightest part of the image is the sun right on the horizon with the foreground and sky both being darker than the center of the image.

- **Cost range.** GNDs, as they're known, can vary greatly in price from $22 for smallish resin versions to upward of $150 for high-quality glass versions. This is a case where you get what you pay for and if your budget allows for it, a good quality glass version will do a better job. Still, it's better to have and use a GND, even a resin one, than it is to not use one.

- **Filter length.** The most versatile GNDs are rectangular and longer than they are wide. These can be shifted up and down in the filter holder to best match up the effect with the portion of the sky that needs holding back.

- **Software approaches.** It's possible to simulate the effect of a GND in image-editing programs, some of which even have a specific software filter to mimic the effect. The problem is you're dealing with overexposed highlight areas where no information has been recorded by the imaging sensor. These software approaches will darken a too-bright area, but won't restore any detail (clouds that might have been recorded) because there is no record of it.

Figure 11.13
Graduated neutral density filters can have a soft transition (top left), hard-edged transition (top right), or fade from one color to another (bottom).

Here's a quick summary of the things you need to know to use a graduated or split-density density filter:

■ **Choose your strength.** Some vendors offer graduated/split ND filters in various strengths, so you can choose the amount of darkening you want to apply. This capability can be helpful, especially when shooting landscapes, because some skies are simply brighter than others. Use an ND2 or ND4 (or 0.3 or 0.6) filter for most applications.

■ **Don't tilt.** The transition in the filter should match the transition between foreground and background, so you'll want to avoid tilting the camera—unless you also rotate the filter slightly to match.

■ **Watch the location of your horizons.** The ND effect is more sharply defined with a split ND filter than with a graduated version, but you need to watch your horizons in both cases if you want to avoid darkening some of the foreground. That may mean that you have to place the "boundary" in the middle of the photograph to properly separate the sky and foreground. Crop the picture later in your image editor to arrive at a better composition.

■ **Watch the shape of your horizons.** A horizon that's not broken by trees, mountains, buildings, or other non-sky shapes will allow darkening the upper half of the image more smoothly. That makes seascapes a perfect application for this kind of neutral density filter. However, you can use these filters with many other types of scenes as long as the darkening effect isn't too obvious. That makes a graduated ND filter a more versatile choice, because the neutral density effect diminishes at the middle of the image.

Color Control and Special Effects Filters

Sometimes you want color with just a little more oomph, and sometimes you want color that should be there, but isn't. Fortunately, there's a whole class of filters designed to help with those problems.

While you can certainly tweak image colors in an image-editing program such as Photoshop, it's still frequently easier to get the effect you want out in the field by using a filter. The advantage to this is you are in a position to check the result either via your camera's LCD screen or through a portable hard drive/view or laptop computer. This approach gives you the chance to try again if the resulting effect isn't to your liking. If you wait till you get home, you may not be able to get the effect you want on your computer and then, you're stuck.

Here are some of the choices available:

■ **Intensifiers.** Sold under several different names (intensifiers, enhancers, Didymium filters) they serve to intensify just one or two colors while not affecting any others. A "redhancer" for instance, will make the reds in a scene stronger without influencing any other colors. These filters can be useful for landscape or fall foliage photos. There are a wide variety of these filters on the market (one camera store lists 10 different versions in the 77mm size alone).

- **Split color.** These filters follow the same approach as split-graduated neutral density filters except they're not neutral and are more concerned with adding a color-cast than blocking light (although the darker part of the filter will rob you of some light). These filters are useful for changing the color of the sky while leaving the foreground unaffected. Sepia, tobacco, and orange versions of this filter are popular (a certain cable TV channel seems to use them for all their documentaries) but they are also available in other colors such as blue, green, red, brown, and yellow. One such filter is shown at the bottom in Figure 11.13 in the previous section. They may have a transition from one color, such as amber, brown, red, cyan, or blue, to clear, or from one color to another contrasting hue. For example, filters that have a ruddy sunset glow on one half, and a blue tone on the other can simulate sunrise or sunset effects, or simply add an interesting color scheme, as in Figure 11.14. You'll find dozens of graduated filters available to provide the looks you want. Because the density in these filters can cancel out overly bright portions of the image and bring those areas within the dynamic range of your sensor, the effects you get with graduated/split filters can be superior to the same treatments applied in an image editor.

- **Sunrise/sunset filters.** While it's possible to use an orange or red split color filter to get a sunset/sunrise like result, such an image rings a bit hollow because while the sky looks like it was shot when the sun was low in the sky, the foreground doesn't. For years photographers would use a rectangular filter holder and position a stronger color filter in the top half of the holder and a weaker version upside down in the bottom half to create a more realistic sunset/sunrise image. Cokin eventually came up with a sunrise/sunset filter that gradually transitions from a light orange to a darker orange so you only have to carry one filter for that effect these days.

Special Effects Filters

Special effects filters can do a variety of things from creating star-like effects to double images to multi-color images and more. While some of these effects can be created in software, some can't, and as always, there are certain advantages to achieving an effect in the field where you can make adjustments to exposure and camera positioning if need be.

- **Cross screen filter.** This filter, sometimes called a star filter, gives light sources a star-like effect. You can achieve a similar result by stretching a black nylon stocking over a lens or holding a piece of window screening in front of the lens. (See Figure 11.15.)

- **Soft FX filter.** Helps soften small blemishes and wrinkles without degrading other elements of the photo.

- **Split field filter.** This filter is half diopter, half clear. It's used in situations where you want to have a close-up element and a distant element and need both to be in focus.

- **Radial zoom filter.** A clear center spot doesn't affect your subject in the center, while everything else in the frame is turned into a zoom effect.

Figure 11.14 A variety of filters, like the split color filter used for this shot, exist to help you make colors more intense or get Mother Nature to cooperate with your photographic needs.

Figure 11.15 A star/cross-screen filter effect.

- **Multi-image filter.** Takes whatever's in the center of the frame and creates multiple versions of it. There are 5, 7, 13, and 25 models, which multiply the subject by the number of the filter.
- **Rainbow filter.** Puts a rainbow into your image. While it's an interesting idea, it seems to be very difficult to get a natural-looking effect with this filter.
- **Mirage filter.** Creates a reflection of your subject similar to a reflecting pool.

Part III

Expand Your Shooting World

Everyone has a favorite type of photography. I especially love shooting sports, visiting new places and capturing memories of what I see, and photographing people. Yet, it's important to avoid falling into a rut. You'll find that leaving your comfort zone and taking pictures of subjects that you don't normally photograph is one of the best ways of gaining inspiration that affects everything you shoot. Travel photography will make you a better landscape shooter. Mastering portrait photography will help you improve your macro photography skills. New subjects bring new perspectives, and new ways of applying what you already know to subjects both familiar and unfamiliar.

That's why I hope you'll look over the six interesting realms of photography in this Part and jump to one of the types that you don't normally shoot. I'll give you enough background in each that you can hit the ground running as you explore a new area. The first two Parts of this book have helped you master your camera and its capabilities; this Part will help you master a half dozen particularly exciting types of photography.

For example, you'll learn how to shoot great travel pictures in Chapter 12. I tend to emphasize foreign travel in the chapter, but the techniques I provide work just as well close to home. Chapter 13 gives you tips on people photography, with a lot of detail on formal studio lighting for those who want to improve their portrait photography technique. I shoot three or four concerts and performances, ranging from rock to country to folk to ballet each month, and have been doing it for decades, so I hope you'll find my tips for capturing these events in Chapter 14 useful. Chapter 15 covers landscapes, wildlife, and nature photography. I began my career as a sports photographer for a daily newspaper, so I have a lot to tell you about action photography in Chapter 16. And, those who need something to do indoors on a rainy day (or outdoors on a good day!) should find my macro photography advice in Chapter 17 useful.

Travel Photography

Travel photography is a great way to practice your digital photography skills. Vacations are a good time to investigate this type of photography. You're relaxed. You're out to have fun. You definitely have your digital SLR along with you to document the sights and sites that you've paid thousands of dollars to visit. When you get home, all you'll have will be the souvenirs you picked up, your memories, and the photographs that help you preserve those memories.

Of course, "travel photography" is actually an interesting blend of several different types of picture-taking activities, including landscape, architectural, and street photography. Even if you're on a whirlwind 14-city tour of Europe, you'll find that between each of those cities are scenes created by Mother Nature that deserve your artistic attention. If you can, take the time to stop and photograph them. Then, when you reach the next city, be prepared to photograph the monuments, towers, cathedrals, and other interesting aspects of urban life, including people on the street. This chapter provides a broad overview of some of the things to keep in mind as you venture forth on your traveling photo expedition. Because I travel outside the USA several times a year shooting photographs specifically for books like this one, I'm going to depart—slightly and only briefly—from topics photographic to give you some tips that, I think, will help you in your quest to take better pictures.

Foreign Photography Field Trips—Fun and Affordable

When I leave the United States, I tend to visit Europe more than any other overseas destination, because the hop across the pond is an easy and inexpensive one from my part of the country. However, most of my advice applies to travel within the United States and visits to Asia, South America, Africa, and other continents, too. The point I'd like to emphasize most is that if you want to photograph exotic locations, you can do it inexpensively and in a way that's rich in local color and experiences.

If you ignore (for the moment) the cost of airfare to your destination, the other costs for an overseas trip (food, transportation, admissions, hotels, etc.) can be remarkably affordable. I once spent a full week in Toledo, Spain, photographing that city's ancient treasures for a total expenditure of $600. Another time, I spent two weeks in Europe for $1,200, about half of that spent on transportation because I rented a car and paid the equivalent of $5.60 a gallon for diesel fuel. Last year, it was nine days for $965, for all expenses. All these, as I noted, don't include airfare.

If you do as I do, and pay many routine expenses (groceries, gasoline, utility payments) with a credit card that grants airline mileage points for every dollar spent, it's easy to pick up one free round-trip overseas plane ticket per year (but, if you are able to pay fewer bills with your credit card, most can manage a free trip every two years, tops). If you *have* to pay for a plane ticket, it usually adds to the price of your photo expedition around $600–$1,000 (and up, depending on where you live, and where you are going).

How do you get into travel photography on the cheap? Just follow these tips:

- **Travel like a native, not like an American.** In Europe, I stay in the same hotels and eat in the same restaurants Europeans do, while my fellow Americans are often sequestered at the Hilton. Public transportation is far better than we have in the United States, easy to understand, fast, and cheap. While Americans are eating in touristy restaurants, I am dining on much better food a couple blocks away at one-quarter the price.

- **Avoid tours.** I stay away from the packaged tours; I'm visiting to take pictures, not simply shown the sights by bored locals. A two-week, $4,000 (per person) guided tour can cost you half or one third as much if you're willing to spend a little time on Google discovering the major things of interest in the places you want to visit—or even to determine what those places are. I do use Orbitz to pick up non-guided packages, such as airfare/car rental (a week in Ireland for $500 was nice!) or sometimes airfare/hotel when I'm staying put and don't want to choose my own lodging.

 Certainly there is a place for guided tours with one-day-per-city itineraries, especially if a trip to Europe is a once-in-a-lifetime event for you. But you can transform that single visit into three or four, for the same cost, if you choose to visit Europe like the Europeans do.

- **Don't worry about language barriers.** Guides make their money based on your belief that you need someone who "speaks the language." Tourism is big business in most countries these days, and anyone you encounter in hotels, restaurants, or on the street will have vast experience in dealing with English speakers. Indeed, I found a recent trip to Barcelona very frustrating, because it was almost impossible to use my college Spanish, generally because the natives I dealt with had learned that speaking to Americans in English helps avoid confusion. So, in a restaurant I'd order "pollo asado con patatas bravas y un agua mineral sin gas," and the server would repeat back, "chicken and fries and a bottle of water, right?" In the last year, the situation was much the same during visits to Vienna, Krakow, Budapest, Paris, and Brussels. I had more difficulty being understood in Ireland than in Prague.

■ **Choose your hotels carefully.** When I searched travel websites for hotels for a trip to Valencia, even the "cheap" and "special deals" hotels were ridiculously expensive (usually a couple hundred dollars a night) and located in the business and commercial centers, or on the beach, none of which had anything I wanted to photograph. Instead, I stayed in a quiet, tiny 18-room hotel nestled deep in the cobblestoned spider web streets of the ancient quarter of the city, within a hundred yards of the cathedral. Although the hotel's 18th century building was older than the USA, it was freshly remodeled, had air-conditioning, Wi-Fi, and a friendly family-run staff. My cost? $66 a night.

■ **Eat right.** Enjoying—and photographing—the local food while you travel is part of the fun. But keep in mind that those restaurants near the tourist attractions don't have to please you, because they don't depend on repeat business. In Valencia, the "Menu of the Day" offerings are usually the cheapest way to have a tasty meal at any restaurant, but I found that the tourist traps were charging 20 to 25 Euros for these meals ($29 to $37 at the time, which is not really out of line for a good dinner anywhere). But I found better food and service at the restaurants favored by Valencians, at 10 Euros ($14.88). I even found a *buffet libre* that let me sample a variety of dishes for 8.95 Euros.

In countries like Thailand, Cambodia, and Vietnam, excellent food costs so little that some city apartments for residents of those countries don't even include a traditional kitchen. Eating out, inexpensively, is a way of life. You can even kill three birds with one stone by signing up for a cooking lesson offered in major cities in many different countries. You'll eat well, learn how to prepare an exotic new dish or two, and discover some excellent photo opportunities (See Figure 12.1.)

Figure 12.1
When visiting a new locale, take a one-day class, learn something new, and find photo opportunities!

- **Travel right.** In Asia and parts of South America and Africa, tuk-tuks (a kind of three-wheeled auto rickshaw) afford much better photographic perspectives than taxis—if you're traveling with no more than two companions. Because they are only partially enclosed, you will be able to take photos as you pass through crowded streets.

In Europe, self-driving is an option—albeit an expensive one considering the price of fuel. On my last trip, I paid the equivalent of $5.60 a gallon. But, it was worth it to be able to spend a week driving through the mountains and along the Mediterranean coast, stopping and photographing anywhere I pleased. Car rental/fuel ended up accounting for about half my costs on that trip. But if you really want to get to know a destination, you'll stay put in one spot for a few days, using your feet or local transportation to explore photo opportunities. Bus routes will take you from village to village with ease and comfort, and at very low cost. For one recent trip, I traveled from Madrid to Valencia by high-speed rail, and used a double-decker tourist ("hop-on/hop-off") bus the first two days I was there ($13 a day) to get an overview of the city. The bus had two completely different routes ("historic" and "maritime") and I was able to get on and off at any point, explore a particular area on foot completely, and then catch the next bus, which arrived at 30 minute intervals. Although in Europe most of the places of interest will be in the old town quarters, larger cities have efficient subways and bus systems. I used "10-trip" and "bonobus" passes to move through Madrid and Valencia effortlessly.

- **Mix it up.** Riding local transportation, staying in modest hotels, and eating in restaurants favored by the natives means you'll be shoulder-to-shoulder with the people who really know the city best. As I said earlier, language is no barrier. I speak enough Spanish and French to amuse the Spaniards and annoy the French, can read and sometimes understand Italian, and struggle along with English, but have never had any problems communicating—even in the Czech Republic. Those Europeans who are not multi-lingual still have lots of experience dealing with those from other lands, and are eager for the chance to show off their countries.

Some of the best travel/photo tips I've gotten have come from the people who live in the countries I visit. One recent October I signed up for some classes at a college in Salamanca, Spain, and the instructors there were a treasure trove of information about what to see and where to take pictures.

What to Take

Travel photography is no more equipment- or gadget-intensive than ordinary scenic or architectural photography. If anything, it is less so, because, if you're traveling by air, you'll probably want to travel light. Fortunately, you can take some great pictures with only basic equipment. I expand my kit only for domestic trips where I want to experiment with new techniques, new gadgets/cameras, and interesting lenses. This section will introduce you to my recommendations for both types of kits.

My "Domestic" Kit

At one end of the spectrum is the "basic" equipment I tote along when I am traveling to my destination by car. Last winter's weather was particularly nasty in my Midwest base of operations, so I loaded up my vehicle and took refuge in the Florida Keys for a month to photograph Key deer, pelicans, and the fascinating denizens of Key West. My goal was to familiarize myself with some new equipment, and work on techniques I'd been trying to perfect. This section will be brief, and chiefly to compare a "bulk and weight is no object" collection with my more manageable "Air Travel" kit. The gear I took included the following tools:

- **Several cameras.** While one good dSLR and a backup camera of some sort is essential for any trip, an excursion by motor vehicle allows taking along several cameras. I equipped myself with my (current) favorite 16MP dSLR and a second high-resolution model for landscapes. I also packed a third camera that had been permanently converted to infrared operation, allowing me to experiment with photos like the IR image shown in Figure 12.2, of the Blue Hole on Big Pine Key.

- **More lenses than I really needed.** Because size/weight was not a concern, I took along all the lenses that I *thought* I might need, including some zooms with overlapping focal lengths, such as a 70-200mm f/2.8, 28-200mm f/3.5-5.6, and 24-120mm f/4 lenses. I ended up doing some tabletop product photography during the trip, and the 24-120mm optic proved to be amazingly good as a "macro" lens. I also took along a 500mm f/8 telephoto, a 16-35mm f/4 zoom, a 15mm f/2.8 fisheye, a Lensbaby "distortion" optic, and both 1.4x and 1.7x telephoto converters (which boosted my 70-200mm lens to a maximum of 280mm and 340mm for wildlife photography). You'll find descriptions of what each of these types of lenses can do for you earlier in Chapter 6.

- **Full-size tripod and monopod.** The wildlife photography I planned called for a sturdy full-size carbon fiber tripod and a monopod, both with versatile ballheads. They fit nicely in the trunk of my car, along with a swiveling collapsible camp stool I could sit on while awaiting my prey.

- **Upgraded computer.** I always take a laptop or ultrabook on trips, but for driving excursions I often add a 24-inch LED monitor that disassembles into a compact screen/base package. I also took along a full-size keyboard and mouse, and several 2TB USB 3.0 hard drives. I was able to view and edit my images on two screens (the monitor and the laptop's LCD) just as if I were using my desktop in my office.

My Air Travel Kit

Of course, most of my travel is by air. Experienced air travelers will tell you one thing: Travel light, because once you leave home, everything you take will have to be carried with you everywhere you go. You'll want to take everything you absolutely need, but *nothing* else. I didn't always believe this, especially when venturing some place I'd never been before, eager to capture every possible detail with every possible piece of equipment I owned. I'll never do that again. Since I tend to be at the extreme end of the travel-light spectrum, I'm going to show you exactly what I take on a typical 7-to-14-day overseas trip, and then explain some more realistic options for normal people.

Figure 12.2 Big Pine Key's Blue Hole, the largest body of fresh water in the Florida Keys, given a blue cast through the magic of infrared photography.

Here are the core items I carry with me:

- **Main carry-on.** Most airlines allow you a main carry-on suitcase, plus one smaller "personal" item. (Check before you go; not all adhere to this allowance.) My "main" bag is a rather small backpack with wheels and a handle. The only thing that goes inside the backpack is my camera bag and all my equipment. There's method to the madness. The rolling backpack can be used to wheel itself (with my camera bag inside) and the "personal item" around the airports, trains, or other means of transportation until I reach my first hotel. Then the camera bag comes out, the clothing is rinsed out and dried wrinkle-free, and then toted around in the backpack for the rest of the trip. A single carry-on item becomes two pieces once I've arrived.

- **Personal carry-on item.** This may be a laptop case, large purse, briefcase, or similar. Mine is a compact 16 × 12 × 5–inch tote bag into which I squeeze my most important items, including a Gitzo Traveler tripod, and all clothing that I won't be wearing onto the plane (generally three pairs of slacks, three shirts, underwear, socks) plus toiletries. The clothing is mix-and-match (one pair of slacks has zip-off legs, turning it into a pair of shorts) and squeezed down to an amazingly compact size using those vacuum-seal travel bags. ScotteVest (www.scottevest.com) supplies much of my travel apparel, including the vest and jacket I wear on the plane (both supplied with plentiful pockets for an iPad, travel documents, etc.).

- **Camera bag.** I use several different camera bags, depending on the length of my trip and how many locations I will be visiting. I tend to favor backpacks and sling bags, but can use a shoulder bag if I know I won't need to set down my bag often in locations where it might "wander" off.

- **Main camera.** Although I don't find a heavy "pro" camera objectionable most of the time, when I am traveling light, I prefer a smaller camera, because it's going to be around my neck all day long. I once carried a top-of-the-line pro camera around Barcelona for a week, and it felt like a boat anchor.

- **Backup camera.** It's really embarrassing to come home with no pictures or fewer pictures because your camera failed. That's never *happened* to me, but, considering that most of my trips are not as a tourist but as a photographer who is there specifically to shoot pictures, I want a backup. My most frequent traveling companion uses the same camera system I do, so I can "borrow" her camera if I need to. She serves as my second shooter, anyway, wandering off to grab pictures of interesting subjects while I concentrate on my primary subject. However, I travel alone quite frequently, and when I do I either take a second camera body that uses the same lenses (and it may spend most of the trip in the hotel room's safe), or a pocket-sized camera. Fortunately for us travelers, dSLR manufacturers are meeting pressure from super-compact mirrorless cameras by introducing even smaller digital SLR models. Figure 12.3 shows a dSLR at left that compares somewhat favorably to the compact model next to it. It's a bit taller and thicker, and its lens is larger, but the dSLR is small enough to make an excellent backup—or main—camera.

Figure 12.3
Use a backup camera for emergencies, or when you want to leave your main camera back in the hotel, and as a second camera, say, for shooting wide-angle shots when you have a telephoto mounted on your main camera.

■ **Two or three lenses.** I usually take just two primary lenses, and shoot almost everything with those. If I am using a full-frame camera, those two lenses are almost always a 28-200mm f/3.5-f5.6 zoom and a 16-35mm f/4 zoom with image stabilization. I use the fast wide-angle zoom for more than half my shots, as it's suitable for architecture, available-light street scenes at night, interiors, and even close-ups. The 28-200mm zoom comes in handy when I need longer focal lengths. I use it for a lot of street photography, as it allows me to shoot people discreetly at a distance using a focal length of 200mm and, at that focal length and an f/8 aperture, I can get sharp images and selective focus to isolate my subjects.

If I'm using a cropped sensor camera, I substitute a 10-24mm f/4 zoom for the 16-35mm lens to get approximately the same field of view I got with the full-frame camera. No matter what type of camera I am using, I often throw in a "fun" lens, either a 15mm f/2.8 fisheye (for a full-frame camera) or 10-17mm f/3.5-4.5 fisheye zoom for a cropped sensor camera.

■ **More memory cards than I need.** I take a minimum of five 32GB memory cards, and, if my trip will be for longer than a week, I tote along my "old" arsenal of five 16GB and five 8GB cards. (Each time I upgrade to the next largest size, I retain the old cards as backups.)

The lesson here is that *every* piece of equipment must justify being packed for your trip, based on exactly how much you can comfortably carry. At one extreme, there is a trip taken by motor home or a roomy vehicle with enough space to hold everything you want to carry, as I did on my trip to the Keys. At the other extreme are hiking or bicycle journeys when every ounce must be carried on your back or saddlebags the whole way. In the middle are trips by plane, bus, or other transport that require you to schlep everything into each hotel, then out again when you move on. No matter how you travel, you won't want to take along some gadget or accessory that you never really use.

Other than your camera, lenses (if you have a dSLR), memory cards, and, probably, a tripod or monopod (preferably a small carbon-fiber model that collapses down to a small size), what else do you need to take?

Here are some suggestions:

■ **Battery charger with adapters.** Unless your camera takes easily found batteries, such as AA cells (not many dSLRs other than a couple older Pentax models do), you'll need to take along your charger and, if you're traveling outside your home country, an adapter that will let you plug your charger into local electrical outlets. Most newer chargers are the universal type that work with both 110 and 220 volts, but their plugs might not fit the sockets overseas. If your adapter is not a universal type, you'll need a current converter, as well. Take some socket converters so your plugs will fit in the sockets of the countries you visit.

■ **Plastic bags.** Take plastic bags with you everywhere, even when you're not planning to shoot photos. You can buy foods or snacks, dump the packaging, and carry your equipment around in the plastic bags. The bags can protect your equipment from humid climes or help you separate exposed from unexposed memory cards. (Write EXPOSED on one of the clear bags.) A gallon-sized clear bag makes a good raincoat for your camera. Cut a hole in it and you can take pictures even if it's wet outside.

■ **Camera bag.** I happen to own a large LowePro bag that holds two camera bodies and six or seven lenses, plus all the filters and other accessories I need. I usually take everything with me when I am traveling close to home, because you never know when you might need that infrared filter. On longer trips when I am traveling lighter, the large bag stays at home and I use one of several smaller bags, each sized to take only the equipment that is going with me. All I care about are a few resizable compartments so I can stow each item individually, without needing separate cases for them, or

Figure 12.4 A camera bag with an all-weather cover can be invaluable to protect your gear against rain, snow, or sand.

worrying that they will dent each other as I move around. A sturdy strap, the ability to open the bag quickly, and surefire protection from the elements are also important. It doesn't matter whether your bag is a backpack, belt pack, chest bag, or shoulder bag. Use what feels comfortable to you. An all-weather cover, like the one shown in Figure 12.4, proved invaluable one day I spent shooting in Prague in a drenching downpour.

■ **Other stuff.** I usually find room in even the smallest bag for a cleaning cloth, a Giottos Rocket blower for removing dust from the camera or sensor, a Carson Mini-Brite illuminated magnifier for *finding* the dust, one of those plastic rain ponchos that fold down to the size of a pack of playing cards (I got mine on *The Maid of the Mist*), and maybe a roll of gaffer tape. You never know when you might need to tape something down or up, or otherwise require gaffing. While your camera's self-timer can help prevent user-induced camera shake when shooting long exposures off a tripod, an infrared or wired remote release is also handy to have.

MY FAVORITE GADGET COSTS $69

Although it's not a photographic gadget, the best value, ounce for ounce, of any device I tote along with me overseas is a $69 phone from Mobal Communications (www.mobal.com). I found it even more useful than my Garmin GPS, which did well with the winding European streets, but had problems pronouncing names like *Staroměstské náměstí.* But even if you have a GSM phone that works in Europe and are willing to purchase a SIM card when you arrive, the Mobal phone is better.

It's a fairly full-featured Samsung 3G phone, with all the useful apps you might expect. You buy (*not* lease or rent) this phone for $69, and then own it (and your international phone number) for life. You never pay another penny, other than for the calls you actually make, which cost $1.95 or so per minute. It works in more than 190 countries, including the USA. At the time I wrote this a more basic $29 model was also available, and you could upgrade to a $199 Android smartphone.

My "second shooter" and I used these phones to keep in touch as we wandered around separately, called back to the United States once or twice a day for updates, and used them to confirm reservations locally. Totally invaluable. Certainly, you can buy a SIM card for your current GSM phone in Europe, but you may need a different one for each country you visit (your incoming phone number *changes* each time you plug in a new card), and these cards expire. The Mobal SIM card never expires, and works in every country you visit. (So far, we've used ours in France, Holland, Belgium, Ireland, Spain, Austria, Poland, the Czech Republic, Thailand, Cambodia, and Viet Nam.) There are no monthly charges or minimums. When you get back home, throw the Mobal in a drawer and take it out again the next time you travel. If you really want to use your current phone, Mobal will sell you a SIM card for your unlocked GSM phone (assuming it uses the right frequencies for the country you visit) for $9. I think it's easier to just buy their phone.

The Backup Question

Earlier, I mentioned I always have a backup camera available should I run into an equipment problem, and I take along many, many memory cards. (I took twenty 32GB cards to the Keys for a month, and that proved to be a bit of overkill.) But that backup isn't sufficient when you're traveling far from home. The number of memory cards you have on hand is rarely a limitation when shooting close to home. Most of us own enough cards to shoot all the pictures we care to until we get a chance to download them to our computers. Unless I am immersed in a major project, I rarely shoot more than 1,000 pictures in a single day and can fit all those photos on a few memory cards. The picture changes dramatically once you leave home with no chance to return to your personal computer for a few days or a few weeks. You'll find your memory cards fill up faster than Yankee Stadium on Bat Day. So, what do you do?

Here are a few possibilities:

- **Take a laptop.** If you have a laptop computer and want to lug it around on a trip, you can tote it with you and download your photos to its hard drive at the end of a shooting session. I don't know about you, but I sit in front of a computer all day, and when I travel for fun, the last thing

I want to carry with me is a computer. If you are insane enough to want to take the computer anyway, it makes a sensible choice for moving your photos from your camera. You can copy them to your laptop's hard drive, burn the pictures onto a DVD, maybe mail them home so that you'll still have your pictures even if your laptop's hard drive crashes, you lose it, or it's stolen.

■ **Take an ultrabook/netbook.** I haven't taken my full-size laptop overseas in ages. But I do sometimes take along a compact MacBook Air ultrabook, or old Asus netbook that serves the same purpose. Like a laptop, an ultrabook/netbook has built-in Wi-Fi capabilities (and Wi-Fi is ubiquitous overseas), and a built-in hard-drive (of the solid-state persuasion in the MacBook Air). There's no built-in DVD burner, but you can attach a tiny hard drive the size of a deck of cards and have a second or third backup of your memory cards' content. (See Figure 12.5.) You can also use the computer's keyboard for e-mail or even editing documents or images. To be honest, since I got my iPad (see Chapter 10), I don't always carry the MacBook Air. With Apple's camera connection kit, I can copy memory cards to the iPad's 64GB of storage space if I need to.

■ **Take a portable storage device.** A lightweight, battery-operated stand-alone personal storage device (PSD) might be easier to carry with you than a laptop, although, with the advent of ultrabooks, these devices have fallen from favor. They have built-in readers for memory cards; some have screens for viewing images, and they are very, very fast in transferring photos. The chief disadvantage is that the average PSD costs as much or more as an ultrabook or netbook, but are still two-thirds the size of their more full-featured rivals.

■ **Visit a hot spot.** It's difficult to find a city of any size that doesn't have a free Wi-Fi hot spot or cyber café nearby. An increasing number of hotels offer Wi-Fi and/or a computer guests can use, even if it means a trip to the lobby. On my last trip overseas, virtually every city of any size had a McDonald's with free Wi-Fi, too (and this was in Europe). The first thing I noticed while spending two weeks in Salamanca was the large number of young people clustered on the steps of a building across a narrow street from a McDonald's—they were all taking advantage of the free Wi-Fi service.

Figure 12.5
Ultrabooks can be used for backup— plus you can send e-mail and surf the web from a Wi-Fi hotspot.

■ **Use a camera with dual card slots.** An increasing number of cameras offer two memory card slots. This is the solution I favor above all others. I typically carry enough memory cards that I can shoot an entire trip on one set of cards, and still have enough cards left over to copy all (or most) of my pictures over to a spare card. I may come home with three copies of each image: one on the original memory card, one on a backup card, and one on my portable hard drive or iPad.

Tips for Getting Great Travel Images

While most of what you learn elsewhere in this book about getting great photographs also applies to travel photography, here are some additional things to keep in mind as you rove about, camera in hand. If you follow these guidelines, you can come home with some magnificent pictures. Here are some tips:

■ **Think like a movie director.** You're telling a story with your travel photography, just as a movie director spins a yarn on the big screen. Use an overall photograph of a scene or city (an "establishing shot" in movie parlance) to establish the location and mood. Then capture some images at medium range, and finish off with close-ups that concentrate on local color and life.

For example, if you're charmed by a particular square in a European town, you might grab an overall shot, at night, when there are few people about, as in Figure 12.6. During the day, you could grab an image of some interesting architectural details (see Figure 12.7), before zeroing in on some street photography close-ups that show how older cultural ways have remained (see Figure 12.8) even as newer trends impinge (see Figure 12.9). All these images were captured in Old Town Square (Staroměstské náměstí) in Prague.

■ **Shoot details.** The biggest mistake neophyte photographers make is not getting close enough. You're a veteran shooter, so you'll want to get in close and capture details that really show the differences in culture. Sometimes, the best way to picture a building or other memorable sight is to capture individual snippets of its design. Indeed, parts of some buildings or monuments may be more interesting than the structure as a whole. Doorways, entrances, roofs, and decorations all make interesting photographs. Best of all, you can often use a telephoto or normal lens to capture details. I thought the lion sculpture in Figure 12.10 was interesting, and you probably wouldn't have guessed that the image is of a Spanish mailbox slot.

In other situations, a detail may tell a little story about the structure you're photographing. The gaping holes and crumbling stones you might capture in a shot of a wall of a crumbling castle weave a tale of assaults, sieges, and Medieval warfare, even if the destruction happens to have been caused by natural erosion rather than combat. Cobblestones worn by the incessant pounding of human feet, weathered siding on an old barn, or even the shiny perfection of a slick new glass office tower can express ideas better than any caption.

■ **Stop to smell the roses—and view the scenery.** Scenic photography is sometimes problematic in a travel environment, because there is sometimes a need to meet your schedule and get on to the next city. If traveling by car, you might pull over, gawk at an impressive lake or mountain vista, then hurry to get back into the car and move on after taking a few pictures. You certainly don't have the time to maneuver to the perfect position, or to stick around until sunset so you can capture the waning light of day. When day wanes, you need to be checked into your hotel room! Travel with a tour group in a bus is likely to be even more hurried.

So, you'll have to make a special effort to stop and smell the roses or, at least, take their photo. You may never pass this way again, so take the time to scope out your scenic view, find the best angle, and shoot it first. That way, if you're forced to move on you'll at least have a good basic shot. Then, take the remaining time to look for new angles and approaches. Use a wide angle to emphasize the foreground, or a telephoto to pull in a distant scene. (See Figure 12.11.)

Figure 12.6 Set the stage for your travel story with an establishing shot.

Figure 12.7 Capture some images from a medium distance to show the character of the place.

Figure 12.8 Then concentrate on details that show how cultural elements survive…

Figure 12.10 You'd never guess this was a Spanish mailbox.

Figure 12.9 …even as their replacements become more popular.

Figure 12.11 Even when traveling between big cities, you may spot a scenic image to capture.

Photographing People

Some of my favorite types of travel photography are street photos, taken of people going about their daily lives. People can be among the most interesting subjects of your travel photographs, especially if you've traveled to a foreign land where clothing, cultures, or even the packaging of common products that people use, like soda or candy bars, can be different from what we are used to. Your photographs of people can evoke the lifestyles, working environment, and culture or simply catch people in their daily lives, as in Figure 12.12, or in the act of working on their crafts, as shown in Figure 12.13.

There are a few things to keep in mind when photographing people during your travels:

■ **Don't gawk.** I once watched a group of camera-toting foreign visitors in a California supermarket giggling and snapping picture after picture of an American woman doing her shopping while wearing a full set of immense hair curlers. The tourists thought she was very amusing, but the poor woman was rightly annoyed. She was out about her business and was not an exhibit on display for the enjoyment of travelers from another country where, apparently, curlers are not so casually worn outside the home. As exotic as the folks from a country where you are a guest may appear to you, they aren't circus performers, and you should treat them with

Figure 12.12 Capture ordinary people in their daily lives for some special memories of your visit.

Figure 12.13 Artisans make excellent subjects.

respect. The fellow dressed in native costume in Figure 12.14 was pleased to be photographed—those weren't his everyday clothes, and he was proud of his heritage.

- **Ask permission.** In the same vein, it's good to ask permission to shoot, even if you only nod your head in the person's direction before taking the picture to see if they smile or glower. That approach works even when there is a language barrier, because photography and taking pictures is a universal language. Once you've gotten the okay, suggest, even if only by gesture, that your subject resume their normal activities so your photos will look natural. When photographing children, you should always ask their parents first, as I did for the photo shown in Figure 12.15.

- **Offer thanks after shooting.** Let them know how much you appreciate the favor. If your subject is interested, you can show him or her the results of your shooting on your camera's LCD. You can offer to mail a print or e-mail the photo, if appropriate. When photographing street musicians and other performers, it's only polite to leave them a tip in exchange for capturing their art in a photo.

- **Be aware of taboos and legal restrictions.** Some cultures frown on photographic images of people. Photographing women (or even a man asking a woman for permission to shoot) can cause problems. You may get into trouble photographing soldiers, military installations, airports, or even some public buildings. Try to learn about these restrictions in advance, if you can.

Figure 12.14 This fellow was there to be photographed, and happy to oblige, as long as he was treated with respect.

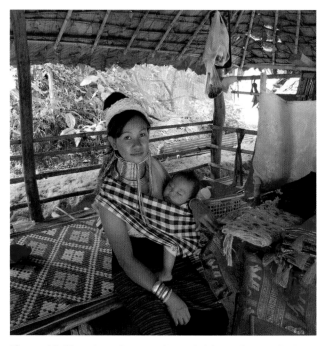

Figure 12.15 When photographing children, always ask their parents' permission.

Photographing Monuments and Architecture

Every place you visit, whether overseas or in the good old USA, has sights that you absolutely *must* capture, if only to prove you've been there. Perhaps you need to grab a good shot of the Pittsburgh skyline from Mount Washington (see Figure 12.16) or, if you must, the Eiffel Tower. Photographic monuments, castles, ancient places of worship, ruins, and other sights can be rewarding and exciting. Some of the most dramatic architectural photos are taken at night, so you'll want a camera capable of long time exposures without excessive noise. A time exposure setting, useful for the infamous "painting with light" technique (described in Chapter 7) is another important capability.

Figure 12.16
A city skyline is a traditional—and worthy—photographic subject.

Lens selection is especially important when shooting this type of subject. For many scenes, you'll need a wide-angle lens and, up to a point, the wider the better. There are several reasons for needing a wide lens or zoom setting:

- **Interiors.** For interior shots, you'll need a wide setting to capture most rooms or spaces. Unless you're shooting inside a domed stadium, cathedral, or other large open space, you'll find yourself with your back to the wall sooner or later. A wide-angle lens helps you picture more of a room in one image. Figure 12.17 shows one of the rooms in Casa Batllo, one of the most famous homes in Barcelona, designed by *modernisme* architect Antoni Gaudí. Grabbing this shot called for an ultra-wide 17mm zoom lens setting (on a full-frame camera).

- **Exteriors.** Exterior photos often require a wide-angle setting for the same reason. The structure you're shooting is surrounded by other buildings, and you can back up only so far. A wide angle is required to grab an image from the best (or only available) vantage point. For Figure 12.18, there was literally only one place I could stand to capture the "crooked house" framed by the archway of the village gate in Albarracín, Spain. The shot required a wide-angle lens, a tripod

Figure 12.17 This small room could only be captured with a wide-angle lens.

Figure 12.18 A wide-angle lens allowed the only vantage point possible for this shot.

to allow precise positioning of the camera, and a good deal of patience while I waited for a break in the passersby who were strolling through the gate and up the streets.

■ **Emphasis.** Wide angles help you include foreground details, such as landscaping, that are frequently an important part of an architectural shot, or to provide extra emphasis to that foreground. The path leading to the old church wasn't nearly as long as it appears in Figure 12.19. A wide-angle lens exaggerated the foreground.

A lens with a wide f/stop is also desirable for nighttime and interior photos. Even if you want to use the smallest f/stop possible to increase depth-of-field, there will be times when you want to shoot wide open in very dim conditions. A "wide-open" setting of f/2.8 is to be much preferred over one that's on a lens that can open only as wide as f/4 or f/5.6.

Telephoto lenses have their application in travel photography, too. I was actually not very close to the muddy scene shown in Figure 12.20 (thank goodness); I actually had to zoom to 200mm (on a full-frame camera) to get the photo. Teles will let you reach out and grab the subjects you want, even if they are located down a muddy road, behind fences or otherwise inaccessible.

Figure 12.19 The wide-angle perspective emphasized the foreground in this shot.

Figure 12.20 Distant subjects may require a telephoto lens.

Getting Permission

Your first challenge in photographing some well-known sights might be to discover whether you're allowed to shoot a picture of a particular subject in the first place. The good news is that most of the time you don't need permission to photograph the outside of a building or structure, especially those edifices that, on some level, exist expressly as a photographic opportunity. So, you don't have to ask if you can photograph the Pyramids of Egypt, the Eiffel Tower, or the Chrysler Building in New York City. The Pyramids are historical monuments; *la Tour Eiffel* has come to symbolize The City of Lights (and all of France); and the architecture of the Chrysler Building was deliberately designed to call attention to the success of the automotive company.

Groups of buildings, such as city skylines, require no permission. Nor do you usually need permission to photograph ordinary office buildings or even private homes, at least in the United States, as long as they are on what is called "permanent public display" and can be photographed from public places. If you have to take a photograph while standing on private property, you may need the permission of the property owner. Interior photos of non-public buildings may require permission, as well. Shooting photographs inside public buildings can be restricted, or there may be some limitations on whether you can use a tripod or electronic flash. Museums may limit flash photography.

Towns may prohibit use of tripods in the public buildings or parks. Police in Paris have been known to disapprove the use of tripods, which are considered a "professional" tool, without getting a permit. That's a shame, because a tripod is especially helpful for photographing monuments and architectural subjects. Certainly, indoor photos will often be taken using long exposures under the natural lighting present in the room or space, so a tripod is essential for holding the camera steady. Outdoors, a tripod makes a steady base for the camera so you can compose your shot carefully, and is also useful for making panoramic exposures. If you photograph a building at night, you'll want a tripod to hold the camera for exposures that can take a second or two.

Security forces at many manufacturing plants will offer to take custody of your cameras while you're on site. Secure facilities such as federal buildings, military installations, financial institutions, or airports may have guards who will automatically be suspicious of anyone attempting to take pictures. I was innocently taking family photographs of my kids at Heathrow Airport in London a while back, when I was approached by a British policeman who informed me in the most apologetic way that what I was doing was prohibited. I'm glad I didn't try to whip out a tripod and set up for a more formal shot!

Use of the photographs you create is another matter entirely. Private and editorial use, as in books like this one, generally requires no special permission. However, if you want to use a photograph of someone's home in an advertisement or other marketing application, you'll want to get the owner's permission, what is called a "property release" (and similar in many ways to a model release).

Have Fun!

The most important thing to remember is that travel photography is fun. For many of us, visiting exotic locations is our final frontier, and, as photographers, our voyages provide us with an ongoing mission: to explore strange new worlds, to seek out new life forms and new civilizations, to boldly photograph where no one has photographed before.

13

People Photography

Some digital photographers specialize in one kind of picture or another, such as landscapes, sports, or close-ups. But everyone who uses a camera enjoys taking pictures of people, even if their main efforts are concentrated elsewhere. Unless you're a hermit, you love to photograph your friends, family, colleagues, and even perfect strangers. Human beings are the most fascinating subjects of all.

The person you photograph today may look completely different tomorrow, or might even adopt several different looks in a single afternoon with a quick change of clothing or hairstyle. Change the environment and surroundings, and you can change the way you capture your subject's personality. Modify the lighting, and a person can be pictured as sinister, powerful, or glamorous. It's your choice.

Photographs such as the lively celebrity photography of Richard Avedon, or Yousuf Karsh's powerful portrait of Winston Churchill, are some of the greatest images ever captured. The value we place on photographs we take of each other can be measured by the number of people who say the one object they'd grab on their way out of a burning home would be the family photo album. After all, photographs of our friends and family are a way of documenting our personal histories, and the best way we have of preserving memories. The fact that there are so many different categories of people-oriented pictures, from fashion photography to portraiture, demonstrates the depth of this particular photographic field.

Each individual brand of people picture deserves an entire book of its own. You'll find lots of good books on family photography, group portraiture, wedding photography, photojournalism, or figure photography. Most of the digital photography books you see try to cram little snippets of information about a broad range of these categories into a single chapter or two. I'm going to take a different approach. This chapter will concentrate on just one variety of people picture, the individual portrait, and will cover it in a bit more depth. I'm going to give you some guidelines on lighting that

are glossed over by most other books. What you learn here about posing and lighting applies broadly to other kinds of photography, so my goal is to get you interested enough that you try some other types, whether you opt for weddings or Little League team photos.

Home Studio—or Nature's Studio?

For many years, most portraits were created in a studio of some sort. This custom pre-dates photography by a handful of centuries, because, unless you were royalty and were able to do exactly as you pleased, it was more common to venture to the artist's studio, where the lighting, background, props, and other elements could be easily controlled. That soft and flattering "north light" used to illuminate portraits could be best guaranteed by painting in a space designed for that purpose.

Studio portrait sittings remained the norm after the invention of photography, because photos often took minutes to create. Traveling photographers sometimes carried along tents that could be used as portable darkrooms or studios. Even after more portable cameras and faster films and lenses freed photographers to capture documentary images and insightful candid pictures anywhere, portraits were still most often confined to studio settings.

The social unrest and anti-establishment feelings of the late '60s and early '70s placed a new premium on natural, less formal photography that emphasized realism, an emphasis that has remained today in this age of smart phone photography, "selfies," and Instagram. When "candid" wedding photography became sought-after, professional photographers were eager to set up lights in your living room to create family portraits in your own habitat. Before long, what was labeled as "environmental" portraiture became common, posed photographs with scenic backgrounds, such as the one shown in Figure 13.1. Enterprising pros either set up "natural" settings in their own studio backyards or compiled a list of parks, seashores, and other sites that could be used for these informal portraits.

The most interesting part of the whole phenomenon was that this new kind of professional portraiture didn't change much, except the setting for the photograph. Consumers then and now love casual snapshots for their immediacy, but still prefer professional portraits to be well-posed portraits, using flattering lighting, attractive backgrounds, and the other qualities they came to expect from formal studio portraiture in the old days. What consumers wanted was a studio-quality portrait taken in a less formal setting, usually with more casual dress and less rigid posing. Environmental and home portraits incorporate the professional's skills, even if they needn't be taken in a studio.

While the portraiture industry hasn't come full circle, an updated version of time-honored portrait photographic techniques has returned to favor, and studio work commands much of the respect it traditionally has had. Portraits are still taken outdoors, but many are captured indoors in the studio. There may be more props, more latitude in dress, and variety in poses now, as anyone who's seen the kind of pictures high school seniors covet for their yearbooks knows. So, as a digital photographer, you'll probably find yourself taking people pictures in *both* kinds of settings. It's helpful to be comfortable with both.

Studio portraits are usually more formal. With a professional-looking backdrop or a "serious" background such as those omnipresent shelves of professional journals you see in so many executive portraits, a studio portrait can have a formal or official appearance. Even the crazy Mylar backgrounds and wacky props they're using for high school portraits these days retain a sense of "this is a professional portrait" in the finished product.

Location portraits, on the other hand, end up having a casual air no matter how hard you try to formalize them. The most carefully staged photo of the Speaker of the House posed on the steps of the U.S. Capitol will still look less formal than a relaxed portrait of the same legislator seated in a studio with only the American flag and shelves of law books in the background.

My feeling is that you should master both studio and location portraiture. You'll want a studio-style picture for a newspaper head shot or for mounting over the mantel, but will probably prefer an environmental picture to hang above the couch in the family room or use for your holiday greeting cards. It's great to have an option.

It's probably best to learn studio work first, because all the lighting and posing techniques you learn for your home studio can be applied elsewhere, as you can see in Figure 13.2. You may be using

Figure 13.1 Today, portraits are rarely confined to studio settings.

Figure 13.2 The same flattering lighting techniques learned in the studio can be applied outdoors, too.

reflectors rather than flash units for your portraits out in the park, but the principles of putting light to work for you are the same. The following section will get you started working in your own home studio.

Setting Up Your Studio

Any convenient indoors space can be transformed into a mini-studio for use in capturing both portraits and close-up photos of objects. Of course, people pictures require more room than photographs of your ceramic collection, and few homes have space that can be devoted to studio use on a full-time basis. Two of my last three homes had large semi-finished attic space that I was able to commandeer as a studio. When I had an office addition built for my current residence, I had the choice of having a crawl space underneath or a full basement. I opted for a basement room with high ceilings, so I ended up with a 24 × 16–foot multipurpose room that can be used as a studio.

Those of you with newer homes *sans* attic, or who live in parts of the country where basements are not common, probably don't have an extra room for a studio. Even so, I'll bet you have space that can be pressed into service from time to time. A garage makes a good location, especially if you live in warmer climes or are willing to confine your studio work to warmer weather. Some garages can be heated efficiently for year 'round use, too. Just back your vehicle out of the garage and you have space to shoot. I know several part-time professional photographers who work exclusively from rooms that were originally the garage. Their studios don't much resemble a garage today, but that's how they started off.

Of course, a garage studio is impractical in California, and a few other places where the denizens pay more for living space than the rest of us make. Generally, such space is used permanently for storage, practice space for your kid's band, or maybe even as living quarters. In big cities like New York, many people don't even own cars, let alone garages. Try suggesting to someone who dwells in a studio apartment in the Big Apple that, say, 200 square feet should be set aside for a home studio.

If space is limited, see if enough space can be cleared in your family room, living room, or other indoor location to set up a few lights, a background, and perhaps a tripod on a temporary basis. You want a place that can be used without disrupting family activities (which is why even the largest kitchen is probably a poor choice) and where you can set up and tear down your studio as quickly as possible. You'll use your home studio more often if it isn't a pain to use.

What You Need

The next section will list the basic items you need to have on hand. There's enough overlap that if you're well-equipped for macro photography, you've got most of what you need for individual portraits, too.

Your Portrait Camera

There are few special requirements for a digital camera that will be used for portraiture. Here's a list of the key things that make a digital SLR ideal for portraiture:

- **Lots of megapixels.** Portraiture is one type of photography that places a premium on resolution. Even if you plan on making prints no larger than 5 × 7 inches, you'll find a 21 to 24 megapixel (or more) camera useful, because those extra pixels come in handy when you start retouching your portraits to make your subjects look their best. I think you'll find it hard to resist making 8 × 10 and larger prints of your best efforts, too, so you'll be glad you sprung for a few million more pixels when you bought your camera.

- **A modest zoom lens (at least).** For the most flattering head-and-shoulders pictures, you'll want a lens that has a zoom setting in the 80mm to 105mm (on a full-frame camera) or 50mm to 75mm range (on a cropped sensor camera). Shorter focal lengths often produce a kind of distortion, with facial features that are closer to the camera (such as noses) appearing much larger in proportion than features that are farther away from the camera (such as ears), as you can see in Figure 13.3. By the time you zoom in to the 135mm to 200mm (or longer) telephoto settings, the reverse effect happens: The camera's perspective tends to flatten and widen the face, bringing nose and ears into the same plane. The 80mm to 105mm settings are just about perfect.

- **Some way to use multiple light sources.** If you want the most control over your lighting, you'll want to use several light sources. Electronic flash is often the best option, so your camera should have a way of triggering one or more external flash units that are used separate from the camera. You may be able to connect extra flash units with a standard PC/X connector (the PC is said to stand for Prontor-Compur, two early shutter manufacturers, not "personal computer"), a hot shoe connector that can accommodate either an external flash or an adapter you can plug an external flash into. Some more advanced digital SLRs should be able to work with flash triggered wirelessly. (See Chapter 7 for more on using external flash.)

Figure 13.3
The wide-angle setting (left) emphasizes subject matter (such as a nose) that is closer to the camera. A more natural look comes from a telephoto setting (right).

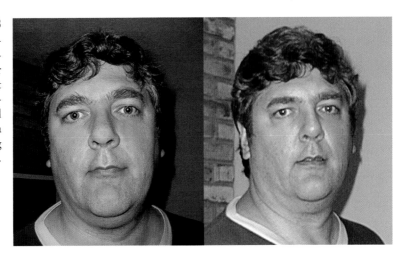

Backgrounds

Backgrounds are an important consideration for more formal portraits. You can get great casual pictures with the gang posed on the couch in the living room, and, in fact, you should try some of the lighting techniques discussed later in this chapter in that sort of an environment. Good lighting can elevate the family room portrait well above the snapshot category. However, if you want a true studio portrait, you're going to have to arrange for a more formal background. Luckily, that's easy to do.

Seamless paper, available in 9- and 12-foot widths and around 36 feet long, is another good choice. A paper backdrop can be easily damaged, becoming wrinkled with handling and dirty as people walk on it. When a piece becomes soiled, you just rip it off and roll off some more. If you can, avoid using seamless paper on thick carpets. They don't provide enough support for the paper, so it rips more easily. A wood or tiled floor may be a better choice.

You've probably admired those abstract backgrounds with, perhaps, a cloud effect, or stippled blotches of paint, like the one shown in Figure 13.4, although the "blotchy" backgrounds are rapidly becoming somewhat dated. They are still handy to have for more formal portraits. Painted backdrop canvases are available for big bucks from professional photography supply houses ($99 to $300 and up), but you can easily make your own, as I did.

While professional photographers won't blink an eye at purchasing backdrops they can use repeatedly, most don't hesitate to create their own props and backgrounds to give their photography a customized, personal flavor.

Figure 13.4 Dabbing with a sponge and paint on a piece of canvas can create a workable backdrop for portraits.

TIP FROM THE PROS: HOW WIDE IS A YARD OF CLOTH?

If you answered "36 inches," you lose and don't get to advance to Final Jeopardy. A yard of cloth is 36 inches *long*, but the width of the bolt can vary. Some are as narrow as 18 inches. Other types of cloth come in 45 inch or larger widths. I've had great luck with velour cloth backdrops. For portraiture, the key is to purchase cloth that is wide enough and long enough to allow posing one or more people full-length. Find a bolt that is 54 to 60 inches wide. Purchase a piece that is a lot longer than you think you need. Six yards isn't too much when you want to stretch the cloth up to the ceiling, then drape it down on the floor. Make sure your fabric is easily washable, because it will get soiled from people walking on it. Buy as many different colors as you can afford.

When my studio was in operation professionally, I used the reverse side of 4 × 8 sheets of paneling to create dozens of backgrounds for individual portraits. Of course, I had a permanent studio in which to store them. You're probably better off using sheets of awning canvas. The secret is to use a sponge to paint them with colors. You'll be surprised at the results, even if you're not the artistic type. Start painting using lighter colors in the center and work your way toward the edges with darker pigments. The sponge will give the surface an arty splotchy effect that will look great, especially when it's out of focus. Browns and earth colors are recommended for men; brighter colors, especially blues, work well for women and children. Remember, if you make any mistakes or don't like your initial results, you can always paint over them.

Here are some ideas that you can use for getting a simple background:

- **Look for a blank wall.** Take down photos on the wall if you need to in order to make the wall blank. But be careful of picture hangers that can create distractions in the background. You might be able to position your subject so that those things are blocked.

- **Put up a sheet.** Use a plain, freshly ironed sheet and hang it on a wall, across some windows, over a bookcase, or anywhere that you can hold it up. Small clamps that you can get from a hardware store can help you position and hold the sheet.

- **Get some foam board.** Go to an art supply store and pick up a big sheet of foam board (or Fomecor). You can get these with white or black surfaces, either one of which can be effective as a simple background.

- **Consider a formal photo muslin background.** Many camera stores carry muslin backgrounds that are designed specifically for photographers. You can also get stands and other accessories to help you hold up such a background. Be wary of getting highly patterned or very colorful muslin backgrounds because most photographers find their novelty wears off quickly.

- **Get a painter's cotton drop cloth from a painting store.** Painting stores, and painting sections of large hardware stores, will have cotton drop cloths available for painters. These typically come in a tan or white color and can be excellent for backgrounds. You may need to get some stands from a camera store in order to hold it up.

- **Make your own photo cloth background.** Get a painter's drop cloth and some cans of gray, black, and off-white paints, then spray soft blobs of tone across the drop cloth for a simple background. Go for subtle and gentle patterns so as not to distract from your subject.

- **Try some seamless background paper.** Larger camera stores will have roles of seamless paper that you can hold up with a couple of stands. You then pull the paper down from the roll for a simple background behind your subject. A 53-inch wide roll that's 12 yards long can cost $25 or less.

Visible Means of Support

You'll need stands for your background, lighting, and camera, although there are many portrait situations in which you'll want to dispense with a tripod (such as when you're taking photos by electronic flash). Unlike macro photographs, portraits are often taken from a variety of angles and distances from the same basic setup.

Whether you're using cloth backdrops, seamless paper, or another background, you'll need some sort of framework to support it. I prefer sturdy light stands for lightweight backgrounds, and ceiling supports for heavier paper rolls. You may not be able or willing to nail anything to your ceiling (this is one instance when having a basement or attic is great), but you can still build some sort of easily disassembled framework to hold your backdrop.

Light stands make good supports, and are a once-in-a-lifetime investment. Unless you manage to lose one, they'll last forever. You'll need to add clamps or other fasteners to fix your lights and, perhaps, umbrellas to the stands.

A tripod is not essential for people photography, particularly if you're using motion-stopping electronic flash, and in many cases a tripod can be detrimental. You'll want to be able to roam around a little to get various angles, move in and out to change from full-length or three-quarters portrait to close-up. For Figure 13.5, I posed my subject against a brightly lit wall, held a flash with a diffuser at arm's length to my right, and, with no tripod to encumber me, was able to move around to get the shot I wanted.

The only time you'll really need a tripod for portraits is when you need to lock down the camera to get a precise composition, or when you're working with relatively low light levels and need the tripod to steady the camera. For example, you might be shooting a series of head shots for your company and would like each photo to be taken from the exact same distance and angle. Or, you may be taking pictures using diffused window light or with household lamps as your illumination. In both cases a tripod can be useful as a camera support.

RIGHT OF SPRINGS

You can purchase spring-loaded vertical supports that fit tightly between your floor and ceiling, but can be released and stored when not in use. These work well with sturdy ceilings, or those with overhead beams. You can try making your own: cut a 2 × 4 a few inches shorter than your ceiling height. Pad one end of the 2 × 4 so it won't damage your ceiling, then put the end that rests on the floor in a coffee can with a spring mechanism of your choice (Actually, I've used sponges as a cheap substitute for springs.) Press the 2 × 4 down to get enough slack to slide it in place, then release to allow your spring to hold it firmly in a vertical position. The spring must be strong enough to resist the downward pull of your backdrop material.

Figure 13.5
Electronic flash
and a hand-held
camera lead to
spontaneous
poses.

Make Light Work for You

Lighting is one of the most important tools for creative portraiture. The way you arrange your illumination can have a dramatic effect on the mood of a photo. Lighting can focus interest on your subject. You can even use lighting techniques to improve the looks of a subject with less-than-perfect features. You'll find that portrait lighting is a great deal more complex than the lighting you might use for many other types of subjects. Close-ups need to be lit carefully, and your scenic and architectural pictures will look better if the illumination is just so. For sports photography, much of the time you won't have control over the kind of light you use. Portraiture, on the other hand, looks best when the lighting is carefully crafted.

As a result, while very good portraits can be taken with just one light source, you'll find that mastering multiple light sources opens new creative avenues. But note that I said multiple light *sources*. You don't have to clutter your home or office studio with dozens of different lighting fixtures. Often, a skylight, window, or reflector can serve as an effective light source. Outdoors, you may work with the light from the sun, supplemented by reflectors or electronic flash. You'll learn how to use these light sources later in this chapter.

Here are your choices:

- **Incandescent photo lightbulbs.** Years ago, you could go in any photo store and find photo bulbs, including those with a blue tone that matched the color balance of daylight films. They were commonly screwed into an inexpensive reflector and used for lighting people. Incandescent photo bulbs are still available though hard to find. They are very inexpensive and put out a lot of light. They come in blue for daylight white balance and white for tungsten balance. However, their color temperature can shift over time, they are relatively fragile, and they tend not to have a very long life.

- **Fluorescent photo lightbulbs.** Photo lightbulbs are now available as compact fluorescent lamps (CFL). They are relatively inexpensive and put out a reasonable amount of light without getting hot. However, their color temperature can shift as they age, they are relatively fragile, and they have a shorter life than other CFLs. If the fluorescent lamps aren't balanced for daylight illumination, you'll need to set your camera's color balance to match that of the fluorescents, or shoot RAW and adjust the white balance in your image editor.

- **Photo quartz lights.** Quartz lights have a very good reputation for putting out a lot of very consistent light at a specific color temperature. They have a long life, are fairly rugged (as long as you don't bang them around when they are hot), and are an inexpensive type of photo light for their output and life. You can buy them with very specific housings that are designed to meet photographers' needs. They have a color temperature that will match the Tungsten white balance on your camera. Their biggest disadvantage is that they get very hot.

- **Hardware store quartz lights.** One way to try out quartz lights is to go down to your hardware store and get some work lights that use a quartz light. They have the same advantages and disadvantages of the photo quartz lights except that their housings are not as convenient for photographers and they often have a protective grill over them that must be removed or it will cause shadows on your subject. But they are very inexpensive.

- **Photo fluorescent lights.** A number of companies like Westcott (www.fjwestcott.com) make special lighting fixtures that use fluorescent lights specifically designed for photography. These tend to be physically large light fixtures that are not always very portable, and they can be expensive. They do put out a consistent light with a consistent color balance that will match either Tungsten or Daylight white balance on your camera. And they don't get hot. The bulbs in these units are more fragile than quartz lights.

- **Hardware store fluorescent lights.** You can buy work lights that use fluorescent lightbulbs. These won't have as much power as the ones that are designed for photography, but you can increase your camera's ISO sensitivity to compensate. They are relatively inexpensive. However, their color balance will vary from unit to unit and you may need to use your camera's manual or custom white balance to match them.

- **Photo LED lights.** The newest type of continuous light source is the LED photo light. These fixtures are made up of rows of tiny LED lights that work together to create light for your subject. LED lights are very rugged, use very little power, and are never hot. They can be balanced for either Daylight or Tungsten white balance. Their disadvantages: they are lower powered than any other continuous light source and are quite expensive for the amount of power they create.

- **Hardware store LED lights.** Once again, you can try out LED lights from your hardware store or home improvement center. Look for LED work lights that have many rows of these small lights. You'll need lots of LEDs to provide enough power to actually be useful. These lights are less expensive than the photo LED lights, but will usually be bigger for the same amount of power and you will be limited as to how much power you can get. Their color balance can vary from unit to unit and you may need to use your camera's manual or custom white balance to match them.

- **Small flash units.** You can get small, accessory flashes that can attach to your camera. Many of these units today will also work wirelessly with your camera so that you can use multiple flash away from the camera. These units offer excellent autoexposure capabilities, have very fast durations, and are always daylight balanced. They are easily packed into a camera bag and they will never overheat your subject. Disadvantages include: the short flash duration means that you cannot see the light on your subject, the more powerful of these units can be expensive, and even the most powerful of these is limited in the amount of light it can put on your subject.

- **Studio flash.** Studio flash, including *monolights* (studio strobes with flash and power pack in a single unit), are large flash that put out a lot of illumination. These are designed specifically for photographic use. You may need extra gear in order to sync a group of them with your camera. You will need a flash meter for setting exposure manually, or you will have to resort to trial and error testing, as the camera's flash metering system cannot accurately gauge the output of studio flash.

These units have brief flash durations (effective, "short" shutter speeds), are always daylight balanced, and will never overheat your subject. They come with modeling lights that can be left on to help you see where the flash will be affecting your subject. Disadvantages include: the strong and short burst of light from the flash can be disturbing to some subjects, units can be expensive, and modeling lights are sometimes not strong enough to give you a clear indication of what the flash is going to look like.

Existing Light

The existing light indoors or outdoors can be perfect for good people pictures. Rembrandt reportedly cut a trapdoor in the ceiling of his studio and used that to illuminate many of his portraits. If you have a room with a skylight, you may find that suitable for portraits at certain times of day. Some memorable pictures have been taken using only the soft light that suffuses from a window. Indeed, you'll find references to "north light" (a window orientation that produces diffuse light from dawn to dusk) throughout painting and photographic literature.

Just because the lighting is already there doesn't mean you can't modify it to your advantage. You can lower the blinds part way to reduce or soften window light. You can use reflectors to bounce light around in interesting ways.

Electronic Flash

Electronic flash is often the best choice for indoor portraiture. The short duration of flash captures a moment in a fraction of a second, without danger of blur from a slow shutter speed. The high intensity of flash means you can use small f/stops if you want, so all of your subject will be in sharp focus. Flash can be reduced in intensity, as well, giving you the option of using selective focus, too. Flash can be harsh and direct, or soft and diffuse.

The chief problem with electronic flash is that it is difficult to preview how flash illumination will appear in the final picture. Fortunately, there are ways to overcome this limitation, as I'll show you later in this section. A second problem is that many digital cameras don't have a connector that lets you plug in an external flash, as I mentioned earlier. A shoe mount adapter with a connector for an external flash usually costs less than $30.

Electronic flash comes in many forms, from the built-in flash on your digital camera to external battery-powered units to "studio" flash that operate from AC power or large battery packs. Unless you're moving into portraiture in a big way, you don't need studio flash units. If you do decide to make the investment, there are some surprisingly economical AC-powered studio flash setups for serious amateurs and pros on a budget. A single-unit (flash head and power supply in one module) "monolite" can cost less than $200.

Some add-on flash units have a built-in device called a slave sensor that triggers the flash when the sensor detects another unit firing. These can be safely used with any camera, as they have no direct connection to the camera. You can also purchase detectors that attach to any flash unit, turning it into a slave flash. As I mentioned in Chapter 7, look for a slave unit with a digital mode that can be set to ignore the pre-flash of your dSLR's built-in flash unit.

If you use your electronic flash on stands, you may be able to rig an incandescent light along each side to give you some indication of what your lighting looks like. These "modeling" lights work especially well if your electronic flash is pointed at a reflector such as an umbrella. That's because the softening effect of the umbrella reduces the variation in illumination that results when the flash and incandescent lamp aren't in precisely the same position.

Figure 13.6
Careful lighting can produce effects like this, in which the earring stands out sharply from the shadows.

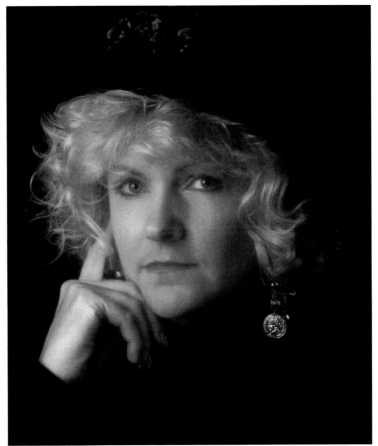

The ability to see the exact light you're going to get can be very important. For Figure 13.6, I carefully manipulated the lights so the model's hat fell into shadow, and most of the right side of her face was in shadow as well, except for the dangling earring. You can't achieve lighting effects like this on a hit-or-miss guesstimate basis.

Incandescent Lights

You'll find that incandescent lights are inexpensive—even the halogen models that replaced the older tungsten models—easy to set up, and make it simple to preview your lighting effects. You never have to worry about what your lighting will look like if you use incandescent lamps.

Unfortunately, lamps are not as intense as flash and may not provide enough illumination for good hand-held exposures at short shutter speeds. Or, if the lamps are intense enough, they may be too hot to pose under for long periods of time. In addition, incandescent lamps are much redder than the illumination provided by daylight or electronic flash, so you may have to change your camera's white-balance control to compensate. (Many digital models have automatic white-balance control, but it's not foolproof.)

While you can use just about any light, you might want to investigate incandescent lamps made especially for photography, available from your local camera shop or online photo retailer. They aren't overly expensive, and are easier to buy hardware for, such as mounting clamps, umbrella adapters, and so forth.

Gadgets

There are dozens of different gadgets and accessories associated with portraiture. The best news is that you can make many of them yourself, so you don't have to pay a lot of money to spice up your portrait-shooting arsenal. Here are some versatile gadgets you might want to consider.

Flat Reflectors

Reflectors bounce some of the illumination from other light sources onto your subject, serving as a low-cost secondary light source in their own right. Large sheets of foamboard (which you can stand up and lean against things at the proper angle), poster board, Mylar sheets, or anything that reflects light can be used.

Soft Boxes and Diffusers

Soft boxes use diffuse white material, such as cloth, to create a soft lighting effect. Soft boxes can simulate window light and create a diffuse, flattering illumination suitable for photography of women, children, teens, and any adult men who aren't tenacious about preserving those craggy furrows they think of as facial character lines. A kind of mini soft box can be purchased for electronic flash units that are normally used on the camera, to diffuse the light. There's no reason why one of these units, shown in Figure 13.7, can't be used with an off-camera flash, too.

Gobos and Cookies

Gobos and cookies are the opposite of a reflector. They can be a black drape or sheet placed between a light source and the subject to block some light, and are handy when you have an unwanted light source, such as a window, that's spoiling the effect you want. These items are actually more of a tool for video and cinema photographers and for stage productions, because they can include cutouts that let some light through to produce an interesting combination of light and shadows, such as window frames, trees, or logos. However, still photographers should know about them and use them when appropriate.

Barn Doors/Snoots

These are devices that limit where the light from a flash or lamp goes. A barn door has two or four hinged flaps you can move into or out of the path of the light. Subtle adjustments can be made to "feather" the light on your subject. Snoots are conical devices that focus the light down to a narrow spot. They are excellent for creating a light that illuminates a small area, such as the hair of the subject.

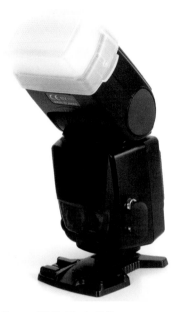

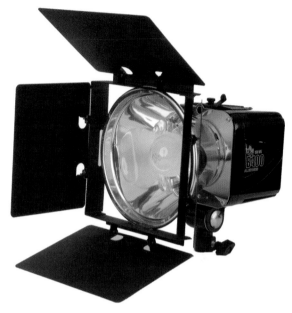

Figure 13.7 Flash diffusers are a sort of mini soft box.

Figure 13.8 Barn doors let you direct the light carefully.

You can easily make your own barn doors or snoots out of cardboard or tin (which is a better choice for accessories used near hot incandescent lamps). Spray paint them with black heat-resistant barbeque grill paint. Or, use purchased units, like those shown in Figure 13.8.

Umbrellas

A good set of umbrellas is the best investment you can make for portrait photography. Umbrellas soften the light in ways you can control and use for artistic effect. You can bounce light off an umbrella onto your subject, or, in the case of translucent white umbrellas, shine your illumination through the fabric for an especially diffuse effect. In either mode, a soft-white umbrella provides very diffuse illumination, but you can also purchase umbrellas with opaque shiny silver or gold interiors that provide a broad light source that still has snap and contrast. Umbrellas produced for professional photographers are compatible with various lighting clamp systems that make them easy to set up and manipulate.

GOING FOR THE GOLD

Gold umbrellas, in particular, are prized for the warm illumination they provide. They are used extensively for fashion and glamour photography because of the flattering skin tones their light produces. Silver umbrellas have more contrast and snap than soft-white models. The edges of the illumination provided by silver umbrellas are more sharply defined, so you can angle the umbrella to "feather" the light on your subject (placing strong light on some parts, while fading to less light on others).

However, you can also use ordinary umbrellas of the type people take out into the rain. I found a source selling white umbrellas that collapse down to less than a foot in length for about $5 each. I really liked these when I was a traveling photojournalist who was unable to travel light (two or three cameras, five or six lenses, and two electronic flash units were my minimum kit), but tried to trim weight where ever I could. I picked up a dozen and found I could hold the umbrella and flash unit in my left hand and shoot with the camera held in my right hand. You can jury-rig clamps to hold them to light stands or other supports. Collapsible umbrellas usually have small diameters and must be used relatively close to get a soft, wrap-around lighting effect. Larger sizes are needed to provide illumination from greater distances (say, 10 to 12 feet).

Portrait Basics

Here are some things to think about for portrait composition:

- **Headroom.** Never compose your shot with the subject's head in the middle of the picture. That puts too much space or headroom over the top of your subject. That is wasted space in the composition. Keep a small amount of headroom over your subject.

- **Full body compositions.** When using the whole body of your subject in a portrait, use a wrap-around background that extends onto the floor toward the camera so that the subject can stand on it. That simplifies the overall image. In addition, never cut off a person's body at the ankles. That is a very uncomfortable place for the edge of the frame.

- **Half-body compositions.** Move in closer and you emphasize the top half of your subject. A half-body composition shows off the person's torso, arms, head, and hair.

- **Head-and-shoulder composition.** Move in closer and you show the upper part of the person's body and his head. This can really show off the personality of your subject. This framing does not show the arms, but does show off the head, shoulders, and hair. This is a traditional formal portrait composition.

- **Tight face composition.** Move in closer so that only the face is used in the composition. This means cutting off the top of the head so that you don't see it. By eliminating things like the top of the head, you force the viewer to really focus in on the subject's face, especially the eyes.

The Nature of Light

Lighting is the palette you'll be using to paint your photographic portraits. The next two sections will introduce you to some basic techniques, using some diagrams I've put together that will help you set up professional-looking lighting on your first try. However, you don't need to stick to the setups I'm going to describe anymore than you'd want to paint using only one shade each of red, blue, green, yellow, orange, or other colors. Once you understand how various types of lighting affect your portrait, you'll want to expand on the basic techniques to achieve special looks of your own devising. This section covers some basics.

The character of the light you use is just as important as the direction it comes from. As a photographer, you probably already know that light can be hard and harsh, or soft and gentle. Neither end of the spectrum is "good" or "bad." Each type of light, and all the gradations in between, has its own advantages and disadvantages.

A spotlight or a lamp in a reflector, or an electronic flash pointed directly at a subject is highly directional and produces a hard effect. Hard light is harsh because all the light comes from a relatively small source. This kind of light can be good if you want to emphasize the texture of a subject, and are looking for as much detail and sharpness as possible. In fact, many kinds of photographic projection and optical gear take advantage of point-source lighting to maximize sharpness. A photographic enlarger, for example, may be equipped with such a source to get the sharpest possible image from a piece of film. Of course, the point-source light emphasizes any scratches or dust on the film, so the technique works best with originals that are virtually perfect from a physical standpoint.

Most portrait subjects benefit from a softer light, like that used in Figure 13.9. You can soften this light in many ways, using umbrellas, diffusers, and other techniques. It's even possible to add a little softness in Photoshop, as I did with this particular photo.

Figure 13.9
Soft illumination works best for many subjects, including women.

Direct versus Soft

As I've noted, direct light is not as good a choice for portraiture. People rarely look their best under a direct light, because even a baby's skin is subject to imperfections that we don't see under home illumination (which is deliberately designed to be non-harsh). Only in direct sunlight are we likely to look our worst. Figure 13.10 shows how a direct light focuses a sharp beam on a human subject.

Most portraits are made using softer illumination, such as that produced by bouncing light off an umbrella. As the light strikes the umbrella (or other soft reflector), the light scatters. It bounces back toward the subject and appears to come from a much larger source—the umbrella itself rather than the bulb or flash unit that produced it. Figure 13.11 shows a much softer beam of light bounced onto the subject from an umbrella. Of course, the light is bouncing in all directions and spreading out, but my illustration shows just the cone of light falling on the subject. The blunt "apex" of this cone gets smaller the farther away you move the light, and larger the closer it gets.

But you probably already guessed by now that the distance of the light source from the subject also has a bearing on the quality of light. In Figure 13.11, the umbrella is fairly far from the subject, so the light source seems to come from a relatively small area, even though it's bouncing off an umbrella. The effect is less harsh than direct light, of course, but still not as good as we can achieve.

For Figure 13.12, I moved the umbrella in much closer to the subject, making the blunt end larger. The apparent source of the light is now much broader, relatively, and correspondingly softer. You'll need to keep this characteristic in mind as you set up your lights for portraiture. If you need to move a light back farther from the subject, you'll also need to take into account the changing nature of the light. A larger umbrella may help keep the lighting soft and gentle. Or, you simply might want to have slightly "edgier" lighting for your subject. As long as you are aware of the effect, you can control it.

Figure 13.10 A direct light forms a sharp beam of high-contrast light on your subject.

Figure 13.11 Bouncing light from an umbrella produces a much softer light source.

Figure 13.12 Moving the light in closer provides an even broader, softer effect.

Balancing Light

As you'll see in the next section, you'll often be using multiple illumination sources to light your portraits. It's important to understand some of the principles that go into balancing light from several different sources in a single photograph. Here are some tenets to work by:

That Inverse Square Law Again

As I first mentioned in Chapter 7, moving a light source twice as far away reduces the light by 4X (not 2X). In photographic terms, that translates into two f/stops, not one f/stop, to compensate. For example, a light source placed 8 feet from your subject will provide *one-quarter* as much illumination as the same source located just 4 feet from the subject. After moving the light twice as far away, you'd have to open up two f/stops to keep the same exposure.

You can make the inverse square law work for you. If you find a source is too strong, either by itself or relative to other light sources you're using, simply moving it twice as far away will reduce its strength to one-quarter its previous value. Or, should you need more light, you can gain two f/stops by moving a light source twice as close. (Keep in mind that the softness of the light is affected by the movement, too.)

There are times when you won't want to adjust the light intensity entirely by moving the light because, as you've learned, the farther a light source is from the subject, the "harder" it becomes. In those cases, you'll want to change the actual intensity of the light. This can be done by using a lower power setting on your flash, switching from, say, a highly reflective aluminum umbrella to a soft white umbrella, or by other means.

Using Ratios

When lighting a subject, the most common way to balance light is to use ratios, which are easy to calculate by measuring the exposure of each light source alone (either with your camera's exposure meter or using an external flash meter). Once you have the light calculated for each source alone, you can figure the lighting ratio.

For example, suppose that the main light for a portrait provides enough illumination that you would use an f/stop of f/11. The supplementary light you'll be using is less intense, is bounced into a more diffuse reflector, or is farther away (or any combination of these) and produces an exposure, all by itself, of f/5.6. That translates into two f/stops' difference or, putting it another way, one light source is 4 times as intense as the other. You can express this absolute relationship as the ratio 4:1. Because the main light is used to illuminate the highlight portion of your image, while the secondary light is used to fill in the dark, shadow areas left by the main light, this ratio tells us a lot about the lighting contrast for the scene. (I'll explain more about main and fill lights shortly.)

In practice, a 4:1 lighting ratio (or higher) is quite dramatic and can leave you with fairly dark shadows to contrast with your highlights. For portraiture, you probably will want to use 3:1 or 2:1 lighting ratios for a softer look that lets the shadows define the shape of your subject without cloaking parts in inky blackness.

If you use incandescent lighting or electronic flash equipped with modeling lights, you will rarely calculate lighting ratios while you shoot. Instead, you'll base your lighting setups on how the subject looks, making your shadows lighter or darker depending on the effect you want. If you use electronic flash without a modeling light, or flash with modeling lights that aren't proportional to the light emitted by the flash, you can calculate lighting ratios. If you do need to know the lighting ratio, it's easy to figure by measuring the exposure separately for each light and multiplying the number of f/stops difference by two. A two-stop difference means a 4:1 lighting ratio; two-and-a-half stops difference adds up to a 5:1 lighting ratio; three stops is 6:1; and so forth.

Figure 13.13 shows an example of 2:1, 3:1, 4:1, and 5:1 lighting ratios.

Figure 13.13 Left to right: Lighting ratios of 2:1, 3:1, 4:1, and 5:1.

Using Multiple Light Sources

As I warned you in the previous section, the best portrait lighting involves at least two, and often three or more light sources. The light sources don't always have to be incandescent lights or electronic flash. Figure 13.14, for example, was shot using window light (from the rear), light bounced from a flat reflector to the right side of the image, and from another reflector, an umbrella placed at camera position (which you also can't see). This section will introduce you to each type of light source and the terminology used to describe it.

Main Light

The main light, or key light, is the primary light source used to illuminate a portrait. It may, in fact, be the only light you use, or you may augment it with other light sources. The main light is often placed in front of the subject or slightly behind, and on one side of the camera or the other. Some

Figure 13.14
Only window light and reflectors were used for this portrait.

kinds of lighting call for the main light to be placed relatively high, above the subject's eye-level, or lower at eye-level. You usually won't put a main light lower than that, unless you're looking for a monster/crypt-keeper effect. Figure 13.15 shows a portrait with the main light positioned to provide the most illumination on the side of the face that's turned away from the camera. (This is called *short lighting,* and will be explained later in the chapter.)

Placed to the side, the main light becomes a side light that illuminates one side or the profile of a subject who is facing the light. Placed behind the subject, the main light can produce a silhouette effect if no other lights are used, or a backlit effect if additional lighting is used to illuminate the subject from the front. I'll show you how to create lighting effects using the main light shortly.

You'll usually position the main light at roughly a 45-degree angle from the axis of the camera and subject. The main light should be placed a little higher than the subject's head—the exact elevation determined by the type of lighting setup you're using. One thing to watch out for is the presence or

absence of catch lights in the subject's eyes. You want one catch light in each eye, which gives the eye a slight sparkle. If you imagine the pupils of the eyes to be a clock face, you want the catch lights placed at either the 11 o'clock or 1 o'clock position. You might have to raise or lower the main light to get the catch light exactly right.

You most definitely do not want *two* catch lights (because you're using both main and fill lights) or no catch light at all. If you have two catch lights, the eyes will look extra sparkly, but strange. With no catch light, the eyes will have a dead look to them, as in Figure 13.16. For this example, I used the same photo so you could see the difference (removing one, then both of the original catch lights), but you won't normally get identical shots with different catch light effects in them. Sometimes you can retouch out an extra catch light, or add one with Photoshop, but the best practice is to place them correctly in the first place.

Figure 13.15
The main light is off to the right and slightly behind the subject, illuminating the side of the face that's turned away from the camera.

Figure 13.16 Two catch lights (left), or no catch light at all (middle) look bad. One catch light (right) looks great.

Fill Light

The fill light is usually the second-most powerful light used to illuminate a portrait. Fill light lightens the shadows cast by the main light. Fill lights are usually positioned on the opposite side of the camera from the main light.

The relationship between the main light and fill light determines, in part, the contrast of a scene, as you learned in the section on calculating lighting ratios. If the main and fill are almost equal, the picture will be relatively low in contrast. If the main light is much more powerful than the fill light, the shadows will be somewhat darker and the image will have higher contrast. Fill lights are most often placed at the camera position so they will fill the shadows that the camera "sees" from the main light. Figure 13.17 shows a main light and fill light in a typical lighting setup. In Figure 13.18, the fill light is to the left of the camera and is lighting up the shadows on the side of the face closest to the camera. I'll show you the effects of using main and fill lights in the sections that follow.

Background Light

A light illuminating the background is another common light source used in portraits. Background lights are low-power lights that provide depth or separation in your image. Place the background light low on a short light stand about halfway between your subject and the background, so that the subject hides the actual light from view. This light can also provide interesting lighting effects on the background when used with colored gels or cookies. You can even turn the background light toward the back of the subject, producing a halo or back-light effect.

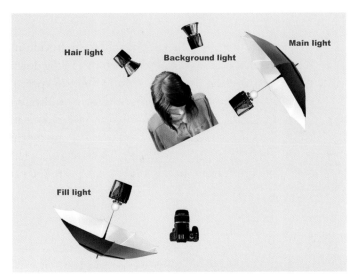

Figure 13.17
Main and fill lights complement each other.

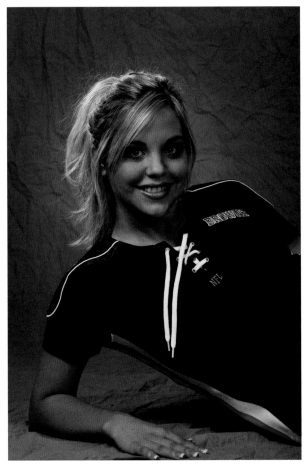

Figure 13.18
Both a hair light and background light were used here to provide separation from the background.

Hair Light

A hair light is usually a small light directed at the hair of the subject to provide an attractive highlight. Often, a snoot or barn door is used to keep the hair light from spilling down on the subject's face. A hair light must be controlled carefully so it doesn't form an overexposed hot spot on the subject's head. A low-power light like the background light, the hair light also provides separation from the background, which can be very important if your subject has dark hair and is posed against a dark background. Place the hair light in a high position shining down on the subject's head, then move it forward until the light spills over slightly onto the subject's face. At that point, tilt the light back again until it is no longer illuminating the subject's face. You can see a hair light at work in Figure 13.18.

Lighting Techniques

Although I'll describe each of the most common lighting techniques, you'll want to set up some lights and see for yourself exactly how they work.

Short Lighting

Short lighting and broad lighting (discussed next) are two different sides of the same coin. Together, they are sometimes referred to as "three-quarter lighting," because in both cases the face is turned to one side so that three quarters of the face is turned toward the camera, and one quarter of the face is turned away from the camera.

Short lighting, also called narrow lighting, is produced when the main light illuminates the side of the face turned away from the camera, as shown in the bird's-eye view in Figure 13.19. Because three-quarters of the face is in some degree of shadow and only the "short" portion is illuminated, this type of lighting tends to emphasize facial contours. It's an excellent technique for highlighting those with "interesting" faces. It also tends to make faces look narrower, because the "fat" side of the face is shadowed, so those with plump or round faces will look better with short lighting. Use a weak fill light for men to create a masculine look.

This is a very common lighting technique that can be used with men and women, as well as children.

In Figure 13.20, our subject is looking over the photographer's left shoulder. The main light is at the left side of the setup, and the fill light is at the photographer's right. Because the fill light is about twice as far from the subject as the main light, if both lights are of the same power, the fill light will automatically be only one-quarter as intense as the main light (thanks to the inverse-square law). If the shadows are too dark, move the fill light closer, or move the main light back slightly. If your light source allows "dialing down" the power, that's an even better choice, because moving the light sources changes the character of the light slightly.

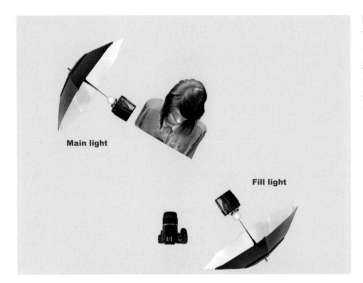

Figure 13.19
With short lighting, the main light source comes from the side of the face directed away from the camera.

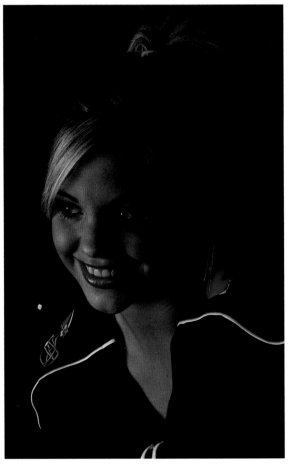

Figure 13.20
A typical portrait illuminated using short lighting looks like this.

Broad Lighting

In many ways, broad lighting, the other three-quarter lighting technique, is the opposite of short lighting. The main light illuminates the side of the face turned toward the camera. Because most of the face is flooded with soft light (assuming you're using an umbrella or other diffuse light source, as you should), it de-emphasizes facial textures (teenagers may love this effect) and widens narrow or thin faces. Figure 13.21 is the lighting diagram used to produce the image shown in Figure 13.22, which pictures the same subject as above, but with broad lighting instead. Broad lighting may not be the best setup for this young lady, because she has a broad face, but styling her hair so it covers both sides of her face reduces the effect. That let me use broad lighting and its feature-flattering soft light.

Butterfly Lighting

Butterfly lighting was one of the original "glamour" lighting effects. The main light is placed directly in front of the face above eye-level and casts a shadow underneath the nose. This is a great lighting technique to use for women, because it accentuates the eyes and eyelashes, and emphasizes any hollowness in the cheeks, sometimes giving your model attractive cheekbones where none exist. Butterfly lighting de-emphasizes lines around the eyes, any wrinkles in the forehead, and unflattering shadows around the mouth. Women love this technique, for obvious reasons. Butterfly lighting also tends to emphasize the ears, making it a bad choice for men and women whose hairstyle features pulling the hair back and behind the ears.

Butterfly lighting is easy to achieve. Just place the main light at the camera position, and raise it high enough above eye-level to produce a shadow under the nose of the subject. Don't raise the light so high the shadow extends down to his or her mouth. The exact position will vary from person to person. If a subject has a short nose, raise the light to lengthen the shadow and increase the apparent length of the nose. If your victim has a long nose, or is smiling broadly (which reduces the distance between the bottom of the nose and the upper lip), lower the light to shorten the shadow.

You can use a fill light if you want, also placed close to the camera, but lower than the main light, and set at a much lower intensity, to reduce the inkiness of the shadows. Figure 13.23 is the diagram for applying butterfly lighting (without a fill light), while Figure 13.24 shows the final result. Notice that the ears aren't a problem with this portrait, because they are hidden behind the model's hair. Because this young woman has blonde hair, I've toned back on the use of hair light in all the photos.

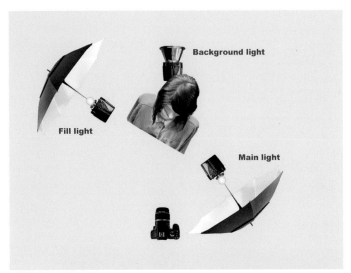

Figure 13.21
This diagram shows how the lights are arranged for a typical broad lighting setup. Remember, you can also use a mirror image of this arrangement.

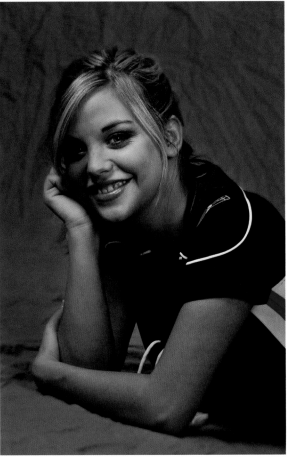

Figure 13.22
A portrait made using broad lighting de-emphasizes facial textures.

Figure 13.23
This diagram shows the basic arrangement for butterfly lighting.

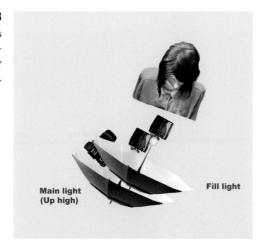

Figure 13.24
Butterfly lighting is a great glamour lighting setup.

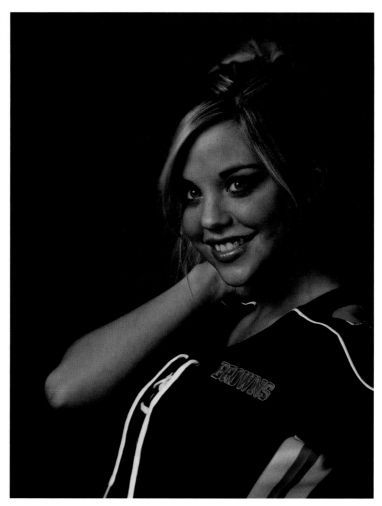

Rembrandt Lighting

Rembrandt lighting is another flattering lighting technique that is better for men. It's a combination of short lighting (which you'll recall is good for men) and butterfly lighting (which you'll recall is glamorous, and therefore good for ugly men). However, it also works for women, as shown in Figure 13.25. The main light is placed high and favoring the side of the face turned away from the camera, as shown in the figure. The side of the face turned toward the camera will be partially in shadow, typically with a roughly triangular shadow under the eye on the side of the face that is closest to the camera. For Rembrandt lighting, place the light facing the side of the face turned away from the camera, just as you did with short lighting, but move the light up above eye-level. If you do this, the side of the face closest to the camera will be in shadow. Move the light a little more toward the camera to reduce the amount of shadow, and produce a more blended, subtle triangle effect, as shown in Figure 13.26. Eliminate or reduce the strength of the fill light for a dramatic effect, or soften the shadows further with fill light.

Side Lighting

Side lighting is illumination that comes primarily directly from one side, and is good for profile photos. Side lighting comes primarily directly from one side of the camera. You can use it for profiles or for "half-face" effects like the Fab Four on the much copied/parodied cover of *Meet the Beatles/With the Beatles*. The amount of fill light determines how dramatic this effect is. You can place the main light slightly behind the subject to minimize the amount of light that spills over onto the side of the face that's toward the camera. Figure 13.27 shows you how to set up a light for side lighting, and Figure 13.28 shows the results. Note that a subject with long hair that covers the cheeks may have most of her face obscured when sidelit in this way. Either comb the hair back or go for a mysterious look.

Outdoor Lighting

You can apply virtually all the techniques you learned in the studio to your outdoors portraits. Once you've mastered short lighting, broad lighting, butterfly lighting, and the rest of the basic setups, you can use them outdoors by being flexible enough to work with the less controllable lighting you find there.

For example, you might have to position your subject to take advantage of the position of the sun as a "main" light, and use reflectors to create your fill. A search for some shady spot might be required to provide a soft enough light source. The sun might end up as your hair light. Figure 13.29 shows an outdoor portrait lit entirely with available light, using reflectors to fill in the shadows.

Figure 13.25

Arrange your main light high when working with a Rembrandt lighting effect.

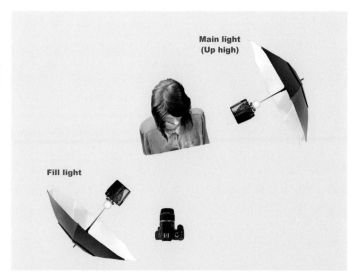

Figure 13.26

Rembrandt lighting lends an Old Masters' touch to portraiture.

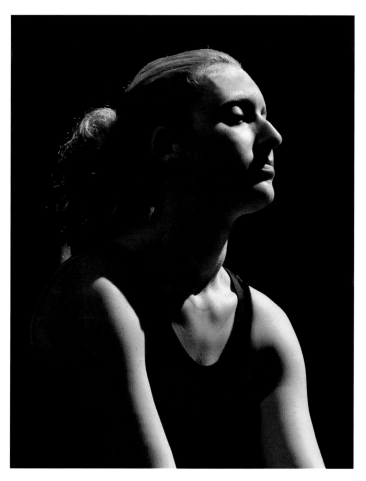

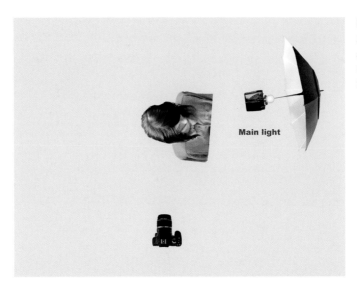

Figure 13.27
Side lighting is applied with most of the light coming from one side.

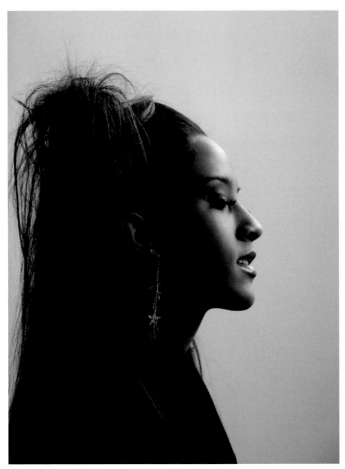

Figure 13.28
Side lighting can create dramatic profile photos.

Figure 13.29 Using sunlight, reflectors, and other aids, you can duplicate good studio lighting, such as this portrait, outdoors.

A Touch of Glamour

Glamour photography is another topic that's worth a book or two of its own. But, there's no reason why you can't add a touch of glamour to your own people pictures, whether you're shooting young and attractive male or female models, or attempting to make your Aunt Tillie look as good as possible. Although this next section *will* concentrate on some young and attractive subjects I've been lucky enough to photograph, you can easily apply all these concepts to any individual or group portrait you shoot. I'm using these particular subjects for the same reason that the commercials for workout videos use buff, athletic spokespeople, rather than folks who look like me (and who *really* need to work out). Viewing the kind of results you *can* get under ideal conditions with ideal subjects can be inspiring and motivational.

I'm going to provide a list of quick tips you can use in this section, but your best bet is to experiment with different techniques and poses and find some that you like. Work with those at first, try some variations, and add more poses as you become comfortable. Just keep in mind that your goal is not to use your subject as a mannequin that you can bend and twist any way you like. It's better to let the subject assume a pose that he or she is comfortable with. Then, you can make slight adjustments that reposition awkward limbs or produce better facial expressions.

CHOOSING POSES

There are an infinite number of good poses, but you're interested in starting with just a few. Your best bet is to clip photos from magazines with poses that you like, or purchase a posing guide with hundreds or thousands of different poses included. After you've worked with these canned poses for a while, you'll be more comfortable working with your subject for poses on your own.

The important thing is that your subject(s) must be relaxed and comfortable. The days when portrait subjects had to be immobilized in head braces for their daguerreotypes are long past. Don't make them stand for anything other than a full-length portrait. Stools make a great seat because they discourage slouching. An individual can sit tall in a stool, alert and ready to take your direction. Because they have no backs, stools won't intrude upon your picture, either. But don't be afraid to use other kinds of resting places, or from incorporating them into the photo.

If you're photographing an individual, you can try different poses as you work. For group pictures, you'll probably want to try and arrange everyone in a pleasing way and take several sets of pictures with each pose before moving on. Use basic compositional rules to arrange your subjects. For example, if photographing two or more people, don't have all your subjects' heads on roughly the same level, as at left in Figure 13.30. Instead, vary their height. The pose at right in Figure 13.30 forms a classic pyramid shape, one that should be a basic compositional element in any portrait or glamour shot.

Figure 13.30
To avoid having all the heads in a "lineup" at exactly the same level (left), vary the positions slightly, as at right in this example.

When shooting individuals, you can vary the camera's viewpoint slightly to portray your subject in a more flattering way. For example, raise the camera slightly above eye-level if you want to elongate a nose or narrow a chin, broaden a "weak" forehead, or de-emphasize a prominent jaw line. If your subject has a wide forehead, long nose, or weak chin, lower the camera a little. If you encounter someone with a strong jaw and long nose, however, you're in a heap of trouble.

Nobody's perfect, and a portrait is a bad time to discover exactly where an individual's imperfections lie. Here are some general tips to keep in mind to minimize defects:

- **The eyes have it.** The eyes are the most important component of any portrait, as they will always be the center of attention. They must be sharp and lively, even if you're going for a softer look in the rest of the portrait. (See Figure 13.31.)

- **Watch the feet.** The edges of hands are more attractive than the backs or palms of hands. The bottoms of feet are downright ugly, but you can sometimes get away with side views if the feet are young enough and there are other things to look at in the photo.

- **You can minimize shiny craniums.** Bald heads are pretty cool these days (if you're a male) but if your subject is sensitive about a bare pate, elevate your victim's chin and lower your camera slightly.

- **Minimize noses and ears.** For long, large, or angular noses, try having your subject face directly into the camera. To minimize prominent ears, try shooting your subject in profile, or use short lighting so the ear nearest the camera is in shadow.

- **Soft is better.** If you want to minimize wrinkles or facial defects such as scars or a bad complexion, use softer, more diffuse lighting; take a step backward and photograph your subject from the waist up to reduce the relative size of the face; keep the main light at eye-level so it doesn't cast shadows; and consider using a diffusing filter (or add diffusion later in your image editor).

- **Watch for reflections.** If your subject is wearing glasses, be wary of reflections off the glass. Have him raise or lower his chin slightly, and make sure your flash is bouncing off the face at an angle, rather than straight on.

- **Diffuse for a romantic look.** Diffusion is a great way to add a soft, romantic look to a portrait. You can purchase diffusion filters, or make your own by smearing a little petroleum jelly around the edges of the plain glass skylight filter. Or, you can add diffusion within your image editor, as was done with Figure 13.32.

- **Reflectors are your friends.** Outdoors, you don't have access to main and fill lights like you do in the studio, but large reflectors can be just as good, as you can see in Figure 13.33. If your subjects are accompanied by a friend or parent, ask them to hold the reflector for you. I always

Figure 13.31 The eyes are the most important component of any portrait shot.

Figure 13.32 Diffusion is a great technique, and you can apply it during the exposure or later, in your image editor, as was done here.

manage to convince my helper to hold the reflector in front of his own face so he can't see the model. That's the best way I've found to keep the companion from offering lame suggestions that ruin the session.

■ **Go for the gold.** A healthy golden glow can be beneficial to any type of portraiture, but when it comes to glamorous images, it's hard to overdo it. The image in Figure 13.34 was shot at sunset, using the golden back lighting to add a halo effect. A gold reflector was used to illuminate the model's face for an overall look that's heavy on warmth.

■ **Get some movement.** Ask your subject to jump, and capture him in mid-air. Have him moving around, and grab your best shots when your subject is relaxed and thinking about his activity rather than the fact that he is being photographed. If you have a remarkably cooperative model (payment is the best way I've found to encourage cooperation), you can get some killer shots. For Figure 13.35, my model repeatedly dipped her hair into the chilly waters of Lake Erie, and then flung her head back to create a cascade of water droplets. She had to repeat the action a dozen times, but I was very patient, considering that I was dressed warmly and completely dry during the shoot.

Figure 13.33 Reflectors can brighten inky shadows outdoors.

Figure 13.34 A golden glow adds to the glamour look.

Figure 13.35 Your glamour shots can come alive if you incorporate a little movement.

EYES WIDE SHUT

If you're using flash for your individual or group portraits, you'll find that people may blink during a flash exposure, and you'll end up with a photo showing their eyelids instead of their eyes. The problem is particularly troublesome when shooting groups: The more people in the picture, the better the odds one of them will have her eyes closed. While you can review each shot on your LCD, a faster way is simply to ask your subjects to watch for the flash and then tell you whether it was red or white after the picture was taken. If the flash was red, they viewed it through closed eyelids and that particular picture, at least, is no good.

You'll want to take lots of photos to capture various expressions and angles. Keep talking with your subject, and not just to provide her with instructions on where to place her arms and legs, or tilt her head. Mention how great she's doing; tell her how much she is going to like these photos.

Over time you'll develop a breezy line of patter that keeps your models relaxed. When working with amateurs, I use some funny stock phrases like, "Oh, I see you've done this before," or "Sorry, but we have to keep doing this until I get it right." You don't have to be *that* corny, but you'll soon collect a stockpile of jokes and phrases that will put your subjects at ease. And, if everybody is having fun, you'll find your people pictures are a lot more enjoyable for everyone involved.

Portraits on the Street

Photographing on city (or village) streets is a traditional type of photography, more akin to photojournalism than portraiture, as you can see in Figure 13.36, taken from a moving tuk-tuk. One exciting aspect of this kind of work is that you may be photographing people you don't even know, including those who are so busy at just being themselves that they may only be barely aware that you are taking their picture. Although we all have privacy concerns these days, unless you're a professional photographer, or want to use a street photo in advertising, as long as you're polite and not operating in a clandestine manner, you really have few legal aspects to worry about. Street portraits are a lot of fun. (See Figure 13.37.)

You will feel uncomfortable photographing on the street if people are constantly looking at you. In addition, that can make it harder to get truly candid and effective photographs. Anything you can do to blend into your location will help you take better pictures. Sometimes that is as simple as just being relaxed and casual about your photography. Wear clothing that is appropriate to the location. Even if you are not going to wear clothing that matches the locals, you can wear clothing that is closer in color and tone. For example, if you are in an area where no one wears shorts, then if you wear shorts, you are going to stand out.

Figure 13.36 The streets of any city in the world offer excellent opportunities for dramatic and interesting photography.

Here are some other ideas to help you blend in as you shoot:

- **Keep your gear simple.** If you are carrying a lot of gear, including multiple cameras around your neck, people will notice you. If you keep your gear simple so that it does not dominate your person, you will become more like the other people on the street.

- **Know your gear.** Nothing draws more attention than a photographer who is fumbling and struggling with his or her gear. Big, colorful camera bags, especially those with your camera name boldly displayed, are absolute giveaways that you are a photographer and will make it difficult to blend in. Keep your camera in a bag until you are ready to shoot, and fewer people will pay attention to you.

- **Keep your settings simple.** Before you start photographing, pick a lens that you expect will work best; set a white balance for the conditions; and choose an aperture.

- **Shoot with live view.** Often you do have to bring your camera up to your face to photograph, but if you can shoot without doing that by using live view, especially with a tilting LCD, you will attract less attention and be able to see what is going on around you as you shoot.

- **Shoot from locations out of the flow of the crowd.** If you start photographing out in the middle of the street, people will notice you and may react unfavorably. Find places that are casual and out of the flow of things so that you can photograph unobtrusively. A sidewalk café just off the main square of a European city, for example, would be a good place to start. This does not mean you should hide because that is going to look suspicious.

- **Smile a lot.** A smile goes a long way when you are photographing on the street.

Be ready to shoot your street portrait at all times. By photographing quickly, you can respond immediately to interesting things that are happening, and people often won't notice that you are photographing, or if they do, they won't react too much to it because it seems so casual.

Here are some ways that you can shoot quickly and efficiently:

- **Know your shot before you bring your camera up.** This is probably the number one way to shoot quickly. Scan the location and visualize your shot before you pull your camera up to shoot. You want to be able to bring your camera up, point it at the subject, and shoot immediately.

- **Be sure your camera is ready to go.** Your camera must be set and ready to go if you are to shoot quickly. You need to bring your camera up to shooting position and squeeze the shutter knowing the camera is going to be taking the picture you want. Be sure your camera has not gone to sleep.

- **Preset your zoom.** With practice, you can figure out an approximate framing of a subject and your zoom setting. If you can preset your zoom to that framing, that's one less thing to do when you are ready to shoot. One way of doing this is to pre-frame your shot with something nearby, but not your actual subject.

- **Pre-focus.** Pre-focusing is like presetting your zoom. The easiest way to do this is to find something nearby that is about the same distance away from you as your subject is. Use your autofocus to focus on that point or use manual focus. You can lock focus with autofocus, but you don't have to—just having your lens at an approximate focus distance will help your autofocus work better.

- **Practice bringing your camera up to shooting position.** You need to bring your camera to a shooting position in a comfortable and quick way. That really only happens with practice.

Remember that a good photograph is more than just a subject. Street photography can result in very confusing compositions if you are not careful. Constantly focus your mind on keeping your compositions clear and direct. Many of the ideas for composition on the go from the last chapter also work here. Here are some modifications to those ideas to help you specifically with city street photography:

- **Be simple.** Simple compositions tend to be clear and direct. Think about how you can simplify a composition before you bring your camera to shooting position.

- **Fill the viewfinder.** Get in close so the subject fills up your viewfinder. This might not be possible in all situations, or it may make you uncomfortable to get physically close to your subject. In that case, use your telephoto zoom to ensure that you are visually close in the photograph.

- **Check your LCD.** It is easy to get distracted by the tensions of city street photography so that you lose track of how well you're doing with your compositions. The way to get yourself back on track is to check those compositions on your LCD at least once in a while as you shoot.

- **Be aware of backgrounds.** Backgrounds will often make or break a street photograph. Watch backgrounds as you are approaching your subject, even before you shoot. Find a camera position that will minimize problem backgrounds. Be aware of what the background is doing to affect your subject.

- **Watch for distractions.** Distractions crop up when you are shooting on the street. Once again, become aware of the possibility of distractions slipping in along the edges of your picture. Look for potential distractions before you bring your camera to shooting position.

Vary Your Shots

Often when photographers are walking through a street taking photos, their pictures start to look the same because they are using the same focal length, they're shooting at the same distance from the subject, and they're not varying their shots. They are capturing different subjects, and sometimes that might be all that is needed. However, it can be interesting to photograph a city street location when you start looking for different shot types.

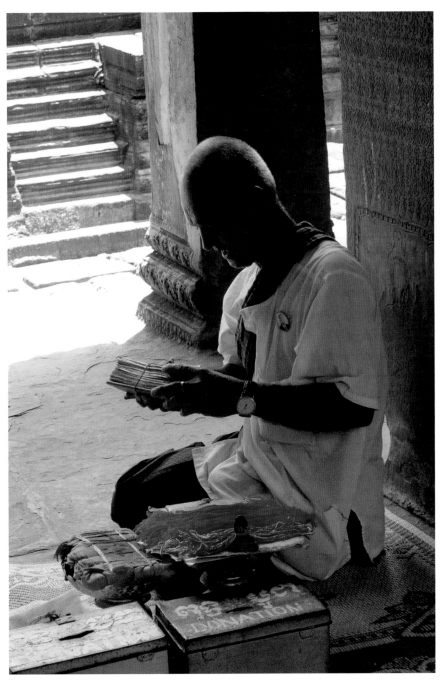

Figure 13.37
Simple compositions clearly show off your subject.

Hollywood does this all the time when creating a movie. Wide shots show off the location where a scene is taking place. Move in closer to get a medium shot to feature interactions between actors. Going in closer yet, Hollywood filmmakers will use a close shot to show off details and an extreme close shot to emphasize a very specific detail. This variety of shots makes the movie more interesting and more watchable. Looking for a variety of shots like this can help your street photography as well. Here are some things to look for when using these shot types for city street photography:

- **A wide shot is about how much you see around your subject.** A wide shot does not mean that you are using a wide-angle lens, although it might. A wide shot simply refers to how much you are seeing of a scene—how wide the view is around your subject, not the lens you're using. (See Figure 13.38.)

Figure 13.38
A wide shot emphasizes your subject's surroundings.

- **Wide shots capture the feeling of a location.** A wide shot of a city street showing the people on it can be an effective way of capturing the personality and feeling of a location.

- **Wide shots show setting and environment.** That's why you use them. When you get close to your subject, you might not see details of the location.

- **Avoid centering your subject in a wide shot.** Use the space around your subject to show interesting interaction of the subject to its surroundings. Centering your subject tends to make for rather dull street photographs because viewers will only look at what is in the center of the picture and not spend as much time with the image.

- **A medium shot is about interaction.** Medium shots mean that you tighten up your frame around your subject so that you emphasize the interaction of the subject with nearby people or objects. It is possible to see other interactions, but a medium shot means that you are close enough that you only see the subject and its immediate environment.

- **Medium shots can be done with any focal length.** Just as in a wide shot, a medium shot is more about the framing than it is about the focal length.

- **A close shot is about details.** When you tighten up your composition so that you are basically only seeing a single subject and the details of that subject, you are getting a close shot.

- **Close shots are not just about close-ups.** A close shot is simply a way of emphasizing details. If you are after the details of a person, you don't have to get right on top of them with a close-up to do that. All you are doing is framing in tightly to emphasize important details.

- **Extreme close shots emphasize and dramatize a single detail.** When you frame up really tight to a subject so that you only see a small detail, such as a close-up of a street person's tattoo, you have an extreme close-up that will often have a strong impact on a viewer. However, such extreme close-ups will miss a lot of details about the person or location that can also be important. That's why photographers rarely shoot extreme close-ups.

14

Photographing Concerts and Performances

We can't all be Bob Gruen or Annie Leibovitz and capture the pulse of rock music in our photographs. We can't even aspire to equal lesser-known, but equally respected photographers of other types of performances, such as dance photographers Lois Greenfield or David Cooper. But we can all enjoy photographing concerts, festivals, plays, ballets, and many other types of presentations at local venues. I've been shooting these events for most of my photographic life, and continue to enjoy perfecting my skills three or more times each month.

In one sense, concert and performance photography is a type of photojournalism. The goal is to capture a moment or series of moments and tell a story, just as we do when practicing the art of photojournalism. With that in mind, I always tell new performance/concert shooters that two time-honored rules of photojournalism apply quite well to this type of photography:

1. If your pictures aren't good enough, you're not close enough.—*Robert Capa*
2. F/8, and be there.—*Unknown (possibly Weegee)*

If you keep these two rules in mind, everything else is just detail. Capturing the flying fingers of a legendary guitar hero (whether local or international), as in Figure 14.1, always trumps the very best photo you could possibly take from the 27th row of the upper balcony. In this chapter, I'm going to show you how you can get up close and personal with performers, and what to do when you get there.

Figure 14.1

If your performance photos aren't good enough, you probably weren't close enough.

Brushes with Greatness

Those who can, do. Those who cannot, sometimes end up taking pictures of those who can. As a failed musician, I instead turned to photography and photojournalism as a career. (This is why my band, *The Babylonian Disaster Squad* does not appear in your CD or MP3 collections.) I actually began photographing future Rock and Roll Hall of Famers while still in high school, not knowing at the time that my contemporaries Gerald Casale (at left center in Figure 14.2) and Joe Walsh (at far right in the figure) would have more successful careers with Devo and The Eagles (respectively), than I would as an aspiring (in my dreams) *Rolling Stone* photographer. Jerry and Joe are shown performing at the West Main Elementary School gymnasium in my home town, roughly at the time all three of us enrolled at nearby Kent State University.

Two years later, I was still using awful direct flash techniques to photograph B.B. King, and the bug had bitten me. I was wrestling my way to the foot of the stage to photograph Janis Joplin, Country Joe and the Fish, Jose Feliciano, and dozens of other performers you may or may not have heard of.

So, can you expect to find yourself front-and-center to photograph Bruce Springsteen at his next Super Bowl performance, or perhaps capture intimate shots of the Joffrey Ballet in *The Nutcracker?* Frankly, no. But there are lots of ways you can get great shots of nationally known performers as well as local acts without resorting to false credentials or a backstage pass.

Figure 14.2 Future Devo and Eagles stalwarts Gerald Casale and Joe Walsh were early victims.

Figure 14.3
Here's B.B. King in
another (obviously)
non-digital
photograph.

Here are some tips:

- **Volunteer your time.** One local folk music venue—which hosts Grammy-winning acts several times a month—has a staff that is mostly volunteers. I help out there with my photography to gain better access at shows. One local dance troupe also makes use of unpaid help. By agreeing to set up a studio in their practice space and shoot images for their brochures, I was able to capture some excellent posed images, like the ones shown in Figure 14.4, with the bonus of a professional choreographer on hand to direct the shoot.

- **Attend dress rehearsals and sound checks.** For plays, dances, concerts, and other types of performances, you may be able to gain access to a dress rehearsal or sound check. It's important not to disturb the practice/tune-up session. By staying out of the line of sight of the choreographer or director, you can usually shoot to your heart's content from some of the choice seats stage right or left. Verb Ballets is a nationally respected professional dance company in Cleveland, and I've photographed many of their dress rehearsals. The company used the image in Figure 14.5 as a poster for their Fresh Inventions/Danceworks 10 production.

Figure 14.4 Volunteer to provide studio shots for publicity.

Figure 14.5 This two-second exposure (timed so it would end when the center dance stopped moving) ended up as a poster.

- **Look for side projects/nostalgia tours in small venues.** Surely you've heard of Paul McCartney and Wings; Crosby, Stills, and Nash; Tom Petty & the Heartbreakers; Badfinger; Traffic, Toad the Wet Sprocket; The Moody Blues; or Bootsy Collins? You're unlikely to be able to photograph any of these arena acts in a large venue. But Denny Laine (of Wings and the Moody Blues), Stephen Stills, Benmont Tench (Tom Petty keyboardist), and other members of the aforementioned groups have all played in side projects at a local 600-seat theater where I have a regular aisle seat in Row 2. Nostalgia tours are great for those old enough to have developed a solid hankering for the Good Old Days. Dave Mason, shown in a black-and-white capture in Figure 14.6, survived playing in Traffic, accompanied Jimi Hendrix on guitar for the recording of *All Along the Watchtower,* and says he could live quite well from the royalties off Joe Cocker's version of his *Feelin' Alright.* Yet, I was able to photograph him from eight feet away as he toured small venues recently. Thanks to my photographic efforts, my official Bacon Number is 1.0, after meeting the actor while shooting him and his band, The Bacon Brothers.

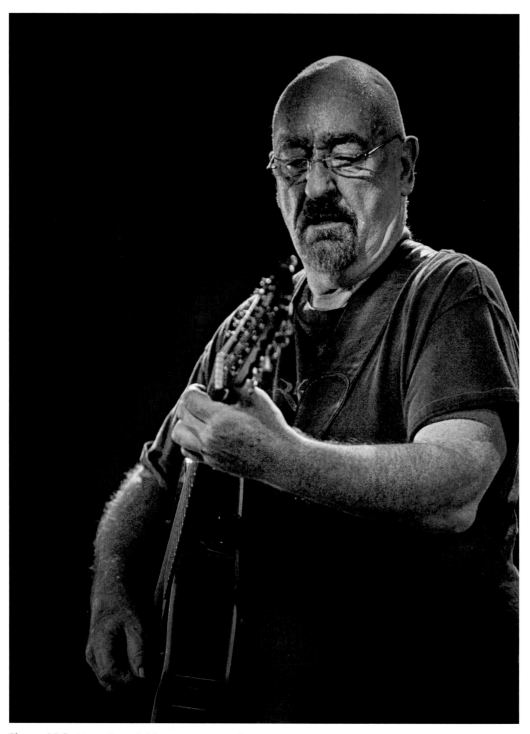

Figure 14.6 Living legends like Dave Mason often tour small venues.

■ **Shoot up-and-coming bands.** I have no way of knowing whether the Cleveland band "Jackie," featuring electrifying songstress Jackie LaPonza will make it big nationally, but the group's lack of a recording contract doesn't make the band any less exciting to shoot, as you can see in Figure 14.7. And if local talent does score on the national scene, you'll have some photos to really brag about.

■ **Photograph tribute bands.** It's about 45 years too late to be photographing the Beatles, but cover and tribute bands with look-alike personalities and sound-alike repertoires are plentiful, as shown in Figure 14.8. Select the right angles, and your pictures could—almost—be the real thing. Indeed, Tim Owens, a singer who grew up six miles from me, ended up transferring directly from frontman for local tribute band British Steel to replace Rob Halford in Judas Priest. You never know.

Figure 14.7
Local bands can be just as exciting to photograph as nationally known acts.

Figure 14.8 Tribute bands are the next best thing to the real act.

- **Take pictures for charity.** Last summer, I was lucky enough to be the "official" photographer for Rock United, a fundraiser for United Way of Cleveland, which gave me "all access" (and free admission!) in exchange for some photographs supplied on DVD to the sponsors. Community service is a great way to get up close for the best pictures.

- **Explore genres.** I started out photographing rock and blues bands, because that's the type of music I played as a failed musician. (I also played in a jazz/big band combo, but never aspired to make a living at that.) I *liked* other types of music, but it was really a revelation when I began photographing folk artists like Loudin Wainwright III, Western/swing bands like Riders in the Sky and Asleep at the Wheel, and bluegrass artists like Ralph Stanley and the Gibson Brothers. After photographing blues legend James Cotton (see Figure 14.9) and Celtic virtuosos Enter the Haggis in the same month, I discovered that "alternate" acts were just as interesting to photograph. You can expand your musical and photographic horizons simultaneously.

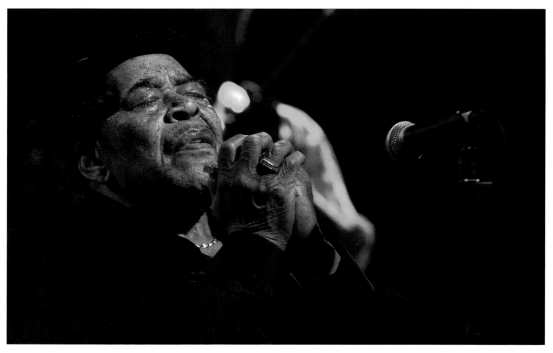

Figure 14.9 I was lucky enough to photograph Howlin' Wolf's harp player legend James Cotton as a young man 35 years old, then again, last year for this photo.

Arming for Battle

I am fond of reassuring aspiring photographers that you can take almost any picture with almost any camera. You don't need a fancy pro dSLR to shoot concerts and performances. Even a simple point-and-shoot camera can be pressed into service. However, the right gear *does* make it possible to take certain photographs easily that are difficult to shoot without certain equipment. And, in other cases, particular features make grabbing the picture you want somewhat easier and more convenient. But, in all cases, the most important tools you have are your feet and your brain. Maneuver yourself into the right spot and shoot creatively, and you'll end up with a winning photograph regardless of what equipment you have available.

That said, this section will list some of those "conveniences" that particularly lend themselves to photography of concerts and performances. Don't fret if you're missing some of these: you still have your feet and brain to rely on.

- **A fast zoom lens.** A fast, sharp zoom lens that can be used wide open will simplify your life tremendously. I shoot 90 percent of my concerts with a 70-200mm f/2.8 lens that has image stabilization (Nikon, Canon, and third-party vendors all make similar lenses), and I love the results I get. I use the lens hand-held at 200mm and either f/2.8 or f/4 with the ISO of my camera set at 3200, and get shots like the one in Figure 14.10. You can get by with optics that are not quite as fast (see the tips that follow this one), but a similar lens makes your life simpler.

- **Low-light performance.** Most stages are illuminated by spots and other lights, so you can usually get by with ISO settings of ISO 800 to ISO 1600. Those are well within the "low noise" performance range of most modern dSLRs. I use ISO 6400 and higher only because my camera does a particularly good job at that setting, and it lets me bump up the shutter speed a notch when I want to freeze those flying fingers. I captured bassist Jack Casady (from Jefferson Airplane and Hot Tuna) at ISO 12,800 with very good results, as seen in Figure 14.11. But if you have a camera that produces good images at ISO 800 to ISO1600, you're in good shape, particularly since a little noise in a concert or performance photograph is not usually very objectionable. Noise tends to show up worst in backgrounds, and, in stage performances, the backgrounds are dimly lit, either masking the noise or making it easy to remove with noise reduction or simple blurring techniques in your image editor.

- **Image stabilization or a monopod.** At one time, I photographed many concerts using a monopod. You'll find that a monopod (as opposed to a tripod) can be used without interfering with the other paying customers' enjoyment of the performance, as long as you don't sling it around like a weapon. (And the venue allows you to use one.) More recently, I've left the monopod at home and relied on image stabilization. The bulk of my concert photos are taken at 1/180th second at f/2.8 or f/4 and ISO 3200. I can slow down the shutter to 1/60th to 1/15th or even a full second if I want to incorporate subject motion in my shot, as with Figure 14.12.

But, even if you want to allow the subject to blur, it's generally a good idea for the camera itself to be steady, so everything else in the shot is sharp and clear. Either a monopod or image stabilization will provide the steadiness you need.

■ **Certain camera features.** There's no denying that certain camera features not found in every model can expand your creative opportunities. For example, if your camera has built-in double-exposure capabilities, you can grab pictures like the one shown in Figure 14.13. Sweep Panorama or Easy Panorama, found in some Sony and Nikon models, lets you capture interesting extra-wide-view shots. If your camera has full HD capabilities, you can even come home with a sound video of your favorite band.

Figure 14.10
A zoom lens, shot at the maximum aperture of f/2.8 captured this emotion-filled moment.

Figure 14.11 Many newer cameras perform very well at higher ISO settings.

Figure 14.12 If your camera is steady, you can use a longer shutter speed to add a feeling of motion to your image.

Figure 14.13
Double-exposure capabilities let you capture interesting shots.

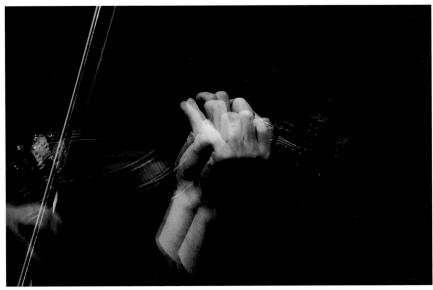

Getting Into Position

Location, location, location is important in fields other than real estate. Even if you've got a good seat, if you're free to move around, you'll want to do so. Otherwise, every shot you take will have the same point of view. I like to shoot the first half of a concert from my second-row aisle seat (in my favorite venue, the rows are staggered so there is no one in front of me in the first row). I can shoot most members of the band from this position (except, usually, for the drummer), study how they work, and plan how I'll be shooting when I do get up and roam.

It's usually pretty easy to move to the side of the stage to shoot images like the one shown in Figure 14.14. I kept the lens wide open and used selective focus so that "Paul" was sharp and "George" and "John" were progressively blurry. All three were illuminated differently, providing additional separation between them.

I admit I'm fond of selective focus, and used my freedom to move about to capture the image seen in Figure 14.15, highlighting the guitar player in the background. Then, I moved around backstage and photographed him from behind, as in Figure 14.16. It would have been nice to get the crowd in the background, but you'll find that they are usually illuminated so poorly, compared to the stage performers, that they are all but invisible. (This can be a kindness for hard-working bands playing to less than a packed house.)

You'll find that the more you move around, the better the variety in your photographs.

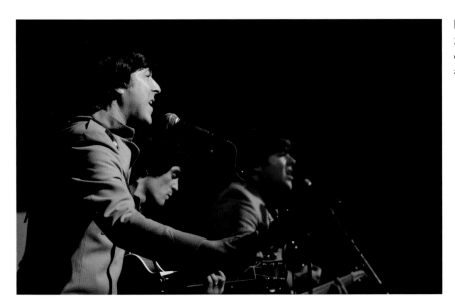

Figure 14.14
Shoot from the sides of the stage, as well as the front.

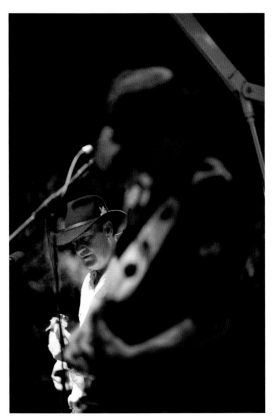

Figure 14.15 Side views let you isolate one performer creatively.

Figure 14.16 If you can get backstage, you'll find other interesting views.

Interesting People

The more you shoot, the more you'll discover that performers are flat-out interesting people, at least from a photographic standpoint. Costumes are an important part of a musician's image, an actor's character, and a dancer's repertoire. Add in some attitude, an interesting face, and a few quirky mannerisms, and you've got a prime subject for an interesting portrait—entirely separate from the individual's performance.

My portrait of the country guitarist didn't need a guitar or any of the accoutrements of his stage persona to make for the interesting shot you see in Figure 14.17. The bass player in Figure 14.18 reeked of menace as his band played some ominous tune, although in real life he was a cheerful, engaging fellow. As you shoot concerts and other events, go beyond the music to explore the character of the performers, and I think you'll be pleased with the results.

I cornered the actor shown in Figure 14.19 after a performance and asked him to pose for a picture. He immediately went back into character, every part of his body assuming the essence of the Renaissance fellow he was portraying, and cracked a wicked grin. As he posed and I snapped away, all I could say was, "I see you've done this before!"

Figure 14.17 I photographed this fellow as the good 'ole boy he was in real life, not the musician who generated excitement on stage with his music.

Figure 14.18 Dark moods can make for interesting portraits of musicians.

Figure 14.19
Talk to actors after a
performance; you'll
find they make
excellent portrait
subjects.

Techniques

I'm going to finish off this chapter with a compendium of a few of my favorite techniques for photographing performances. This is one type of photography where creativity is given a premium, and there is no penalty for going over the top. The most extreme techniques you can dream up just might be the ones that make it to the cover of a CD or end up gracing a poster.

■ **Selective focus to blur backgrounds.** Indoors on stages, you'll rarely have to worry about backgrounds. Outdoors, especially at festivals like the one pictured in Figure 14.20, you'll find lots of distractions that can intrude on your photo. Bad backgrounds can be especially detrimental when you've got a musician performing while some gawker behind them sucks down a cotton candy. For this picture, I used a large aperture to blur the tents behind the violinist as much as I could.

Figure 14.20
Blur the background to reduce distractions.

- **Continuous shooting secrets.** I love using continuous shooting at performances for several reasons. First, I've found that, even with image stabilization and an acceptably fast shutter speed, some camera blur still creeps in. That's often the case when I swivel the camera to reframe slightly, or am less than gentle when I press the shutter release. With the camera set on 5 fps or faster burst mode, I often find that one of the *center* pictures is the sharpest, because it's captured after the initial movement has subsided. Continuous shooting also captures a variety of different shots of performers who are playing their instruments quite rapidly. A difference of as little as 1/20th of a second can make a big difference in the final image of a fast-fingered violinist, leaping ballerina, or ukulele virtuoso Jake Shimabukuro, shown in Figure 14.21.

Figure 14.21
Use continuous shooting to capture the critical moment.

■ **Telephoto compression.** A long lens can be used to compress the distance between objects in the frame, as was the case with Figure 14.22. Drummers, who generally sit at the back of the stage, are notoriously hard to photograph anyway (unless they're seated on a raised platform). So, a long lens and a bit of compression caused by a telephoto focal length can give you a special shot.

Figure 14.22
Use a telephoto to compress distances.

■ **Use framing.** Carefully composing your image so that one subject is framed by another is an effective technique for tying together different members of a group, as I did with Figure 14.23. You can also see the effect of telephoto compression in this shot.

Figure 14.23 Framing helps unite several performers in one shot.

■ **Blown highlights? No problem!** I tend to shy away from recommending image editors to fix problems that should have been corrected in the camera, but am willing to make exceptions for concert photography. Rock music, in particular, has a long history of special effects, dating back to Frank Zappa's signature solarized photo on the cover of his 1966 album Freak Out! So, faced with blown highlights, I didn't hesitate to apply some posterization effects to create an entirely new image for Figure 14.24. Try to capture your image in the camera first, but don't be afraid of applying creativity in your image editor, too.

Figure 14.24

Sometimes, manipulating an image in an editor can provide a new look you couldn't get in real life.

■ **Reflections.** I have a few dozen shots I like in which reflections form an important part of the image, but chose this one, seen in Figure 14.25. I really did capture a reflection of Chris Sherman (aka Freekbass) in the sunglasses of his guitarist T-Sly, but made one small tweak to the image to make it better (in my opinion). Hint: Freekbass is *not* left-handed.

Figure 14.25
Reflections can be interesting.

■ **Mood lighting.** A recent show I shot with Todd Rundgren featured constant backlighting, lasers, and smoke. Again, no problem! The weird colors are part of the mood of the performance, so I shot what I saw and didn't worry about making color or exposure corrections. (See Figure 14.26.)

Figure 14.26
Stage lighting adds
to the mood.

- **Multiple exposures.** If your camera has built-in double-exposure capabilities, you can use it to produce interesting images like the one shown in Figure 14.27. The dancers performed the routine once at the beginning of the dress rehearsal, and when they ran through it a second time, I was ready for this moment. The dark background found in many stage performances simplifies using multiple exposure techniques.

Figure 14.27
Double-exposures can convey a feeling of movement in an otherwise static shot.

15

Scenic, Wildlife, and Nature Photography

One of the cool things about photography is that so many of the most interesting creative avenues run parallel to each other, criss-cross, or even meander down the same path from time to time. Once you get outdoors and begin shooting, the whole world is your subject. Animals, plants, and scenic vistas all beg to be captured and enjoyed. This chapter will help you deal with the world of nature—basically, anything that does *not* include humans.

As a result, you'll find tips here for photographing wildlife of all sorts—but not, for example, people riding horses. Scenic photography can include human-made structures, such as the charming old barns often found in rural landscapes. Nature photographs can include flowering plants, trees, and other flora, but, generally, not photographs of formal flower gardens. However, photographing plant life most often incorporates elements of close-up and macro photography, so I'm not going to explore that topic in this chapter. You'll find what you need to know to photograph subjects close to the lens in Chapter 17.

Scenic Photography

I've put scenic photography first because it is as old as photography itself. The first known permanent photograph, taken in 1826 by French chemist Joseph Nicèphore Nièpce, is a view of the courtyard outside his laboratory. Because early photographs required exposures that were extremely long (Nièpce's scenic required an eight-hour time exposure in full daylight), stationary subjects like trees and mountains were perfect pictorial fodder. When early photographers weren't strapping our ancestors into chairs for painfully tedious portraits, they were creating scenic photographs.

Of course, we've come a long way since then, both in the way photographs are taken, and the esteem in which they are held. That first photograph was made using a pewter plate coated with asphalt, and when Nièpce submitted the "heliograph" to England's King George IV and the Royal Society, it was rejected. Today, the same photo could be exposed onto a solid-state sensor in 1 1/16,000th of a second (the fastest shutter speed on the latest digital cameras), and photographs are more highly valued. For example, a signed 16 × 20 print of Ansel Adams' "Monolith, Face of Half Dome" will set you back $37,000 at the Ansel Adams Gallery (www.anseladams.com, if you'd rather have the photograph than a new SUV).

This section focuses on several different varieties of scenics and offers some tips for getting some interesting shots of landscapes, sunsets/sunrises, fireworks, and other types of scenic images.

Scenic Essentials

Scenic photography isn't particularly equipment- or gadget-intensive. Your digital camera and its standard zoom lens will be fine in most cases, as long as your lens has a sufficiently wide focal length to take in expansive vistas. If you're planning to include night photography in your scenic repertoire, particularly if you're going after fireworks pictures, you'll want a digital camera that can capture long exposures at boosted ISO ratings without introducing excessive noise into the picture. All dSLR cameras have special noise reduction features that are able to separate actual image detail from random noise by comparing two separate photographs and then, in effect, deleting anything that doesn't look like picture information.

A main concern when selecting a camera for scenic photography will be the lens. A wide zoom range, extending from a true wide-angle perspective to a decent telephoto setting gives you the flexibility you need to photograph wide-open spaces or focus in on a distant mountain. Choice of focal length is important when shooting scenics, because it's not always practical to drive a few miles closer to a mountain, and it may be impossible to back up any further for a wider view (thanks to a cliff, forest, ocean, or other impediment at your back). Telephotos can bring distant subjects closer, and de-emphasize things in the foreground that you don't want in the picture. Wide angles, in contrast, make distant objects look as if they are farther away while emphasizing the foreground, as you can see in Figure 15.1.

If you think landscapes aren't hard-wired into our thinking, the next time you print a photograph, check out the name applied to the "wide" orientation in your printer's Setup dialog box. You may be printing an abstract image, a photo of a football game, or even a group portrait, but the name applied to a picture or document that's wider than it is tall is *landscape*. Scenics have been a favorite subject for artists throughout history, from Da Vinci to Dali to Daguerre.

Nine Simple Rules for Composing Your Landscapes

Landscape photos, in particular, are an opportunity for you to create thoughtful and interesting compositions. Those mountains aren't going anywhere. You're free to move around a bit to get the best angle, and, unless you're including people in your pictures for scale, you don't have to worry

Figure 15.1
To emphasize the foreground, use a wide-angle lens or zoom setting.

about an impatient subject. If you can't pull all the elements of a scenic photograph together to create a pleasing composition, you're not trying hard enough.

In one sense, good composition is the most important aspect of landscape photography. Certainly an action photo or a portrait needs to be composed well for maximum effect, but if you've captured a once-in-a-lifetime moment in an important sports contest, no one is going to complain because the football needed to be a little more to the left. And, to be honest, do you really care about how well a close-up photo of Angelina Jolie or Brad Pitt is composed? Yet, mountains are everywhere, seashores look pretty much alike the world around, and nice-looking amber waves of grain are not especially distinctive. How you arrange the elements in photographs of these subjects can make all the difference.

There are nine simple rules for composing photos effectively. I'll review each of them in this section. In brief, they are as follows:

- **Simplicity.** This is the art of reducing your picture only to the elements that are needed to illustrate your idea. By avoiding extraneous subject matter, you can eliminate confusion and draw attention to the most important part of your picture.
- **Choosing a center.** Always have one main subject that captures the eye.
- **Orientation.** Your image can be framed in either portrait or landscape orientation.
- **The Rule of Thirds.** Placing interesting objects at a position located about one-third from the top, bottom, or either side of your picture makes your images more interesting than ones that place the center of attention dead center (as most amateurs tend to do).
- **Lines.** Objects in your pictures can be arranged in straight or curving lines that lead the eye to the center of interest, often in appealing ways.
- **Balance.** We enjoy looking at photographs that are evenly balanced with interesting objects on both sides, rather than everything located on one side or another and nothing on the other side.
- **Framing.** In this sense, framing is not the boundaries of your picture but, rather, elements in a photograph that tend to create a frame-within-the-frame to highlight the center of interest.
- **Fusion/separation.** When creating photographs, it's important to ensure that two unrelated objects don't merge in a way you didn't intend, as in the classic example of the tree growing out of the top of someone's head.
- **Color and texture.** The hues, contrasts between light and dark, and textures of an image can become an important part of the composition, too. The eye can be attracted to bright colors, lulled by muted tones, and excited by vivid contrasts.

Simplicity

Let nothing intrude into your photograph that doesn't belong there, and your viewer will automatically focus on the information you intended to convey. In scenics, extraneous subject matter can include busy backgrounds, utility wires, ugly buildings, or even stray people who interfere with the natural setting. Striving for simplicity is one of the reasons for excluding humans from landscape

photographs, even if human-constructed buildings appear in your idyllic canvas. When we spot a person in a photograph, our eye tends to gravitate to the human form, and the vista we wanted to present becomes secondary.

Avoiding humans is one way to simplify your image. Indeed, some photographic competitions explicitly prohibit evidence of "the hand of man" (or, more properly, "the hand of humans") in certain categories of scenic and wildlife photography. That can be a challenge, at times, because human influence in an otherwise natural scene may be subtle to the untrained eye. For example, does Figure 15.2 show a pristine beach on a remote tropical isle—or do the carefully trimmed palms and manicured sand reveal a shoreline that's been prepped for human enjoyment? (It's actually a beach next to a State park in the Florida Keys, and the sand was trucked in, as all the sand on the reef-laden Atlantic coast of the Keys has long ago fled to Bermuda.)

Of course, you can still achieve a simple composition without eradicating all traces of human beings. But, aspects for achieving simplicity may not be simple even when you embrace the presence of the human race. For example, you probably won't have much choice in your background. The clouds, mountains, or ocean off in the distance aren't going to change their colors or move to suit you. However, you can make a background work for you by shooting on a day with a cloudless sky (if a plain-blue background suits your composition) or one with abundant fluffy clouds, if that's what you're looking for.

Crop out unimportant objects by moving closer, stepping back, or using your zoom lens. Remember that a wide-angle look emphasizes the foreground, adds sky area in outdoor pictures, and increases the feeling of depth and space. Moving closer adds a feeling of intimacy while emphasizing the texture and details of your subject. A step back might be a good move for a scenic photo; a step forward might be a good move for a scenic that includes a person.

Figure 15.2 Your scenic vistas might not be as natural as you think, even if they are still charming.

Remember that with a digital camera, careful cropping when you take the picture means less trimming in your photo editor, and less resolution lost to unnecessary enlargement. Finally, when eliminating "unimportant" aspects of a subject, make sure you truly don't need the portion you're cropping. For example, if you're cropping part of a boulder, make sure the part that remains is recognizable as a boulder and not a lumpy glob that viewers will waste time trying to identify. And cutting off the heads of mountains can be just as bad as cutting off a person's head in a portrait!

Front and Center

Next, you should decide on a single center of interest, which, despite the name, needn't be in the center of your photo. Nor does it need to be located up front. No matter where your center of interest is located, a viewer's eye shouldn't have to wander through your picture trying to locate something to focus on. You can have several centers of interest to add richness and encourage exploration of your image, but there should be only one main center that immediately attracts the eye. Think of Da Vinci's Last Supper, and apply the technique used in that masterpiece to your scenic photography. There are four groups of Apostles that each form their own little tableaux, but the main focus is always on the gentleman seated at the center of the table. The same is true of scenic photos. One huge mountain with some subsidiary crests makes a much better starting point than a bunch of similarly sized peaks with no clear "winner."

Figure 15.3 shows two images shot on the Mediterranean coast on the same morning from roughly the same spot. At left are some waves crashing over rocks. There's no real center of interest, and no real reason to look at one particular rock or rivulet of water instead of another. At right, the rocks have become the center of interest and clearly dominate the image, even though an island at upper left and the risen sun at upper right balance the image vertically.

The center of interest should always be the most eye-catching object in the photograph; it may be the largest, the brightest (our eyes are drawn to bright subjects first), or most unusual item within your frame. Shoot a picture of a beautiful waterfall, but with a pink elephant in the picture, and the pachyderm is likely to get all of the attention. Replace the waterfall with some spewing lava, and

Figure 15.3 A photograph without a center of interest is boring (left); the center of interest need not be in the center of the photograph (right).

the elephant may become secondary. Gaudy colors, bright objects, large masses, and unusual or unique subjects all fight for our attention, even if they are located in the background in a presumably secondary position. Your desired center of attention should have one of these eye-catching attributes, or, at least, shouldn't be competing with subject matter that does.

Avoid having more than one center of attention. You can certainly include other interesting things in your photograph, but they should be subordinate to the main subject. A person can be posed in your scenic photograph to provide scale, but if the person is dangling by a tree branch over a precipice, viewers may never notice the Grand Canyon in the background.

In most cases, the center of interest should *not* be placed in the exact center of the photograph. Instead, place it to one side of the center, as shown in the figure. We'll look at subject placement in a little more depth later in this chapter.

Landscape "Portraits"

The orientation you select for your picture affects your composition in many different ways, whether your photo uses a landscape (horizontal) layout or a portrait (vertical) orientation. Beginners often shoot everything with the camera held horizontally. If you shoot a tall building in that mode, you'll end up with a lot of wasted image area at either side. Trees, tall mountains shot from the base, and images with tall creatures (such as giraffes) all look best in vertical mode.

Recognize that many landscapes call for a horizontal orientation, and use that bias as a creative tool by deliberately looking for scenic pictures that fit in the less-used vertical composition. Some photos even lend themselves to a square format (in which case you'll probably shoot a horizontal picture and crop the sides).

Figures 15.4, 15.5, and 15.6 illustrate the kind of subject matter that can be captured in all three modes, each presenting a different view of the same scene, the Cliffs of Moher in County Clare, Ireland. Figure 15.4 emphasizes a panoramic view that shows how far the majestic cliffs project out into the Atlantic Ocean. Cropped vertically, as in Figure 15.5, the 700-foot (plus) height of the cliffs becomes the focus. The square composition of Figure 15.6 provides a more static look that's less interesting than the horizontally and vertically oriented views. When capturing or cropping to a square (which is sometimes necessary because of intrusive or unwanted elements at the sides and top/bottom of the frame, try to include curves and lines that draw the viewer's eye into and around the image. In Figure 15.6, the sea and sky provide a partial frame for the cliffs and help give the image a little more life.

Rule of Thirds

You'll see the idea of dividing your images into thirds referred to as the rule of thirds quite a bit, and this is one case in which I'm not obsessive about avoiding hard-and-fast rules. It really is a good idea to arrange your pictures using this guideline much of the time, and when you depart from it, it's a great idea to know exactly why.

Figure 15.4 Some scenes look best in a horizontal format, especially when they lend themselves to a panoramic perspective.

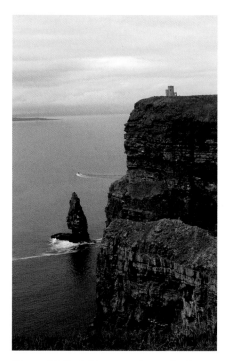

Figure 15.5 Subjects can be vertically oriented if you want to emphasize height.

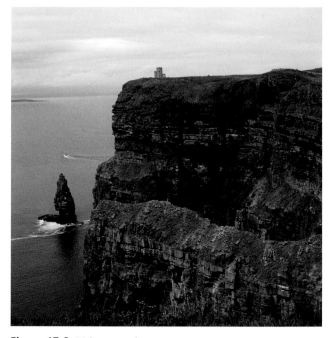

Figure 15.6 Take care when composing square pictures to avoid a static look. Include lines or curves, or other elements that lead the eye through the composition.

Earlier, I mentioned that placing subject matter off-center is usually a good idea. Things that are centered in the frame tend to look fixed and static, while objects located to one side or the other imply movement, because they have somewhere in the frame to go, so to speak.

The rule of thirds works like this: Use your imagination to divide your picture area with two horizontal lines and two vertical lines, each placed one-third of the distance from the borders of the image, as shown in Figure 15.7. (Some cameras provide a rule-of-thirds grid in the viewfinder to help you.) The intersections of these imaginary lines represent four different points where you might want to place your center of interest. The point you choose depends on your subject matter and how you want it portrayed. Secondary objects placed at any of the other three points will also be arranged in a pleasing way.

Horizons, for example, are often best located at the upper third of the picture, unless you want to emphasize the sky by having it occupy the entire upper two-thirds of the image. Tall subjects may look best if they are assigned to the right or left thirds of a vertical composition. Figure 15.7 shows a vista at the edge of the Grand Canyon arranged into thirds. Notice how the horizon is roughly at the one-third mark, while the dominant tree at right is located at the intersection of vertical and horizontal one-third lines. While this image illustrates the application of the rule of thirds, it also shows its fallibility. Unless you're documenting the foliage that grows at the rim of the Grand Canyon, the most exciting view would have been to move a bit closer to show the depth and breadth of the canyon itself, whether or not the composition could have been divided neatly into thirds. Figure 15.8 shows a more interesting view of the Grand Canyon, and doesn't allow the rule of thirds to dictate exactly where the main elements are placed.

One important thing to consider is that if your subject includes an animal, a vehicle, or anything else with a definable "front end," it should be arranged in a horizontal composition so that the front is facing into the picture. If not, your viewer will wonder what your subject is looking at, or where the animal is going, and may not give your intended subject the attention you intended. Add some extra space in front of potentially fast-moving objects so it doesn't appear as if the thing is just about to dash from view.

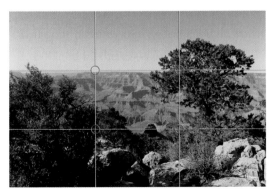

Figure 15.7 The rule of thirds is a good starting place for creating a pleasing composition.

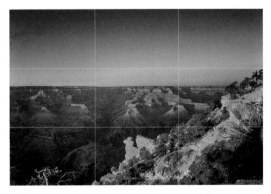

Figure 15.8 But departing from the rule is often a good idea when subjects lend themselves to a different composition.

Oddly enough, it's not important to include this extra space in vertical compositions for anything that doesn't move. A tree can butt right up to the top of an image with no problems. We don't expect the object to be moving, therefore we don't feel the need for a lot of space above it. If your scenic was taken at Cape Kennedy and a booster rocket intrudes, it would be best positioned a bit lower in the frame.

Using Lines

Viewers find an image more enjoyable if there is an easy path for their eyes to follow to the center of interest. Strong vertical lines lead the eye up and down through an image. Robust horizontal lines cast our eyes from side to side. Repetitive lines form interesting patterns. Diagonal lines conduct our gaze along a gentler path, and curved lines are the most pleasing of all. Lines in your photograph can be obvious, such as fences or the horizon, or more subtle, like a skyline or the curve of a flamingo's neck.

As you compose your images, you'll want to look for natural lines in your subject matter and take advantage of them. You can move around, change your viewpoint, or even relocate cooperative subjects somewhat to create the lines that will enhance your photos.

Lines can be arranged into simple geometric shapes to create better compositions. Figure 15.9 shows an image with a variety of lines. The strongest line is the curve of the main path, which leads our gaze through the picture to the Cathedral Rock formation in the background. The path's broad swathe is crossed by the shadows of the trees. The vertical lines of the trees along the path lead our eyes toward the top of the photo. This is the sort of picture that engages the viewer's attention, luring them into spending more than a few seconds exploring everything it contains.

Figure 15.9
The curved lines of the path interact with the horizontal shadows and the vertical lines of the trees.

Balance

Balance is the arrangement of shapes, colors, brightness, and darkness so they complement each other, giving the photograph an even, rather than lopsided, look. Balance can be equal, or symmetrical, with equivalent subject matter on each side of the image, or asymmetrical, with a larger, brighter, or more colorful object on one side balanced by a smaller, less bright, or less colorful object on the other.

Figure 15.10 shows an image at top that on first glance has a balance of sorts. The light tones of the castle image at the far right are more or less offset by the darker foliage on the left side. However, because the castle is clearly intended to be the center of interest for this photo, the more you look at it, the more you get the feeling the picture is a bit lopsided.

By taking a step back, we can include more of the road and wall leading to the castle, and a bit more of the structure on the right side, as shown in the middle version. This cropping does several things.

Figure 15.10

Top: The large light and dark masses on the right and left sides of the picture don't really balance each other as they should. Middle: Cropping less tightly provides a better balanced picture with converging lines that draw our eyes to the castle. Bottom: Removing the tree branches improves the picture even further.

It balances the picture, while moving the center of interest closer to one of the "golden" intersections defined by the rule of thirds. The walls and road provide converging lines that attract our eye to the castle.

Even so, there's still something wrong with this picture. The tree branches at the right side aren't connected to anything. They appear to be growing out of the side of the picture frame. We can crop most of them out and improve the balance of the image even further, as you can see in the bottom version.

Framing

Framing is a technique of using objects in the foreground to create an imaginary picture frame around the subject. A frame concentrates our gaze on the center of interest that it contains, plus adds a three-dimensional feeling. A frame can also be used to give you additional information about the subject, such as its surroundings or environment.

You'll need to use your creativity to look around to find areas that can be used to frame your subject. Windows, doorways, trees, surrounding buildings, and arches are obvious frames. Figure 15.11 shows a classic "environmental" frame, with the tree branches in the foreground framing the upper-half of the photo.

Frames don't even have to be perfect or complete geometric shapes. Figure 15.12 shows how rocks in the foreground form a frame for the vista above. Generally, your frame should be in the foreground, but with a bit of ingenuity you can get away with using a background object, such as a bridge, as a framing device.

Figure 15.11
Trees are a classic prop used to construct frames for scenic photographs.

Figure 15.12
Frames just need to provide a space for the image to reside within, as in this photo in which the foreground rocks frame the vista above.

Fusion/Separation

Our vision is three-dimensional, but photographs are inherently flat, even though we do our best to give them a semblance of depth. So, while that tree didn't seem obtrusive to the eye, in your final picture, it looks like it's growing out of the roof of that barn in your otherwise carefully composed scenic photograph. Or, you cut off the top of part of an object, and now it appears to be attached directly to the top of the picture.

You always need to examine your subject through the viewfinder carefully to make sure you haven't fused two objects that shouldn't be merged, and that you have provided a comfortable amount of separation between them. When you encounter this problem, correct it by changing your viewpoint, moving your subject, or by using selective focus to blur that objectionable background.

Figure 15.13 is a good example of an undesired fusion. The scene from the edge of this lake actually looked interesting in real life, with the fallen tree extending out into the water toward the distant shore. (Take my word on this.) Unfortunately, the slight telephoto lens setting I had to use to capture the image from my vantage point compressed the near and distant subject matter together, making a big mess. You can't really tell how far the fallen tree and the opposite shore are from each other, and the details blend together. A slightly higher view would have been better, clearly putting the foreground tree into the foreground and opening up some clear water between it and the far shore, but that viewpoint wasn't physically possible in this case.

Your best defense for side-stepping fusion problems of this sort is to be aware that it can happen, and to recognize and avoid mergers as you compose your images.

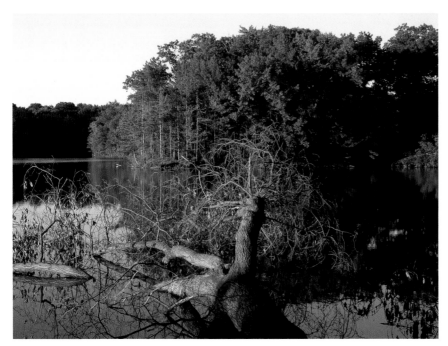

Figure 15.13
Watch your compositions so that individual objects don't merge or fuse together.

Color and Texture

Color, texture, and contrasts are an important part of the composition in Figure 15.14. The warm sunset colors, the deep blue of the Mediterranean Sea, and the rough texture of the rocks in the foregrounds provide sharply contrasting elements that attract the eye and leads it through the picture from the brightest area (which typically attracts the eye first) to the foreground. When shooting in color, the hues in the photo are an important part of the composition. Texture and contrasts in tones can be effective in both color and black-and-white photos.

Figure 15.14
Imaginative use of color and texture can add interest to a landscape photo.

Key Types of Landscapes

This section will provide you with a little advice on how to shoot the most common type of scenic photographs, including mountain scenery, sunsets, sea and water scenes, panoramas, and fireworks. All of them are easy to picture, but there are a few tricks you'll want to pick up to get the best shots.

Mountains

Although I label this category "Mountains," this kind of scenic photography really encompasses any broad expanses of nature unencumbered by large numbers of buildings. The same concepts apply whether you're in Idaho or Iowa.

Your main decision is a choice of lens or zoom setting. A wide-angle setting makes distant objects appear to be farther away, emphasizing the foreground of your photo. A longer telephoto setting brings far-away objects like mountains closer, but compresses everything in the foreground.

Although digital camera sensors aren't especially sensitive to ultraviolet light (thus eliminating the need for a "UV" filter most of the time), a useful tool for photographing distant objects is a skylight or haze filter, which filters out some of the blue light that cloaks mountains and other objects located far from the camera.

Mountain scenes lend themselves to panorama photographs. Panoramas are another cool effect that give you wide-screen views of very broad subjects. There are several ways to shoot panoramas. The simplest way is to simply crop the top and bottom of an ordinary photo so you end up with a panoramic shot like the one extracted from the full-frame picture in Figure 15.15.

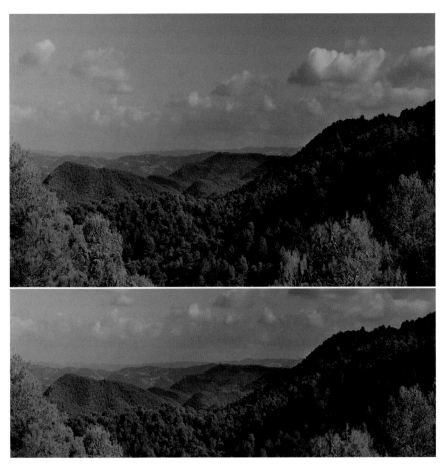

Figure 15.15
Crop a full-frame photo to produce a panorama.

You'll get even better results if you plan ahead and shoot your original image so that no important image information appears in the upper and lower portions. By planning ahead of time, you can crop your image and get a more natural-looking panorama.

Another way to shoot a panorama is to stitch together several individual photos. Your digital camera might have a panorama mode, like the "sweep panorama" feature found in several Sony and Nikon cameras, which takes several images and combines them automatically. However, the most common mode doesn't actually shoot a panorama for you. You take the first picture and the camera shows you the edge of that picture in the LCD viewfinder, so you can use the semi-transparent review version to line up your second or third shot in the panorama series. Then, the individual pictures are stitched together using an image editor. Photoshop and Photoshop Elements have a panorama-stitching feature.

When shooting panoramas, you might find it useful to use a tripod so you can smoothly pan from one shot to the next overlapping picture. Strictly speaking, the pivot point should be under the center of the lens, rather than the usual tripod socket location on the digital camera, but you should

still be able to stitch together your photos even if you don't take the picture series absolutely correctly from a technical standpoint.

Sunsets/Sunrises/Dawn/Dusk

Sunsets and sunrises are popular subjects because they're beautiful, colorful, and their images often look as if a lot of thought went into them, even if you just point the camera and fire away. The dawn hours just before or after sunrise, and the evening hours clustered around sunset are also prime shooting times. Some photographers specialize in these times.

Although photographically early morning and evening pictures are almost identical, I prefer sunsets to sunrises for a couple technical reasons. First, I am not usually awake in time to see a sunrise, although I sometimes catch one when I go to bed late after an all-night session browsing the Internet. Second, at the latitude where I live, for much of the year, it's a lot warmer at sundown than at sunrise, and I don't particularly like cold weather. Finally, it's more difficult to scout out your location for a sunrise shot than it is for a sunset shot. Sunset follows a period of lightness (called "daytime"). You can spend hours looking for just the right spot and use the waning daylight to decide exactly where to stand to capture the sunset as the sun dips below the horizon. Dawn, in sharp contrast, occurs after a really dark period, and you may have difficulty planning your shot in the relatively short interval just before sunrise.

Here are some tips for shooting photos during the "golden hours":

- **Adjust white balance and exposure for sunrise/sunset.** If your camera has an automatic white balance control that can be overridden, see if you have a Sunset/Sunrise white balance setting as well as a Sunset/Sunrise programmed exposure mode. The former will let you avoid having the desired warm tones of the sunset neutralized by the white balance control, and the latter can allow you to get a correct exposure despite the backlighting provided by the sun. With sunset photos, you generally *want* a dark, silhouette effect punctuated by the bright orb of the sun. This is a good time to experiment with manual exposure, too, as I did for Figure 15.16, a sunset scene of Lake Erie from high atop the Terminal Tower in Cleveland, Ohio. It was deliberately underexposed, and the white balance set for daylight to produce an even warmer image tone.

- **Don't stare at the sun, even through the viewfinder.** I usually compose my sunset photos with the sun slightly out of the frame, then recompose just before taking the photo.

- **Avoid splitting your photo in half with the horizon in the middle.** Your picture will be more interesting if the horizon is about one-third up from the bottom (to emphasize the sky) or one-third down from the top (to emphasize the foreground). Remember the rule of thirds.

- **Sunrises or sunsets don't have to be composed horizontally!** Vertically oriented shots, like the one shown in Figure 15.17, can be interesting. In that photo, I broke several "rules" by using vertical orientation for a "landscape" photo, and didn't limit myself to the actual dawn hours. It was captured high up in the Montserrat chain near Barcelona at around eight in the morning,

well past sunrise, but before the sun had a chance to burn away the morning fog. I deliberately underexposed the photo to create an image that evoked sunrise, even though it was several hours later.

- **Shoot silhouettes.** Take advantage of the sun's backlighting to get some good silhouettes, whether the silhouette is a tree or two (as in my example), a church spire, or some other subject matter.

- **Use fill light if you need to.** If you have a person or other object in the near foreground that you *don't* want in silhouette, try a few shots with your camera's flash turned on. The mixed lighting effect can be dramatic.

- **Plan carefully and work fast.** Once the sun starts to set or begins to rise, you might have only a few minutes to shoot your pictures, so be ready, have your camera settings locked in, and take many pictures. If some prove to be duds, you can always erase them.

- **Make sure your lens is focused at infinity.** Sunsets can fool the autofocus mechanisms of some cameras. Use manual focus if you must.

- **Exposures can be longer** than you might have expected when the sun dips behind the trees or below the horizon, so have a tripod handy.

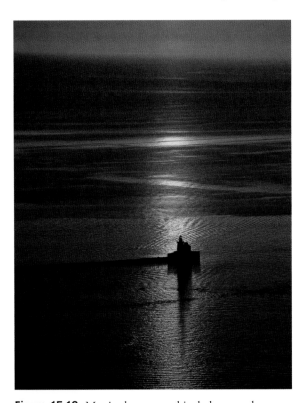

Figure 15.16 Manipulate your white balance and exposure to get the most dramatic effects.

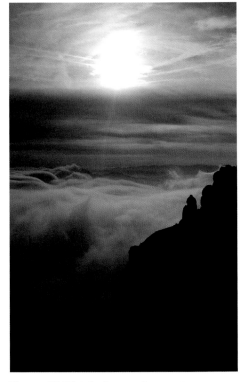

Figure 15.17 The hours after sunrise can provide some dramatic lighting.

Sea and Water Scenes

Whether you're at the ocean, by a lake, alongside a river, beneath a waterfall, or following the tow-path of a canal, water makes for some great scenic photography, not only for the beauty of the water itself, but for the reflections and the excitement when the water is moving. Your images might take a languid approach, like that of the placid Irish sea inlet shown in Figure 15.18, or mix in a bit of kinetic energy from the ocean or a roiling stream or river, like that pictured in the fast-flowing river in Figure 15.19.

Figure 15.18
Water scenes can be
calm and cool…

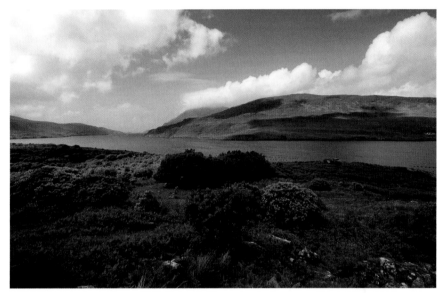

Figure 15.19
…or water scenes
can portray
movement.

Here are a few tips for photographing water:

- **Use a tripod and long exposures to capture waterfalls and streams.** That's the technique I used to capture the silky-smooth river in Figure 15.19. The water will blur, giving you the next best thing to laminar flow in a photograph. The tripod keeps the rest of the image rock solid and sharp. You might have to use a neutral-density filter to achieve a long enough exposure in daylight, so streams and waterfalls in open shade are better than those in full sunlight.

- **Watch your exposures at the ocean.** The bright sand can fool the exposure meter of your camera, giving you underexposed pictures. Review your first few shots on the LCD and dial in some EV corrections if necessary.

- **Incorporate the reflections in the water into your photographs.** Many of the scenic photos in this chapter use water and reflections to good effect. (See Figure 15.11, shown previously.) The light bouncing off the surface of the water has a special look and you'll find the reflections add interest to your image.

Changing Seasons

If you live in an area where the seasons change, you'll have the opportunity to photograph interesting landscapes under a variety of conditions without the need to stray far from home. It's always rewarding to go back and revisit favorite scenes at different times of the year to get a new perspective. Figure 15.20 shows a scene captured at a Western Reserve high school campus in the fall (left), and then again a few months later when winter arrived.

Figure 15.20
The same scene, in fall (left) and winter (right).

Winter is particularly challenging. Photographing in snow is a lot like photographing at the beach: You have to watch out for glare and overexposures. Otherwise, snow scenics can be captured much like other landscape-type photographs. There are a few things to watch out for however. One of them is cold. Batteries of all types put out less juice in cold temperatures, and those in your digital camera are no exception. Keep your camera warm if you want it to perform as you expect.

Also, watch out for condensation on the camera, particularly on the lens, which can occur when you bring your cold camera into a warmer, humid environment, even if only for a few moments. (Perhaps you're ducking in and out of the shelter of a car between shots, as I often do in colder climes.) Then, when you go back out in the cold, you've got a moist camera in your hands. If your camera uses an optical viewfinder instead of an electronic viewfinder or SLR system, you may not notice water drops on your lens until it's too late. Consider using a skylight filter that you can clean off with a soft cloth as necessary. These filters are tougher than the glass of your lens and cheaper to replace if they get scratched.

Figure 15.21 shows a typical snowy scene. It took me a long time to get back into the swing of shooting winter scenes. After living for a few years in Rochester, NY (which has nine months of winter and three months of bad skiing), I moved elsewhere specifically to reduce my opportunities for photographing in snow. Now I've grown to love them again.

Figure 15.21
Be careful to avoid underexposure under the bright conditions found in snow scenes.

Infrared Landscape Photography

If you have a digital camera that can handle it, infrared (IR) landscape photography can be a lot of fun. By photographing an image primarily using the infrared light that bounces off your subject matter, you end up with eerie monochrome photographs featuring white foliage and dark skies, like the image shown in Figure 15.22. Because everyday objects reflect infrared in proportions that differ sharply than that of visible light, the tonal relationships are wildly unexpected.

Scenic photos lend themselves to the IR treatment for a number of reasons. People photographed by infrared light often look pale and ghastly. Landscapes, on the other hand, take on an otherworldly look that's fascinating. You'll need to do some work and buy some add-ons to get started with infrared photography, but this section should get you started in the right direction.

What You Need

To shoot infrared photos, you need several things. One of them is a digital camera that can capture pictures by infrared illumination, as well as a filter that blocks virtually all light except for near infrared (NIR) illumination.

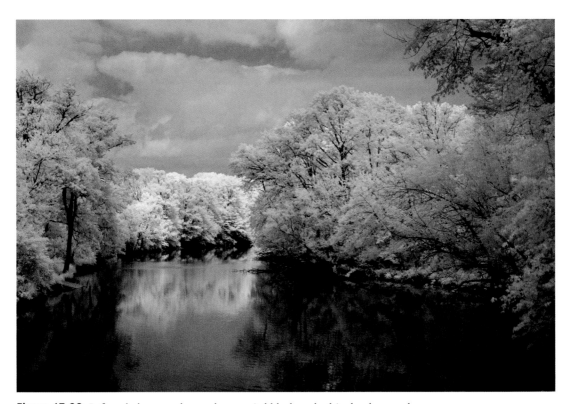

Figure 15.22 Infrared photography produces weird black-and-white landscape photos.

The sensors found in digital cameras generally are very sensitive to infrared light in the range of 700–1200 nanometers, which is a good thing if you want to take infrared pictures, and not so good if you don't want infrared illumination to spoil your non-infrared photographs. Accordingly, many digital cameras now include a filter or "hot mirror" that specifically blocks IR light from the sensor. Some enterprising souls have opened their cameras and removed the filter so they could take IR photographs, replacing it with a piece of glass to preserve the camera's autofocus capabilities.

Some digital cameras have no IR-blocking filter or hot mirror at all (you may have to special order these, or have the camera converted), or have filters that block only part of the IR light, so you might be able to take infrared photos with your camera without needing to dismantle it and remove the IR filter manually. An easy way to check for IR capability is to photograph your television remote control. Point the remote at your camera in a darkened room, depress a button on the remote, and take a picture. If your camera can register IR light, a bright spot will appear on the photograph of the remote at the point where the IR light is emitted.

You'll also need an IR filter to block the visible light from your sensor. Find a Wratten #87 filter to fit your digital camera. You can also use a Wratten 87C, Hoya R72 (#87B), or try #88A and #89B filters. A simpatico camera store may let you try out several filters to see which one works best with your camera. These filters aren't necessarily cheap, easily costing $60 to $100, depending on the diameter. Some can be purchased for less than $30, however.

Taking IR Photos

Once you're equipped, you have to learn to contend with the quirks and limitations of IR photography. These include:

- **Light loss.** The IR filter blocks the visible illumination, leaving you with an unknown amount of infrared light to expose by. Typically, you'll lose 5 to 7 f/stops, and will have to boost your exposure by that much to compensate. A tripod and long exposures, even outdoors, may be in your future.

- **Difficulty metering.** Exposure systems are set up to work with visible illumination. The amount of IR reflected by various subjects differs wildly, so two scenes that look similar visually can call for quite different exposures under IR.

- **Difficulty seeing.** Because the visual light is eliminated, you'll be in a heap of trouble trying to view an infrared scene through a digital SLR. The LCD view may be a little weird, too.

- **Focus problems.** Infrared light doesn't focus at the same point as visible light, so your autofocus system might or might not work properly. You may have to experiment to determine how to best focus your camera for infrared photos. If you're shooting landscapes, setting the lens to the infinity setting probably will work (even though *infrared infinity* is at a different point than visible light infinity).

- **Spotty images.** Some removable lenses include an anti-IR coating that produces central bright spots in IR images. A few Canon lenses fall into this category. Test your lens for this problem before blaming the artifacts on your filter or sensor.

- **Color mode.** Even though your pictures will be, for the most part, black-and-white, or, rather, monochrome (usually magenta tones or a color scheme described as "brick and cyan"), you still need to use your camera's color photography mode.

You'll find lots more information on the Internet about digital infrared photography, including the latest listings of which cameras do or do not work well in this mode. If you ever tire of conventional scenic photography, trying out digital IR can respark your interest and give you a whole new viewpoint.

Wildlife Photography

Photographing animals, especially if you seek to do so in their natural habitats, is one of the most challenging types of photography. In few other picture-taking pursuits is it necessary for you to first painstakingly locate your subjects, sneak up on them, take their photograph under (sometimes) harsh conditions, under the constant threat that your subject may flee, attack you, or otherwise become uncooperative. Child photography is the only other similar category I can think of.

Here are some of the things you'll need to consider if photographing wildlife is one of your favored activities:

- **You'll need a long lens.** The longer the better. If you're photographing actual creatures in the wild (rather than domesticated animals, those in preserves, or in zoos), a 200mm lens or equivalent is the absolute minimum. That's the focal length I used to capture the timid frog in Figure 15.23. Dedicated wildlife photographers are usually seen toting 400mm or longer lenses, and often have a 1.4X or 1.7X teleconverter in their pocket.

- **A fast lens won't hurt.** If you're out tromping through the woods or a field and light levels are low, a 300mm f/2.8 lens will be a lot more useful to you than a 300mm f/4 lens. Fast lenses let you use higher shutter speeds that will help you freeze Bambi's father as he scampers through the underbrush. Those fast shutter speeds (and image stabilization) will help if you choose to hand-hold your optical bazooka.

- **Forget about hand-holding.** The best wildlife photographs are taken with a long lens (see above), securely mounted to a sturdy tripod. The tripod reduces potential camera shake, and lets you line up your distance shot accurately. For Figure 15.24, I used a 500mm f/8 mirror lens (a *catadioptric* lens that uses internal mirrors, like that found in reflector telescopes, to reduce the length of the lens to a more manageable size). The camera and lens were firmly mounted on a tripod. Even with a high shutter speed (say, 1/2000th second) I wouldn't have achieved such a sharp image (despite the compact size and light weight of the mirror lens) without a tripod. **Note:** Mirror lenses are somewhat rare these days, due to the "doughnut" shaped blurs

Figure 15.23 A long lens will help you capture wildlife even if it's relatively close at hand.

Figure 15.24 A long lens mounted on a tripod is your best weapon for capturing distant wildlife.

("bokeh"—see Chapter 6 for more on that) in out-of-focus highlights. I've found, however, if you're shooting a subject, like the heron in the figure, posed against a background with few highlights, the doughnuts are not numerous or objectionable.

- **Use continuous shooting mode.** Think of wildlife photography as a type of action photography. Your subjects may be moving fast, and firing off a quick burst of shots may mean the difference between just missing a shot, and getting a stellar series.

- **Think like a hunter.** Indeed, most of the "safaris" in Africa these days consist of photographers hunting and tracking down vanishing wildlife species. You can do the same when foraging for photographic subjects closer to home. If you have some hunting experience, so much the better, as you'll know how to find your quarry without alarming them, and how to deal with woodland creatures (bears, etc.) that don't like being interrupted.

Stalking Your Prey Made Easy

Of course, you don't need to sign up for a photo safari in Africa, or tromp through the woods for days on end to locate suitable subjects. Here are some tips that will let you ease into wildlife photography painlessly:

- **Stay home.** Even if you live in an urban apartment, you'll probably find wildlife right at your doorstep or windowsill. The young cardinal shown in Figure 15.25 fell in love with his reflection in my kitchen window and would perch on a branch just outside for hours, alternately looking into the house, or flying at the window trying to convince the "other" bird to move. You'll likely find interesting wildlife close to home, too, especially if you live in a suburban or rural environment where creatures share your space.

■ **Visit a zoo.** For those who live in snowy climes, the local zoo is a secret destination that only photographers can fully appreciate. Every zoo has an indoor display where animals can be photographed in warmth and comfort. I'm a member of a zoo that's a wonderful refuge in winter, as the reptile house, an indoor aquarium (including a display of backlit jellyfish), and a heavenly tropical rainforest exhibit await me on icy cold days.

The chief problem I have with zoos is that the photographs tend to look like they were taken in a zoo, not out in the wild, bringing to mind the "like shooting fish in a barrel" simile. Proper wildlife photography should be *hard* and involve stalking and at least a modicum of inconvenience and/or pain. In zoos, the backgrounds and "environment" tend to look a bit phony, as you can see in the shot of the meerkat in Figure 15.26. Moreover, for most of us, shots of exotic animals are *always* captured in zoos, unless we're fortunate enough to go on a safari. So, as nice as your photograph of that giraffe is, the first thing a viewer is going to do when looking at it is wonder in what zoo it was taken.

Figure 15.25 Wildlife can be photographed right from your home.

Figure 15.26 Zoos can be a great location to photograph "wild" life.

Figure 15.27 This fellow resided at a bird rescue facility.

- **Visit a preserve or sanctuary.** The owl shown in Figure 15.27 has an injured wing, and had taken up temporary residence at a bird rescue facility near me. Although he was truly wild, he'd gotten used to human presence enough to pose for pictures without much of a fuss—as long as I remained 15 to 20 feet away and photographed him through a long lens. The telephoto lens and relatively wide aperture I used blurred the background to isolate the owl in the frame.

- **Go where the wildlife is.** If you know where to look, and are patient, the wildlife may come to you. There's a park near me, only a few miles from one of the largest urban areas in my state, with a nature preserve that includes a raging river, waterfalls, and teems with wildlife. A few hundred yards from a freeway, I can set down my camera bag, set up my tripod, and wait for truly wild creatures to show up.

Scouting Prime Locations

If shooting in the wild is your goal, scouting great locations, local or farther afield, should be your strategy. Perhaps you live near a National or State Park, a preserve, a rookery, or other area that abounds with wildlife. If you know a field or meadow where butterflies hang out, you can easily snag pictures of *lepidoptera* like the one in Figure 15.28.

Although I travel around the world looking for interesting subjects, once a year I schedule a trip to Florida, which seems to have attracted more than its fair share of interesting wildlife. One stop is always Merritt Island on the Atlantic Space Coast, where, as you can see in Figure 15.29, there are more birds than you can shake a stick at (and stick-shaking is probably illegal, anyway). The nearby Viera Wetlands are also worth a visit, especially during nesting/hatching season.

Figure 15.28
Take along a short tele or macro lens to shoot butterflies.

Last winter, I spent four weeks shooting in the Florida Keys, where I encountered the endangered Key deer on Big Pine Key, as pictured in Figure 15.30. And, like everywhere in Florida, there were lizards, iguanas, alligators, and other wildlife that are a bit exotic for us Northerners. (See Figure 15.31.)

Figure 15.29
Birds of a feather flock together with birds of yet another feather.

Figure 15.31 You won't have to hunt reptiles; they'll often find you when you least expect them.

Figure 15.30 Key deer can be timid, but may be easily photographed by non-aggressive photographers.

16

Capturing Action

The essence of all still photography is to capture a moment in time. That's never more true than when you're photographing action, whether it's your kids' Little League or soccer teams, a volleyball game at your company picnic, a bowling tournament, or a quick snap of a fast-moving ride at an amusement park. Whether the action is frozen or blurred (perhaps intentionally), it's apparent that the photograph has sliced off a little piece of motion.

Other types of photography also isolate a moment, although it may not appear to be so at first glance. Architectural photos freeze a moment, but a structure can sit stolidly for decades or centuries and change very little. Photographs taken from a certain hilltop location outside Toledo, Spain look very much like the vista captured in El Greco's 16th century masterpiece *View of Toledo*.

Still-life photos and portraits also capture a moment in time. That bowl of fruit you photographed may become a snack an hour later or over-ripe if left for a week. You'll recognize nostalgically that a particular instant is represented in a portrait of your child years later when the child has grown to adulthood. Even so, there's something special about action photography. I think it's because a good action picture provides us with a view of an instant that we can't get in ordinary life. A snap of a hummingbird frozen in mid-air lets us study the fast-moving creature in a way that isn't possible in nature. A picture of a home run ball the moment it is struck by the bat offers a perspective of a home run that even the umpire never gets to see.

This chapter will concentrate on techniques for capturing action with a digital SLR. I'll explain some of the key tricks of the trade here, concentrating on the special capabilities of digital SLR photography in this chapter, and will cast my net far outside the sports arena when fishing for action-shooting opportunities.

Sports in a Nutshell

Before we take a closer look at specific action-shooting techniques, we might as well get some of the special aspects of sports photography out of the way. That's because several of the keys to getting good sports photos have nothing to do with photography *per se*. In some ways, it's just as important to know where to stand during a sports event as it is to understand the finer points of using your camera. Indeed, it probably won't surprise you that knowing how to position yourself and learning where to point the camera, and deciding the exact moment to press the shutter can be as important to your success as understanding the right ways to expose and compose your picture.

If you stop to think about it, sports action is a continuous series of moments, each a little different from the last, all leading up to *the* decisive moment, when the bat strikes the ball, the power forward releases the basketball at the apex of a jump, or when the puck slides past the goalie into the net. A decisive moment can follow the peak action, too, as when a pitcher slumps in defeat after giving up a walk-off home run. The best sports photography lies in capturing the right moment and the right subject, under the right circumstances. You don't want a technically perfect shot of a third-string receiver catching a football at the tail end of a 57-0 blowout. You want to capture the hero of the game at the turning point of the contest.

To see how far we've come, check out my first published photo as a professional photographer in Figure 16.1. It's one of those classic "basketball instead of a head" shots, taken with flash back in the dark ages prior to digital photography when action shots with inky-black backgrounds were acceptable. This particular picture was published partially because of the basketball/head juxtaposition, and partially because it showed a local college basketball hero blocking a shot (or committing a foul, depending on your bias). Lacking one of those two elements, it probably wouldn't have been printed at all, because it didn't illustrate a truly decisive moment in the game, and it suffered from more than one technical problem.

Stark flash photos are no longer acceptable, nor do you see much in the way of black-and-white action photography. Today, you're more likely to see a photo like Figure 16.2. Digital cameras have sensors that are fast enough to capture action indoors or out, in full color, and in sequences that show the unfolding story of a play or an individual's efforts.

The Importance of Position

Where you position yourself at a sports event can have a direct bearing on your photo opportunities. If you're up in the stands, your view of the game or match is likely to be limited and fixed. You'll have better luck if you are able to move down close to the action, and, preferably, given the option of moving from one position to another to take a variety of shots.

After you've taken a few sports photographs, you'll find that some places are better than others for both opportunities and variety. In or near the pits at an auto race provides a great view of the track as well as close-ups of the incredible pressure as crews service vehicles. At football games, you'll get

Figure 16.1 An unusual viewpoint and star power got this otherwise mundane photo published.

Figure 16.2 Today, full-color action photos are easily taken indoors, without flash.

one kind of picture at the sidelines, and another from the end zone. Soccer matches seem to revolve around the action at the net. Golf is at its most exciting on the greens (although you'll encounter limitations on your photography at pro matches). Each sport has its own "hot" spots.

You probably won't gain access to these locations at professional or major college-level contests. However, unless you're a pro sports photographer, you'll find that shooting lower-level events can be just as exciting and rewarding. If you want to get a good spot at a high school or college match, start out with some of the less-mainstream or more offbeat sports. You're more likely to be given field access at a Division I-A lacrosse match than at a Division I-A (now called Football Bowl Subdivision) football game. However, at Division II and III levels you might still be able to get the opportunities you need if you call ahead and talk to the sports information director. I shoot a half-dozen basketball games each year at the college pictured in Figure 16.2; I just show up and shoot—the school doesn't even sell tickets to its home games. One Division III school near me has been NCAA champions in football 11 times since 1993, and had a 110-game regular-season winning streak when I wrote the first edition of this book. Yet, the folks at this mini-powerhouse can be quite accommodating to visiting photographers. Ask, and ye shall photograph a receiver!

Key Sports: Play by Play

Every sport is a little different when it comes to coverage. With some, like football, the action is sporadic, punctuated by huddles and time-outs, but lightning-fast when underway. Others, such as soccer, may have things going on all the time. Golf sometimes seems like it consists mostly of walking, interrupted by a few moments of intense concentration. You'll do best with sports that you understand well, so take the time to learn the games. Simply knowing that if a football team is down by 14 points with six minutes left in the game and it's third down with 20 yards to go, you probably aren't going to see a running play, can be an advantage.

Here are some quick guidelines for shooting some of the most popular sports:

- **Football.** Get down on the sidelines and take your pictures 10 to 20 yards from the line of scrimmage. It doesn't really matter if you're in front of the line of scrimmage or behind it. You can get great pictures of a quarterback dropping back for a pass, handing off, or taking a tumble into the turf when he's sacked. Downfield, you can grab some shots of a fingertip reception, or a running back breaking loose for a long run, or crushing forward for a gain of a yard or two (see Figure 16.3). Move to one side of the end zones or a high vantage point to catch the quarterback sneaking over from the one-yard line, or the tension on the kicker's face when lining up for a field goal.

- **Soccer.** You can follow the action up and down the sidelines, or position yourself behind the goal to concentrate on the defender's fullbacks and goalie and the attacking team's wings and strikers. I don't recommend running up and down the field to chase the action as possession changes. Soccer games usually last long enough that you can patrol one end of the field during the first half, then remain there when the teams switch goals in the second half to cover the other team. However, if a game is one-sided, you'll discover that most of the action takes place around the goal that the overmatched team will be constantly defending. Figure 16.4 shows some soccer action.

- **Baseball.** Everyone wants a seat behind home plate, but that's not where you'll want to shoot your pictures. Although the grimaces on the pitcher's face are interesting, the backstop netting will tend to diffuse your photos somewhat. I take a lot of photos at professional baseball and softball games, and, lacking press privileges, I try to buy seats in the front row next to the visitor or home team's dugouts. Those vantage points let you photograph the batters at work, get good shots of the pitchers, plus the action at the bases. There tends to be more going on at the first base side, and that's a good choice if you want to photograph a right-handed pitcher after the ball is delivered. (You'll see the pitcher's back during the wind-up.) Reverse sides for a left-handed pitcher.

- **Basketball.** One of the advantages of basketball is that the sport is more compact. The majority of the action will happen around the backboards. High angles (from up in the stands) are generally not very good, and low angles (perhaps seated in the first row) are less than flattering for an array of very tall people. Shots from almost directly under or above the rim can be an

Figure 16.3 Football, soccer, and other field sports lend themselves to shots taken from the sidelines.

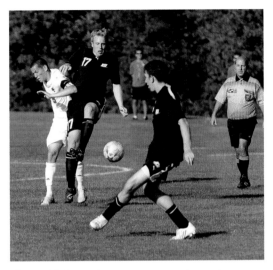

Figure 16.4 To shoot great soccer photos, keep your eye on the ball.

exception to these rules, however. If you can shoot from eye-level close to the basket, you'll get the best shots.

- **Golf.** Golf is one of the most intimate of sports, because it's entirely possible to position yourself only a few feet from world-famous athletes as they work amidst a crowded gallery of spectators. Distracting a golfer before a shot will get you booted from the course quickly, and digital SLRs, unlike their point-and-shoot brethren, don't have fake shutter click noises that can be switched off. That clunk you hear when the mirror flips up and the shutter trips is the real thing! You might want to move back, use a telephoto lens, remain as quiet as a mouse, and remember to time your photography to minimize intrusion. Remember, this is one sport where even the commentators on television whisper during a putt.

- **Hockey.** This form of warfare-cum-athletic event can look good from a high vantage point, because that perspective makes it easier to shoot over the glass, and the action contrasts well with the ice. However, if you can sit in the front row, you'll find a lot of action taking place only a few feet from your seat. You might want to focus manually if your dSLR's autofocus tends to fixate on the protective glass rather than the players.

- **Skating.** Skating events also take place in ice arenas, but eye-level or low-angles and close-ups look best. Catch the skaters during a dramatic leap, or just after.

- **Wrestling/Martial Arts.** Unless you have a ringside seat and are prepared to dodge flying chairs (in the pro version), wrestling is often best photographed from a high, hockey-like perspective. Amateur wrestling and martial arts are best when shot right at the edge of the mat. (See Figure 16.5.)

- **Gymnastics.** Look for shots of the athlete approaching a jump or particularly difficult maneuver, or perhaps attempting a challenging move on the parallel bars or rings.

- **Swimming.** Some great shots are possible at swimming events, particularly if you are able to use a fast enough shutter speed to freeze the spray as the swimmer churns through the water. You'll get good pictures from the side if you can get down very low and close to water level. At the end of the pool, turns are fairly boring, but you can get some exciting head-on shots at the finish.

- **Track and Field.** There are so many different events that it's hard to classify track and field as a single sport. If you can get under the bar at a pole vault, or position yourself far enough behind the sand pit to shoot a long jumper without being distracting, you can come up with some incredible shots. Or, move next to the starting blocks of a dash or relay.

- **Motor sports.** Racing action will challenge your action-stopping capabilities. If you shoot these events as a car or motorcycle is headed down the straightaway toward you, a slower shutter speed can do the job. On one hand, the action can be a bit repetitive. But that can be an advantage because you have lap after lap to practice and fine-tune your technique to get the exact photo you want. Motocross and motorcycle stunt jumping can provide some especially exciting moments.

- **Rodeo.** More sports action and powerful animals, although the snorting bulls and broncs and their snorting riders are typically more rugged than beautiful (See Figure 16.6.). I favor rodeos where for a small additional fee (actually double the base admission price), you can grab a table set up next to the fence and get an eye-level view of the action only a short telephoto lens away.

Figure 16.5 Wrestling and martial arts are best captured from the edge of the mat.

Figure 16.6 Rodeos are non-stop action.

In the background, cowboys waiting to ride, and the "bullfighters" and clowns who help fallen riders add to the interest.

- **Horseracing.** Sports action and beautiful animals all in one sport! What could be better? As in motor sports, you might get the best pictures shooting head-on or as the steeds make a turn. Finish line photos are likely to look like those automated finish line photos used for instant replays, but if you get the opportunity, try a low angle for an interesting perspective.

- **Skiing.** It's unlikely you'll be out all over the slopes taking photos during the race, but if you can find an interesting turn or good angle at the finish line, go for it. Remember to keep your camera and batteries warm between shots and watch out for condensation on the lens when you and your camera pass from icy cold to warm conditions.

Continuous Shooting Basics

In the past, sports photographers used motor drives on their film cameras, which let them shoot an entire 36-exposure roll of film in about 12 seconds at a 3 fps clip. Today, the digital equivalent of the motor drive is called continuous shooting or burst mode, and dSLR technology makes this technique much more practical. Instead of being limited to 36 shots (or 250 shots if you used a special motor drive with bulky 33-foot film cassettes), you can take hundreds of photos without "reloading," depending on compression, file size, and image format. Best of all, digital bursts don't waste film. If your sequence shots turn out to be duds, you can erase them and take more pictures using the same media. Nor do you need a special accessory for your digital "motor drive." All digital SLRs and most digital point-and-shoots have the capability built in.

One important thing to keep in mind is that continuous shooting is not a cure-all for poor timing. The typical digital SLR can fire off 3 to 10 frames per second for as long as the camera's buffer holds out. A few cameras write to their filmcards so quickly that in some modes the buffer never really fills, so you can shoot continuously until your card fills. Even so, you still might not capture the decisive moment in your sequence. The action peak can still happen *between* frames, or, if your dSLR is limited to bursts of a few seconds in length, after your buffer fills and the camera stops firing sequence shots. A brawny burst mode is no replacement for good timing and a bit of luck. Clicking off a picture at exactly the right moment will almost always yield better results than blindly capturing a series of frames at random. Figures 16.7 and 16.8 show a pair of pictures, one taken a fraction of a second too late, and the other at just the right moment. If you're shooting at 5 frames per second, a 90 mph fastball will travel 26 *feet* between frames.

Use your camera's sequence mode as a supplement to your customary techniques to grab a few pictures you might not have gotten otherwise, or to create sequences that are interesting in themselves, like the one shown in Figure 16.9.

Figure 16.7
The shutter fired only 3/100ths of a second too late to capture the ball as it passed the batter.

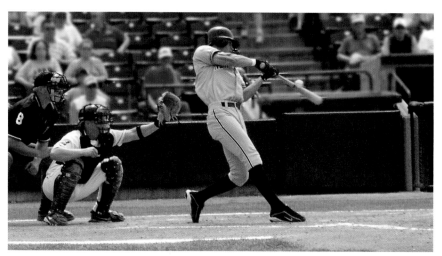

Figure 16.8
Perfect timing (actually luck) accounts for this shot of a ball striking the bat.

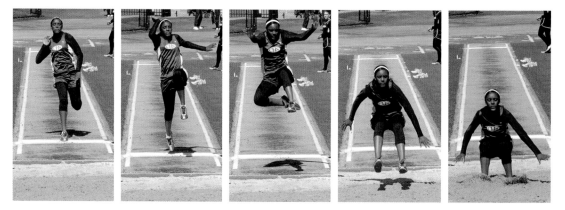

Figure 16.9 Continuous shooting can let you capture a sequence of shots in a single second.

Selecting Your Shooting Mode

Your dSLR may have just a continuous shooting mode, and your choices may range from turning it on to turning it off, and nothing more. Other digital cameras, particularly SLR-like cameras using an electronic viewfinder, may have several frames-per-second speeds from which to choose. These are often grouped under the category "drive" mode, in honor of the original motor drives found in film cameras. Here is a list of the most common sequence shooting modes for dSLRs:

■ **Single-frame advance.** This is the default mode of your camera. One picture is taken each time the shutter release is pressed. Because of the capacious and speedy buffers found in dSLRs, you can probably take single frames as quickly as you can keep pressing the button. Only the most fleet of finger, using low-end cameras with deficient buffers, will be able to outrun the camera's recording capabilities in single-frame advance mode. You'll know when the buffer is nearly full by an indicator in your viewfinder. Some cameras have an LED that blinks when you must wait; others have a bar indicator that grows or shrinks. I prefer systems that provide a constant update of the available room left in the buffer through a numeric indicator. This will count down from, say, 4, through 3, 2, and 1 until the buffer fills, then count up again as additional room is made available for more shots.

■ **Continuous advance.** This is the default burst mode, and may be the only one your dSLR has. The camera continues to take photographs, one after another, for as long as you hold down the shutter button, or until the buffer fills. Most dSLRs have frame rates of at least 2–3 frames per second to 4 fps or more, up through 8–12 fps with the pro gear favored by sports photographers who make their living snapping off sequences. The number of frames you take is usually limited by the size of your camera's buffer and the size of the files you're grabbing. That is, you'll usually be able to take more JPEG shots in a row than RAW photos or RAW+JPEG shots. However, some dSLRs are so speedy that the file format makes little difference. If you're lucky, you'll be able to squeeze off 10–40 or more shots in one burst. If you're not so lucky, your camera may choke after 6 to 9 exposures. Keep in mind that you have to review all those images. (Tip: I always review all my images right away, and immediately move the best shots to a new folder, so I never again have to look at those leading up to, and after, the critical moment.)

■ **High-speed continuous advance.** Some cameras have both a low-speed and high-speed continuous advance option. In that case, you may be able to set the frame speed for the low=speed mode separately (usually your choice of 1 to 5 frames per second), while the high-speed mode is flat-out, pedal-to-the-metal 8 or 10 fps.

■ **Time lapse/interval.** Although this is a sequence mode, it operates over a period that can extend for many, many seconds, and it is best used for taking pictures of slow-moving events, such as the opening of a flower. Some cameras have time lapse/interval mode built in. Others require the use of a USB cable tethered to your computer to allow software to trigger the camera's individual exposures. A growing number of cameras can be operated over short distances using Wi-Fi connections and a smartphone app.

■ **Bracketing.** Bracketing is a "drive" mode when the camera takes several pictures in sequence, using different settings for each picture. This improves your chances of getting one shot that has a better combination of settings. The most common bracketing procedure is to take several pictures at different exposures, with some underexposed and some overexposed (based on the meter reading). Many digital cameras can bracket other features, such as color correction, color saturation, contrast, white balance, or special filters. Bracketing can work two ways, in both semi-automatic and full-automatic mode, to use a rifle metaphor. In semi-automatic, with the camera set for single shot mode, the camera takes one photo in a bracketed sequence (up to the number of shots you've specified) each time you press the shutter release down all the way. In full auto (which requires changing to continuous shooting mode), the camera snaps off a string of bracketed photos (up to the number of shots you specified for the sequence) as long as the shutter release is pressed.

Sequence shooting is one application where having a faster memory card can pay off. The more quickly your camera can offload its buffer to the memory card, the more pictures you can capture in one burst. As I mentioned earlier, the file format and amount of compression chosen can affect the burst length with some (but not all) dSLRs. You'll usually find a chart in your camera's manual showing the number of shots you can expect to get in a particular sequence mode, and your camera will usually display the number of shots remaining in the buffer as you shoot.

Another thing to keep in mind is that you generally won't be able to use your camera's electronic flash when shooting more than one frame per second, unless you happen to own a special flash unit designed for rapid-fire shooting. Even so, you'll probably be limited to close-up photos, because fast-recycle flash units operate by using only a fraction of the available power for each shot. At such a reduced power setting, the flash is able to fire over and over relatively quickly, but it doesn't provide as much illumination and can't reach out as far as the same flash in full power mode. Frequent flashes can overheat a flash unit, too. You'll do better if you plan on shooting your sequences without flash.

Choosing Your Lenses

With money matters, it may be all about the Benjamins, but with dSLRs, the topic always seems to focus on lenses. Of course, the ability to *choose* which lens you use is one of the undeniable advantages of the dSLR in the first place. That's why you'll find so much coverage of lenses in this book.

Now we're taking a closer look at action photography, and it's time to talk about lenses once again. Indeed, lenses are one of the *key* aspects of action photography. When you're taking portraits, you'll probably use (or wish you could use) a prime lens of a focal length considered ideal for portraits, but then settle for a zoom lens of the appropriate range. For close-up pictures, you'll want a special micro/macro lens if you can afford one, or will make do with what you have. There really aren't that many choices. There are a few lenses and focal lengths that are best for portraits, macro photography, and other applications, but selecting the one you use won't take weeks out of your life.

Not so with action photography. The online forums I frequent are rife with never-ending discussions on the best lenses for action photos, with criteria ranging from focal length, maximum aperture, bokeh, or presence/lack of vibration reduction placed under the magnifying glass. This section explains some of the factors to consider.

Zoom or Prime Lens?

Until the 1990s, zoom lenses simply didn't offer sufficient quality for everyday use for the serious photographer. The only real exception was for sports photography, because a zoom lens can be the most efficient way to follow fast-moving action. Reduced image quality came with the territory, and non-zoom, prime lenses were still the preferred optic. Early zoom lenses were extremely slow in terms of maximum aperture, often didn't focus very close, and frequently changed both focus and f/stop as you zoomed in and out.

Things have changed! Today's zoom lenses can provide excellent quality. Some of them are sharp enough and focus close enough that they can be used for macro photography. Modern autofocus and autoexposure systems make focus and aperture shifts largely irrelevant. However, one thing hasn't changed: zooms that normal people can afford to buy are still relatively slow. Affordable zooms typically have f/4.5 maximum apertures at the widest setting, and f/5.6 or worse in the telephoto position. That can be a drawback for available-light action photography at night, indoors, or outdoors on very cloudy days, unless you choose to use a higher ISO setting and risk visual noise in your image.

If you're shooting outdoors in full daylight most of the time, a zoom may be your ideal lens. A 28mm-200mm lens on a camera with a 1.5X crop factor gives you the equivalent of a 42mm to 300mm zoom lens, which from the sidelines of a football game will take you from the bench to the opposite side of the field. A 70mm-300mm zoom sacrifices a little of the wide-angle view in favor of a really long telescopic perspective. Zooms can be great. Unfortunately, *fast* zooms can be expensive. The 70-200mm f/2.8 zoom I prefer for outdoor sports costs more than $2,000, and the 28-70mm f/2.8 zoom I use for indoor sports is only a few hundred dollars cheaper. To afford such lenses you either need to be a professional, a well-heeled amateur with lots of money to spend on a hobby, or (like me), lucky enough to find mint-condition used lenses at a distress sale at a considerable discount.

Prime lenses can be a slightly less expensive option if you want the absolute sharpest image, or will be shooting under very demanding lighting conditions. I have an 85mm f/1.4 lens that, through the magic of the digital crop, gives me the equivalent of a 128mm f/1.4 telephoto that's perfect for low-light action photography. My 105mm f/2 lens has only a little less reach than a very expensive 180mm f/2 optic. Because of my lens's speed, I'm able to get shots like the one shown in Figure 16.10, taken using a wide aperture to throw the background out of focus.

Remember that a fast telephoto lens lets you use higher shutter speeds to stop action or reduce the effects of camera shake, without needing to resort to boosted ISO, which can increase the amount of noise in your picture. Also keep in mind that truly fast telephotos cost an arm and a leg. One

Figure 16.10
A fast prime lens lets you get in close; use a higher shutter speed, and get images like this one.

WHAT'S THE BEST F/STOP?

To get the sharpest images, you'll almost always want to stop down one or two f/stops from the widest available aperture your lens provides. That is, an f/2.8 lens often produces its best results at f/5.6. Unfortunately, with action photography, a high shutter speed is often desirable, so you'll find yourself shooting wide open more than you'd like.

In that case, the maximum aperture of your lens can be important when shooting action in low-light situations. A "slow" lens can limit the maximum shutter speed you can use, thus affecting your ability to freeze action. For example, if your lens opens no wider than f/8 (a common limitation for longer lenses and zoom settings), the best you can do with your camera set to ISO 100 in full daylight is 1/500 at f/8. Your camera may have a 1/1,000 or briefer setting, but you can't use it without increasing the ISO setting to 200 or higher, thus increasing your chances of detail-robbing noise in your photos. If daylight is waning or you're shooting indoors, an f/8 lens may limit you to sluggish 1/250th or 1/125th second speeds.

So, a larger maximum aperture is better, assuming that the lens performs well wide open; an optic that is a bit fuzzy at its maximum aperture is no bargain. Keep in mind that the maximum opening of some zoom lenses varies, depending on the focal length setting. That is, a lens that rates an f/4.5 aperture at the 28mm setting may provide only the equivalent of f/6.3 or slower when zoomed all the way to the telephoto position.

vendor's 300mm f/2.8 prime lenses cost almost $6,000; 500mm or 600mm f/4 top $10,000; and the same manufacturer's 400mm f/2.8 can set you back close to $10,000. So, your quest for a fast, super-long telephoto lens may be brought quickly to Earth by incredible price tags.

Prime lenses may offer better quality and faster maximum aperture, but can get pricey, unless you opt for manual focus models. Zooms are usually economical in the 70mm to 300mm range, even if they're a bit slow. (However, there's a very nice 200mm-400mm f/4 zoom available for a mere $6,000.)

Focal Lengths Needed

For most action photos, the longest zoom setting is more important than the shortest. Few sports other than basketball near the baseline require a really wide-angle lens. Most of the time you can't get as close to the action as you'd like. Many benefit from the equivalent of a 135mm to 150mm telephoto optic, particularly if you're unable to patrol the sidelines and must shoot from the stands. Sports like basketball and volleyball do call for shorter focal lengths and wider angles, because you may be literally on top of the action.

For indoor sports, your best focal lengths might range from 35mm to 105mm. Outdoors, you'll probably need 70mm to 200mm or 300mm, unless you're forced to shoot from up in the stands. Non-sports action photography may still limit where you can stand to make your shot, as you can see in Figures 16.11 and 16.12. Don't forget that as your lens gets longer, you'll need to use higher shutter speeds or a tripod to reduce or eliminate blur from camera/lens shake (or use a vibration reduction lens to compensate).

Those using some digital SLR cameras can benefit from using lenses designed for 35mm cameras with a sensor that's smaller than the 24mm × 36mm full frame. As you've learned, when mounted on a non-full-frame dSLR, the focal length of a lens is multiplied, so a 200mm tele actually

Figure 16.11 At the short tele position, your zoom can take in the big picture.

Figure 16.12 Zoom in and you're right in the middle of the action.

produces the same field of view as a 320mm long lens (when used with one particular digital camera with a 1.6X crop factor).

Many dSLRs can be fitted with attachments called teleconverters that provide additional magnification. The extra focal length comes at a cost: The effective aperture is reduced by the add-on optics, robbing you of an f/stop or more. For example, one popular 1.4X teleconverter eats up one full f/stop's worth of exposure; the same vendor's 1.7X teleconverter demands an extra stop and a half of exposure, while the 2X version needs two extra stops. The good news is that if you're willing to settle for the lower magnification versions, the 1.4X teleconverters don't reduce the resolution of the final image by very much. A popular combination among Nikon photographers is Nikon's 70-200mm f/2.8 VR zoom with a 1.4X converter, which becomes a 98-280mm f/4 zoom with a little more reach on a full-frame camera. (Or, roughly 150mm–420mm equivalent on a crop-sensor model.)

Action Exposure Concerns

You'll find a more complete discussion of exposure modes and features in Chapter 4. However, for action photography, you'll want to choose the right exposure mode for the job at hand. Here's a quick recap of the kind of options you may have, and how they relate to action pictures:

- **Fully automatic.** Serious photographers don't use fully automatic mode very much, particularly for action photography. It's usually not wise to let the camera's logic choose both shutter speed and aperture using its built-in rules, simply because the camera has no way of knowing what it's being pointed at. For example, the camera may elect to shoot at f/8 using whatever shutter speed provides the correct exposure until the exposure becomes long enough to encourage hand-held blurring (at, say 1/30th second). Then it will switch to a wider f/stop, as necessary. This is not the best mode for action photography.

- **Programmed automatic.** Digital SLRs have more sophisticated programming that takes into account the shooting environment when deciding exposure settings. For example, if photographs are being taken in dim light, the camera assumes that you're indoors; in bright light, it assumes that you're outdoors. Lens openings and shutter speeds are selected based on typical shooting situations in these environments. In Program mode, unlike full Auto, you may be able to bump the shutter speed up or down from the recommended setting, and the camera will change the aperture to compensate. This is something like a dumber version of Shutter-priority, discussed shortly.

- **Programmed scene modes.** Your digital camera has selective programs you can choose for automatic exposure under specific conditions. The one you want to opt for is the action/sports setting. In such cases, the camera will try to use the shortest shutter speed possible. It might even automatically boost the ISO rating (if you've set ISO to Auto) or use other tricks to optimize your exposure for fast-moving subjects. If you must use fully automatic exposure, this may be your best choice. At least the camera can be "told" that it's shooting action pictures and be trusted to compensate a bit.

- **Aperture-priority.** In this mode, called either A or *Av* mode, you set the lens opening, and the camera automatically chooses a shutter speed to suit. Use this if you want to select a specific f/stop, say to increase/decrease depth-of-field. Because Aperture-priority offers little control over shutter speed, you probably won't use it frequently for sports photos.

- **Shutter-priority.** In this mode, called either S or *Tv* mode, you choose a preferred shutter speed, and the camera selects the lens opening. That lets you select 1/500th or 1/1,000th second or shorter to stop action, yet retain the advantages of automatic exposure. This is the mode to use if you're taking photos under rapidly changing light conditions. I use it for outdoor sports on partly cloudy days in which a playing field may alternate between bright sunlight and overcast within the space of a few minutes, depending on how the clouds move. It's also a good choice for photos taken as the sun is setting, because the camera automatically compensates for the decreasing illumination as the sun dips below the horizon.

- **Manual exposure.** I end up using manual exposure for some of my action photographs. Indoors, the illumination doesn't change much. Most sports arenas, gymnasiums, and other sites have strong overhead illumination that allows taking pictures at 1/250th second at f/2.8 using ISO 400 or 800 settings. I might also use flash indoors. Outside, I carefully watch the lighting and change exposure to suit.

Attaining Focus

With action photography, the speed and accuracy of automatic focus can be crucial. Manual focus is frequently impractical when you're trying to capture subjects that may be racing toward you, away from you, or across your field of vision. The autofocus of most dSLRs operates quickly enough for action photography that the operation doesn't introduce massive shutter lag delays into the picture-taking equation.

Here are some tricks you can use to optimize your results:

- **Select your mode.** Choose your autofocus mode carefully to suit the kind of action you're capturing. Your dSLR probably gives you a choice between multi-point, spot, or user-selectable focus. If your subject will usually be in the center of the frame, spot focus may be your best bet. If your fingers are fast and your brain is faster, and you can train yourself to choose a focus point as you shoot, you can sometimes select the autofocus area as you compose the picture, as in Figure 16.13. Some cameras offer the option to lock in on the object closest to the camera, which can work well for action (assuming the closest subject is the one you want to capture, and not, say, a referee).

- **Disable macro.** Your dSLR lens might have a lock feature that disables macro focus distances. That keeps the lens from seeking focus all the way from infinity down to a few inches away. When you're shooting action, it's unlikely that your subject will be closer than a few feet, so go ahead and lock out the macro range to speed up autofocus.

- **Override focus.** Some lenses/cameras have an autofocus/manual override setting, which uses the autofocus mechanism first, but allows you to manually refocus if you need to. That can come in handy to fine-tune focus if you have time or can think quickly.

- **Prefocus.** You might be able to prefocus on a specific point where you expect the action to take place if you partially depress the shutter button. Some cameras also have a focus lock/exposure lock button that fixes either or both settings at the value selected when you depress the shutter release. With locked focus, you can take the photograph quickly by depressing the shutter button the rest of the way when your subject is where you want within the frame.

Figure 16.13
If you're fast enough, you can tell your camera's autofocus system which focus zone to use.

TRAP FOCUS

Think your reaction time isn't sufficiently speedy to capture the critical moment? Use trap focus, a technique available with some cameras to allow you to set a focus point and have the camera automatically take a picture when a subject reaches that point. Trap focus is set up using different controls and options with each type of camera, so I can't tell you exactly how to activate it here: check your camera manual. But, in general, it works like this: The camera should be set to single-area autofocus, so that only one of the available focus zones is used. That allows you to specify what area of the frame is "live." Then, you need to use your camera's capability of decoupling autofocus activation from the shutter release button, so that autofocus is locked in *only* by an autofocus lock button on your camera, instead. That button may be labeled AF-L or AE-L/AF-L.

Once the camera has been set up like this, the shutter release button no longer starts and locks in autofocus. Typically, the camera is also set for what is called *focus priority*; the shutter release won't actually trip the shutter unless the subject is in focus. (What you don't want is *release priority*, which takes a picture as soon as the shutter release is pressed, whether the subject is in focus or not.)

Now compose your shot and set the focus by aiming the focus indicator in the center of the frame at a subject located at the exact distance you want to capture (say, the finish line at a footrace) and pressing the button that activates autofocus. The camera will focus at the point you've selected. Next press and hold the shutter button. As soon as something comes into focus, the shutter will fire.

- **Use manual focus.** Manual focus might be a good choice when you know in advance where the action will be taking place (for example, around the hoop in a basketball game) and can help your camera operate more quickly than in autofocus mode. Manual focus works especially well with shorter lenses and smaller apertures, because the depth-of-field makes precise focus a little less critical.

- **Selective focus.** Manual focus also works when you're concentrating on a specific area, or want to control depth-of-field precisely. For example, at baseball games I may decide to take a series of shots of the batter, pitcher, or first baseman. I can prefocus on one of those spots and shoot away without worrying about autofocus locking in on someone moving into the field of view. My focus point is locked in. Selective focus can also concentrate attention on the subjects in the foreground.

Selecting an ISO Speed

By now you're aware that the lower the ISO setting on your digital camera, the less noise you'll get and, usually the better the quality. But low ISO settings and action photography don't mix well. If you're trying to freeze action, you'll want to use the highest shutter speed possible, while retaining a small enough f/stop to ensure that everything you want to be in focus will be in focus. When available light isn't especially available, the solution may be to increase your dSLR's ISO setting, as was done for the shot of the amusement park ride in Figure 16.14.

Fortunately, ISO speeds are another area in which digital SLRs often excel. Because of their larger sensors, a dSLR can usually function agreeably at higher ISO settings without introducing too much noise. Many digital SLRs produce good results at ISO 3200, and may still offer acceptable images at ISO 6400 or above.

Your digital camera may automatically set an appropriate ISO for you, bumping the value up and down even while you're shooting to provide the best compromise between sensitivity and image quality. Or, you can set ISO manually. The easiest way to settle on an ISO rating is to measure (or estimate) the amount of illumination in the venue where you'll be working, and figure some typical exposures (even though your camera's autoexposure mechanism will be doing the actual calculation for you once you're shooting).

Outdoors, the ancient "Sunny 16" rule works just fine. In bright sunlight, the reciprocal of an ISO rating will usually equal the shutter speed called for at an f/stop of f/16. The numbers are rounded to the nearest traditional shutter speed to make the calculation easier. So, at f/16, you can use a shutter speed of 1/100–1/125th second at ISO 100; 1/200–1/250th second with an ISO rating of 200; 1/400–1/500th second at ISO 400; and perhaps up to 1/1,000th second at ISO 800. Select the ISO setting that gives you the shutter speed you want to work with. If the day is slightly cloudy (or really cloudy), estimate the exposure as one-half or one-quarter what you'd get with Sunny 16.

Indoors, the situation is dimmer, but you'll find that most venues are illuminated brightly enough to allow an exposure of f/4 at 1/125th second at ISO 800. For a faster shutter speed, you'll need

Figure 16.14
You don't have to stop shooting action when the sun sets: just boost your ISO setting.

either a higher ISO setting or a brighter venue. In modern facilities, you probably will have more light to work with, but it's always safe to use a worst-case scenario for your pre-event estimates. Don't forget to set your white balance correctly for your indoor location. If one of your camera's manual choices doesn't produce optimal results, consider running through your system's custom white balance routine to create an especially tailored balance for your venue.

Using a Tripod or Monopod

Most big, long lenses, even those with image stabilization built in, have a tripod socket for mounting the camera on a support (or, if they don't, should). A tripod, or its single-legged counterpart the monopod, steadies your camera during exposures, providing a motion-damping influence that is most apparent when shooting with long lenses or slow shutter speeds. By steadying the camera, a

tripod/monopod reduces the camera shake that can contribute to blurry photos. Although tripods are used a bit less at sports events these days, they can still be an important accessory.

You might not want to use a tripod at events where you need to move around a lot, because they take up a bit of space and are clumsy to reposition. Tripods are most useful for sports like baseball, where the action happens in some predictable places, and you're not forced to run around to chase it down. Monopods are a bit more portable than tripods, but don't provide quite as much support. Some action photographers rely on chestpods that brace the camera against the upper torso, but today the trend is toward image stabilization lenses and cameras that accommodate and correct for slight camera movement.

How much camera shake can you expect? One rule of thumb is that if you're not using anti-vibration equipment, the minimum shutter speed you can work with is roughly the reciprocal of the focal length of the lens. That is, with a 200mm lens, if you're not using a tripod you should be using 1/200th second as your slowest shutter speed. Step up to a 500mm optic, and you'll need 1/500th second, and so forth. Your mileage may vary, because some lenses of a particular focal length are longer and more prone to teetering, and some photographers are shakier than others. I tend to double the rule of thumb with shorter lenses to be safe, and quadruple the recommendation with longer lenses. For example, if I am not using a monopod, I shoot my 500mm lens at a shutter speed no slower than 1/2,000th second.

Basics of Freezing Action

To freeze or not to freeze? That is a question? Actually, for many types of action photos, totally freezing your subjects can lead to a static, uninteresting image. Or, as you can see in Figure 16.15, completely stopping the action can produce an undesirable effect. A little selective motion blur can add to the feeling of movement. Motor racing photographers, for example, always select a shutter speed that's slow enough to allow the wheels of a vehicle to blur; otherwise, the vehicle looks as if it were parked. However, including a little, but not too much blur in your pictures is more difficult and challenging than simply stopping your subjects in their tracks. Some of the best action pictures combine blur with sharpness to create a powerful effect. This section will show you how to put the freeze and partial freeze on your action subjects.

Figure 16.15 No, this helicopter's rotors haven't stopped, and no crash is impending. They were frozen in mid-spin by a fast shutter speed.

Motion and Direction

From your dSLR's perspective, motion looks different depending on its speed, direction, and distance from the camera. Objects that are moving faster produce more blur at a given shutter speed if the camera remains fixed. Subjects that cross the field of view appear to move faster than those heading right toward the camera. Things that are farther away seem to be moving more slowly than those in our immediate vicinity. You can use this information to help apply the amount of freeze you want in your image.

- **Parallel motion.** If a subject is moving parallel to the back of the camera, in either a horizontal, vertical, or diagonal direction, it will appear to be moving fastest and cause the highest degree of blur. A high pop fly that's dropping into the infield will seem to be moving faster than one that's headed out of the ball park (away from the camera) for a home run, even though, in reality, Barry Bonds can probably propel a baseball *much* faster than the impetus the laws of gravity will apply to a falling popup. A racing car crossing the frame is likely to appear to be blurry even if you use a high shutter speed.

- **Head-on motion.** Motion coming toward the camera, like the hurdler shown in Figure 16.16, appears to move much slower, and will cause much less blur. That same race car headed directly toward you can be successfully photographed at a much longer shutter speed.

- **Motion on a slant.** Objects moving diagonally toward the camera will appear to be moving at a rate that's somewhere between parallel and head-on motion. You'll need a shutter speed somewhere between the two extremes. Motion coming toward the camera on a slant (perhaps a runner dashing from the upper-left background of your frame to the lower-right foreground) will display blur somewhere between the two extremes.

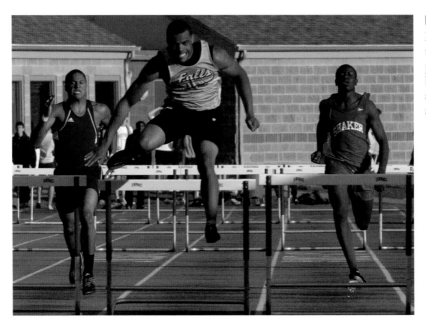

Figure 16.16

Motion coming toward the camera produces much less blur, and can be stopped with a slower shutter speed.

- **Distant/close motion.** Subjects that are closer to the camera and larger within the frame blur more easily than subjects that are farther away and smaller in the frame, even though they're moving at the same speed. That's because the motion across the camera frame is more rapid with a subject that is closer to the camera and appears larger in the viewfinder.

- **Camera motion.** Blur is relative to the camera's motion, so if you pan the camera to follow a fast-moving object, as in Figure 16.17, the amount of blur of the object you're following will be less than if the camera remained stationary and the object darted across the frame. On the other hand, if the camera motion isn't smooth, but is jittery and not in conjunction with the movement of the subject, it can detract from the sharpness of the image.

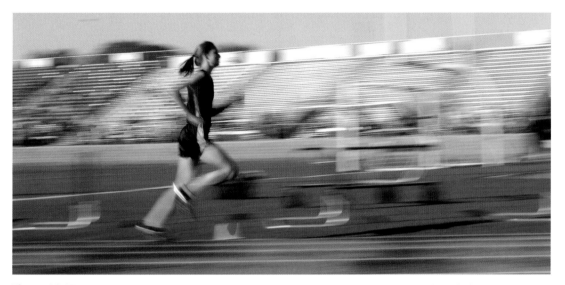

Figure 16.17 Panning the camera with this distance runner stopped the action at a relatively low 1/125th second shutter speed.

Action Stopping Techniques

This section will summarize the basic techniques for stopping action under the most common types of shooting situations. Your particular photo opportunity may combine elements from more than one of these scenarios, and you're free to combine techniques as necessary to get the best results.

Stopping Action with Panning

The term *panning* originated in the motion picture industry, from a camera swiveling motion used to follow action as it progresses from one side of the frame to the other. Derived from the term *panorama*, a pan can be conducted only in a horizontal direction. The vertical equivalent is called a *tilt*, which is why your tripod's camera mount may be called a *pan and tilt* head. You'll rarely need to "pan" vertically, unless you're following a rocket as it takes off for outer space.

Suppose a marathon runner is racing across your field of view. If she's close enough and moving fast enough, even your highest shutter speed may not be able to stop the action. So, instead, you move the camera in the same direction that the runner is moving. Her apparent speed is much slower, relative to the camera, so a given shutter speed will be able to freeze the action more readily, as you can see in Figure 16.17. Blur from subject motion is reduced. Yet, the background will display more blur, due to camera motion.

Panning can be done with a hand-held camera (just plant your feet firmly and pivot at the waist), or with a camera mounted on a tripod that has a swiveling panorama (pan) head. The more you practice panning, the better you'll get at following the action. You might find that if your panning speed closely matches the subject's actual speed, a shutter speed as slow as 1/60th to 1/125th second can produce surprisingly sharp images. Use of a lower shutter speed causes the background to appear blurrier, too.

To pan effectively, you should try to move smoothly in the direction of the subject's movement. If your movement is jerky, or you don't pan in a motion that's parallel to the subject's motion, you'll get more blurriness than you anticipate or want. Take a step back, if you can. The farther the subject is from the camera, the longer you'll have to make your pan movement, improving potential sharpness.

Panning is a very cool effect because of the sharpness of the subject, the blurriness of the background, and some interesting side effects that can result. For example, parts of the subject not moving in the direction of the overall pan will be blurry, so your runner's body may be sharp, but her pumping arms and legs will blur in an interesting way, as you saw in Figure 16.17.

Freezing Action Head On

Another way to stop action is to photograph the subject as it heads toward or away from you. A runner who is dashing toward the camera can be effectively frozen at 1/250th or 1/125th second, but would appear hopelessly blurred when crossing the frame (if you're not panning). Head-on shots can be interesting, too, so you might want to use this angle even if you're not trying to boost your effective shutter speed. The water skier and boat in Figure 16.18 were moving at a pretty good clip, but because they were headed away from the camera (albeit at a slightly diagonal angle), it was possible to freeze the action at 1/125th second. The fact that the water spray is a little blurry probably adds to the picture, rather than detracting from it.

Freezing Action with Your Shutter

A third way to stop motion is to use the tiny time slice your shutter can nip off. A fast shutter speed can stop action effectively, no matter what the direction of the motion. The trick is to select the shutter speed you really need. A speed that is too high can rob you of a little sharpness because you've had to open the lens aperture a bit to compensate, or use a higher ISO rating that introduces noise. There are no real rules of thumb for selecting the "minimum" fastest shutter speed. As you've seen, action stopping depends on how fast the subject is moving, its distance from the camera, its direction, and whether you're panning or not.

Figure 16.18 Movement toward or away from the camera can be captured at lower shutter speeds.

Many cameras include shutter speeds that, in practice, you really can't use. The highest practical speed tops out at around 1/2000th second. With a fast lens and a higher ISO rating, you might be able to work with 1/4,000th second under bright illumination. Yet, there are digital cameras available that offer shutter speeds as brief as 1/16,000th of a second. So, the bottom line is usually that, to freeze action with your shutter speed alone, you'll probably be using a speed from 1/500th second to 1/2,000th second, depending on the illumination and what your camera offers.

Freezing Action with Electronic Flash

Electronic flash units, originally called "strobes" or "speedlights," are more than a great accessory for artificial illumination. The duration of an electronic flash is extremely brief, and if the flash provides the bulk of the illumination for a photograph, some great action-stopping results. One of the earliest applications of electronic flash was by Dr. Harold Edgerton at MIT, who perfected the use of stroboscopic lights in both ultra-high-speed motion and still (stop-motion) photography capable of revealing bullets in flight, lightbulbs shattering, and other phenomena.

Some flash units have a duration of 1/50,000th second or less, which is very brief, indeed. One way of controlling an automated flash unit is to vary the duration of the flash by using only part of the stored energy that's accumulated in the unit's capacitors.

If the subject is relatively far away, the entire charge is fed to the flash tube, producing the longest and most intense amount of illumination. If the subject is relatively close, only part of the charge is required for the photograph, and only that much is supplied to the flash tube, producing an even briefer flash. Yet, even the longest flash exposure is likely to be shorter than your camera's shutter speed, so electronic flash is an excellent tool for stopping action.

The chief problem with electronic flash is that, like all illumination, it obeys that pesky inverse-square law. As you'll recall, light diminishes relative to the inverse of the square of the distance. So, if you're photographing a subject that's 12 feet away, you'll need *four* times as much light when the subject is twice as far away at 24 feet, not twice as much. Worse, if an athlete in your photograph is 12 feet away when you snap a picture, anything in the background 24 feet away will receive only one quarter as much light, giving you a dark background.

That generally means that a digital camera's built-in electronic flash is probably not powerful enough to illuminate anything two-dozen feet from the camera. You might be able to use your camera's flash at a basketball game, but not at a football game where the distances are much greater. A more powerful external flash unit might be called for.

However, flash is especially adept at stopping close-up action, as shown by Figure 16.19, which illustrates what happens when attempting to use a cryogenically frozen hammer to smash a light bulb. Of course, the exact effect shown in the figure is virtually impossible to achieve, except on April 1, and only with significant help from Photoshop or another image editor, but I decided not to run the traditional bullet-piercing-balloon or hammer-smashing-bulb photo, which we've all seen a million times. My e-mails will tell me which of my readers were paying attention here.

Figure 16.19
Electronic flash can freeze close-up action.

Freezing Action at Its Peak

The final method for freezing fast motion is simple: wait for the motion to stop. Some kinds of action include a peak moment when motion stops for an instant before resuming again. That's your cue to snap a picture. Even a relatively slow shutter speed can stop action during one of these peak moments or pauses. Figure 16.20 shows a motocross jumper at the exact peak of his leap, performing a daring stunt before his motorcycle resumes its downward trajectory.

Figure 16.20

Capture action at its peak and you can use a slower shutter speed.

The end of a batter's swing, a quarterback cocking his arm to throw a pass, a tennis player pausing before bringing a racket down in a smash. These are all peak moments you can freeze easily. Other peaks are trickier to catch, such as the moment when a basketball player reaches the apex of a leap before unleashing a jump shot. If you time your photograph for that split second before the shooter starts to come down, you can freeze the action easily. If you study the motion of your action subjects, you'll often be able to predict when these peak moments will occur.

When Blur Is Better

Some kinds of action shouldn't be frozen at all, as we saw in the helicopter photo earlier in this chapter. Better yet, you can use blur as a creative effect to show movement without freezing it. Figure 16.23 shows a 1/15th second exposure of a basketball player moving down court. Panning wasn't enough to stop the action of his moving arms and legs, or the motion of the ball and other players, making a much better image than a static shot.

Figure 16.21 Some subjects are more interesting in a long exposure.

Some Final Tips

I know this chapter has you psyched up to take some great action photos, but there are a few additional points to consider before you embark on your photo assignment. As with any other kind of shoot, it's always best to be well prepared. There are things you should never leave home without, and not all of them are your MasterCard. Make yourself a checklist like this one:

- **Take spares.** One of the first things I learned as a professional is that excuses like, "My flash cord didn't work!" won't fly. I used to carry at least three of everything, including camera bodies and key accessories. I duplicated only the most essential lenses, but I always had a spare along that would suffice in a pinch, such as an f/1.4 normal lens as well as an f/1.4 35mm wide-angle. You don't need to be a pro to have a lot invested in your pictures. Don't let your vacation or once-in-a-lifetime shot be ruined. Take along extra batteries, extra digital film cards, and perhaps a backup flash unit. You might not be able to afford a spare dSLR body, but you can always squeeze an extra point-and-shoot digital camera into your gadget bag to use if all else fails.

- **Charge your batteries.** Some dSLRs can shoot 1,000 to 2,000 pictures on a single charge, but those figures can be achieved only if you're starting out with a fully charged battery. Modern batteries can be recharged at any time without causing any detrimental side-effects, so you'll want to give all your batteries a fresh jolt just before embarking on any important photo journey. Have a spare battery if you think you might be taking more pictures than your original set will handle. And remember that if you expect to use your flash a lot, battery life will be reduced significantly.

- **Offload your photos and reformat your memory cards.** You don't want to grab a new card, get ready to take a crucial picture, and then discover that the card contains older photos that you haven't transferred to your computer yet. Nothing is more painful than having to decide whether to preserve some junky but interesting photos currently residing on your memory card, or to erase them so you'll have some space for new pictures. Transfer your old pictures to other storage, and then reformat the card so it's fresh and ready to go.

- **Review your controls.** Perhaps you want to take some pictures using rear-sync. Do you know how to activate that mode? Can you switch to burst mode quickly, particularly if the light isn't great? Do you know how to use Shutter-priority mode, or select a fast shutter speed? Practice now, because the pressures of trying to get great pictures of fast-moving action can prove confusing.

- **Set up your camera before you leave.** If you're planning on using a particular ISO method, want to change from your camera's default focusing mode, or intend to use a particular exposure scheme, make those settings now, in calmer surroundings. In the excitement of the shoot, you may forget to make an important setting. I once shot a whole batch of action photos in full daylight not remembering that I'd manually set white balance to tungsten for some tabletop

close-ups the night before. If you're shooting in RAW format, you can fix goofs like that, but if you're not, you can't provide perfect correction, even with an advanced image editor like Photoshop.

- **Clean and protect your equipment.** Unless you're looking for a soft-focus look, you'll want to make sure your lenses and sensor are clean. If you expect rain or snow, use a skylight filter. If necessary, make a "raincoat" for your camera out of a resealable sandwich bag with a hole cut in it for the lens to stick out.

17

Close-Up Photography

Many of the most enjoyable types of digital photography are, unhappily, seasonal. If you love to shoot baseball or football sports action, you'll have to wait until baseball or football season kicks off. Should your passion be shooting autumn colors as the leaves change after summer's end, you'll have to wait until September and October of each year. Wildlife and nature photography isn't impossible during the winter months, but it's usually more exciting during the spring. Architectural photos often look their best with leaves on the surrounding trees. Weddings seem to proliferate in June. Just when you get really involved in a particular type of photography, the "season" for it ends.

But close-up photography is a photographic pursuit you can enjoy all year long. Each April, I'm out there chasing down blossoming flowers and looking for interesting bugs to capture on digital film. In July, I end up at the beach shooting shells and shore creatures. Come late September, I grab close-up shots of leaves. And during the long winters, I have my macro tabletop set up so I can shoot pictures of anything that captures my fancy. Indeed, close-up photography and portraits are what I photograph most during the cold months.

I'm hoping this chapter will encourage you to try out macrophotography yourself because digital SLRs are the perfect tool for this kind of picture taking. You'll discover whole new worlds in a water drop, teeming life under any bush or tree, and fascinating patterns in common household objects.

Macro Terminology

It's easy to get confused over some of the terms applied to macrophotography. Even the name itself is sometimes misunderstood. Macrophotography is *not* microphotography, which involves micro-film and other miniature images; nor is it photomicrography, which is taking pictures through a microscope. Nor, necessarily, is it close-up photography, which, strictly speaking, applies to a tight shot in cinematography. Macrophotography is generally the production of close-up photos, usually

taken from a foot or less. Because the terms macrophotography and close-up photography are nevertheless used interchangeably these days, I'll do so in this book.

There are several other terms that cause confusion. I'll clarify each of them for you.

Magnification

In macrophotography, the amount of magnification is usually more important than how close you can get to your subject. For example, if you're photographing a coin and want it to fill the frame, it makes little difference whether you shoot the coin using a 50mm lens from 4 inches away or with a 100mm lens from 8 inches away. Either one will produce the same magnification. Because of this, close-up images and the macro capabilities of cameras and lenses are usually described in terms of their magnification factor, rather than the camera/subject distance. Moderate close-ups may involve 1:4 or 1:3 magnifications. Normal close-up photography requires 1:2 or 1:1 magnifications. Larger-than-life-size images may involve 2:1 or 4:1 (or 2X or 4X) magnifications. The small stone carving in Figure 17.1 was photographed at approximately a 1:4 ratio.

Yet, the newcomer to macro photography invariably wants to know "how close can I get?" That's a logical question. If you're used to taking pictures of subjects that are located from six feet to infinity,

Figure 17.1

Sometimes getting up close and photographing a detail of a larger subject, such as this two-inch-wide section of a stone carving, provides an interesting perspective.

the desire to get close, preferably as close as possible, takes on special significance. However, if you think about it, the distance between your lens and the subject isn't the most important thing. You want a bigger view of your subject, so the size of the subject on your sensor (or film) is the key factor. Instead of focusing on distance, think *magnification.*

It's easy to see why, through a simple thought experiment. You don't even have to whip out your camera. Imagine taking a photograph of a coin from your coin collection from 8 inches away, with your camera set to its widest zoom setting, say, the equivalent of a 35mm lens. Now, move the camera back so it's 12 inches away from the coin, but zoom in to your camera's maximum telephoto setting, say, 200mm. (Not all cameras can focus close at all zoom settings, but, fortunately, this is a thought experiment.) Which photograph will have the larger image? Which will be a more satisfactory close-up of your coin?

Figure 17.2 shows an aloe vera plant photographed from about 2 feet away using the equivalent of a 28mm wide-angle lens. For Figure 17.3, I moved back to about 5 1/2 feet and shot at the 80mm zoom setting. Note that the magnification of each image is exactly the same (at least, in terms of the flowerpot), even though one photo was taken at a distance that's nearly three times as far.

There are other differences in the photos, which I'll point out in the Perspective section.

In macro photography, it's not how close you can focus, but the final size, or magnification, of the image that is important. A lens that focuses very close only at the wide-angle setting will not produce the same results as one that focused close at both wide-angle and telephoto settings. Indeed, there are situations in which you'd want to use one or the other, because both wide-angle and telephoto settings can produce distortions in your final image, depending on the subject matter and how close you are to it. Subject distance can be important for some types of close-up photography: if you're shooting a skittish critter such as an insect or frog, you might prefer to use a longer lens at

Figure 17.2 This photo was taken using a 28mm zoom setting from about 2 feet away.

Figure 17.3 This picture was taken using the 80mm zoom setting from 5 1/2 feet away.

a greater distance, still keeping the same image size because the magnification of the longer lens is greater, as I'll explain shortly.

Because final image size depends on both the lens focal length and distance to the subject, magnification is the most useful way of expressing how an image is captured with macro photography. If your magnification is 1X, the object will appear the same size on the sensor (or film) as it does in real life, completely filling the frame. At 2X magnification, it will be twice as big, and you'll only be able to fit half of it in the frame. At .5X, the subject will be half life-size and will occupy only half the width or height of the frame. These magnifications are most commonly referred to as ratios: 1X is 1:1, 2X is 2:1, .5X is 1:2, and so forth. As you work with close-up photography, you'll find using magnifications more useful than focusing distances.

Focal Length and Magnification

Focal length determines the working distance between your camera/lens and the macro subject at a given magnification. As with most real-world decisions, the choice of focal length is necessarily a compromise. For example, if you want a life-size photo (1:1) of a tree frog, you could shoot it from a few inches away with a 50mm lens, or twice as far away (which should make the frog less apprehensive) with a 100mm lens.

To focus more closely, the lens elements of a general-purpose or macro lens must be moved farther away from the sensor, in direct proportion to the magnification. (To simplify things, I'm going to assume we're using a fixed-focal-length, or *prime* lens, rather than a zoom lens.) So, the optical center of a 60mm lens must be moved 60mm from the sensor (about 2.4 inches) to get 1:1 magnification. That's a relatively easy task with a 60mm lens. To get the same magnification with a 120mm lens, you'd have to move the optical center much farther, 120mm (or almost 5 inches), to get the same 1:1 magnification. (As I mentioned in Chapter 6, the "optical center" can be somewhere other than the physical center of the lens; with a long lens, the optical center may be close to the front element of the lens.)

For this reason, most so-called "macro" zoom lenses actually produce 1:4 or 1:5 magnifications. There are specialized macro prime lenses for digital cameras in the 60mm, 80mm, 105mm, and 200mm range, but these are special optics and tend to be expensive. However, they might still be a better choice for you if you do a lot of close-up photography.

That's because of the increased working distance the longer lenses offer. At extreme magnifications, a shorter lens may have the front element less than an inch from the subject. That introduces perspective problems and makes it difficult to get some light in there to illuminate your subject. Your camera may be so close to the subject that there isn't room to light the front of the subject. Forget about your built-in flash: It is probably aimed "over" the subject and either won't illuminate it at all or will only partially illuminate it, and may even be too powerful. Or, your lens may cast a shadow on the subject.

So, your choice of focal length may depend on the desired working distance and whether a particular focal length produces the perspective you need.

Perspective

As you just learned, close-up pictures can be taken from a relative distance (even if that distance is only a few feet away) with a telephoto lens or long zoom setting. The same magnification can also be achieved by moving in close with a shorter lens. The same apparent perspective distortion that results from using a wide-angle lens close to a subject and the distance compression effects of a telephoto apply to close-up and macrophotography. Figure 17.4, captured with a fish-eye lens from less than a foot away from the grille of a custom car, looks like nothing you've ever seen before.

So, if you have a choice of tele/wide-angle modes for macrophotography, you'll want to choose your method carefully. Relatively thick subjects without a great deal of depth and those that can't be approached closely can be successfully photographed using a telephoto/macro setting. Subjects with a moderate amount of depth can be captured in wide-angle mode. If you find that a wide setting tends to introduce distortion, settle for a focal length somewhere in between wide and telephoto. Figure 17.5 shows an image I produced one day when I had nothing to photograph. I decided to do some "figure studies" of a shapely miniature jug, using close-up techniques. I used light and a telephoto zoom set to macro mode to capture images of portions of the jug.

The most important types of subjects affected by perspective concerns are tabletop setups such as architectural models and model railroad layouts. Use the right perspective, and your model may look like a full-scale subject. With the wrong perspective, the model looks exactly like what it is, a tiny mock-up.

You may be able to detect the difference perspective makes by comparing the images in Figures 17.2 and 17.3 shown earlier, or, more easily, by examining the two versions of the porcelain clown shown in Figure 17.6. The version on the left was shot with a longer lens, a short telephoto, while the version on the right was shot with a wide-angle lens, with the camera moved in closer to produce the same image size for the clown. Objects that are closer to the camera, such as the clown's nose, appear

Figure 17.4 Wide-angle lenses provide an interesting perspective for close-up shots.

Figure 17.5
A telephoto perspective and a creative use of light make this photo of part of a jug interesting.

Figure 17.6
The telephoto shot (left) has a different perspective than the wide-angle picture (right).

proportionately larger in the wide-angle shot at right, while objects that are farther away, such as his ears and his flowered hat, appear proportionately smaller. At any given magnification, you'll want to choose the focal length of your lens carefully to provide the kind of perspective that you're looking for.

Depth-of-Field

The depth of sharp focus with three-dimensional subjects can be a critical component in macrophotography. You'll find that depth-of-field is significantly reduced when you're focusing close. Although the relatively short focal length of the lenses used with digital cameras provides extra depth-of-field at a given magnification, it still may not be enough. You'll need to learn to use smaller apertures and other techniques to increase the amount of sharp subject matter. A lens that has a wider range of f/stops, with, perhaps stops as small as f/32 or even smaller, can be helpful to increase depth-of-field. Of course, you need to know that any DOF gains made with smaller f/stops can be lost to a phenomenon known as *diffraction,* which crops its ugly head as you stop down. (Diffraction is why most lenses produce their best results one or two f/stops from wide open, and actually lose a bit of sharpness as you stop down, even while depth-of-field increases.)

Figure 17.7 shows three different versions of a photo of an array of crayons, taken with a 60mm macro lens. In all three cases, focus was on the yellow-green crayon in the upper middle of the frame. The image on the left was shot at f/4, the middle version at f/11, and the one at right at f/22. You can easily see how the depth-of-field increases as the lens is stopped down.

Figure 17.7 Depth-of-field increases as the f/stop is changed from f/4 (left) to f/11 (middle) and f/22 (right).

You'll also need to learn how to *use* your available depth-of-field. Typically, the available DOF (which, as you've just seen, varies by f/stop) extends two-thirds behind the point of sharpest focus and one-third in front of it. Figure 17.8 shows the same crayons in a slightly different arrangement, all taken at f/4. In the version at left, I've focused on one of the crayons in the front row. The middle shot, taken at the same f/stop, was focused on the middle crayon. The version at the right was focused on the rear-most row. With the lens almost wide open, depth-of-field is so shallow that only the crayon focused on is sharp. I could use that creatively to apply selective focus, or I could have stopped the lens down, focused on the center crayon, and perhaps brought all of them into focus.

Figure 17.8 See how depth-of-field changes when the lens is focused on the crayon in front, middle, or back rows.

Figure 17.9
Raising the viewing angle spreads the depth-of-field over a broader area than shooting head-on.

I also could have increased depth-of-field by changing angles so that more crayons were approximately the same distance from the lens. For Figure 17.9, I cranked the tripod up a little higher and shot down from a different angle. The f/stop is still f/4, but more of the crayons are in focus.

Getting Practical

Of course, macrophotography isn't all about terms and definitions. You need to understand how to apply these concepts to your picture taking. This section will look at some of the practical aspects of shooting close-up images.

Macro or General-Purpose Lens?

The selection of a lens for macrophotography can be important because not all lenses do a good job of taking close-up pictures. Some, particularly zoom lenses with a long range, may not focus close enough for practical macro work. Others may not be sharp enough, or might produce distortion, color aberrations, or other image problems that become readily apparent in critical close-up environments. Or, you might find that a particular lens or focal length is not suitable because, to get the magnification you want, the lens itself must be so close to the subject that it intrudes on properly lighting the setup.

Many general-purpose lenses can be pressed into service as close-up optics and do a fine job if they have sufficient sharpness for your application and are relatively free of distortion. If you frequent the photography forums, you'll see paeans of praise for this lens or that when used for macro shots. It's entirely possible to work with a lens you already own and get good results.

I was shooting architecture with a 17-35mm f/2.8 zoom lens when I encountered this flower amidst the plantings around a plaza. This particular lens focuses down to 1 foot at its 35mm zoom setting, so I was able to take the photo shown in Figure 17.10. I would have liked to have gotten even closer, but I didn't really need to. Simply enlarging the center portion of the frame in an image editor gave me the true macro image you can see in Figure 17.11.

Of course, if you do a lot of close-up work, you'll be happier with a lens designed specifically for that job. Such lenses will be exquisitely sharp and built to focus close enough to produce 1:1 or 1:2 magnification without any add-on accessories. Macro lenses are optimized for shooting at close focus distances. The typical non-macro lens is designed with the expectation that the distance between the subject and the optical center of the lens will be much *greater* than the distance from the optical center to the sensor plane. However, when shooting close-ups, it's frequently the case that the distance from the subject to the optical center of the lens is only a few inches, or even much less, while the distance to the sensor plane is more or less fixed at a couple inches. Macro lenses designed for this "backward" orientation can produce sharper results. (And this is exactly the reason why a non-macro lens can give you sharper images if you *reverse* it, using an adapter, to give it the "backward" orientation of the typical extreme close-up photo.)

Figure 17.10 A wide-angle lens that focused down to 1 foot served as a "macro" lens for this shot.

Figure 17.11 Enlarging the center portion of the frame produced a dramatic close-up.

Close-Up Gear

In addition to a macro lens, there are other pieces of equipment that can come in handy for macro-photography, ranging from special close-up attachments that fit on the front of the lens, lens "extenders" that move the optical center of the lens farther away from the sensor, and accessories like ring lights that make illuminating your subject easier.

Close-Up Lenses/Attachments

Close-up lenses and attachments, which screw onto the filter thread of a lens, are the least expensive macro equipment you're likely to find. Close-up "lenses" differ from true macro lenses, despite their confusingly similar names. Macro lenses are prime lenses or macro zoom lenses designed to focus more closely than an ordinary lens. The add-ons that have traditionally been called close-up lenses are actually screw-on, filter-like accessories that attach to the front of your camera's prime or zoom lens.

These accessories are useful when you want to get even closer than your camera's design allows. They provide additional magnification like a magnifying glass, letting you move more closely to the subject. Close-up lenses, like the one shown in Figure 17.12, are generally labeled with their relative "strength" or magnification using a measure of optical strength called "diopter." A lens labeled "No. 1" would be a relatively mild close-up attachment; those labeled "No. 2" or "No. 3" would be relatively stronger. Close-up lenses are commonly available in magnifications from +0 diopter to +10 diopters. You can stack multiple close-up lenses to achieve more magnification, although it's best to use no more than two at once to avoid optical degradation of the image.

Figure 17.12 A close-up lens attachment can bring you even closer than your camera's minimum focusing distance.

The actual way close-up magnification is calculated is entirely too complicated for the average math-hating photographer because there's little need to apply mumbo-jumbo like *Magnification at Infinity=Camera Focal Length/(1000/diopter strength)* in real life. That's because the close focusing distance varies with the focal length of the lens and its unenhanced close-focusing capabilities.

However, as a rule of thumb, if your lens, a telephoto, say, normally focuses to one meter (39.37 inches; a little more than three feet), a +1 diopter will let you focus down to one-half meter (about 20 inches); a +2 diopter to one-third meter (around 13 inches); a +3 diopter to one-quarter meter (about 9.8 inches), and so forth. A +10 diopter will take you all the way down to about two inches—and that's with the lens focused at infinity. If your digital camera's lens normally focuses closer than one meter, you'll be able to narrow the gap between you and your subject even more.

In the real world, the practical solution is to purchase several close-up lenses (they cost roughly $20 each and can often be purchased in a set) so you'll have the right one for any particular photographic chore. You can combine several close-up lenses to get even closer (using, say, a +2 lens with a +3 lens to end up with +5), but avoid using more than two close-up lenses together. The toll on your sharpness will be too great with all those layers of glass. Plus, three lenses can easily be thick enough to vignette the corners of your image.

One of the key advantages of add-on close-up lenses is that they don't interfere in any way with the autofocus or exposure mechanism of your dSLR. All of your lenses will continue to work in exactly the same way with a close-up lens attached. There are some disadvantages, too. As with any filters, you must purchase close-up lenses in sizes to fit the front filter threads of your lenses. You'll either need close-up lenses for each filter size appropriate for the optics you want to use them with or use step-up/step-down adapter rings to make them fit.

Finally, close-up lenses come with a sharpness penalty, especially when you start stacking them together to achieve higher magnifications. A photo taken with a close-up lens will be a little less sharp than one taken without.

Extension Tubes and Bellows

One of the coolest things about digital SLRs is that if you can't move the lens far enough away from the sensor to get the magnification you want, you can pop off the lens and insert gadgets that provide that extension for you. The simplest variety is called *extension tubes,* as seen in Figure 17.13.

These are nothing more than hollow tubes with a fitting on the rear similar to that on the back of a lens, and which connects to the lens mount of your camera. The front of the extension tube has a lens mount of its own, and your lens is attached

Figure 17.13 Extension tubes can turn any lens into a close-focusing macro lens.

to that. Extension tubes look a little like teleconverters (which increase the focal length of your lens), except they have no optics inside. They do nothing but what their name says: extend. Extension tubes are available in multiple sizes, often as a set, with, say, 8mm, 12.5mm, and 27.5mm tubes that can be used alone or in combination to produce the amount of extension needed.

Some tubes may not couple with your camera and lens's autofocus and autoexposure mechanisms. That doesn't preclude their use because you may be focusing manually anyway when you're in macrophotography mode, and setting the f/stop and shutter speed manually may not be much of an inconvenience, either. Newer sets are compatible with your lens's full set of features, except, possibly, image stabilization, making them even more convenient to use.

A bellows is an accordion-like attachment that moves along a sliding rail to vary the distance between lens and camera continuously over a particular range. Where extension tubes each provide a fixed amount of magnification, bellows let you produce different magnifications, as much as 20:1 or more. I favor an older bellows attachment, used with a correspondingly ancient macro lens. It has a tilt and shift mechanism on the front column, which allows you to vary the angle between the lens and the back of the camera (where the sensor is). This shifting procedure can help you squeeze out a little more depth-of-field by tilting the sharpness "plane" in the same direction your subject matter "tilts" away from the camera.

A bellows attachment, like the one shown in Figure 17.14, frequently has a rotating mechanism that allows you to shift the camera from horizontal to vertical orientation. Some bellows have two rails: one for adjusting the distance of the lens from the camera, and a second that allows moving the whole shebang—bellows, camera, and all—closer or farther away from the subject. That allows it to function as a "focusing rail." Once you've moved the lens out far enough to achieve the magnification you want, you can then lock the camera/bellows distance and slide the whole assembly back and forth to achieve sharpest focus.

Figure 17.14 A bellows with slide and tilt capabilities lets you tweak a little extra depth-of-field out of your extreme close-up photos.

SOME WACKY COMBINATIONS

I discovered that the deliberate and contemplative nature of macrophotography has an interesting advantage. Once you've freed yourself from fretting over the lack of autofocus and/or autoexposure with your macro setup, you'll find you can attach a wider variety of lenses to your camera than you might have thought. For example:

- **Nikon lenses on Canon dSLRs**. There are adapters, like the one shown in Figure 17.15, that allow fitting Nikon lenses to Canon SLR cameras for use in manual mode. If you'll be working manually for macrophotography anyway, such adapters are more practical.

- **Old-school compatibility**. Pentax dSLRs that accept older Pentax lenses may also be able to use original extension tubes and lenses in manual mode. The same is true for lenses and accessories produced for Nikon and other camera lines. Even though older Nikon lenses ordinarily must be converted for use on modern Nikon dSLRs, you'll find that if a non-automatic extension tube can be mounted safely on your Nikon, you can then attach just about any older lens to that extension tube without fear of damaging your camera body.

- **Lens flip-flops**. Reversing rings are available that let you attach your lens to your camera in reverse fashion, with the lens mount facing *away* from the camera, as shown in Figure 17.16. This configuration can let you focus closer and may produce sharper results. If you're using manual focusing, this setup is no more inconvenient than the normal focusing mode. However, the lens must be one with an aperture ring to allow you to change f/stops.

Figure 17.15 If you have or can borrow a Nikon macro lens, you can fit it to your Canon dSLR with an adapter.

Figure 17.16 A reversing ring lets you mount a lens backward, which sometimes lets you focus more closely and can improve image quality.

Be careful when attaching bellows or extension tubes to your camera to avoid damaging your lens mount or camera body. Even if a bellows is nominally compatible, you may have to attach an extension tube to the camera body first and then fasten the bellows to the extension tube to allow the mechanism to clear projecting parts of the camera. Remember that, since you'll be manually focusing, and the distance between the lens and sensor is important only in terms of magnification, you can mix and match lenses, bellows, and cameras among vendors. For example, a Nikon bellows that costs less than $100 can be mounted on a Canon or Sony camera with the proper adapter, and then, using another adapter, you can mount Nikon, Canon, Sony or other lenses on the front of the bellows.

Of course, bellows, extension tubes, and similar attachments can be expensive (although there are many bargains available in pre-owned equipment), so you won't want to make the investment unless you do a lot of close-up photography. Another downside is that the farther you move the lens from the sensor, the more exposure required. You can easily lose 2 or 3 f/stops (or much more) when you start adding extension.

Tripods

You'll probably need a tripod to support your camera during macrophotography sessions. Tripods steady the camera for the longer exposures you might need and allow consistent and repeatable positioning, which might be necessary if you were, perhaps, taking pictures of your toy soldier collection one figure at a time. Get a sturdy tripod with easily adjustable legs, sure-grip feet, and a center column that lets you change the height over a decent range without the need to fiddle with the legs again. A center column that's reversible, as shown in Figure 17.17, is a plus because you can use it to point the camera directly down at the flower or shoot from low angles that are less than the minimum height of the tripod. A ball head, which lets you rotate the camera in any direction, is easier to use and more versatile than the tilt-and-swing type tripod head shown in the illustration.

Figure 17.17
A tripod with a reversible center column lets you shoot from lower angles.

A good tripod not only frees you from needing to have three or four different hands, but it makes it easier to focus and frame an image through a digital camera's LCD screen. A tripod is also a consistent and repeatable support, so if you're taking photographs of your model train collection, the camera can remain the same distance from your rolling stock picture to picture and session to session.

You'll quickly discover that not just any tripod is suitable for close-up photography. Some models are little better than camera stands and the worst of them wobble more than you do. Digital cameras are so small (many weighing only a few ounces) that you might be tempted to go with an equally petite tripod. Don't succumb to the temptation! Although you might not need a heavy-duty studio tripod like the one I use, you still need something that's rigid enough not to sway while you compose your image, and heavy enough to remain rock-solid during a long exposure. There are smaller tripods available that don't flex under tiny amounts of pressure, and resist swaying with every gust of wind or other minor environmental shakes.

Here are some things to look for in a tripod used for close-up photography:

- **Quick adjustable legs.** Legs that adjust easily so you can change the height of the tripod quickly. You'll need to make some altitude adjustments while taking pictures, of course. However, you'll find that you frequently need to set up a tripod on uneven surfaces, from stairs (indoors) to a sloping hill (outdoors). Legs that adjust quickly make it easy to set each leg at a different appropriate length for a steady mount on a less-than-flat surface.

- **Sure-grip "feet."** Rubberized feet at the end of each leg are good for gripping slippery surfaces. Some tripods have feet that can be adjusted to use spiky tips that can dig into dirt, grass, or other iffy surfaces.

- **An adjustable center column.** You'll need one that's long enough to let you move the camera up or down by a foot or two without the need to adjust the legs.

- **A center column that's reversible.** This feature comes in handy when you need to point the camera directly down at the floor for some close-ups.

- **A versatile head.** The traditional tilt and swing head or ball head that flips in horizontal and vertical directions may be found on older and less expensive tripods. More common are *ball heads* that swivel in all directions, so you can quickly change the camera angle. With some professional tripods, heads are a component that's purchased separately. Figure 17.18 shows a typical ball head from Photo Clam (http://wp.photoclamusa.com/) and its key components.

- **Solid support.** Cross-bracing that holds the legs of a lightweight tripod rigid even when extended fully can be useful. Sturdier tripods might not need any cross-bracing.

- **Light weight.** If you're taking your tripod out in the field, you might want an extra-light model that can be toted around conveniently, but which doesn't sacrifice rigidity. Tripods built of carbon fiber or carbon fiber and magnesium, or basalt, typically weigh one-third less than aluminum models, yet are just as sturdy.

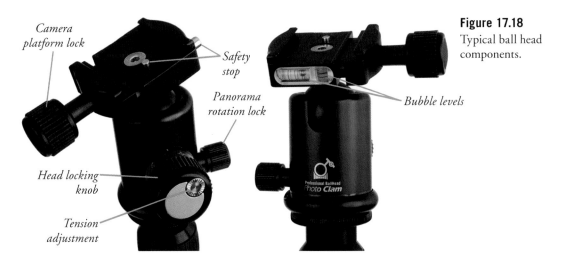

Camera platform lock

Safety stop

Panorama rotation lock

Bubble levels

Head locking knob

Tension adjustment

Figure 17.18
Typical ball head components.

If you take pictures of small, flat objects (such as stamps, coins, photographs, or needlepoint), you might want to consider a special kind of camera support called a *copystand*. These are simple stands with a flat copyboard and a vertical (or slanted) column on which you fasten the camera. The camera can be slid up or down the column to adjust the camera-subject distance. A slanted column is best, because it ensures that the camera remains centered over a larger subject area as you move the camera up. Copystands provide a much more convenient working angle for this type of photography, particularly if your digital camera allows swiveling the lens and viewfinder in different directions.

DON'T CARRY THAT WEIGHT

When you're shooting in the field, take along one of those mesh bags that oranges come in. You can fill it up on-site with rocks, tie it to the center support of your tripod, and use it to add extra hill-hugging weight to a lightweight camera support.

Other Gear

Although you can work with existing light, you'll find your creative possibilities are broader if you use external light sources. Macro subjects other than living creatures will usually sit still for long exposures, so incandescent lighting—perhaps something as simple as a pair of desktop gooseneck lamps—may suffice.

Or, you can use electronic flash to freeze action. As I mentioned earlier, your dSLR's built-in electronic flash isn't ideal for macro work, so you should investigate external, off-camera flash units. Frequently, your camera's internal circuitry may be able to trigger the same vendor's external flash attachments by radio control. Or, you can set your internal flash to its very lowest power setting and use that to set off an external flash through a triggering device called a *slave unit*, described in

Chapter 7. In that case, the internal flash may provide nothing more than a little fill on your subject, with most of the illumination coming from the external flash.

There is also a device called a ring light, which is a circular light shaped like a round fluorescent tube (and may in fact be one in its incandescent incarnation). A ring light can solve your close-quarters illumination problems by providing an even, shadow-free light source at short camera/subject distances.

Consider using reflectors, umbrellas, and other light modifiers to optimize your lighting effects. A simple piece of white cardboard can work well and can double as a background. Aluminum foil or Mylar sheets can provide a bright, contrasty reflection source. I also use pure-white pocket rain umbrellas that cost me $5, but which unfold to 36 inches or more to create great, soft-light reflectors. If you want diffuse, omni-directional lighting for photographing things like jewelry, nothing beats a tent, which is an enveloping structure of translucent material that fits over your subject, with a hole to fit the lens through. Light can then be applied to the outside of the tent to illuminate your picture. You can make your own "tent" using something as simple as a plastic milk bottle.

Some Shooting Tips

You're ready to start shooting close-ups. I'm ready to give you some helpful tips. Try this mixed bag of tricks on for size (to coin a mixed metaphor) as you shoot your first macros:

- **Focus carefully.** Some cameras allow switching autofocus to a center-oriented mode or spot mode or let you choose which focus sensor to use. Use those features if your subject matter is indeed in the middle of the picture or somewhere within one of the focus zones. Or, switch to manual focus if your camera offers it. Use a large f/stop if you want to work with selective focus, as shown in Figure 17.19. At left is an image in which the camera was focused on the cup in front. Because the lens was almost wide open, the jug in back is out of focus. At right, focus was on the jug in back, throwing the cup in front out of focus.

 You might want to use Aperture-priority mode and select the *smallest* f/stop available to *increase* the depth-of-field. And keep in mind what you learned about how depth-of-field is arranged: Two-thirds is allocated to the area in front of the plane of sharpest focus, and only one-third to the area behind it. Figure 17.20 shows a dandelion shot with the widest f/3.5 lens aperture, so only the closest portion of the flower is in focus. Figure 17.21 shows the same dandelion captured using f/22.

- **Take advantage of selective focus.** You don't always want to have maximum depth-of-field. You can use a wide open aperture to isolate your subject, as in Figure 17.22. The wider aperture also allows using a higher shutter speed, which can be necessary when shooting plantlife outdoors, because the slightest breeze can cause your subject to waver or flutter in the wind.

- **Watch alignment.** If you're shooting your subject head-on, check to make sure the back of the camera (where the sensor is located) is parallel to the plane in which your main subject lies. That's the plane you'll be focusing on and where the maximum amount of sharpness lies. If the

Figure 17.19 Focus on the front (left) and back (right).

Figure 17.20 With the lens wide open, only the closest portion of the dandelion is in focus.

Figure 17.21 If you stop down the lens to a smaller aperture, the depth-of-field increases.

camera is tilted in relation to the plane of the main subject, only part of the subject will be in sharp focus.

- **Stop that jiggle!** If your subject is inanimate and you're using a tripod, consider using your digital camera's self-timer or remote control to trip the shutter after a delay of a few seconds. Even if you press the shutter release button cautiously, you may shake the camera a little. Under incandescent illumination with a small f/stop, your camera will probably be using a slow shutter speed that is susceptible to blurring with even a little camera shake. Use of the self-timer or remote control will let the camera and tripod come to rest. (You may also want to lock up your mirror.)

- **Bring models to life.** One cool use for close-up photography is to make miniatures look life-size through careful selection of perspective and focus. Set your camera at a height proportional to the position that might be used to shoot the "real" object, and you can get results like the shot of the toy train in Figure 17.23.

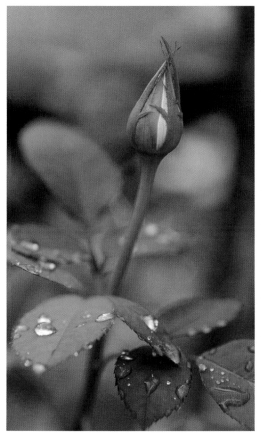

Figure 17.22 Use large apertures and selective focus to isolate your subject from its background.

Figure 17.23 Choose your camera angle carefully to make a model appear to be full size.

- **Find new worlds in common objects.** Figure 17.24 shows a pile of ordinary cast-iron cannon balls. Their rusted exteriors make an interesting close-up shot, but when you zoom in *really* close, as in Figure 17.25, the relics become something mysterious. You can shoot macro photos of everything from grains of sand to drops of water to create compelling and mysterious images.

- **Carry a spray bottle of water.** If you're shooting plants, you can spritz some ready-made "dew" on the leaves and petals for a glistening look. (See Figure 17.26.) If you're not, you can readily hydrate as you work.

- **Stop, look, listen!** Wait a few seconds after you hear the camera's shutter click before doing anything. You might have forgotten that you're taking a long-time exposure of a couple seconds or more! The click might have been the shutter opening, and the camera may still be capturing the picture. If you have picture review turned on, wait until the shot shows up on the LCD before touching the camera.

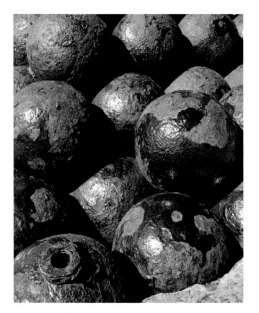

Figure 17.24 A pile of cannonballs makes an interesting subject...

Figure 17.25 …that can become mysterious when captured close up.

Figure 17.26 When shooting flowers, carry a spray bottle to spritz the blossoms with water droplets.

Index